Theatre of Sound
Radio and the Dramatic Imagination

Dermot Rattigan

Carysfort Press, Dublin

A Carysfort Press Book

Theatre of Sound | Radio and the Dramatic Imagination

First published in Ireland in 2002 as a paperback original by
Carysfort Press, 58 Woodfield, Scholarstown Road,
Dublin 16, Ireland.

Typeset by Carysfort Press
Cover design by Alan Bennis

Printed and bound by Leinster Leader Ltd
18/19 South Main Street, Naas, Co. Kildare, Ireland

This book is published with the financial assistance of
The Arts Council (An Chomhairle Ealaíon), Dublin, Ireland.

To the fond memory of my late parents,

Martin and Josephine

Acknowledgements

I would like to express my profound gratitude to:

Dan Farrelly
and
Elizabeth Cahill
whose advice and encouragement have helped me in the
writing of this book;
Una Farrelly for her warm hospitality.

I would also like to express my appreciation to Alan Beck, Barry
McGovern, Lucy Gough, Daniel Reardon, and Richard Allen Cave.

Contents

Preface

Is radio drama 'blind' or 'invisible'? One view is that radio drama is a fireside Cinderella, who hasn't yet made it to the media ball. But already in 1924, George Bernard Shaw championed the 'invisible play', and recognized the new art form in itself and its aesthetic possibilities. *Theatre of Sound* is a rich and provocative book which opens up all sorts of avenues for exploration. Its enthusiasms will move students, teachers, and radio listeners into new insights.

The key to Dermot Rattigan's analysis is a versatile sense of sound and especially music. He is particularly savvy on the need to extend our analytical vocabulary, and he builds on his earlier career in broadcasting and music. I especially appreciate that radio drama is 'orchestrated' (Chapter Three), a theme that runs through the book, and that music is under-used by playwrights and directors. Chapter Fifteen, 'Music', links theory and meta-phors of music to some recent work on how we listen.

Theatre of Sound is particularly timely. We are into a new age of digital radio drama when it is possible to hear Irish plays around Europe (via the Astra satellite and Sky) and worldwide, on the Internet. As one of the Irish diaspora, I enjoy the latest from RTE, and the strengths of Irish acting, directing and writing. That long RTE tradition, which unites Irish radio plays across the UK and Republic, needs defending as never before. The digital age also means new competition because it is now

possible – for some listeners – to compare radio plays across the world.

So while *Theatre of Sound* is very useful in consolidating recent scholarship, I can guess at Dermot Rattigan's next book. The digital age is transforming both production and writing. Directors can be confident about moving out of the studio and into all sorts of locations. For some independent productions, it is cheaper to do so. There are the adventurous like John Dryden (Goldhawk Productions in London) who provides a cross-over between film and the radio play. After all, our ears have been transformed in the digital age, and not just because of Dolby surround-sound in the cinema and home THX systems. We are all now 'super-listeners' (Gianluca Sergi) and radio drama constantly has to play catch-up. There are some concise ideas on the future in Chapter Seven, 'Radio and Language'.

This book comes in a season of anniversaries. November is the eightieth birthday of the B.B.C. (14 November 1922 - 14 November 2002) and it is now twenty-five years since the first academic conference on radio drama (see Chapter Five, 'Under Milk Wood', for material from this).

Dermot Rattigan is a valued contributor to the yearly London conference at Goldsmiths, and part of a growing team of scholars and a renaissance of published work on the subject. (See, on the Internet, the Radio Hub at http://www.ukc.ac.uk/sdfva/radio/index.html.) This leap forward is also due to close collaboration with leading practitioners, such as RTE's Daniel Reardon and Gordon House of the B.B.C. Radio directors are very generous with their time (and patience), admitting scholars and students into their studios, to observe productions in the making.

Scholars of radio drama can cut the theoretical pie in any number of ways. But this book extends from audience reception theory – and I appreciate the apt phrase, 'role reversal' for how active listeners are – to storytelling (in Chapter Eight), and deep reflections on radio versions of *King Lear* in Part Three. This latter is a radically new analytical approach and a synthesis of the best approaches in this book. Comparative analysis is the regular task of much scholarship on the novel, stage play and in musicology. Adaptations or 'transforming', especially into film,

is a new 'hot' area of postmodernist study. For radio, beyond Zilliacus on Samuel Beckett, rarely has there been such an insightful and elegant explanation of this transformation process.

After reflecting on *Theatre of Sound,* can we say 'What you see is what you hear'? Is listening to radio drama more 'real' than seeing? 'Blind' or 'invisible'? Our ongoing debate about the nature of radio drama is now more critically based as a result of Dermot Rattigan's essential and thought-provoking book.

This book is not just a coherent and wide-ranging volume for specialists, but it should attract new audiences to radio drama and serve as a well-informed and pleasurable guide to new writers.

Alan Beck

Drama Lecturer at the University of Kent, Canterbury
BBC Research Fellow in Radio Drama

Part One | Traditions

Introduction | What is a radio play?

William Ash's concise one sentence definition of what constitutes the radio play encapsulates the complexities of the art form into one easily understood concept: 'The radio play can be defined quite simply as a story told in dramatic form by means of sound alone.' [1]

The simplicity in Ash's statement also highlights the fundamental difference between radio drama as a dramatic art form and the other dramatic art forms of theatre, film and television, that is, it is a performance medium that is exclusively based in sound. Exploring what constitutes radio drama as a dramatic performance genre forms the basis of this investigative work.

Radio drama is not handicapped by the absence of any visual output, on the contrary, its 'sightlessness' is the basis of its unique appeal, which promotes an imaginative visualization on the part of its listeners. Orson Welles recognized the uniqueness of the radio medium when he advocated that the radio play requires a 'drastically different' approach from that of the visual stage.

> This is because the nature of the radio demands a form impossible to the stage. The images called up by a broadcast must be imagined, not seen. And so we find that radio drama is more akin to the form of the novel,

to story telling, than to anything else of which it is convenient to think.[2]

My aim here is to create the concept of radio/sound drama in its performed medium as being an inclusive form of aural performance literature. This represents a challenge to the perceived acceptance of radio drama as being a lesser art form when compared to the other dramatic genres.

The radio drama experience can be divided into three main processes.

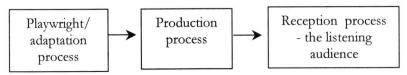

However, performed radio drama is the combination of two inter-dependent processes generally referred to as the production process. (i) The performance process (words, voices, utterances, silences/pauses, music etc.) and (ii) the technical process (acoustics, aural distancing, fades, electronic processing etc.).Voice and words are considered to be the primary aural agents in radio drama, that is, both are mutually dependent upon each other. Therefore, the consideration of voice and vocal types, as they apply to vocal acting for the microphone, is critically important in that the emphasis in vocal performance is less on what is said (textual basis) than on how it is said (performance basis). The aural affects of vocal performance in influencing imparted aural meaning are exponentially explored in the sections on Radio Production Analysis of *King Lear*.

The uses of sound effects, silence/pause, verbal utterance and aural spatial relationships are somewhat easier to categorize for performed radio drama; however, the area of music creates greater difficulty. There are at least two dialectical views on the use of music in radio drama. One stems from the view of music as being purely external to the internal dramatic action, that is, that music has a role as an external structural framing device with possible extended significance in creating a sense of mood. In this case the internal elements of the music, its composition and

sounds have no meaningful significance to the drama itself, for example: plot, characterization, unspoken thoughts, anticipatory functions etc. The other view, less frequently expressed, is that music, accepted as an equal with all other sonic/aural events, can define and impart meaning on a sub-textual level as a paralanguage in its own right, for example, the music's compositional structure of melodic, harmonic, rhythmic, instrumental and tonal elements. This musical paralanguage is only truly meaningful when qualified by or within the context of the drama and the spoken dialogue. The debate concerning music and meaning, once confined to the discipline of pure music study, is now a shared area of research with the science of psychoacoustics and the human perception of sound. The concept of 'music-making-meaning' is a long accepted belief by many composers, particularly those composing in the 'programme' music genre. Regrettably, not enough radio drama productions make use of music's illustrative potential as an aural signifier of sub-textual information.

The argument that radio drama is an aural literature is based on the premise that what is heard as the radio play by a listener is the totality of sonic elements orchestrated in the radio production as the performance text. The production's performance text becomes *de facto* the sonic dramatic text for the listener as he/she aurally 'reads' it as an aural form of literature. This peculiar role reversal is somewhat unique to radio drama and highlights a significant problem in the debate concerning an inclusive critical analysis of the genre; that is, whether the printed dramatic text is alone a sufficient or an accurate enough means to form a perceptive aurally imaginative analysis of the work through sound. As sound needs to be 'heard' to be realized and, by extension, continuously heard if a sound is intended to be continuously present, therefore, sound indications symbolized by words in a text can prove a most difficult task for most people to imaginatively hear and retain. I would further argue that as reading is an acquired skill, sounds symbolized as words are naturally read as words and where their literal meaning may be understood, it is more difficult to imaginatively hear the physical sound, particularly complex sounds, represented as words.

Therefore, the importance of the physical sound for the dramatic action can often be overlooked in a literal reading of the text. The problem is greatly exacerbated where sound that is symbolized as words at one point in a text is intended to continue as an integral part or sonic backdrop during later parts of the text. It is also important to note that some dramatic radio texts may contain little or no *obvious* sound indications but may be contextually implied or added during the production process and may only become aurally apparent when the play is heard. In these cases, the sonic possibilities and importance of sounds to the text may remain visibly and aurally hidden to the reader.

Examples of aural 'sound' notated as word symbols abound in the textual form of radio drama. One example is a sequence of separate sounds which, when sequentially and sonically realized, form a completed sound entity, a sound montage. An example of this type of sound design is required by Tom Stoppard in his radio play, *Artist Descending A Staircase*. The sequence of sounds once completed as a montage, which includes verbal and non-verbal utterances, is repeatedly played as an integral part of the ensuing dialogue. The opening sequence in the play forms a type of contextualized counterpoint to the actor's dialogue following.

In this example Stoppard employs three interesting devices. First, he composes a sound montage using a successive sequence of sound events just as a piece of music is composed. Second, he repeats the sound montage <u>not</u> as an accompaniment to, or a backdrop for, the dramatic dialogue but as an integral part of the dialogue. Stoppard indicates this in the script by annotating precise points in the sequence of sound events, which now becomes a counterpointing inanimate sonic character between MARTELLO and BEAUCHAMP. These annotations are clearly not intended to visually remind the reader that the sound montage is repeating. Instead, Stoppard uses them as (i) an orchestrated sonic exposition of the unfolding plot and (ii) as a structural device for performance timing.

Artist Descending A Staircase (Tom Stoppard)[3]

We hear, on a continuous loop of tape, a sequence of sounds which is to be interpreted by MARTELLO *and* BEAUCHAMP *thus:*

(a) DONNER *dozing: an irregular droning noise.*

(b) *Careful footsteps approach. The effect is stealthy. A board creaks.*

(c) *This wakes* DONNER, *i.e. the droning stops in mid-beat*

(d) *The footsteps freeze.*

(e) DONNER's *voice, unalarmed:* 'Ah! There you are ...'

(f) *Two more quick steps, and then Thump!*

(g) DONNER *cries out.*

(h) *Wood cracks as he falls through a balustrade.*

(i) *He falls heavily down the stairs, with a final sickening thump when he hits the bottom. Silence.*

After a pause, this entire sequence begins again ...Droning ... Footsteps ... (as before).

MARTELLO: I think this is where I came in.

 (TAPE: *'Ah! There you are...'*)

BEAUCHAMP: And this is where you hit him.

 (TAPE: *Thump!*)

MARTELLO: I *mean*, it's going round again. The tape is going round in a *loop*.

BEAUCHAMP: Well, of course. I record in loops, lassoing my material–no, like trawling–no, like–no matter.

 (TAPE: DONNER *reaches the bottom of the stairs.*)

MARTELLO: Poor Donner.

 (MARTELLO *and* BEAUCHAMP *are old men, as was* DONNER.)

 (*The* TAPE *starts as before.*)

> BEAUCHAMP:　　(*over* TAPE): Round and round, recording layer upon layer of silence while Donner dozed after a heavy lunch, the spools quietly folding silence upon itself, yes like packing linen into trunks...Fold, fold until the footsteps broke it...and woke him-
>
> (TAPE: *'Ah! There you are......'*)
>
> How peaceful it was...(etc.)

The author, radio drama producer or musician will most likely read the sequence not as a sequence of descriptive words but as collection of aural sounds making a sound montage. This enables them to imaginatively 'hear' the complete sound montage and retain the running sequence of sounds during the ensuing dialogue. Readers of the text who are not familiar with thinking-in-sound will certainly understand that the opening directions refer to a series of sounds but may not imaginatively hear and retain the sound montage as a sonic counterpoint in the ensuing dialogue. This example in part lends support to the view that performed/produced radio drama is an inclusive aural literature in its sonic realization.

A further example from the play highlights a greater problem for all concerned in trying to imaginatively 'hear' the resulting composition of abstract sound from a purely literary description.

Artist Descending A Staircase (Tom Stoppard)

> BEAUCHAMP's *'master-tape' is a bubbling cauldron of squeaks, gurgles, crackles and other unharmonious noises. He allows it to play for longer than one would reasonably hope.*

Although the reader may adequately guess at the type of sound produced as indicated by the text e.g. a squeak, a gurgle, a crackle etc., it is much more difficult for the imagination to hear them as a composed sound montage; for example, how high pitched are the squeaks? What are the sounds of gurgles? What is the tempo of the crackles? What are the 'other unharmonious noises'? And

what is the completed sound of the montage when they are all put together? Should the composed montage be merely dissonant or humorously dissonant? Here is a typical example of a textual sound montage that can only make aural sense after it has been sonically realized. But this sound montage, beyond the fact that it is 'sound', is also highly significant at this point in the play to the ensuing dramatic action. Firstly, as a composition it could be described as an aural symbolic icon of BEAUCHAMP's creative mind; secondly, it provides the initial focus for a humorously bitter discussion on the meaning of art. BEAUCHAMP and DONNER at this point are two elderly artists, (DONNER, a visual painter and BEAUCHAMP, a sound painter!), both engaged in their own war of mutual disrespect for each other's art.

Artist Descending A Staircase (Tom Stoppard)

BEAUCHAMP's *'master-tape' is a bubbling cauldron of squeaks, gurgles, crackles and other unharmonious noises. He allows it to play for longer than one would reasonably hope.*

BEAUCHAMP:	Well, what do you think of it, Donner? Take your time, choose your words carefully.
DONNER:	I think it's rubbish.
BEAUCHAMP:	Oh. You mean, a sort of tonal debris, as it were?
DONNER:	No, rubbish, general rubbish. In the sense of being worthless, without value; rot, nonsense. Rubbish, in fact.
BEAUCHAMP:	Ah. The detritus of audible existence, a sort of refuse heap of sound…
DONNER:	I mean, *rubbish*. I'm sorry, Beauchamp, but you must come to terms with the fact that our paths have diverged. I very much enjoyed my years in that child's garden of easy victories known as the avant garde, but I am now engaged in the infinitely more difficult task of painting what the eye sees.
BEAUCHAMP:	Well, I've never seen a naked woman sitting about a garden with a unicorn eating the roses.

DONNER: Don't split hairs with *me*, Beauchamp. You don't
 know what art is. Those tape recordings of yours
 are the mechanical expression of a small intellectual
 idea, the kind of notion that might occur to a man
 in his bath and be forgotten in the business of
 drying between his toes…(etc.)

The ability to read and silently 'hear' the music from printed music notation is another example of 'imaginative sonic reading.' Music notation employs a different iconic system from that of the printed word. The trained musician, for example, can silently 'read' an orchestral score and imaginatively hear the pitches, melodies, harmonies, rhythms, dynamics and instrumental colours in the piece notated as a series of dots across a number of lines. In this case most musicians have developed the ability through training not only to think in sound but also to imaginatively 'hear' sound from its silence upon the printed page. The music composer who writes music from the silent imagination is perhaps the greatest exponent of this ability. I would also extend this example to include radio drama playwrights who write from their aural imagination with words, sounds and music. Their work expressed as text on the silent page awaits its sonic realization and aural reception.

The production process that transmogrifies a literary dramatic text into an aural dramatic text is illustrated in the diagram below. The 'dramatic text' [represented as D–(minus)] is the author's literary inception, a basis for performance but as a literary text it remains silent and without dramatic realization. The 'performance text' [represented as D +] becomes the sonic realization of the dramatic text. Through the juxtaposition and combination of the interactive elements involved in the radio drama production process, the dramatic text is transformed and transcodified into a sonic performance text the listener hears both as the radio play and as an aural (dramatic) literature. I would argue, therefore, that the combined elements of the production process form an identifiable and structural syntax for the sonic performance of radio drama realized as an aural literature.

In order to present a degree of clarity, I have grouped certain technical elements to the left of the circle (e.g. balance, fades, microphone distances etc.), language functions to the right and music functions underneath. It is important to realize that all the elements combine to perform in a semiological system of interlocking functions, bound together as the spokes of a wheel are.

Transcodification of textual codes through performance and production into aural codes:

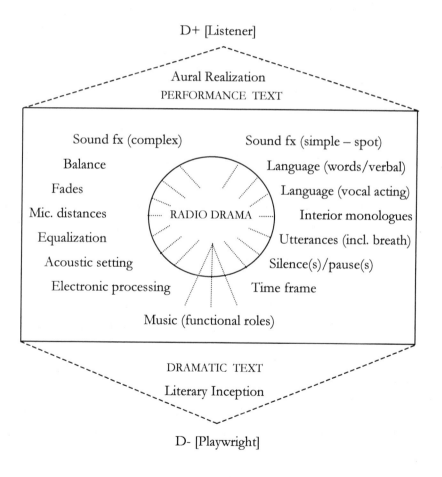

D+ [Listener]

Aural Realization
PERFORMANCE TEXT

Sound fx (complex) Sound fx (simple – spot)

Balance Language (words/verbal)

Fades Language (vocal acting)

Mic. distances RADIO DRAMA Interior monologues

Equalization Utterances (incl. breath)

Acoustic setting Silence(s)/pause(s)

Electronic processing Time frame

Music (functional roles)

DRAMATIC TEXT
Literary Inception

D- [Playwright]

The above example illustrates some of the main sonic elements involved in the radio drama production process. These elements can be described as 'visually invisible' but 'aurally visible' to the listener, and are as critically important to the sonic realization of radio drama as those of sets, props, lighting, costume, make-up, gesture, movement, voice, blocking etc., are to the visible stage performance.

1 | Who's Listening? Some Statistics

When television was introduced on a wide scale in Britain in the 1950s, its rapid growth in popularity was contrasted by an equally rapid decline in radio listening. This was exacerbated by an economic upturn following the years of post-war economic depression, which heralded a dramatic socio-cultural change in the entertainment patterns of the nation. BBC radio as it was then, began to sound reminiscently old, particularly to a new emerging youth culture influenced by the even newer musical import of rock and roll. To the older generation, BBC radio was a reminder of a 'radio sound' then best forgotten, the sounds of the war years; of air raid sirens, the sounds of huddled fear in bomb shelters, of threats of invasion, of black-outs with the sounds of radio as the tangible link to an uncertain world outside, of the sounding need for reassurance, of the nervous if insatiable need for the sound of news, the sounds of war reports; the sounds of hardship and rationing, of the disruption to normal life, of the fragmentation of family life, the absent sounds of husbands at war and the never to be repeated sounds of those killed in action, of children relocated to distant parts of the country, the sounds of the surviving wounded, and finally, the sounds of economic depression and an uncertain future that immediately followed the war.

The advent of television offered something new, different and intriguing. It came to represent the view both economically and

socially of a new confident world order. To all intents and purposes television provided a miniaturized version of the cinema screen in the home. During the 1950s, television rapidly began replacing radio as the new provider of home entertainment in Britain and the U.S.A. In America the Golden Age of radio had been finally put to rest once television made its impact in the early 50s. Radio in the U.S.A. was primarily a commercial venture where audience figures for any particular station had a direct bearing upon the station's advertising revenues. In its fight to maintain its audience ratings, radio relied upon its elite weapon, its sense of immediacy. The media theorist, Marshall McLuhan, made a terse assessment of the effects of television upon radio programming from the North American perspective.

> One of the many effects of television on radio has been to shift radio from an entertainment medium into a kind of nervous information system. News bulletins, time signals, traffic data, and, above all, weather reports now serve to enhance the native power of radio to involve people in one another. Weather is that medium that involves all people equally. It is the top item on radio, showering us with fountains of auditory space or *lebensraum.*[1]

The BBC in Britain held the monopoly on broadcasting for both radio and television until the 1960s and the advent of licensed commercial broadcasting. For a public service broadcaster principally financed by the national licence fee and barred from taking advertising by its charter, the need to compete for audiences as a commercial necessity was a less critical factor. The emphasis was placed upon quality programme content rather than maintaining a quantity of listeners in the knowledge that well planned and executed programmes were being 'actively' listened to. This, however, did not prevent the inevitable competition between the new visual form of television broadcasting and the established sonic form of radio broadcasting. Whereas the radio audience has often been described as a 'private' listening audience, the introduction of television generated a new category of audience, the semi-private or group audience, which had a collective and direct effect upon

the number of people listening to radio. This new television audience came together as a 'collective' to *watch* the television in a similar way to a theatre or film audience. Although the television audio was heard, the primary focus of attention was visual, where moving pictures were presented in a pre-formed and pre-packaged visible identity.

Radio, by its nature, always broadcasts on a macro scale, that is, to all listeners at the same time; but is heard on a micro scale by individual listeners in the private act of conscious (active) and unconscious (passive) listening. It is the individual listener's ability aurally to interpret and through the neurological process imaginatively to reconstruct the radio signal that gives radio its oft quoted accolade, that it alone has the unique ability to communicate directly with each *individual* while broadcasting to *all* listeners. Following the popularity of television and its inevitable draw upon radio audiences, concerns were being expressed as to whether there would remain a sustainable audience for well planned and time consuming radio programmes. The concern expressed in 1959 by Donald McWhinnie, a distinguished BBC radio drama producer, is therefore understandable, 'that radio at its best is a private experience; the problem in the modern world is whether there is any continuing use for it.' [2]

Radio did survive its competition, rescued in part by new concepts in music broadcasting and the invention of the portable or transistor radio in the early 1960s. The growing opinion in the late 1950s that radio was a dead medium curiously remains current today as an inaccurate and ingrained assumption despite overwhelming facts to the contrary. Now, eighty years after the establishment of radio broadcasting in the 1920s, radio world-wide continues to maintain its position as an 'almost universal medium of communication.' [3] In the new millennium and despite continuous and intense competition from other entertainment industries, radio continues to flourish and to attract new audiences. It is acknowledged as playing an equal if not a more important communicative role than television in the daily life of most nations.

> Radio is provided with its cloak of invisibility, like any
> other medium. It comes to us ostensibly with person-
> to-person directness that is private and intimate, while
> in more urgent fact, it is a subliminal echo chamber of
> magical power to touch remote and forgotten chords ...
> Even more than the telephone or telegraph, radio is that
> extension of the central nervous system that is matched
> only by human speech itself.[4]

McLuhan's philosophical assessment of radio's psychological
appeal is interesting in the light it throws upon radio's unique
relationship with its listeners. Sound, once heard, is absorbed
through the human body, its tissues, central nervous system,
neurological system etc. Therefore any sound, but in particular
'invisible' sound such as radio sound, touches a remote primate
response in the human once it is heard.

In Britain, for example, radio has never been healthier.
Contemporary radio proves to be a vibrant, competitive and fast
moving industry. Today, despite the fact that every home has as
many as five radio sets, twelve million new sets are sold every
year compared to just four million television sets. The statistics
record that 85% of the adult population listen to radio and the
average listener did so for over twenty hours a week.[5] Radio's
commercial operators view it as an industry whose growing
power and influence in people's lives translates into a simple
equation, that is, increased listeners equals increased revenue
through advertising. The Radio Advertising Bureau in Britain
estimated that 'commercial radio's revenues in 1995 amounted to
£270.2 million, a growth of more than 20% from the previous
year.' [6] These statistics reflect upon a vibrant and booming
commercial radio industry.

Radio in all of its broadcasting formats tends to play a greater
part than television in the daily lives of most people. Whether
listening in the home, driving in the car, commuting on public
transport, walking in the street with a Walkman/headphones etc.,
people are *listening* to some form of personally chosen sound.
Perhaps because the radio signal is an invisible entity and is
'freely' there, or perhaps, because *listening* is primarily a private
activity, we overlook the fact that at any one moment in time

thousands upon thousands of individuals are *listening* to the same radio signal. A disparate group of private individuals drawn together as a collective audience through a shared *listening* experience.

Despite the overwhelming statistics showing strong growth and a healthy prognosis for the future of the radio industry, radio drama remains stubbornly regarded as a 'Cinderella' art form by almost all but its audience and practitioners. Such ill-founded assertions, even from within the radio industry itself, are drawn from that curiously ingrained and commonly held assumption that speech radio is a dead medium.

In 1971 Martin Esslin estimated that a 'drama performance broadcast [by the BBC] on Saturday night with a repeat performance on Monday afternoon drew an audience of 1.5 to 2 million listeners. The equivalent, that is, of a run of between 1500 and 2000 sold-out performances in a theatre holding a thousand people – a run of more than five years.'[7]

Richard Imison (Script Editor, BBC Radio Drama) writing in 1984 provided some interesting up-dated statistics: 'In 1984, the output was as large as ever, with well over 300 original single plays on Radio 4 and Radio 3, out of a massive total of nearly 2000 broadcasts, including series and serials, adaptations, features, readings and poetry emanating from the BBC's Drama Department. In the course of the year nearly 80 playwrights had their work performed, for the first time in any medium ... The experimental play which may be given wide critical attention in the national press having been seen by a few hundred people (or less) in a fringe theatre is likely to attract at least fifty thousand in radio. Daytime drama on Radio 4, broadcast every day of the week and including three original plays alongside repeats of evening plays such as Saturday Night Theatre or the more demanding Monday Play, was regularly heard in 1984 by about three million.'[8]

In his Preface to the *Best Radio Plays of 1987* Imison states that the number of times individual listeners switched on to a radio play in the course of the past ten years was a prodigious seven billion. Placing this figure in context Imison adds: 'We may all have been

counted amongst that seven billion but the figure astonishes us because our experience was essentially a personal, individual one, carrying little sense of being shared by others. On Cup Final day at Wembley we can, exceptionally, see in one place a crowd of people equal only to one fifth of the audience for any Afternoon Play [BBC 4] yet the notion seems unreal even in terms of this simple comparison.' [9]

A senior radio drama producer with RTE recently told me that the average listenership figure for the hour long 'Tuesday Play' (9.00 p.m. - 10.00 p.m.) was about 50,000 listeners. When the somewhat unfavourable time of the broadcast is taken into account this remains a sizeable minority audience. He added that considerably higher audience figures have been recorded for well advertised/publicized drama specials.

In the following comparison I use the figure of 50,000 radio listeners to a *single* broadcast compared to their hypothetical placement at three Dublin theatres representing capacity sell-out seating for a large, medium, small, and studio space environment. Repeating Esslin's 1971 calculations in a contemporary Irish setting produces audience attendance figures for a single play that in theatre terms would be described as an 'outstanding success' but what I would describe as provocatively revelatory.

The comparison is based upon a week of 6 nightly sell-out theatre performances where six nightly performances per week is the norm for all of the theatres.

[Perfs. = **Perf**ormances; Wks. = Weeks; Mths. = Months]

RTE: The Tuesday Play (listeners) 50,000

	[Seating]	Perfs.	Wks.	Mths.
The Abbey Theatre	628	80	13	3[+]
The Gate Theatre	371	134	22	5½
Andrews Lane Theatre (S)	220	227	38	9½
Andrews Lane Theatre (St.)	75	666	111	28

Radio drama in Ireland has an existing sizable minority audience and an audience that includes many regular 'theatre goers' and participants. Radio can also provide an important audience access point for emerging and established playwrights. Indeed, the potential for increased audience growth in this genre could be substantial. The need for a rethink on radio drama policy to include possibly some level of Arts Council involvement is timely. The radio play has, and continues to be, an important if a much neglected part of our literary heritage. Yet, there is a fundamental reluctance at many levels to accept radio drama as a dramatic art form in its own right. Such reluctance, I believe, is at best a begrudging acknowledgement of the plays written for this medium. At its worst it denies those works and their writers their rightful place within the dramatic literary heritage of the nation. This denial, with the notable exception of a handful of major playwrights, fosters a belief in academic, educational, and broadcasting circles that radio drama is no more than some type of ephemeral hybrid that evaporates in the ether.

One justifiable defence for the academic neglect of radio drama is the deplorable dearth of published radio plays in print form. With the notable exception of some playwrights, Beckett, Pinter, Stoppard etc., virtually all other transmitted radio plays never appear in print. One has to acknowledge the existence of a vast literary presence in radio drama especially the literary output of specifically written radio/sound plays. In simple human terms, playwrights have to, metaphorically, sit down and physically write the play onto paper as they would for any other dramatic medium. The radio playwright's primary publisher is the commissioning radio station, therefore, the actual publication of the play is its broadcast. While the production/broadcast is the dramatic (sonic) realization of a play and the ultimate form of radio drama publishing it is imperative beyond the broadcast that the availability of both the broadcast and its text be made accessible. Whereas the intellectual copyright is owned by the playwright and the dramatic performance copyright by the radio station, the tangibility of the genre will never be concretized if its evidence is locked away as 'broadcasted' archive material and quickly forgotten about.

At a literature conference in 1977, Peter Lewis identified three main obstacles, which he believed hindered radio drama in gaining academic respectability: (i) its very newness, (ii) its lack of tradition, and (iii) its lack of a critical vocabulary. Now, eighty years on from the birth of broadcasting, his first two points have less relevance. However, I am in full agreement with Lewis on the third point, that a lack of a critical vocabulary is tantamount to a lack of criticism. This echoes the dialectical dichotomy spoken of earlier with regard to forming a structure of analysis that is accurate in contributing analytical tools that are capable of incisive critical assessment of the 'distinctive artistic characteristics' of radio drama. The emphasis, heretofore, upon textual based criticisms of radio drama would appear to have fallen short of that elusive and specialized critical vocabulary. Though music can be analysed for its structural and compositional elements from its silent form upon the page, and even accepting the highest degree of imaginative aurality, it is not until the music is played that the sonic reality of its silent form takes its proper shape. The radio play is no different. This work, it is hoped, will begin to address that third obstacle.

The radio drama audience is comprised of those who deliberately tune-in to hear a play; those who generally listen to radio at the times plays are broadcast; and those who casually tune-in and decide to stay-with the play or not, depending upon the interest it holds for them. The critical point here, which is sometimes overlooked, is a testimony to radio drama's dramatic and entertainment value to the listener when it is considered that it is being provided 'free' on the airwaves to a non-captive audience who choose to listen. 'Great' radio can certainly be accused of 'captivating' its audience but never can it be accused of making its audience 'captives.' Given the myriad choice of alternate stations broadcasting at the same time, the listener can 'tune-over', or make the simpler choice of 'turning-off.' The distinctive difference between radio drama listeners and the cinema/theatre audience is <u>not</u> that the radio listeners receive their entertainment free; but that they freely choose to listen. And whereas television by its nature demands a high degree of visual entrapment, radio

frees both the individual and their imagination. 'Radio was not considered to be intrusive in the way that television was.' [10]

Alan Beck recognizes that radio drama in Great Britain is a 'huge industry with a wonderful tradition, employing some 14,000 actors a year, and a turnover in fees of about £6 million. Equity estimates that BBC Drama and Light Entertainment [radio] issued some 14,500 actor's contracts in 1996. Fees earned by London contracts in the last financial year amounted to £3,012,000.' [11] In stating that 'radio is part of the daily life of almost everyone who lives in the UK ... even people with in-car CD systems listen to more radio than records,' [12] the radio critic, Gillian Reynolds quotes from a 1994 RAJAR survey which estimates that 'there are 40,804,000 listeners each week who take in 847,735,000 hours of output.' She adds that 'music is our first choice, news and sport come next, but a long way after; deeper explorations of thought or fact through documentary, features and drama attract much smaller audiences yet their numbers still bear comparison with television programmes or newspaper articles in the same vein.' [13]

Statistical figures in the United States also show a substantial increase in general radio listening. David Bartlett (President of the Radio-Television News Directors – Washington D.C.), quoting from the 1992 statistics, states that 'there are 22% more radios in the country than in 1980.' [14] In 1992 there were 576.5 million radio sets in use and in the same year Americans bought 71 million radios in 1992 (including 38.3 million battery operated models – portable radios) giving an average of over 5 radio sets per household. 95% of Americans listened to radio for an average of 3 hours and 20 minutes per day. The statistics prompted Bartlett's assessment that 'with numbers like those radio doesn't sound like a dying medium.' [15] Marilyn Matelski (Professor of Communication, Boston College) estimates that in 1995 advertising revenue from radio 'soaps' amounted to 'more than $900 million in total network revenues each year – one-sixth of all annual network profits.' [16] Clearly people are listening to radio in ever increasing numbers.

Howard Fink's belief that 'radio, especially in its dramatic form, returns us to a pre-print complexity of communication,' [17] is enlightening. Radio, a generic term encompassing a diverse range of programming formats, is universally accepted as being a primary means of mass communication. Radio's level of communication with its audience is quite different from that of television or the cinema. It communicates in an individual and direct way, similar to the actor/audience relationship in live theatre, but perhaps more closely resembling the emotive communication bond between music and its listeners. Radio and recorded music, as distinct from live concert performances, is a purely aural experience. As an aural experience that does not contain a pre-constructed visual image, it can more effectively stimulate an imaginative visual awareness. Sir Christopher Bland (Chairman, BBC) stated that 'the keys to radio's hold over its audiences and its programme-makers are Imagination, and Passion ... radio, unlike television, demands that we use our imagination, in drama and the spoken word, and stimulates it musically as well.' [18]

It would be impossible to substantiate a claim that radio *is* 'all things' to all people, but through its polymorphic nature it philosophically *could* be. The vast global network of on-air radio stations can be reduced to one key point that defines the broadcaster-listener relationship in any country and through any language; and that is listening. By listening, the human species employs the same aural and neurological processes to hear sound and interpret its meaning. Where radio is the generic medium of transmission, individual listening is the actual point of reception. Because of the uniqueness of its medium, the broadcaster-listener relationship; its fundamental element of immediacy or 'liveness'; the diversity of its programming; and the 'invisibility' of its sound, radio defies a singular definition of its entity.

'Radio affects most people intimately, person-to-person, offering a world of unspoken communication between writer-speaker and the listener…The subliminal depths of radio are charged with the resonating echoes of tribal horns and antique drums. This is inherent in the very nature of this medium, with its power to turn the psyche and society into a single echo chamber.' [19]

2 | The Birth of a Genre

> 2 LO calling.
>
> That was *Drake Goes West*, sung by Mr. Leonard Hawke, baritone.
>
> One moment please, while we move the piano.[1]

Such was the style and sound of radio that greeted the listener in the early years of broadcasting. It was 'live' and it was happening in the 'present' as the listener listened. The sounds of the piano being moved, no doubt efficiently but nonetheless manhandled away from the microphone, would have been in stark contrast to the inanimate Received Pronunciation style of the presentation or the rehearsed and polished performances of the artists. The interruption of naturalistic moving sounds puncturing the sound of the otherwise broadcasting 'professionalism' was as unintentional as it was unavoidable – it was after all the 1920s and the fledgling beginning of a new medium of mass communication. Recording tape did not exist in the 1920s, so no form of pre-recording/editing existed[2], and neither was the technique of controlling multiple microphones devised until 1928 – it was 'live' one microphone broadcasting at its best. That sense of naturalism fragmenting the 'professionalism' of the medium placed the listener in the privileged position of eavesdropping on the logistics of making radio – the magic of the wireless made

aurally transparent to its listeners through the immediacy of its medium. Its naturalistic interjections aurally contributed in some way to a belief in the 'truthfulness' of the medium, which in turn may have dampened the creative development of radio's fantasy world, that is, its dramatic medium. The dramatic results of fantasy presented as fact and its unforeseen outcomes will be discussed later in relation to the public reactions over Orson Welles's original radio broadcast of *The War of the Worlds* (1938).

The advent of radio in the 1920s, euphemistically referred to as the 'wireless', was as great a technological revolution then as that of television in the 1950s and the Internet in the 1990s. Radio's contribution towards social change was at its height during its broadcasting monopoly years, and today, in spite of a highly competitive media environment, radio continues to play a significant role both as a reflector of societal trends and as a vehicle for social change. Some examples of this in an Irish context, (with the exception of specifically news orientated programmes), can be witnessed in the public reactions to presenter led programmes such as *The Gay Byrne Show* (RTE1), *The Pat Kenny Show* (RTE1), and in the multiplicity of what now masquerades as public access broadcasting – the 'phone-in' programmes. *The Ryan Show* (2FM)[3] is perhaps the greatest exponent of a type of hybrid crossover programme which includes a mixture of music, entertainment and phone-ins. Other programmes in the Irish context that adopt an almost exclusive phone-in format include *Liveline* (Marian Finucane/Joe Duffy), *Sportscall*, *The Chris Barry Phone-in Show* etc.

The BBC began broadcasting on the 14th November 1922 with the following advertised notice:

> The British Broadcasting Company has arranged to transmit the following programmes each evening, Saturdays and Sundays included, until further notice, from the London broadcasting station 2LO: 6 p.m news bulletin; 8 to 9, music; 9 to 9.30, news; 9.30 to 10, music. [4]

From the beginning the BBC served a dual role: the dissemination of news and information, and the provision of entertainment – initially music but shortly followed by drama, book readings and the broadcast talk, which is a form of scripted verbal lecture. The public reliance upon the radio for news and information was given national prominence by the absence of newsprint during the 1923 General Strike. The production of newspapers effectively ceased for the duration of the strike, which handed radio a golden opportunity. The listening public began to rely upon the radio for news and information which in turn gave the medium an authoritative voice; and for the first time in a socio-historical context it was a single voice. Unlike the differing shades of opinions and varying emphasis on story-lines written by journalists reflecting the political stances in a range of independent newspapers, radio news was the news presented as one voice, editorialized and emphasized by the BBC and broadcast to all. BBC radio at the time was considered the voice of unbiased authority.

Although the aspects of news control and control of the media will not be discussed here, it is worth noting that broadcast news in the 1920s became both a cultural and a media watershed. It was the seminal beginning of what was later described as the development of a national mind-set and the propagation and control of national opinion. Media control has since grown beyond its various national boundaries to be described in the 1990s by Seymour-Ure as the three linked trends of 'concentration, conglomeration and internationalization.' [5] I am not suggesting that the media as such are responsible for the propagation of what could be described as continental xenophobic tendencies. Through overt political control exerted on the media, or, at the very least reflected in the media, the global media have played a significant part, if not in the inception, then certainly in the inculcation and dissemination of diametrically opposed national and international mindsets. Media 'blackouts' and the control or filtration of information has become the *modus operandi* for all governments when dealing with national and international crises. Access to information and its media vehicle of dissemination are generally the first casualties in

any conflict on whatever side. An analysis of the global propaganda war would demonstrate that it has never been a war to win minds and influence imaginations, but more a war waged upon those same minds through the control and effective use of misinformation. To borrow a now commonly used media metaphor, it is more about 'spin-doctoring' a nation's thought processes than documenting the truth.

In recent years commentators have become increasingly aware of the historical importance of radio, not simply as a means of mass communication, but also as a primary agency through which our cultural and artistic values are disseminated.[6] This was recognized earlier by Bertolt Brecht when he commented on the extent to which radio in its early stages was used as a substitute for other forms of communication. 'The radio was then in its first phase of being a substitute: a substitute for theatre, opera, concerts, lectures, café music, local newspapers and so forth.'[7] The new medium of radio was seen as a very real threat to all existing information and entertainment formats. The newspaper industry criticized it as usurping their role in providing what they considered to be accurate and informed opinion. Their fears, more born out of a concern for a loss of revenue because of a perceived fall in newspaper sales, were directly reflected by the theatre industry when radio began broadcasting drama in 1923.

The first serious drama broadcast in Britain was transmitted 'live' on 16 February 1923 and incorporated three scenes from Shakespeare's *Julius Caesar* produced by Professor Acton Bond of the British Shakespeare Society. This broadcast was quickly followed by other radio adaptations of Shakespeare, carried out by Cathleen Nesbitt under the direction of C.A. Lewis, and included the trial scene from *The Merchant of Venice* (23 May 1923); a recitation by the actress Ellen Terry of the Humbert and Arthur scene from *King John* (31 May 1923); excerpts from *Henry VIII* (7 June 1923) and *Romeo and Juliet* (5 July 1923); readings from *Macbeth* by John Gielgud and Ben Webster (18 October 1923). The first full-length Shakespearean play *Twelfth Night*, was transmitted on 28 May 1923.[8]

The BBC, under its Director John Reith and its then Director of Drama R.E. Jeffery (and from 1929, Val Gielgud), saw its

developing dramatic role as one of creating a form of 'national theatre.' It was hoped that Radio would become a 'national' theatre-of-the-air, which would bring to its growing numbers of listeners those great works of literature and the stage. This was viewed with scepticism and alarm by the theatre industry where many theatre managers 'actively discouraged actors from playing for radio until about 1930. They feared competition.' [9] A 1929 BBC Radio Handbook clearly defined its role as filling a space in the nation's cultural life left vacant by the absence of a 'real' national theatre. 'The radio medium has the means of spanning the unprofitable dramatic ground between the business theatre of to-day and the national theatre of tomorrow.' [10] By 1930 the BBC was expected to mount twice as many productions as were mounted on the London stage, and by 1945 some four hundred plays a year, excluding serials, were being broadcast. [11]

There was an increasing awareness of the medium's strengths and weaknesses within the fledgling radio drama department at the BBC. Arguments ensued over the best ways to produce and present radio drama, especially that of Shakespeare. It was a time of experimentation and learning, particularly so for stage actors who had to come to terms with a new dramatic medium whose acting and production techniques were not at that point formulated. The theories and practices of radio drama were developed through experimentation and much trial and error. The actors were aware that there was an audience out there somewhere and that the actor's 'live' performances on the radio were being listened to by perhaps an audience of millions. However, neither of the participants, i.e. actor and listener, could see each other, and only one participant – the listener – could hear the final dramatic result in the totality of sound. This was a radical change for actors who had traditionally relied upon the actor/audience relationship in live theatre. It took many years of experimentation and a momentous change in performance attitude to realize that the actor's point of contact with the 'listening' audience was an inanimate object – the microphone. Advice given in the 1929 BBC Radio Handbook warned producers that 'the actor of ability enters a broadcasting studio with the confidence of long acting experience, often to find that

the microphone demands that he start learning all over again.[12] In 1929, Val Gielgud, the newly appointed Director of Radio Drama, acknowledged that it would take time to change the actor's approach in performing to a radio audience. He advised the actors that 'because the radio audience was a very large one, larger than the audience in any theatre, it was unnecessary for them to project their voices and their personalities as if they were playing in some super-equivalent of Olympia.' [13] Gielgud once recalled the difficulties he faced when he employed the great actor, Henry Ainley, to play Othello.

> In Henry Ainley's mind the studio remained obstinately equated with a super Drury Lane and pulled out every stop of that magnificent organ, his voice, to such effect that I had to station two 'effects' boys – one at each of his elbows – to withdraw him gently but firmly to a distance from the microphone. His performance was magnificent but it was not broadcasting.[14]

It was realized early on that a purely stage performance on microphone was not effective and a new approach towards vocal acting or broadcast acting was required. The search for those illusive qualities, which could transform a dramatic performance simply *relayed* by radio into a 'broadcasting' performance using the *medium* of radio, was hampered in the early years by the technical inadequacy of the medium. It has to be remembered that at this time most listeners were encased in headphones and that reception of the signal was not always free from atmospheric interference. The meticulous enunciation then practised by news announcers to overcome these difficulties was naturally not suited to the pace of dramatic dialogue.[15] An important distinction must be drawn here between the vocal style required for presentation, announcing, news reading, book reading etc., to that required for dramatic dialogue. But there is a further crucial distinction to be drawn between the production of dramatic dialogue for the stage and dramatic dialogue for the microphone. Whereas the stage includes the visual elements in the performance, which greatly helps to create a contextual setting for the dialogue, the radio relies totally upon the voice and

whatever sounds and music accompany it to achieve a similar outcome. The over-dependence on the 'theatre effect' in radio acting was the natural outcome of an actor's training, which could be categorized into two main areas. Physical training concentrated on the visual refinements of stage performance, for example, movement, gesture, costume, make-up, character portrayal etc. Vocal training, including enunciation, articulation, diction, breathing, rhythm, timing etc., concentrated on the need to project vocally from a stage in the theatre in order to be heard clearly by an audience in the stalls.

The author, Basil Maine, severely criticized an early BBC production of Shakespeare's *Much Ado About Nothing*. He wrote that the 'Stratford-on-Avon Festival Company gave the play in a studio without having first put away all thoughts of the stage and its special conditions. The lamentable result was that the comedy (whether of situation or of speech) was either over-stressed or altogether missed … never did imagination run freely enough.' [16] Maine's central criticism of the production was that the players used too much fake laughter and destroyed the natural rhythmic humour in the play. This 'cudgelling of the audience' as he described it separated any 'natural' response by the actors to the humour, whether of situation or of speech. Every actor knows how appallingly hard it is to laugh convincingly on the stage where at least the visual stimuli in the production may help to mask any falsehoods in the humour; but this task becomes exceedingly more difficult in the sonic isolation of radio. Maine's advice may appear terse but entirely appropriate when applied to radio acting. 'Let them remember that laughter is a cadenza of speech and, among players, should be entrusted only to virtuosi.' [17] Stripped of the extra visual additions of facial and physical gestures, make-up, costume etc., which instantly impart suggested meaning, the radio voice is singularly alone in the creation and communication of the completed character. The truthfulness in communicating emotional meaning by the human voice, be it laughter or sorrow, is as fragile as a fine crystal glass where the microphone represents the glass and the actor the handler of the glass. The emotional contents contained in the glass can either be delivered intact or shattered asunder by its

handler. George Bernard Shaw once remarked in a televised talk
that 'the microphone is the most wonderful telltale in the world.
The microphone has a certain magic – it gives you away
instantly.' [18]

Different approaches were sought to overcome the difficulty of
acting to a microphone. Suggestions even included the recording
of stage performances for subsequent broadcast. It stemmed
from a belief that it would have been easier to capture the
spontaneity of a live performance in front of an audience than to
try to recreate it in the confines of a quiet studio. In 1927, R.E.
Jeffery, then director of BBC Radio Drama, suggested 'that there
ought to be a radio studio in which actors would perform to a
live audience who would give them 'the solid, palpable sympathy'
they demanded.' [19] This suggestion found little support, and live
performances of plays either to a studio audience or recorded in
a theatre were rarely tried. This method, however, was later
adopted and continues to remain the preferred production style
for radio comedy shows. It reflects the comedy genre's music-
hall traditions where, above all, the internal timing of the
performance is primarily influenced by audience reaction.

The early difficulties in presenting radio versions of stage plays,
particularly those of Shakespeare with its dreaded 'theatre effect',
were in stark contrast to the sounds of a new emerging genre of
specifically written radio drama. Commenting on the first two
years of drama broadcasting, the BBC Director, John Reith,
expressed his irritation with the excessive 'theatre effect.' 'It
seems to me that in many of our productions there is too much
striving for theatre effect and too little attempt at actually
discovering the actual radio effect when the play is received in
distant homes.' [20] The impenetrable stature of the Shakespearean
play protected it from any form of radiophonic experimentation
in those early years. Yet, there was a keen awareness that it was
through the experimentation with the medium of 'sound' (voices,
words, music, sounds etc.) that radio drama would create its own
unique dramatic performance codes. Lewis aptly differentiates
between plays that are written specifically for the radio medium
as 'radio-drama' and stage plays that are adapted to the radio
medium as 'radio-drama'. [21] The subtle shift in emphasis has

enormous significance. The emphasis in '*radio*-drama' is placed upon the writer's initial inception of exploring the sound of radio in trying to discover or exploit the genre's aural uniqueness and echoing what Reith earlier described as 'the actual radio effect.' The emphasis in 'radio-*drama*' is upon plays originally written for another medium, e.g. the stage, which are adapted for performance in the radio medium. It has to be recognized that not all plays are successful in their adapted forms. The two main criteria for success depend upon (i) the suitability of the play for adaptation, that is, whether its visual elements can be transcodified sufficiently into sonic/aural equivalents; and (ii) the medium awareness and incisiveness of the adaptation and/or translation.

A theoretical conflict began to emerge early on between stage theatre and radio drama and focused upon the perception of 'naturalism.' It was thought that radio was not worth the trouble, requiring, it seemed, a naturalistic style, which was anathema to the stage at that time.[22] This sense of naturalism has its obvious roots in the naturalistic realism found in the theatre of Hauptmann, Strindberg, Ibsen, Chekhov and others. Hauptmann's *The Weavers* may well have been a watershed in presenting on stage the natural realism in the life cycle and tribulations of the working class. Its heroes and heroines were drawn from a socially deprived and culturally repressed humanity. A simpler, plain language as spoken in 'real' life by real people replaced the poetically expressive language of the Classicists and Romantics.

Radio's 'naturalism' is entirely different from that of the theatre's illusionary perceptions. It is naturalism born out of the many attempts to find radio drama's natural 'voice' that was not merely confined to language, but included plot and scenic settings. It was an encompassing search that strove to find the 'actual radio effect' in representing the real, the surreal and the magical, anything in fact that the human imagination is capable of receiving and conceiving through sound. Here, it was soon realized, was a new imaginative aural dramatic form so different from that of the stage. The two genres and the contexts of their creation, performance, and reception are so different that any

direct or parallel comparison between them would seem meaningless.

The world's first *radio*-drama, *Danger* by Richard Hughes, was written and broadcast live in 1923. It was devised more as a radiophonic experiment featuring three miners facing a crisis in a Welsh coal-mine, and although the play was studio based, it was acoustically set in a collapsed and darkened mineshaft. Aware of the potential power of radio, echoing the public perception and belief in the truthfulness of the medium, the BBC warned parents 'not to let their children listen to the play for fear they might be frightened.' [23] Adult listeners were advised to hear the play in the dark. It was naively believed that this new form of aural drama could only be appreciated if its audience were to simulate the 'blindness' of the form and the 'darkness' of its setting. *Danger* set an early point of departure for *radio*-drama and demonstrated from the beginning the potential power of the right words combined with the right sounds upon the listeners' imaginations. It also divided radio drama into two distinct forms: the written radio play as radio-drama and the stage play adapted for radio as radio-drama.

Within six years of *Danger's* broadcast, radio drama had clearly differentiated itself as a genre that was separate and independent of the stage. In 1929 C.A. Lewis attempted to define a theory of difference between the approach of the stage writer and that of the radio writer.

The task of the wireless play-writer differs from that of the stage author because, although in broadcasting limitations of inaudible 'stage business' are very narrow, the limitations of action and *mise en scène* are bounded only by the imagination of the listener himself. The stage author deals in scenes and situations which can be presented to the eye. The wireless author may make use of practically any scene or situation which can be conceived by human thought and imagination.[24]

The early sceptics of radio drama may have criticized its production values for being less than adventurous in the belief that the art of suggesting scene by sound effects, atmosphere by music, and gesture by vocal inflections ('acting with the voice')

has been held up for want of imagination.[25] In retrospect I believe those early criticisms to be unbalanced and unhelpful. They were unbalanced in the knowledge that not only was radio drama a new dramatic art form in the early stages of developing its potential, but radio itself was a totally new technology whose early limited technical capabilities hampered the development of more adventurous broadcasting techniques at that time. The criticisms were unhelpful and biased when comparisons of plays were made between the long established, refined and professional theatre and that of a fledgling radio drama genre. Perhaps such unfavourable comparisons, more than any poor technical standards, were responsible for inculcating a negative and sceptical bias against the value of radio drama as a new and distinctly separate dramatic art form. The genre did establish its credentials and over the years has attracted an enormous group of internationally known writers to the medium, such as Louis MacNeice, Giles Cooper, Dorothy L. Sayers, Henry Reed, Dylan Thomas, Samuel Beckett, Harold Pinter, Tom Stoppard, William Trevor, Fay Weldon, to name a small but identifiable few.

The BBC is the largest 'publisher', in broadcasting terms, of plays and new writings. Esslin states 'that among the two to three hundred new plays specially written for radio which are performed by the BBC each year, there is an average of about fifty by writers who have not previously had a play performed.' [26] These figures were revised upwards in 1986 by Richard Imison, Deputy Head of Drama (BBC Radio) – 'The Radio Drama Department receives some 10,000 scripts a year and, of the 500 original plays it broadcasts, between 70 and 80 are by new writers.' [27]

The greater schism between the theatre and that of the fledgling radio drama medium, as evidenced in the 1929 Radio Times debate between Gordon Craig and Compton Mackenzie, was to pre-empt a more unfortunate division in the approaches taken towards radio drama's developing form and content. Craig held the new medium in total contempt, believing that it could only encourage what he called bad plays. MacKenzie, on the other hand, embraced the medium, having been made aware of its enormous possibilities.

I have realized that radio is going to give the artist the
greatest opportunity he has since the days of Homer to
express himself without the mechanical barrier which the
progress of human inventiveness has raised higher and
higher between the artist and his audience.[28]

The debate concerning the structural development of radio
drama was increasing in intensity between the adopted BBC
'realist' line (represented by its Head of Drama, Val Gielgud) and
the needs of playwrights and some producers for a more
'surrealist' sonic approach to radio production. Influenced by the
production possibilities heard in *Danger*, an aural suggestion
where the audience were eavesdropping on an actual event,
playwrights such as Tyrone Guthrie and Lance Sieveking
spearheaded the move to find a 'radio form' specific to drama.
This concept of a new radio form of drama was an early
realization that what was required was a totally new radiophonic
approach to words, sounds, dramatic themes and characters.
Guthrie's *Squirrel's Cage* (1929), *The Flowers Are Not For You To
Pick* (1930), and Sieveking's *Intimate Snapshots* (1929) were
examples of this new form of radio writing. These new forms of
radio drama were not readily accepted nor encouraged by the
more conservative BBC management line. Indeed, the new
concepts were certainly at variance with the more formal and
classical presentations of Shakespeare or the realism of Chekhov,
Ibsen and others.

Guthrie and Sieveking not only required totally new approaches
to the sonic production of radio drama, new sounds and ways of
more 'intimate' vocal acting, but wrote for a new form of
dramatic 'heroes' and 'heroines' who were socially and politically
drawn from the middle and working classes. In Sieveking's
Intimate Snapshots (1929) he wrote a dialogue for a lift conductor
at a London Underground station and a charlady at a girls'
private school. In his unpublished autobiography he states with
regard to *Intimate Snapshots*:

> One protagonist argues that life is nothing but a series
> of meaningless repetitions day after day, year after
> year, and suggests that somehow men and women
> should try to escape. His opponent holds that there is

no escape from outward daily repetitions but they are merely a background, which doesn't matter.[29]

In Guthrie's *Squirrel's Cage* (1929) the main protagonist is a young man called Henry who works in a city office and who is trapped in the daily treadmill of commuting to his tedious work from a London suburb. Henry wants to escape into the wide world and seek adventure but he is chained to his treadmill, locked into his imagination by Guthrie's excellent radiophonic use of an 'overcrowding' Greek-like chorus in the interludes. In the preface to the play, Guthrie wrote:

> There is no 'narration'; scene and interlude follow one another without a break. After the end of each episode there should be a stroke of a bell, then the scream of a syren (sic), suggesting a rush through time and space. The 'scenes' should be played very intimately – in a rather low key; in contrast to the 'interludes', which are to be bold and reverberating, each one working up to a thunderous climax.[30]

Guthrie wrote four different Interludes, then a fifth – a composite Interlude in which he brilliantly constructs the psychological pressure-cooker affect of unstoppable, chaotic, sound flashbacks. Guthrie clearly hears this Interlude in terms of a musical/sound composition and demonstrates his incisive understanding of the sound medium.

Squirrel's Cage (Tyrone Guthrie) – Interlude V

INTERLUDE V

(Fragments of Interludes II and III are repeated.)

They cross-fade one into the other.

The effect should be a composite image of the 'Commuter's' Day—trains fading into typewriters—railway-lines merging into lines of print—the columns of bobbing bowlers into columns of pounds, shillings and pence…Dissolving views.

Interlude III demonstrates Guthrie's acute musical awareness of rhythm, particularly the influence of external rhythms upon his writing and most especially upon the realization/vocalization of the Interlude.

Squirrel's Cage (Tyrone Guthrie) – Interlude III.

INTERLUDE III

(The rhythmic puffing of a train accompanies the dialogue.)

MANY DIFFERENT VOICES

Tickets please, show your tickets, please. Season, sir? All right!…She's late *again*. I have to run to the office as it is…Do you mind if we have the window *open?*…Care to see the paper, sir?…Do you mind if we have the window *shut?*…Tickets please - all tickets ready, please…Season, sir? All right…Do you mind if we have the window *open?*…It simply means I'll have to go on the 8.10…*I* don't know what this line's coming to…Do you mind if we have the window *shut?*…All tickets ready please - Season, sir? All right…Late again. I don't know what this line's coming to…Do you mind if we have the window *open?*…Simply means I'll have to go on the 8.10…Care to see the paper, sir?…Do you mind if we have the window *shut?*…

ONE VOICE: All tickets ready, please

ALL: Tickets, please.

THE ONE: She's late again.

ALL: Late again.

THE ONE: It simply means I'll have to travel on the 8.10.

ALL: Travel on the 8.10.

THE ONE: I do nothing but travel up and down on these
 suburban trains.

ALL: Suburban trains.

THE ONE: Up and down – up and down.

ALL: Up and down – up and down. Up and down – up
 and down.

THE ONE: Do you mind if we have the window *open?*

ALL:	Up and down–up and down. Up and down - up and down. *(Chorus continues with gathering speed and volume.)*
THE ONE:	Do you mind if we have the window *shut?*
ALL:	*(Faster still, noisy)* Up and down–up and down. Up and down–up and down.
THE ONE:	*(Above the voice of the chorus)* Do you mind if we have the window *up?*
ALL:	Up and down–up and down. Up and down – up and down.
THE ONE:	*(Yelling)* Do you mind if we have the window *down?*
ALL:	*(Now at full speed)* Up and down–*up* and down. Up and down–*up* and down. Up and *down*–up and *down*–up and *down*.

[*A whistle blows.*

THE ONE:	*(Yelling)* All tickets, ready, please!
ALL:	*(Yelling)* Tickets please!
THE ONE:	Season, sir?
ALL:	*All right.*

N.B.– *The Chorus 'up and down' must imitate the rhythmic motion of a train at speed–*'Rum-*tum-tum*–Rum-*tum-tum.*'

In Guthrie's second radio play, *The Flowers Are Not For You To Pick* (1930), he employed the same 'chorused' device as in *Squirrel's Cage*. The main protagonist is Edward, a young clergyman who is in the act of drowning, having fallen overboard from a ship bound for China. In a similar way to *Squirrel's Cage* there is no narrator in the play - a convention that was common at the time to inform the listeners of the unfolding dramatic action. There was, however, a short observation made by the announcer prior to the play, which drew the attention of the listeners to the commonly held belief that a drowning man sees his past life in a series of flashbacks.

The Flowers Are Not For You To Pick (Tyrone Guthrie)

> ANNOUNCER
>
> It is said that their past lives float before the eyes of drowning men. From a ship, bound for China, a young clergyman has fallen overboard…even now he is struggling for life in the water…
>
> [*The sound of Waves fades in.*
>
> His name is Edward. And before his eyes float pictures…voices sound in his ears…voices…voices…his past life…
>
> [*The waves fade as the first scene begins.*

The play then unfolds as a series of flashback scenes of the man's life since childhood, the scenes punctuated by the sounds of the pounding waves. The sounds of the waves that Guthrie required were not the naturalistic sounds of the sea but complex surreal symphonic sounds displaying again his aural sense of rhythmic and melodic sound composition:

> In this play the many short scenes rise out of and sink into a rhythmic sound of splashing, moving seas. This sound should be complex yet symphonic…by its rhythm and tone it may be possible to suggest not merely the water in which Edward is engulfed, but the beating of the heart, the tumult of fear, the immutable laws and irresistible strength of Nature compared with our puny and inconstant selves.
>
> The setting of this play is Irish. This was immediately apparent in the accent of the performers. But it has seemed wiser not to attempt more than the sketchiest indications of this by phonetic spelling.[31]

Such demands for new sounds showed how aurally aware Guthrie was of the medium's sonic potential. Playwrights, however, had to wait until the late 50s and the formation of the BBC Radiophonic Workshop before such radiophonically composed sounds became a reality and widely available.

Guthrie's and Sieveking's writing approaches for a new form of radio drama did not find favour with Val Gielgud. Shortly after the production of *Squirrel's Cage* in 1929, Gielgud wrote a series of articles in the *Radio Times* on the subject of radio drama. He considered as nonsense the then current views expressed about radio as being an abstract medium. Rebuking some of its enthusiasts as being misguided in the pursuit of the ideal radio play composed of purely abstract sounds, he mounted an attack on the work of Guthrie. He wrote that the abstract sound idea is 'only a *reductio ad absurdum* of a practice which has built more than one radio drama about characters so abstract or so symbolical that they are without sufficient identity to make them interesting.' [32]

Hidden behind this criticism was a conceited Aristotelian belief that the divisions in social status drew clear identifiable lines, which arbitrarily decided upon the suitability of particular social types for potential character portrayal. Those whose aspirations and by extension 'interesting' lives defined them as sufficiently identifiable characters when compared to those for whom the commonality of their existence made them uninteresting. The rise, demise and subsequent redemption of the great and mighty was considered to be sufficiently removed from the economic, social, and political basis of the greater population. It was possibly thought that this would safeguard the broadcast from exerting any undesirable influence on the listeners and minimize any form of individual or collective empathy with the drama. The main objection was not the argument for new dramatic forms but more the content that was emerging in those forms. Sieveking and Guthrie's protagonists at that time were considered too identifiably common and not Aristotelian-like according to the BBC line.

The radio critic for the *Listener*, R.D. Charques, observed in 1930 that 'radio drama producers were trying to cope with two irreconcilable objectives; the aim of bringing theatre within the reach of everybody and the creation of a radio form of drama.' [33] In acknowledging the 'classical' plays broadcast by the BBC, he believed that such productions were not advancing the discovery of new radio forms.

The denial of experimentation in both form and content at the time hindered the 'freefall' creative development of new radio drama formats. A regrettable decision, since radio monopolized, and indeed was, the only electronic media provider with the exception of film. Radio drama's form remained enclosed within the preferable content of the BBC line with few exceptions until the 1950s. This was not the case in America, where, from the advent of radio broadcasting in the early 1920s, the policy of de-regulation combined with market force competition ensured a more rapid development and experimentation with diverse forms of radio drama.

3 | Radio's *War of the Worlds*

There are few moments in broadcasting history, which can be said to have had an intensely profound effect upon the listening/viewing audience. MacMillan's declaration of war on Germany; Churchill's famous defiant speech (spoken as broadcast by a radio actor); Kennedy's State of the Nation Address on the Cuban Missile crisis; the news of the assassination of President Kennedy; and the September 11th attack on the World Trade Centre in New York etc. The gravity heard in the vocal delivery of such broadcasts has the ability to stop a nation in its tracks – to make people think about events beyond their control unfurling before their eyes and ears and of the possible ramifications and personal consequences of what is being said. The fear evoked by what is perceived to be uncontrolled or uncertain momentous events can generate states of individual and collective panic from the simple act of buying-in extra provisions to the more dramatic panic-fleeing of people. The 1938 radio broadcast of H. G. Wells's *The War of the Worlds* by Orson Welles and the Mercury Theatre on the Air ranks as one such unique broadcasting phenomenon.

How could a simple radio play cause enough fear to create widespread panic? Was *The War of the Worlds* a brilliantly planned hoax or a genuine radio network scoop? Could a similar broadcast generate a panic reaction today? The exploration of these questions is in part influenced by the structure of American

broadcasting at the time of broadcasting and the socio-psychological role radio played in the daily lives of the American nation. Plausible arguments will be explored in relation to the broadcast, for example, [i] the fear and apprehension of the American people following the growing threat of war in Europe; [ii] the gullibility of a certain section of the listeners in their belief that the radio was reporting fact; [iii] the high production values of the broadcast itself; [iv] the radio drama enactment; and [v] the daringly creative background of the play's main protagonist, Orson Welles. Perhaps more than anything else the cause of panic came down to an unforeseen and unplanned coincidence of fate. Welles's rather nervous and uncharacteristically impromptu verbal addition or back reference, delivered immediately following the broadcast, did little to quell the controversy. Was Welles's version of *The War of the Worlds* an innocent and cleverly adapted radio drama or a carefully planned hoax that simply got out of control?

> 'This is Orson Welles, ladies and gentlemen, out of character to assure you that *The War of the Worlds* has no further significance than as the holiday offering it was intended to be. The Mercury Theatre's own version of dressing up in a sheet and jumping out of a bush, and saying boo! ...So goodbye everybody, and remember, please, for the next day or so, the terrible lesson you learned tonight.' [1]

The development and structure of radio broadcasting in the U.S. since its inception in the early 1920s was quite different from that in Britain or Ireland. In Britain the BBC, formerly known as the British Broadcasting Company and later the British Broadcasting Corporation, developed specifically as a form of state funded broadcasting. The curious anomaly continues to exist between the perceived autonomy of the BBC within its programming structures while the station itself, incorporating BBC Television, is funded principally by a statutory public licence fee collected by the government. A similar situation continues to exist in Ireland since the foundation of 2RN, later RE (Radio Eireann) and since the advent of television in the 1960s, RTE (Radio Telefis Eireann).

In the United States radio stations are 'controlled' [2] to the extent that they have to be licensed to broadcast; but the important difference is that the public are not required to purchase a licence to receive those broadcasts. The elimination of that level of central control – the government charge individuals a licence fee for the use of a radio receiver and in turn pays the fee or a portion of it to the broadcaster to broadcast to the same radio set – ensured a more open, freer, adventurous, if at times 'quirky' broadcasting development.

Owing in part to the vast geography of the U.S.A. (including physical, social and cultural differences) and to the fact that broadcasting was from its beginning an economic venture, its development initially was based upon local broadcasting structures. A contemporary Irish example of this form of broadcasting de-regulation can be evidenced in the 1990 Broadcasting Act, which allowed for the establishment of legal independent and commercially autonomous FM radio stations throughout the country, including specific licences for community based broadcasting. In the U.S.A. local and city based stations vied with each other for a larger listener base – the golden rule of profit-led broadcasting having been learned early on, that is, increased listeners = increased revenue through sales of advertising. It was estimated that Americans spent more than $350 million in 1924 on radio receivers, tubes and other hardware. By 1927, more than 500 AM radio stations had popped up across the country, eager to compete for listeners even if it meant skipping frequencies, boosting transmission power beyond acceptable limits and airing shows with ethically questionable personalities such as the famous 'goat-gland surgeon', Dr. John Binkley.

The concept of national program linkage, or 'networking' was developed in 1926 with the formation of the NBC (National Broadcasting Company), which delivered its Red and Blue networks, and was shortly followed by the establishment of a rival company CBS (Columbia Broadcasting System) in 1927. The concept was that these two major broadcasting companies could deliver 'big' name shows, national news, entertainment and sporting fixtures to the smaller local stations around the country

on an opt-in/opt-out basis. National sponsors and advertisers paid for the network shows by appearing as the credited 'sponsor' – a de-regulated form of buying 'air-time' for the expressed purpose of advertising. On the one hand, NBC made arrangements with individual local stations, which gave NBC coverage across the country, and into Canada, paralleling that of newspaper and magazine distribution. On the other hand, it made commercial arrangements with 'sponsors' to buy time and programmes on the networks which could now deliver a greatly increased listenership that guaranteed a far greater exposure for the advertisement of the sponsor's products in its programmes.

The de-regulated nature of U.S. broadcasting policies and the profit-led ethos of its ownership meant that advertising had become the new mantra for aspiring radio programmers. Sponsors not only purchased spot time on network and local productions in the late 1920s, but they also created their own shows and bought time to air them. In fact, advertising influence grew so quickly that, at times, a single agency could control as much as 10 per cent of a network's schedule. The commercial competition between NBC and CBS was fuelled by new methods of analysing audience response to programmes. This analysis offered more refined methods of discovering the size and nature of audiences for particular programmes and how these audiences changed in time as other programmes competed for them. The size of a programme's audience was the determining factor in attracting greater levels of sponsorship. On the negative side, the price of a programme's failure to be competitive was simply the loss of sponsorship; and without a sponsor, frequently a programme just disappeared, no matter what its positive qualities. By 1932, musical programmes were being replaced in the highest ratings by mystery and crime dramas and by 1933, radio drama of a more serious kind was beginning to rise in popularity.

Through audience research, the networks recognized an important untapped niche market with an enormous potential. 'Programmers and sponsors quickly discovered that housewives, while not directly in the labour force, often controlled the household purse strings.' [3] The networks began running several 15-minute daily drama episodes (serials) and found that daytime

dramas quickly became as successful as their prime-time counterparts.

Most advertising support for the daytime dramas came from sponsors that made household products – Colgate Palmolive, Peet, Procter and Gamble, among others. Thus, the term 'soap-opera' was born to describe the melodramas sold by detergent companies ... By 1939, advertising revenue for the popular serials exceeded $26 million; in 1995, soaps earned more than $900 million in total network revenues – one-sixth of all annual network profits.[4]

By the 1930s, radio provided a cheap, continuous form of popular entertainment, able to appeal at different times to very different audiences, by region, sex, age and class; audiences flocked to the new medium. The development of radio drama in the American context was completely different from its development in Britain. As debates raged in Britain during the 1920s and 1930s about the position of radio drama as a dramatic medium in its own right, (the theatre versus radio drama), the Americans were developing new drama formats and popularising radio as a major provider of dramatic entertainment. While the BBC continued to broadcast 'serious' drama as the only dramatic form envisaged, the Americans responded to popular demands eagerly supported by the sponsors. As Fink states, 'one of the most striking aspects of American radio is that the great majority of programmes shared in the form of drama: not simply dialogue, but dramatic situation, distinct characters, dramatic tension and resolution.'[5] The radio audience had an insatiable appetite for all forms of popular dramatics. Some of the most popular forms of American radio drama included the newly invented form of 'pulp fiction' (Cecil B. De Mille and the Lux Radio Theatre format); 'soap operas', serials, mystery and detective series, variety shows and radio dramatizations of film releases. This is not to suggest that these formats necessarily made good drama. They were nonetheless extremely popular, and that was all that concerned the sponsors and the networks. There were, however, serious forms of radio drama, which the networks produced as 'sustaining' programmes. Being less popular than the other

formats, serious drama largely remained un-sponsored and was financed directly by radio station resources.

Sustaining programmes occupied unsold time, usually outside of prime time, and constituted as small a proportion of the broadcasting day as could be contrived. The contents of sustaining programmes were often of a cultural or educational nature; and it was here, among the serious music and talks, that serious 'prestige' radio drama could be heard.

During the 1930s and 1940s, referred to as the 'Golden Age' of American radio, the radio listenership was enormous but the standards and content of popular radio were artistically low. According to Simon Callow, 'there had been considerable legal pressure on the networks to counteract the overwhelming amount of mindless (and highly popular) banality being dispensed over the airwaves under the sponsorship of commerce, for whom the programmes were the merest peg for their plugs.' [6] Pressure groups developed, forming a coalition of liberals, academics, artists, leaders of labour, agriculture, politics and religion to put pressure on the networks to improve their programming. The pressure groups demanded the revocation of the network licences, and a new allocation of frequencies with one fourth going to educational, religious, agricultural, labour, co-operative and similar non-profit organizations. This measure was heard with some sympathy in the American Congress, which galvanized the networks into trying to transform themselves into quasi patrons of the arts. According to Callow the transformation of the networks into Gonzagas and Medicis was easily and cheaply accomplished. [Callow's descriptive use of the names of two famous rivalling Italian merchant families is entirely appropriate when describing the media war for listeners that existed between NBC and CBS.]

The networks responded to the pressure and began competing with each other in delivering new and challenging programme formats. The pressure groups themselves were offered 'free' slots, free in the sense that they were not charged for airtime. This 'peppered' the schedules with an array of programmes from the creatively artistic to the ponderously serious.

Radio programming in the 1930s and 40s was creative, vibrant, and diverse. The typical broadcast day consisted of first-rate comedy routines, soap operas, action thrillers and variety shows, all of which served as superb entertainment as well as providing instant fame for aspiring actors, writers, producers and directors.[7]

Callow believes 'that is was part of Welles's extraordinary good fortune that he appeared on the radio scene at exactly the moment when it was ready to develop into a major expressive medium.'[8]

Orson Welles may well be something of an enigma, a creative energy that defies precise description. His name instantly conjures up his later persona as a monumental presence whose bearded bloated jowls folded themselves around that low pitched recognizable sonority that always was his trademark – his commanding voice. Welles was first and foremost an actor whether by design or by accident. His trip to Ireland in 1931 as a young sixteen-year-old visionary[9] fortuitously led to a meeting with Hilton Edwards and Michael Mac Liammoir at the Gate Theatre, Dublin. Callow is adamant that his arrival at the Gate Theatre was a supreme example of his being in the right place at the right time. Whether Welles feigned his way into an audition with Edwards and Mac Liammoir is a point of conjecture. Callow suggests that Welles's good fortune had as much to do with his unique physicality as that of talent. 'His physique, voice and personality rendered it more striking than it would have been in most people. Edwards's advice was perfectly judged to the extent that Welles was prepared to take it, ['don't obey me blindly, but listen to me. More important still, listen to yourself.']. It, and whatever other advice he received during his time at the Gate, was the only training he ever received.[10]

Welles returned to America in 1932 and in the following three years worked as an actor on stage playing a number of roles. His radio career began in 1935 as a radio actor with the weekly-dramatized news satire series 'The March of Time' on NBC. His first radio play, *Hamlet*, the Shakespearean play adapted for radio by Welles, was broadcast by the Columbia Workshop (CBS) in 1936. Welles quickly realized the enormous power and creative potential of radio.

Reduced to a voice, relieved of the tedium of having to
learn the script, get into costume and actually move
around the stage, his personality was able to flourish
untrammelled ... The immediacy of its impact, the
flexibility of its language, above all, perhaps, the
circumstances of its creation, were ideal for Welles.[11]

It is a tragic irony that much of the work that made Orson Welles
the now 'long-held' and revered figure both as actor and director
took place in a condensed six to seven year period during his
twenties, 1935 to 1942. During these years Welles worked almost
exclusively with the same group of actors, The Mercury Theatre,
a company which he and colleague John Houseman founded.
The Mercury Theatre began as a stage theatre company but
within a short time were offered a broadcasting contract
renaming the company for broadcasting purposes as 'The
Mercury Theatre on the Air.' Welles became the all-round
impresario with The Mercury Theatre. He acted, directed, wrote
and adapted plays for production. His catalogue of work for this
period is curiously interesting: 13 stage plays (including
adaptations of *Macbeth*, *Julius Caesar*, *Doctor Faustus* and Büchner's
Danton's Death); 3 films, *Hearts of Age*, *Citizen Kane* and *The
Magnificent Ambersons* (plus 2 film sequences shot for inclusion
into stage plays). But most remarkable was Welles's radio output,
which included over a hundred radio dramas including radio
adaptations of works ranging from Dickens to Shakespeare.

Orson Welles gained immediate and international recognition
following the broadcast by 'The Mercury Theatre on the Air' of
H. G. Wells's *The War Of The Worlds*, (30 October, 1938).
Although it can be said that no publicity is bad publicity, Welles
initially wanted to distance himself from being recognized as the
man who fooled or panicked a nation. Whether it had been
deliberate or not, genius or just a clever stunt, Welles suffered
from the notoriety he had attracted following the broadcast. This
was most evident in the rather bizarre critical acclaim and
outright derision he received following the release of the film
Citizen Kane in 1941. Welles continued his radio and acting career
through the 1940s, but the notoriety he had attracted to himself
was to shadow and thwart his even greater Hollywood

aspirations. The myth that grew about him ultimately fanned the flames of corporate and artistic guilt, which only much later recognized him as one of the great artistic minds of the century; a grudging recognition that was safely given in the knowledge that time had distanced Welles from any sense of notoriety. But he was also distanced by the fact that he had grown older and out of touch with post-1960 Hollywood trends. Thwarted by the continuous lack of corporate backing, Welles remained financially unable to threaten the artistic world with his arrogant brand of genius.

Orson Welles and 'The Mercury Theatre on the Air' began their first season of nine weekly radio plays for CBS on 11 July 1938. Welles was quoted as saying that he wanted 'to treat radio with the intelligence and respect such a beautiful and powerful medium deserves.' [12] Their season of plays adapted for radio by Welles himself included *Dracula* (Stoker), *Treasure Island* (Stevenson), *A Tale of Two Cities* (Dickens), *The Thirty-Nine Steps* (Buchan), amongst others. The season proved so successful that The Mercury Theatre were contracted for a follow-on thirteen plays. Some of these play adaptations included *Julius Caesar* (Shakespeare*), Jane Eyre* (Brontë), *Sherlock Holmes* (Conan-Doyle)*, Oliver Twist* (Dickens), *Around the World in Eighty Days* (Verne), and *The War of the Worlds* (H. G. Wells). Fink states that 'everything Welles touched was transformed by his imagination and instinct for the medium. The productions had fast pacing, a sense of intimacy, and a mastery of the radio medium, which Welles could only have learned during his work in popular radio drama.' [13]

The Mercury Theatre's repertoire of plays spanned a range of stylistic genres from comedy to Shakespeare. Their busy weekly schedule together with the rehearse-record routine, or more accurately for that era the rehearse-broadcast routine, of radio drama meant that, as soon as one play was finished, it was straight on to the next. This routine put enormous pressure on Welles to maintain the constant flow of adaptations so it was decided to bring in a new writer. Howard Koch was handed a copy of *The War of the Worlds* and given instructions to dramatize it in the form of news bulletins. Koch's adaptation (which Welles

later un-successfully tried to claim as his own)[14] was a complete bi-location and updating of the novel.

The War of the Worlds radio drama must therefore be viewed in the light of its American adaptation both in its time structure and geographical place setting. Any comparison with the original novel may prove an interesting literary analysis but would shed few insights into Koch's development of his script as a purely American radio drama production, or for that matter, an exploration into the widespread panic which it caused.

H. G. Wells wrote *The War of the Worlds* in 1898. It is a dramatic story of alien war and destruction brought by invading Martian spaceships onto peaceful Victorian Surrey, the heartland of England's rural conservative stability. Arthur C. Clarke in his introduction to the Everyman edition of the novel believes that the 'novel contains what must be the first detailed description of mechanical warfare and its impact upon an urban society. Yet, Wells wrote it not only before the First World War, but even prior to the Boer War.' [15] The two great science fiction writers, H. G. Wells and Jules Verne wrote of scientific probabilities long before science itself could even identify the merest possibilities. Alien spacecraft capable of flying from another planet to earth and waging war on the earth from the air were inconceivable at the time. A review in the Saturday Review dated 29 January 1898 stated:

> ... in *The War of the Worlds*, he [Wells] has had the astonishing good fortune to hit upon a subject so far removed from experience and completely outside common expectation as any which he has ever treated, and yet possible. No astronomer, no physicist, can take upon himself to declare that it is absolutely certain that this planet will never be invaded from a foreign world.[16]

The War of the Worlds (H. G. Wells)

> ## Chapter 1 – The Eve of the War
>
> No one would have believed in the last years of the nineteenth century that this world was being watched keenly and closely by intelligences greater than man's and yet as mortal as his own; that as men busied themselves about their various concerns they were scrutinized and studied, perhaps almost as narrowly as a man with a microscope might scrutinize the transient creatures that swarm and multiply in a drop of water...[17]

The War of the Worlds (H. G. Wells)

> ## Chapter 2 – The Falling-Star
>
> Then came the night of the first falling-star. It was seen early in the morning rushing over Winchester eastward, a line of flame high in the atmosphere. Hundreds must have seen it, and taken it for an ordinary falling-star ... Denning, our greatest authority on meteorites, stated that the height of its first appearance was about ninety or one hundred miles ...[18]

David Garnett writing in *The New Statesman* (13 May 1933), summed up the 'freshness' of Wells's novel:

> Re-reading what are called the Scientific Romances of H. G. Wells in an omnibus volume has filled me with a very childish form of disillusion indeed. For when I read Wells at 15 [1907] I believed those stories in a peculiarly literal way. I knew, of course, that the Martians had not landed in Woking, but I was not at all sure they might not arrive there at any moment; and I think I was convinced that when they did there could be no question as to the course of events.[19]

Almost seventy years on from Garnett's statement and one hundred years after the publication of H. G. Wells's *The War of the Worlds*, the novel remains a thoroughly good read. It remains surprisingly so when considered against the myriad advances in science and technology in the course of this century, e.g. airflight,

interplanetary flight, men walking on the moon etc. As viewers, we are offered an array of science-fiction programme formats, from the abstract to the paranormal (Independence Day, The X Files, E.T., etc.), yet Wells's invading machines from Mars emitting their deadly heat-rays remain chillingly convincing.

Fiction can never be interpreted as 'believable', but good fiction writing can enter the domain of imaginative plausibility, that is, where its illusions could almost be believable if they were to happen. No matter how plausible the illusions may seem, fiction is read from the page in its literary form, in the secure knowledge that subjectively it is non-threatening. The physicality of the book itself puts the reader in control and creates a safe distancing sense of the present from the 'past.' (For example, the book was written, was printed, was published, was procured and is being read by a reader). Regardless of how the story was written, neither Wells's novel nor Koch's dramatic script in their literary forms could ever create a sense of collective panic; Orson Welles's radio drama production did. Yet it should be remembered that those listeners who heard the production from the beginning were not panicked, but many of those who tuned in late were.

A complete performance analysis of *The War of the Worlds* broadcast will not be undertaken at this point. However, consideration of some of the structural and performance elements will help to contextualize the play in relation to its use of the radio drama medium and the panic it caused. It must also be understood in the light of the sociological and psychological state of America in 1938. First, as a CBS network programme it was broadcast across the nation to local stations who had an agreement with CBS. Cantril states that '92 stations carried the broadcast.' [20] Second, Americans used the radio as their main source of news. This echoes the perception of radio as being 'truthful' and, therefore, believable. Third, America was recovering economically following the 1929 economic depression, but the 'feel-good' factor was shadowed to an extent by the threat of war in Europe. Again, radio was the main source of news and information regarding the European crisis. Fourth, opinions were being publicly aired regarding America's state of

defence readiness, particularly in relation to air defence. And fifth, the mysteries surrounding science in general, combined with a widespread lack of understanding, may have left people in a believable and highly suggestive state. Callow believes that the broadcast and the panic that ensued 'was held to offer, on the one hand, doleful evidence of the gullibility of the American people, and on the other, worrying proof of the power of radio.' [21]

The psychologist, Hadley Cantril, undertook a study of the panic caused by the broadcast, (*The Invasion from Mars – A Study in the Psychology of Panic*, published by Princeton University Press, 1940). He states that 'out of the then 32,000,000 families in the United States, 27,500,000 had radios – a greater proportion than had telephones, automobiles, plumbing, electricity, newspapers or magazines.' According to Cantril, '6,000,000 people heard the broadcast where 1,000,000 were frightened or disturbed.' [22] He also quotes a figure from AIPO (The American Institute of Public Opinion) which gave the figure of 12,000,000 listeners who heard the broadcast where 9,000,000 were adults. AIPO also states that 28% (or 3,360,000) of those who listened thought the broadcast was a news bulletin. The fact that the play was interpreted as news is an important point in relation to the broadcast. AIPO's figures may be more accurate at representing the total number of listeners who heard the broadcast, which included those who were listening from the beginning to the CBS network, and those, the greater proportion of listeners, who tuned over late from the NBC network.

The cocktail combination of the sociological state of America at the time; the dramatic structure of the play presented in the form of news bulletins; and the fact that the majority of 'late tuned-in' listeners were not aware that it was a radio play, created the recipe for panic. Those who were tuned to CBS and heard the play from its beginning were not panicked. To those listeners, this was the regular if on this occasion more strange than normal Sunday night radio drama presentation that was clearly signposted from the opening announcement.

* Note: In the following examples the 12 hour clock will be used for the elapsed transmission time (TX time). Therefore: 08:00:00 means eight hours, zero minutes, zero seconds. And: 08:02:16 means eight hours, two minutes, sixteen seconds.

The War of the Worlds : Radio script by Howard Koch

TX Time:		
08:00:00	CUE:	SIGNATURE MUSIC [30 seconds] –
		COLUMBIA BROADCASTING SYSTEM
ANNOUNCER:		The Columbia Broadcasting System and its affiliated stations present Orson Welles and the Mercury Theatre on the Air in *The War of the Worlds* by H. G. Wells.
CUE:		DRAMA THEME MUSIC *[Tchaikovsky 1st Piano Concerto]* – FADE TO WELLES
ANNOUNCER:		Ladies and Gentlemen: the director of the Mercury Theatre and star of these broadcasts, Orson Welles.
WELLES:		*[Serious, solemn voice]*
08:00:35		We know now that in the early years of the twentieth century this world was being watched closely by intelligences greater than man's and yet as mortal as his own...[23]

Howard Koch adapted *The War of the Worlds* into the form of a running news bulletin set in 'current' time (1938) in the United States. He used real and identifiable place names when referring to areas, cities, towns and motorways. He also used a number of prestigious sounding interviewees playing identifiable and important character roles but with fictitious character names. For example, Professors from various observatories, Princeton, Chicago, McMillan University, The California Astronomical Society, the Commanders of the State Militia and the Red Cross, the Secretary for Defence, army personnel, police, eyewitnesses and news reporters. This was an important structural device in

giving the drama a sense of American relevance and a degree of authenticity and authority within the drama frame. This was obvious if perhaps a little confusing to those who were listening to the unfolding drama from the beginning. For many of those listeners who tuned in late the programme was, to all intents and purposes, a real news report of a 'real' Martian invasion featuring real prestigious interviewees and contributors.

Towards the end of Welles's short introduction, Koch brings the listener into present-day 1938 America, and straight into a unique unfolding play. A weather forecast gives way to a simulated live outside music broadcast from a hotel in downtown New York. Live outside broadcasts of music and dance programmes were a common feature of American broadcasting at the time.

In the following examples from the script, I have indicated the elapsed time (real) time of the unfolding drama events using the 12 hour clock and underlined on the left-hand margin. This is indicated as hours, minutes and seconds and is timed from the commercial CD release of the broadcast.[24] In this brief analysis I have also included vocal characteristics, deliveries, sound effects and technical fades from the performance text (the recorded broadcast), which were obviously not present in the dramatic text but heard in the broadcast. These indications in *italics* and underlined are important additions to the script and give some sense of the aural affect of the performed text. It should be noted that the play was performed live from CBS's radio drama studio, New York (Sunday, 30th October 1938) during the scheduled time of 8.00 p.m. – 9.00 p.m., New York time. Following a somewhat sombre, matter of fact introduction by Orson Welles, the drama fades imperceptibly into existence as the end of a weather bulletin is heard at 08:02:16.

The War of the Worlds : Radio script by Howard Koch

WELLES:	*[Slightly quicker phrases but deliberate pause between phrases. Serious, evenly paced ponderous voice]*
<u>08:01:54</u>	In the thirty-ninth year of the twentieth century came the great disillusionment. \| It was near the end of October. \| Business was better. \| The war scare was over. \| More men were back at work. \| Sales were picking up. \| On this particular evening, October 30, the Crossley service estimated that thirty-two million people were listening in on radios.
ANNOUNCER 2:	[FADE IN] *[Matter of fact news/weather forecast voice]*
<u>08:02:16</u>	…for the next twenty-four hours not much change in temperature. A slight atmospheric disturbance of undetermined origin is reported over Nova Scotia, causing a low pressure area to move down rather rapidly over the north-eastern states, bringing a forecast of rain, accompanied by winds of light gale force. Maximum temperature 66; minimum 48.
	This weather report comes to you from the Government Weather Bureau.
	We take you now to the Merdan // Meridian Room in the Hotel Park Plaza in downtown New York, where you will be entertained by the music of Ramon Raquello and his orchestra.
<u>08:02:47</u>	SPANISH THEME SONG…FADES
ANNOUNCER 3:	*[Up-beat entertaining presenter's voice]*
<u>08:03:02</u>	Good evening, Ladies and gentlemen. From the Meridian Room in the Park Plaza in New York City, we bring you the music of Ramon Raquello and his Orchestra. With a touch of the Spanish, Ramon Raquello leads off with "La Cumparista"
CUE:	MUSIC…[FADES]

ANNOUNCER 2: *[Matter of fact, slight sense of urgency, news reporting voice]*

08:03:30 Ladies and gentlemen, we interrupt our programme of
 dance music to bring you a special bulletin from the
 Intercontinental Radio News.

 At twenty minutes before eight, central time, Professor
 Farrell of the Mount Jennings Observatory, Chicago,
 Illinois, reports observing several explosions of
 incandescent gas, occurring at regular intervals on the
 planet Mars. The spectroscope indicates the gas to be
 hydrogen and moving towards the earth with
 enormous velocity. Professor Pierson of the
 observatory at Princeton confirms Farrell's
 observation, and describes the phenomenon as
 (QUOTE) 'like a jet of blue flame shot from a gun'
 (UNQUOTE).

 We now return you to the music of Ramon Raquello,
 playing for you in the Meridian Room of the Park
 Plaza Hotel, situated in downtown New York.

08:04:12 [MUSIC PLAYS FOR A FEW MOMENTS UNTIL
 PIECE ENDS...SOUND OF APPLAUSE]

08:04:32 Now a tune that never loses favor, the ever-popular
 "Star Dust". Ramon Raquello and his orchestra

The music was played from a record in the studio, where the cast
added the applause giving a sense of location and 'liveness.' The
music programme was again interrupted by another news
bulletin. Interrupting the music programme with news bulletins
was a clever device that gave the reports a sense of urgency and
credibility within the drama frame. Moments later [08:06:06] the
audience were brought to Princeton Observatory for a 'live'
interview by the station's roving reporter, Carl Phillips, with the
'famous' astronomer, Professor Richard Pierson (played by
Welles). Phillips finished his interview and 'handed-back' to the
studio at 08:09:10 but in doing so he created a clever temporal
illusion simply by verbal suggestion.

PHILLIPS: 'Thank you, Professor. Ladies and gentlemen, for the past ten minutes we've been speaking to you from the observatory at Princeton...This is Carl Phillips speaking. We now return you to our New York studio.'

The return to the 'studio' was achieved by playing a short ten second piano interlude. This was interrupted by a further news bulletin and a return to a 'live' music programme from a *different* New York hotel, leading eventually to an on-the-spot report from a farm at Grovers Mill, New Jersey, the site of the Martian landings.

It is important to keep in mind the elapsed time frame of the programme. The script constantly moves between Central Time and Eastern Standard Time as part of the dramatic structure. This is a clever disorientating device, which could confuse any unsuspecting listener about the real elapsed time of the ongoing production. For those listening from the beginning, the broadcast would have sounded more like a fast moving drama presentation but not news reality.

The War of the Worlds : Radio script by Howard Koch

ANNOUNCER 2:	
<u>08:09:22</u>	Ladies and Gentlemen, here is the latest bulletin from the Intercontinental Radio News.
	Toronto, Canada: Professor Morse of Macmillan University reports observing a total of three explosions on the planet Mars, between the hours <u>of 7:45 p.m. and 9:20 p.m. eastern standard time</u>. This confirms earlier reports received from American Observatories.
	Now, nearer home, comes a special announcement from Trenton, New Jersey. It is reported that at 8:50 <u>p.m</u>. a huge, flaming object, believed to be a meteorite, fell on a farm in the neighbourhood of Grovers Mill, New Jersey, twenty-two miles from Trenton. The flash in the sky was visible within a radius of several hundred miles and the noise of the impact was heard as far north as Elizabeth.

We have dispatched a special mobile unit to the scene, and will have our commentator, Carl Phillips, give you a word description as soon as he can reach there from Princeton.

In the meantime, we take you to the Hotel Martinet in Brooklyn, where Bobby Millette and his orchestra are offering a program of dance music.

[SILENCE 03"]

08:10:19 SWING BAND FOR 20 SECONDS...THEN CUT

ANNOUNCER 2:

08:10:42 We now take you to Grovers Mill, New Jersey.

[SILENCE 05"]

SOUND FX: CROWD NOISES...POLICE SIRENS

CARL PHILLIPS: *[Slightly urgent – sense of importance–news reporter's delivery]*

08:10:50 Ladies and gentlemen, this is Carl Phillips again, at the Wilmuth farm, Grovers Mill, New Jersey. Professor Pierson and myself made the eleven miles from Princeton in <u>ten minutes</u>. Well, I...I hardly know where to begin, to paint for you a word picture of the strange scene before my eyes, like something out of a modern Arabian Nights.

Well, I just got here. I haven't had a chance to look around yet. I guess that's *it.* Yes, I guess that's the *(pause)...thing,* directly in front of me, half buried in a vast pit. Must have struck with terrific force. The ground is covered with splinters of a tree it must have struck on its way down. What I can see of the *(pause)* object itself doesn't look very much like a meteor, at least not the meteors I've seen. It looks more like a huge cylinder. It has a diameter of...what would you say, Professor Pierson?

The elapsed transmission time at the end of Phillip's interview with Professor Pierson was 08:09:10, when Phillips 'handed-back' to the studio. *We now return you back to our New York studio.* [*FADE IN PIANO PLAYING*]. The real time taken to travel the eleven miles as per the transmission was in fact one minute and forty seconds

(00:01:40) and not ten minutes (00:10:00) as stated by Phillips. This speedy super-human feat makes use of dramatic temporal illusion through verbal suggestion which the audience listening from the beginning of the play may have realized was part of the dramatic time frame.

The constant shifts in time, together with the increasing urgency of interrupted news bulletins certainly added to the dramatic tension in the play and, taken out of context could easily lead to a sense of individual confusion and disorientation, ultimately creating a state of collective panic. The majority of listeners who were listening from the beginning, those who regularly tuned-in to hear the Sunday night play, would have realized that this particular play was using news reportage as part of the dramatic action. However, those who were not listening from the beginning but who tuned in late were at a distinct disadvantage. These late listeners, now the largest group of listeners, heard what they heard and in the most part believed what they heard to be 'live' news reports of an alien invasion. Such was the belief implicitly given to radio, that news reports could only be factual, particularly when they 'sounded' like news. It was unthinkable that the programme could have been anything else but true.

The Mercury Theatre's regular Sunday night drama slot, 8 p.m. to 9 p.m., competed with a massively popular entertainment show on the competing NBC network, *The Edgar Bergen and Charlie McCarthy Show*. A type of comedy/musical radio cabaret show featuring a ventriloquist, his anarchic dummy and a number of guest entertainers. The Mercury audience had a regular listenership of about 4% of the total audience whereas *Bergen and McCarthy* had almost 35%. On the night in question, 30 October 1938, a rather shrill and out of tune soprano began her singing routine on the *Bergen and McCarthy Show* at 8.12 p.m. This marked a point in time when the inevitable happened. Just as today's television audience use a remote control to 'flick' between stations during advertisements or uninteresting sections of programmes, the American radio audience in 1938 did something similar with their radio dials. During the soprano's song they twiddled their radio dials in the hope of finding something more congenial to listen to.

12% of Bergen and McCarthy's audience, twiddling away, suddenly found themselves listening, appalled, to hear a news report of an invasion, by now well under way, by Martians.[25]

The War of the Worlds : Radio script by Howard Koch

SOUND FX:	CROWD NOISES…POLICE SIRENS…GENERAL CONFUSION [Hold behind throughout]
PHILLIPS:	*[Excited news reporting delivery]*
08:11:40	About thirty yards…The metal on the sheath is …well, I've never seen anything like it. The colour is sort of yellowish-white. Curious spectators now are pressing close to the object in spite of the efforts of the police to keep them back. They're getting in front of my line of vision. Would you mind standing on one side, please?
POLICEMAN:	One side, there, one side.
PHILLIPS:	While the policemen are pushing the crowd back, here's
08:11: 54:	Mr. Wilmuth, owner of the farm here. He may have some interesting facts to add // Mr. Wilmuth, would you please tell the radio audience as much as you remember of this rather unusual visitor that dropped in your backyard? Step closer, please.
08:12:14	Ladies and gentlemen, this is Mr. Wilmuth
WILMUTH:	*[Off mic]* I was listening to the radio.
PHILLIPS:	Closer and louder, please.
WILMUTH:	*[Off mic. – moving closer]* Pardon me!
PHILLIPS:	Louder, please, and closer.
WILMUTH:	Yes, sir–*[Clears throat –worried, slightly confused voice]* – while I was listening to the radio and kinda drowsin', that Professor fellow was talkin' about Mars, so I was half dozin' and half…*[pause]*
PHILLIPS:	*[Urgent excited voice]* Yes, Mr. Wilmuth. Then what happened?
WILMUTH:	As I was sayin', I was listenin' to the radio kinda halfways…

In the first thirty-nine minutes of the broadcast the Martians had landed, multiplied and destroyed numerous cities in the U.S.A. before finally destroying New York itself. The dramatic tension was not in the fast moving pace of the broadcast but more in the nuances of the vocal acting and techniques employed in the production. These created a believable authenticity in the sound of dramatic 'breaking' news and of a radio station that was nervously trying to deal with the events. The numerous deliberate three to five second breaks in transmission [SILENCE], when the station was going over to 'live' coverage or vice versa, would have added to the sense of 'live' happenings. Those deliberate, temporary breaks, engineered as transmission signal failures, would not have been interpreted as station errors, but as symptoms of the escalating chaos on the ground.

Critically, the actors' vocal deliveries, tempos and accents closely mirrored the perceived naturalism of their characters from the professional, if tense-sounding news reporters and announcers to the educated and gravely-sounding voices of the professors and other prestigious characters. Every voice and accent played a hierarchical role perceptively matched to its character.

> The actors too were galvanized into startlingly real and precisely observed performances. Frank Readick as Carl Phillips, the reporter on the spot who describes the invasion and then collapses dead at the mike, had listened over and over again to a recording of the report of the explosion of the Hindenburg air balloon from a year or two before and exactly imitated the original commentator's graduation from comfortable report through growing disbelief to naked horror.[26]

The actors' vocal deliveries mirrored their perceived status in life; from the rural accent and speech pattern of the New Jersey farmer, Mr. Wilmuth, *"as I was sayin', I was listenin' to the radio kinda halfways..."* – the measured, matter-of-fact military delivery of 'Brigadier General Montgomery Smith, Commander of the State Militia at Trenton, New Jersey; *"I have been requested by the governor of New Jersey to place the counties of Mercer and Middlesex as far west as Princeton, and east to Jamesburg, under martial law"* – to the gravely

serious, paternal and doom-laden political style delivery from the Secretary of the Interior.

The War of the Worlds : Radio script by Howard Koch

ANNOUNCER TWO:	At this time martial law prevails throughout New Jersey and eastern Pennsylvania. We take you now to Washington for a special broadcast on the National Emergency *[pause]* the Secretary of the Interior.
08:25:52	[SILENCE 03"]
SECRETARY:	*[Educated, slow, steady and deliberate but serious tone]*
08:25:55	Citizens of the nation: I shall not try to conceal the gravity of the situation that confronts the country, nor the concern of your Government in protecting the lives and property of its people.
	However, I wish to impress upon you private citizens and public officials, all of you, the urgent need of calm and resourceful action. Fortunately, this formidable enemy is still confined to a relatively small area, and we may place our faith in the military forces to keep them there. In the meantime placing our faith in God we <u>must</u> continue the performance of our duties each and everyone of us, so that we may confront this destructive adversary with a nation united, courageous, and consecrated to the preservation of human supremacy on this earth.
08:27: 01	I Thank you.

The simple brilliance in both the production techniques and the vocal acting in capturing the essence of dramatic news delivery were critical in maintaining a sense of believability – believable in the dramatic sense for those listening who knew it was a drama production, but unfortunately, believable in a real or even a surreal sense for some of those who just happened upon the broadcast late.

Of those who heard the broadcast, 28% (3,360,000) thought it was a news bulletin. AIPO issued statistics for six American regions which illustrated (i) the percentage of listeners who were frightened by the broadcast; and (ii) the extent of fright those listeners experienced.

AIPO Statistics[27]

	(i) Listeners frightened	(ii) Extent of fright
Mountain & Pacific	20%	40%
Middle Atlantic	15%	69%
West North Central	12%	72%
East North Central	11%	72%
South	8%	80%
New England	8%	71%

As Orson Welles read the rather unusual scripted epilogue to the production at two minutes to nine, one wonders how aware Welles was of the widespread panic the broadcast was actually causing at that precise time.

The War of the Worlds : Radio script by Howard Koch

CUE:	*[MUSIC–FADE]*
WELLES:	This is Orson Welles, ladies and gentlemen, out of character to assure you that *The War of the Worlds* has no further significance than as the holiday offering it was intended to be. The Mercury Theatre's own radio version of dressing up in a sheet and jumping out of a bush and saying Boo. Starting now, we couldn't soap all your windows and steal all your garden gates, by tomorrow night...so we did the next best thing. We annihilated the world before your very ears, and utterly destroyed the Columbia Broadcasting System.

> You will be relieved, I hope, to learn that we didn't mean
> it, and that both institutions are still open for business.
> So good-bye everybody, and remember, please, for the
> next day or so, the terrible lesson you learned tonight.
> That grinning, glowing, globular invader of your living
> -room is an inhabitant of the pumpkin patch, and if your
> doorbell rings and nobody's there, that was no Martian
> (*pause*)…it's Hallowe'en.
>
> CUE: *[SIG. MUSIC] Fade to end*

According to Simon Callow 'the laughter died on Welles's lips
the moment the programme was over. Terrified listeners who
had called CBS angrily threatened violence against Welles and
the company on discovering that they were victims of what
seemed to them to be a malicious hoax.'[28]

There were four standard station announcements during the
course of the broadcast. These station announcements were
common practice identifying the name of the network and
presentation being broadcast that evening e.g. 'You are listening
to a CBS presentation of Orson Welles and the Mercury Theatre
on the Air in an original dramatization of *The War of the Worlds* by
H. G. Wells.'[29] One at the beginning [08:00:10], one at the
station-break [08:39:10], one after the station-break [08:39:30] and
one at the end of the broadcast [08.59:15]. In addition, 60% of all
stations carrying the program interrupted the broadcast to make
local announcements when it became apparent that a
misunderstanding was abroad.[30] In response to the widespread
panic caused by the broadcast, the CBS network carried the
following announcement at 10:30 p.m., 11.30 p.m. and 12:00
midnight on the same evening, 30 October 1938.

> For those listeners who tuned in to Orson Welles's
> Mercury Theatre on the Air, broadcast from 8:00 to
> 9:00 p.m. eastern standard time tonight and did not
> realize that the program was merely a modernized
> adaptation of H. G. Wells's famous novel *The War of the
> Worlds*, we are repeating the fact which was made clear
> four times on the program, that, while the names of
> some American cities were used, as in all novels and

dramatizations, the entire story and all of its incidents were fictitious.[31]

Could a repeat broadcast of *The War of the Worlds* spark panic again? A repeat of the original Orson Welles production most likely never could, but what if a recreated broadcast contextualized within a local geographical area using identifiable place names and prestige interviewees, together with a well acted production which mirrored the 'sound' of local news coverage, were to deceive the public? In 1988 a local radio station in Portugal re-enacted *The War of the Worlds* as a 50th anniversary homage to Orson Welles but placed the play in a Portuguese setting. The *South China Morning Post* newspaper dated 1-11-1988, reported on the panic that resulted from the broadcast.

New broadcast of 'War of the Worlds' sparks panic

Lisbon: A 50th anniversary recreation of the famous Orson Welles *War of the Worlds* radio broadcast caused panic and protests in a district of northern Portugal, police and radio employees said.

Residents reportedly flocked to an area outside the town of Braga yesterday where the local station reported aliens from Mars were landing. Others began fleeing in cars and scores of people called the Police and Fire Department, news reports from the area said. Lines were reported to have formed at petrol stations.

The 90-minute broadcast was a recreation of a radio version of the H. G. Wells novel *The War of the Worlds,* that the actor and director, Orson Welles produced in the United States on October 30, 1938. Welles interrupted regular broadcasts with a report that a meteorite carrying extra-terrestrials had crashed into New York. The nation-wide broadcast of the play in the form of news reports caused panic.

In Portugal, police were called to control between 150 and 200 demonstrators who gathered outside the studios of Radio Braga to protest against the broadcast

that many people at first believed was a factual report, said Paulo Sousa, a reporter at the station.

Sousa said the station was showered with more than 100 calls. "Some called to complain, some to inquire and some to offer congratulations," he said in a telephone interview. Sousa said the broadcast was intended as a homage to Welles and had been well publicized previously in newspapers and on the radio station itself the day before. He said the programme itself contained clues that it was fiction.

Police in Braga confirmed they had been called to the station. They said many people believed the broadcast initially, but added that no serious incidents had been reported.[32]

The War of the Worlds in whatever context (American or Portuguese), did not in itself panic a nation, instead, a proportion of listeners allowed themselves to be panicked by what they imaginatively believed they heard to be true. I believe this may say more about the incalculable and idiosyncratic nature of the human imagination, than necessarily the power of radio in itself. Yes, radio can be powerful, stimulating and highly imaginative, particularly in the post aural depths of the listener's imagination. Understanding this is to understand in part the carefully guarded control exerted upon radio broadcasting in a world-wide context.

4 | A High Hum of Pure Agony

The BBC Radiophonic Workshop is now a rather quaint title for a department in the BBC that had developed into a veritable powerhouse of creative sound productions. Regrettably disbanded after forty years at the end of 1998, its existence at all was entirely due to a handful of BBC drama and sound enthusiasts, who in the 1950s, became fascinated with post war music and sound developments. More importantly they recognized the potential of these new sound developments as a unique addition to radio drama production. Far removed from its early beginnings with a few tape machines and simple electronic devices, the Workshop grew to comprise a host of hi-tech music recording studios and a staff of 'sound' composers. (I use the word 'sound' to encompass all of the Workshop's composers, those with formal music composition training and those with other technical/artistic abilities who were engaged in the composition of sound). The function of the Radiophonic Workshop was from the beginning to compose and produce sounds and music to order for a diverse range of BBC programmes, which spanned the entire radio and television networks. With regard to British radio drama, the Radiophonic Workshop remains the singularly most important milestone in the development of contemporary drama sonorities.

The BBC Radiophonic Workshop is certainly unique within the annals of British broadcasting where its foundation stems from

earlier sound experiments and creations in the late 1940s and
early 1950s in France, Germany, Italy and America. The post-war
years heralded a revolution in recording technology. Modern
recording tape (ferrous-covered plastic), a by-product of German
war engineering, became increasingly available to broadcasters in
the post-war years. Although this new form of tape and the tape
machines to record and play it existed during the war in
Germany, it was the late 1940s before it began to be utilized by
broadcasting organizations. The old turn-of-the-century shellac
disc recording (e.g. early recordings of John McCormack, Enrico
Caruso etc.) was replaced in the 1930s by steel tape and the
infamous and monstrous 'Blattnerphone' recorder, which was in
turn replaced by direct recording onto disc.

The revolution in recording technology, ferrous-covered plastic
tape and its accompanying tape recorder, offered radically new
possibilities for broadcasters and sound composers. As these
recorders came into use, broadcasters realized that entirely new
techniques of programme making became possible. 'Not only
could the new machines record and replay, but the tape could be
easily cut up and manipulated. Sound became a malleable
object.' [1]

Desmond Briscoe, former Head of the BBC Radiophonic
Workshop, realized early on that this new tape was an object of
considerable potential. For the first time sound could be
completely controlled, altered, restructured and metamorphosed
in a form of 'genetic' sound manipulation. 'You could cut it up
with scissors and join the pieces together. Suddenly sound on
tape was for me an entirely different thing with limitless
possibilities.' [2] But before Briscoe came to this realization, years
of successful experimentation and work, which emanated from
European broadcasting organizations, had already established
new forms of avant-garde sound creations.

During the late 1940s two French radio engineers, Pierre
Schaeffer and Pierre Henri established a new form of sound
composition, 'musique concrète', which used recorded real
sounds as the raw materials of composition. 'Musique concrète',
which is still practised as a form of music composition, is a
montage or assemblage of recorded 'live' sounds which are

subjected to two kinds of treatment. The first is tape manipulation or edited reconstruction. Sections of tape are cut (spliced), reversed and reordered in an unrecognizable reconstruction. The second involves electronic modification where tapes are speeded-up and slowed down, also creating unrecognizable sound patterns. Reginald Smith-Brindle suggests that through these two means, relatively familiar sounds can be made unrecognizable and then reassembled to give the most unexpected results. 'The original sounds recorded can be very few indeed; the important thing is that they should be rich, complex sounds, capable of substantial modification.' [3]

Schaeffer's work in Paris and with the 'Groupe de Recherches Musicales' which he established at the French National radio station (RDF), remained adamant in their use of 'living' sounds (voices, instruments and the sounds of life – car horns, traffic, banging doors etc.) as the basis of their musical material. Whereas Schaeffer invented the technological process, his colleague, Henri, created the context for the use of 'musique concrète.' 'Schaeffer created his 'phonegene' machine, which enabled control of the pitch and speed of his natural sounds, Pierre Henri, his close colleague, was commissioned to compose this new music to accompany texts, ballets, films and an opera.'

During the same years another form of avant-garde sound/music (electronic music) was being developed and experimented with in Germany. The first electronic music studio was established in 1951 at the 'Westdeutscher Rundfunk' broadcasting studios in Cologne, under the directorship of Herbert Eimert. The German developments concentrated on using synthetic sound (i.e. electronically generated sounds – sine wave manipulation, oscillation and frequency division) as the basis of their musical compositions which they named 'elektronische Musik.' Elementary electronic sounds had previously been experimented with as musical compositions (e.g. Russolo and the Italian Futurists, Varese, Schillinger, Busoni and Theremin). German 'elektronische Musik' was a serious and 'scientific' attempt not only to create a totally new music in itself, using the sounds of electronics, but also a new musical aesthetic with a theoretical basis for its composition. Eimert argued that in

view of the fact that the electronic composer 'is no longer operating within the strictly ordained tonal system, [the composer] finds himself confronting a completely new situation. He sees himself commanding a realm of sound in which the musical material appears for the first time as a malleable continuum of every known and unknown, every conceivable and possible sound. This demands a way of thinking in new dimensions, a kind of mental adjustment to the thinking proper to the materials of electronic sound.' [4]

'Elektronische Musik' divided the sources of electronic sound into three broad categories depending on the degree in which electrical components were used in either creating or altering the sound, (further sub-divisions of these categories were also made depending upon the instrument type): (i) electro-acoustical instruments which involved the use of any conventional musical instrument including the human voice; (ii) electro–mechanical instruments which included instruments with mechanical vibrating parts – strings, tongue, membranes etc; (iii) electronic instruments whose electronic components alone were used for the production of impulses – thermionic valves, transistors, sine wave generators etc.

The fundamental division between 'musique concrète' and 'elektronische Musik'[5] was in the source of the sounds with which they each worked. Other composers worked by combining both elements thereby placing them under the same 'musical umbrella', which is acknowledged as shaping the new musical avant-garde. In Italy a laboratory set up by the country's broadcasting organization under the composer Luciano Berio combined both elements. Experiments were also in progress at the Philips Research Laboratory in Eindhoven, Holland, and at several studios in America.

The new music appealed to the BBC not so much as an art form in its own right, but in the way it could be used to enhance the sound of radio drama. Here I believe is a crucially important point. Whereas the French and Germans developed their new music pushing the frontiers of electronic sound, it was predominantly developed by music composers who viewed their 'creations' as stand alone concert or art pieces. The artistic purity

of such an approach certainly yielded works of fascinating complexities, but more importantly it helped to develop a structured and analytical approach to electronic music composition. I believe, however, that despite the experimental curiosity of electronic music concerts, the music's true potential was not to be realized in its electronically pure tones presented as sonic/aural concert works, but in its unique sonic blend with voice and the spoken word. The BBC Drama Department saw the potential for these new provokingly imaginative sounds to sonically reach the previously unheard, interior worlds of human and in-human imagination. No longer content with 'stock' sound from the record library, a group of BBC enthusiasts began experimenting with sounds blending the techniques of 'musique concrète' and electronic sound. The application for these new 'un-earthly' tones found a perfect home in the interior imaginative world of radio drama.

Whereas the BBC Radiophonic Workshop formally came into existence in April 1958 under its head Desmond Briscoe, the search for new sounds and sonic approaches to radio drama had begun some years earlier. There was an initial small group of sound enthusiasts which included 'drama producers John Gibson, Douglas Cleverdon, Donald McWhinnie and Michael Bakewell; writer/producer Fredrick Bradnum and playwright Giles Cooper, and studio managers (sound engineers) Daphne Oram and Norman Bain'[6]. This was a collective grouping of the best and most imaginative radio drama brains the BBC possessed. Desmond Briscoe states in his history of 'The BBC Radiophonic Workshop':

> Though we didn't realize it then, round about this time was a golden age of radio, and I was part of it. Music and drama came together for me in a very original and adventurous way. I was fortunate once again in working with so many talented producers. Some of them had been in radio for many years and were extremely distinguished in their careers. Others were comparative new boys encouraging a new kind of writer and new styles of making radio.[7]

The first major collaboration between the group was Donald McWhinnie's production of Beckett's *All That Fall* in 1957. Briscoe described it as a 'classic of its kind.' 'It was the first programme to contain what later came to be known as 'radiophonic' sound, and is acknowledged as one of radio's classic productions ... it was a work of genius, but one that tested the ingenuity of the producer and the practicalities of the medium.'[8]

> It has been revered in radio circles ever since as a rare and important experiment carried out between one of Europe's foremost writers and the BBC in its more experimental mood. It is one of the key programmes of the golden age of radio drama, and – incorrectly – has entered the official catalogues of electronic music as the first British production to contain electronic music. In point of fact the sounds in *All That Fall* were created from concrete sources, and there was no electronic element at all. What little music there was came from ordinary gramophone records subjected to radiophonic treatment.[9]

Some of the sounds created for *All That Fall* involved the sounds of people walking to a simple drum rhythm where the natural footsteps were mixed with the drums in exactly the same rhythm. Tape feed-back was also used, a type of 'flutter-echo' where the sound is repeated after itself but out of synchronization and time sequence. As Briscoe suggests, 'it was particularly good for suggesting a slight 'fantasy feeling' of things happening in a larger-than-life way. For example, when the 'Up-Mail' train hurtles through the sleepy station, the effect was heightened by all the sounds clattering and reiterating.'[10]

When Giles Copper's radio play *The Disagreeable Oyster* was broadcast in 1957, it showed that radiophonic experiments could also be funny – something that was to surprise those critics who associated radiophonic sound exclusively with nightmares, horror and madness.

The Disagreeable Oyster made use of some of the sound techniques created for the infamous Milligan, Secombe and Sellers comedy

programme *The Goon Show*, such as speeded up footsteps and sudden dramatic changes in sound. An early example of the experiments blending sounds and voices was Frederick Bradnum's *Private Dreams and Public Nightmares*, also broadcast in 1957 and produced by Donald McWhinnie. The piece lasted twelve minutes and was subtitled, 'A Radiophonic Poem.' It is perhaps the best example of the early realization of the aural influence of sounds on words and conversely words on sounds. Briscoe believes that the 'Radiophonic Poem' may constitute an art form in itself 'quite distinct from the poem on the page or the poem read aloud. A poetic experience which only exists in terms of a sound complex.' [11] McWhinnie's explanation of the piece defines the essence of the radiophonic poem as a distinctly separate art form. He explained that the work was intended as:

> ...an inextricable conception of word and special sound and an exploratory flight into a new territory of sound. The words were designed to evoke, and be reinforced by, new sounds, sounds never heard before, and to be themselves subjected to technical processes which would achieve emotional effects (with the human voice as basis) quite different from anything the actor can do on his own; the programme was to be put together inch by inch, not as a stunt, but to demonstrate the possibility of groping towards a fresh co-ordination of aural events. [12]

The following extract from the piece echoes my concerns expressed in the Introduction that the textual indication of abstract sound in a script is woefully inadequate for enlightening or encouraging the reader imaginatively to perceive the sonic realization of the sound intended. Even the written dialogue on the page does not give any sonic clue as to its aural effect through vocal performance or the radiophonic treatment of the voice in sound. This exemplifies an aural literary work whose meaning can only become apparent through its sonic realization:

Private Dreams and Public Nightmares (Frederick Bradnum) 1957 [13]

Basic Effects		*Dialogue*
A contrapuntal rhythm	1ST VOICE:	Round and round
		Like a wind from the
		ground
		Deep and deep
		A world turns in sleep.
A comet-like shriek	2ND VOICE:	I fall through nothing,
Acoustic change		vast, empty spaces.
Pulsating beat		Darkness and the
Descending scale		pulse of my life
		bound,
		Intertwined with the
		pulse of the dark
		world.
A developed sound like a cry		Still falling, falling,
		But slower now…

One month after the official opening of the Radiophonic Workshop (April, 1958) the BBC issued a press release to journalists which defined the creative role the Workshop was to play.

BBC Opens Britain's First Radiophonic Workshop

The BBC has set up a Radiophonic Workshop at Maida Vale in London, the first installation of its kind in this country to deal exclusively with the production of radiophonic effects. Thus the BBC is now equipped to provide an aid to productions which neither music nor conventional sound effects can give.[14]

In setting up the Workshop to provide a permanent centre for work of this kind, Briscoe states that the choice of technical equipment had been determined by two categories into which radiophonic sounds mainly fall:

1. Those which can be built up from basic material of natural sounds e.g. voices, bells, musical instruments, etc.

2. Those derived from wave-forms generated by electronic circuits e.g. oscillators, white noise generators, etc.

The BBC Radiophonic Workshop created sounds, music, sonic landscapes and 'happenings' for both BBC radio and television. All creative programme formats for both radio and television, from comedy shows to serious documentaries, have at some time or other employed the skills of the Workshop. From the earliest *Goon Shows* on radio through all the *Dr. Who* episodes on television, the Workshop has been composing its myriad of squeaks, buzzes and wobbly sounds into a veritable repertoire of sound creations. It is naturally at home creating 'out-of-this-world' and 'inhuman' sounds associated with science fiction type genres such as *Dr. Who*, *Quatermass and the Pit*, *Blake's Seven* and *The Hitch-Hiker's Guide to the Galaxy*.

The Hitch-Hiker's Guide to the Galaxy, which became a legend in its own time, began as a BBC Radio 4 series in 1978 and later transferred to television as a cult T.V. series. Briscoe states:

> *The Hitch-Hiker* was obviously just the thing for the Workshop, and sure enough the producer was soon around at Maida Vale shopping for rockets firing, winds howling, earthquakes wiping out prehistoric landscapes complete with animals, volcanoes erupting and giant boulders cracking open and turning into spaceships... and we will also need the sound of an office building flying through space in the grip of seven powerful tractor beams, and treatment to make actors' voices sound slimy and robotic.[15]

The concept of creating and using such sounds may at first appear strangely humorous or indeed purely infantile. One may be tempted to ask, what is the point of spending time and human resources in creating the sounds of giant boulders cracking open and turning into spaceships? The answer is simply that such sounds are instantly recognized for their unique 'out-of-this-world' imaginative potential. They have since become accepted as critical components in the production process of different dramatic genres for both radio and television. There may be humour involved in their making but there is certainly nothing infantile in the creation of abstract sounds arranged into complex sound units by its composer. Whether it is comedy, science fiction, serious drama or documentary, the creation of unusual and 'unreal' sounds can add an extra dimension, and depending upon the context, an ethereal dimension beyond the human perception of purely natural sounds. Such is the potential magic of radio and the power of carefully constructed sound to stimulate the listener's imagination that, for example, a listener can aurally experience the skeletal bones of the dead talking to each other.

David Rudkin's chilling docudrama, a radio drama made in documentary style, *Cries from Casement As His Bones Are Brought to Dublin*, was produced for BBC Radio 3 in 1973 by John Tydeman. Tydeman states that 'only radiophonic sound could successfully interpret the following requirement made by David Rudkin:

> *Long long upcurving electronic anthropoid cry, breaking at last at peak into a frisson-percussion collapse like opening of vast pores, cold ... Sound modulates to high slow-throbbing whine, suggesting pain.* [*Cries from Casement As His Bones Are Brought to Dublin*]

Rudkin also demanded that the bones of Crippen talk to the bones of Casement from the limepit at Pentonville, where they possibly lay together in death, and that whilst talking the bones be wrenched apart.[16]

Rudkin, speaking about the work, said that 'there could hardly be a more radically radiophonic text than this one ... because it [the play] was to be heard in a box, I set most of the action in a box – this was the best way for me to fix those boundaries within which my inner ear could most effectively work.' [17]

Guralnick believes that Rudkin's *Cries from Casement As His Bones Are Brought to Dublin* 'is a docudrama so original that it all but reinvents the genre ... where the text, in large part, depends on the kind of 'subtle resonances' that radio alone can communicate.' [18] Tydeman recognizes the invaluable addition of radiophonic sounds in the creation of particular types of radio drama.

> Sounds from the past we can research, envisage and recreate. But sounds of the future exist only in our imagination, as do the fantasy sounds of an author's invented creation – trolls, spectres, mermaids, inanimate objects to which speech is given, etc. We do not know how certain things sound; we can only imagine them. Such sounds can only be made mechanically, by treating the human voice, by treating man-made sounds, or by creating them electronically. [19]

It is obvious that certain sounds cannot be achieved by simple on-the-spot recording but need to be constructed or composed. It is my belief that greater use of creative radiophonic sound is crucial in the production of more adventurous aural forms of radio drama. It is only when the potential results of experimentation with new sonic possibilities are realized that radio drama will bring forth new forms of writing and dramatic themes for exploration through sound. This not only needs to be recognized by broadcasting institutions but also encouraged by them.

From the precisely constructed naturalistic sounds used in Beckett's *All That Fall* to the esoteric sounds in Rudkin's *Cries from Casement As His Bones Are Brought to Dublin*, radiophonic sound adds that all important inquisitive aural element. Well constructed radiophonic sounds are not just mere sound additions to a play, but can become what I will term a 'sonicvox'

as an important aural character element in the overall production. Such sounds can only be merely indicated in print as the concept of unknown or abstract sound is impossible to 'hear' imaginatively from simply reading it in a text. Radiophonic sounds, as with all the elements in a radio drama production (voices, words, silences, music, sound effects etc.), combine to form the sound drama. Therefore, sounds have a more heightened aural significance in a radio or sound drama than they might have in the visible world of theatre, film, and television. On radio all sounds form an important and integral part of the play's aural realization.

Whereas 'The BBC Radiophonic Workshop' introduced new sound possibilities to radio drama, it has to be said that not all plays use or require the electronic treatment of sounds or voices. Whether a play uses radiophonic sound or not should not be the deciding factor of what makes good or indeed adventurous radio drama. Good radio drama, whether it consists largely of voices and the spoken word with the minimal use of other sonic elements, is good because it is linguistically radiophonic in nature. *Good* radio drama is therefore written with an 'ear' for sound, making the best use of descriptive language, speech rhythms, imaginative concepts and an acute radiophonic awareness of the radio medium.

5 | *Under Milk Wood* (Dylan Thomas)

Perhaps the best known 'dramatic' work for radio is *Under Milk Wood* by Dylan Thomas. Completed in 1954, it was first produced for the BBC by Douglas Cleverdon in the same year, coincidentally the year of Dylan Thomas's death. The commercially released BBC CD[1] (it is also available on cassette) is a release of the 1963 production. It, too, was produced by Cleverdon and used many of the original cast, including Richard Burton as the narrator's voice. A more recent production of *Under Milk Wood* by George Martin (the record producer of The Beatles) was released in 1992[2] and features a host of famous voices including Anthony Hopkins, Jonathan Pryce, Windsor Davies, Mary Hopkin, Gareth Thomas, Sir Harry Secombe, Sian Phillips, Rachel Thomas and others. It is interesting to note that Rachel Thomas played the young ROSIE PROBERT in the original BBC production in 1954 and in the 1963 released production, but in this production she plays the older character MARY ANN THE SAILORS.

The work is undoubtedly a masterpiece for the radio medium and whatever about its literary aspirations, it is a work within the radio medium that has possibly not yet found its rightful niche. Although there are many excellent voice plays by other writers, *Under Milk Wood* is the one work that instantly springs to most people's minds as an exemplar of radio drama; but how should the work be accurately categorized and analysed? – as a radio play? A creative radio feature? Or a radio poem? Zilliacus also

recognizes the problems of categorization, which should not
only concern 'radio purists.' 'Radio purists have had great
difficulties in classifying and evaluating this bastard work from
the point of view of aural art.' [3] In essence, *Under Milk Wood* has
elements of all three formats which makes it unique and perhaps
the greatest example of a broadcasting enigma.

In its original form it was loosely written, recorded and broadcast
in 1954 as a radio feature. (I use the term 'loosely' to mean that it
was not specifically focused on exploiting any particular
programme format and not as a derogatory comment on the
work.) It is perhaps Thomas's own subtitle for *Under Milk Wood*
as a 'play for voices' which has contributed to its subsequent
misinterpretation as being a radio drama proper. One should
closely consider, in the light of the work, whether Thomas was
effectively using the word 'play' as a proper noun or a verbal
noun. Is it 'a play – for voices'? or 'a play for voices'? (in the
sense that it is 'a play on voices' or 'playing with voices'), or,
indeed, in Thomas's own words, 'an impression for voices'? The
dialectical problem posed is, within the modern broadcasting
environment, how can *Under Milk Wood* be categorized in terms
of aural literature?

Under Milk Wood chronicles the aspirations and assignations,
dreams and drudgeries, lives and loves of everything and
everyone that lives in the fictitious little Welsh fishing village of
Llareggub, although Thomas modelled it on the real Welsh
village of Laugharne. *Under Milk Wood – a Play for Voices* was
completed in 1954, but Thomas's earlier provisional title in 1951
for the unfinished work was *Llareggub: A Piece for Radio Perhaps*,
published in May 1952 by Countess Caetani in her quarterly
Botteghe Oscure. In a letter to Countess Caetani accompanying the
unfinished script of *Llareggub: A Piece for Radio Perhaps*, Thomas
writes:

> (Please ignore it as a final title.) Out of it came the idea
> that I write a piece, a play, an impression for voices, an
> entertainment out of the darkness of the town I live in,
> and to write it simply and warmly & comically with lots
> of movement and varieties of moods, so that, at many
> levels, through sight and speech, description & dialogue,

evocation and parody, you come to know the town as an inhabitant of it.[4]

In expressing the opinion that *Under Milk Wood* could more closely resemble a radio poem, that is, a poem intended exclusively for sound and aural realization, Lewis highlights the incongruities in academic categorization and subsequent analysis that have been applied to the work.

> Sometimes they have approached Dylan Thomas's 'play for voices' with orthodox dramatic expectations, believing that he was attempting to write a 'play' in the conventional sense. Sometimes they have brought novelistic criteria to bear, and this is probably due in part to the absurd claims once made for *Under Milk Wood* as a Welsh *Ulysses*, a miniature comic epic of Welsh life compressed into twenty-four hours like Joyce's Dublin Odyssey ... Sometimes they have discussed the work as though it were a basically realistic if somewhat fanciful quasi-documentary about Welsh village life, linking Llareggub with Laugharne where Dylan Thomas himself lived. Generally speaking, critics have assumed that because Dylan Thomas is primarily a poet, *Under Milk Wood* must be an essentially 'literary' work, and have therefore subjected it to 'literary' criticism. While such procedures are certainly not invalid, their validity depends upon taking into account and making allowance for the fact that it is not a 'literary' work in the same way that a poem or a novel is a literary work. In calling it 'a play for voices' Dylan Thomas insists on this very point. *Under Milk Wood* was conceived and written neither for the stage nor the page but for radio, not for the eye but for the ear. Aural impact is consequently of primary importance, and it is as misguided to approach *Under Milk Wood* as 'so many words on the page' as it is a play by Shakespeare.[5]

The dialectics of accurate description and classification do not apply to *Under Milk Wood* alone. Particular radio formats have also evaded clear definitions leading sometimes to vague interpretations of their particular style(s) of programme(s). *Under*

Milk Wood was commissioned by the BBC Features Department
under the aegis of Douglas Cleverdon (BBC Features Producer)
and indeed won The Prix Italia prize for Features in 1954, the
year of its original recording and broadcast. Writing in 1969,
Douglas Cleverdon, senior producer in the BBC Features
Department and the play's original producer, attempted to define
the difference between a radio play and a radio feature.

> Nobody outside the BBC (and, indeed, comparatively
> few inside) can be expected to distinguish between a
> radio play and a radio feature. A radio play is a dramatic
> work deriving from the tradition of the theatre, but
> conceived in terms of radio. A radio feature is, roughly,
> any constructed programme (that is, other than news
> bulletins, racing commentaries, and so forth) that
> derives from the technical apparatus of radio
> (microphone, control-panel, recording gear, loud-
> speaker). It can combine any sound elements – words,
> music, sound effects – in any form or mixture of forms
> – documentary, actuality, dramatized, poetic, musico-
> dramatic. It has no rules determining what can or
> cannot be done. And though it may be in dramatic
> form, it has no need of a dramatic plot.[6]

Cleverdon had also worked in collaboration with colleagues from
the Radio Drama Department; particularly those involved with
the BBC Radiophonic Workshop, which he (Cleverdon) helped
to establish. It should be noted that there were close links
between the Radio Drama and Features Departments at this
time; however, not all of the links were amicable.[7] Cleverdon, in
this regard, had a foot in both camps where he also produced
many radio plays including a number of award winning plays by
Henry Reed. Similarly, McLeish finds it awkward to define the
feature format, in this case trying to draw the boundaries
between the documentary and the feature. He prefers to see the
feature as an atypical, spuriously fluctuating form.

> Whereas the documentary must distinguish carefully
> between fact and fiction and have a structure which
> separates fact from opinion, the feature programme
> does not have the same formal constraints. Here all

possible radio forms meet, poetry, music, voices, sounds – the weird and the wonderful. They combine in an attempt to inform, to move, to entertain or to inspire the listener. The ingredients may be interview or vox pop, drama or discussion and the sum total can be fact or fantasy. A former Head of BBC Features Department, Laurence Gilliam, described the feature programme as 'a combination of the authenticity of the talk with the dramatic force of a play, but unlike the play, whose business is to create dramatic illusion for its own sake, the business of the feature is to convince the listener of the truth of what it is saying, even though it is saying it in dramatic from.[8]

But truth cannot be applied to *Under Milk Wood* and for that matter to any fictional piece. On a factual level it is true that Thomas wrote and finally submitted *Under Milk Wood* as a type of radio feature to the Features Department, but it is also *not* true that he wrote it as a radio play for the Drama Department at that time. Horstmann further compounds the argument by stating that 'the one clear distinction between features and plays seems to be that features deal with fact while plays deal with fiction.[9] Horstmann's terse definition is not necessarily wrong if considered in the context of modern broadcasting changes to radio's form and content. Evans's assessment highlights these changes in the perceptional changing nature of programming.

Many dramatized scripts of the past – 'Under Milk Wood', 'Alfie Elkins', 'Hilda Tablet' – went on the air as features mainly because the BBC's drama experts were then uninterested in work that was considered to be 'loosely constructed', 'formless', or 'lacking in dramatic tension.' Features producers on the other hand, briefed to promote creative writing and innocent of formal dramatic training, knew no better than to encourage such authors as Dylan Thomas, Bill Naughton and Henry Reed. Ideas as to what constitutes a play have undergone a revolution, and all these productions would now be unhesitatingly classified as drama. This is a retrospective triumph for the old-time features brigade

but it also means that the scope of dramatized features
is much reduced. By and large they are now confined,
like narrative and actuality features, to the imaginative
presentation of fact.[10]

Cleverdon states that 'it was mainly for Features producers that
Dylan Thomas worked as a radio actor. This not only afforded a
companionable circle of like-minded radio practitioners; it also
gave him an insight into the techniques of radio writing, which
he himself was to develop still further.' [11] Cleverdon believes that
'radio is *par excellence* the medium for the poet ... there is in radio
no limit to the evocative power of words; it is the medium of the
ear alone.' [12] It is therefore easy to understand how Dylan
Thomas, the poet, was not only influenced and encouraged by
the Features Department, but viewed the feature format as a
nebulous form of aural poetic expression that was part dramatic
and part narrative. If *Under Milk Wood* was neither written nor
produced as a radio play *per se,* it would, therefore, be inaccurate
to categorize and analyse it as such now. My concern here, drawn
from my experience, is the commonly held assumption in many
branches of learning and the performing arts that *Under Milk
Wood* is a typical example, and for many the only example, of
what is considered to be radio drama. My concern is further
heightened when the only cited aural example of radio drama
experienced is the BBC/Cleverdon Features production,
regardless of how laudable that production was or remains
within its own features genre. Thomas's original performance of
the work at the YMHA Poetry Centre, New York (14 May
1953)[13] including a small cast of voices clearly sets the work apart
in composition and rendition as a hybrid dramatic poetry
performance for voices.

Under Milk Wood began its creative life in 1945 as the broadcast
talk *Quite Early One Morning,* first broadcast on August 31st 1945
by the BBC Welsh Home Service. This was a creative/poetic
word portrait of the small town of New Quay on the
Cardiganshire coast in Wales. The eventual shape and, indeed,
some of the characters of *Under Milk Wood* can be seen emerging
from *Quite Early One Morning.* Again, hearing Dylan Thomas
reading *Quite Early One Morning* makes it clear that the

imaginative beauty of the sound of words, rhythms, rhymes etc., is uppermost in his poetic rendition.[14] With regard to the BBC recording and transmission Ferris adds that *Quite Early One Morning* 'was recorded in Wales, and the producer, Aneirin Talfan Davies, offered it to London for the national network. But London was not impressed by the "breathless poetic voice", and the item was only heard in Wales. BBC headquarters had its doubts about Celtic poets.'[15]

Quite Early One Morning (Dylan Thomas)[16]

Quite early one morning in the winter in Wales, by the sea that was lying down still and green as grass after a night of tar-black howling and rolling, I went out of the house...The town was not yet awake. The milkman lay still lost in the clangour and music of his Welsh-spoken dreams...Babies in upper bedrooms of salt-white houses dangling over water, or of bow-windowed villas squatting prim in neatly treed but unsteady hill streets, worried the light with their half in sleep cries. Miscellaneous retired sea captains emerged for a second, then drowned again, going down down into a perhaps Mediterranean-blue cabin of sleep, rocked to the sea beat of their ears. Landladies, shawled and bloused and aproned with sleep in the curtained, bombasined black of their once spare rooms, remember their loves, their bills, their visitors...

...Oh! The town was waking now and I heard distinctly insistent over the slow-speaking sea the voices of the town blown up to me. And some of the voices said:

I am Captain Tiny Evans, my ship was the *Kidwelly*,
And Mrs Tiny Evans has been dead for many a year.
'Poor Captain Tiny all alone,' the neighbours whisper,
But I like it all alone and I hated her...

Open the curtains, light the fire, what are servants for?
I am Mrs Ormore Pritchard and I want another snooze.
Dust the China, feed the canary, sweep the drawing-room floor;
And before you let the sun in, mind he wipes his shoes.

Thus some of the voices of a cliff-perched town at the far end of Wales moved out of sleep and darkness into the new-born, ancient, and ageless morning, moved and were lost.

The success of this (*Quite Early One Morning*) led him to contemplate a full-length dramatized treatment of the subject, and at first there was to be a farcical plot, with a police inspector from London judging the whole place to be insane. The title was to be *The Town was Mad*, or *The Village of the Mad*.

Cleverdon guesses that he wrote 'most of the first half' of such a play during 1949, soon after he had moved back to Laugharne. 'At what stage Dylan drifted from dramatic form of *The Village of the Mad* to the feature form of *Under Milk Wood* is uncertain. It seems to me probable that when he began to write the long, opening sequence of the dreamers in the "lulled and dumfound town", the feature form imposed itself upon him, and he continued in the same vein.' By 'feature' Cleverdon means the use of narrators to introduce other voices, as in the radio features of that period. He recalls that about a third of the final script was written before 'I suggested the obvious solution – that he should drop the plot altogether, and simply carry on with the life of the town until nightfall. He seemed relieved at this proposal.'[17]

I would argue that a radio play does not necessarily have to include a dramatic structure where conflict and resolution are carried out within the unities of time, place and action. This is an unfortunate misinterpretation of Aristotle's *Poetics* introduced into French dramatic literature by Jean Mairet and one which can not be applied as an absolute in dramatic writing. Although the structure of *Under Milk Wood* is framed by the unities of time (twenty-four hours) and place (Llareggub), its unity of action is debatable. To use the musical structure of sonata form as an example of analysis, the exposition, development and recapitulation of the work's dramatic action hinges upon the physical-geographical space that is the fictional village of Llageggub where the individual characters become the collective character of the village itself. There is little character development so to a large extent the characters exist as part of the descriptive, poetic narrative. Therefore their short

intermittent vocal appearances, merely punctuating the rolling narrative, is more in playful affirmation of their existence outside the narrative and within the poetically magic world of Llareggub. Thomas brilliantly bends and shapes the spoken word into an aural feast of phonemes, phrase and rhythmic delight to the ear. Grammar, punctuation and syllabic exactitude are put aside in preference to rhythmic, melodic and harmonic word sounds. In the Joycean tradition of phonetic word crafting, Thomas crafts a language from the world of magical dreams where everything is possible and possibly believable.

In using a similar 'Ulyssean' time frame, Thomas sets the work in a condensed twenty-four hour cycle beginning at night through the following day and back to night again. This condensed twenty-four hour time frame is the listener's 'clairaudient' window of opportunity to eavesdrop on life in Llareggub, a life that will remain frozen in time as the same repeated 'twenty-four hours' forever. It seems that everything in Llarregub from the inanimate to the animate has a meaningful purpose for being there. The ghosts of the 'dead', who watch over and populate Llareggub by night to the ghosts of the 'living' and imagined living, who watch each other and are Llareggub itself. This is a magically simple world experienced in the sounds of its own passing time where the grass can be heard growing, the dew falling, the birds sleeping and the hushed town breathing.

As Thomas wrote: 'Stand on this hill. This is Llareggub Hill, old as hills, high, cool, and green, and from this small circle of stones, made not by druids but by Mrs Beynon's Billy, you can see all the town below you sleeping in the first of the dawn.'[18] The narrative geography of this little village can be imaginatively heard slowly emerging from the darkness of the silence that Thomas requested preceding the work.

Under Milk Wood by Dylan Thomas

SILENCE

FIRST VOICE [Very softly]

To begin at the beginning:

It is spring, moonless night in the small town, starless and bible-black, the cobblestreets silent and the hunched, courters'-and-rabbits' wood limping invisible down to the sloeblack, slow, black, crowblack, fishing-bobbing sea... You can hear the dew falling, and the hushed town breathing... Listen. It is night moving in the streets, the processional salt slow musical wind in Coronation Street and Cockle Row, it is the grass growing on Llareggub Hill, dewfall, starfall, the sleep of birds in Milk Wood...

...Time passes. Listen, Time passes. Come closer now. Only you can hear the houses sleeping in the streets in the slow deep salt and silent black, bandaged night...Only you can hear and see, behind the eyes of the sleepers, the movements and countries and mazes and colours and dismays and rainbows and tunes and wishes and flight and fall and despairs and big seas of their dreams. From where you are, you can hear their dreams...

The more fantastic the characters and places are, the more believable the imaginative visions become. From 'Goosegog Lane', down 'Cockle Row', up 'Donkey Lane' and into 'The Sailor's Arms', the listener is made to feel that they have actually been in this village, even imaginatively lived there at one time. And what of Llarragub's daytime characters? – 'Willy Nilly the postman', 'Ochy Milkman', 'Organ Morgan the church organist', 'Lord Cut-Glass', 'Nogood Boyo', 'Lily Smalls', 'Gossamer Beynon', 'Mary Ann The Sailors', the infamous 'Polly Garter' plus a host of other villagers. All of them become strangely familiar as if they are people whom we seem to identify with from our childhood. In a magical sort of way they were born never to age, fixed in imaginative fantasy for all eternity. Some of the characters are so identifiable that Thomas typecasts them as a collective group without individual names (e.g. First Drowned, Second Drowned, First Woman, Second Woman etc.). The local gossips, that collective group of all-knowing villagers who gather in Mrs Organ Morgan's general shop where everything is sold

from custard to whistles, will always begrudgingly narrate the Llareggub scandals in that familiar insularity of the small village with its self-righteous, neighbourly tone of voice.

Under Milk Wood by Dylan Thomas

FOURTH WOMAN:	There's a nasty lot live here when you come to think.
FIRST WOMAN:	Look at that Nogood Boyo now
SECOND WOMAN:	too lazy to wipe his snout
THIRD WOMAN:	and going out fishing every day and all he ever brought back was a Mrs Samuels
FIRST WOMAN:	been in the water a week
SECOND WOMAN:	And look at Ocky Milkman's wife that nobody's ever seen
FIRST WOMAN:	he keeps her in the cupboard with the empties
THIRD WOMAN:	and think of Dai Bread with two wives
FOURTH WOMAN:	one for the daytime and one for the night…

Even the razor tongued acid breathing Mrs. Ormore-Pritchard, lord and master of both deceased husbands, can show a benevolent softness through Thomas's language.

Under Milk Wood by Dylan Thomas

MRS ORMORE-PRITCHARD:	Mr. Ogmore!
	Mr. Pritchard!
	It is time to inhale your balsam.
MR. OGMORE:	Oh, Mrs. Ogmore!
MR. PRITCHARD:	Oh, Mrs Pritchard
MRS ORMORE-PRITCHARD:	Soon it will be time to get up. Tell me your tasks, in order…
	…And before you let the sun in, mind it wipes its shoes.

Thomas has written language peppered with alliteration, rhythm, metre and rhyme which springs into life when spoken. There is little differentiation between the spoken language of the characters and that of the narrator. In this way, Thomas creates a seamless living entity in his language for places and things as much as for the characters themselves. For example, in Willy Nilly's kitchen everything in it including the kitchen itself imaginatively appears as the overworked, overwrought and under-loved family kitchen which Willy Nilly and his wife take for granted.

Under Milk Wood by Dylan Thomas

> ...And in Willy Nilly the Postman's dark and sizzling damp tea-coated misty pygmy kitchen where the spittingcat kettles throb and hop on the range, Mrs Willy Nilly steams open Mr Mog Edward's letter to Miss Myfanwy Price and reads it aloud to Willy Nilly by the squint of the Spring sun through the one sealed window running with tears, while the drugged, bedraggled hens at the back door whimper and snivel for the lickerish bog-black tea.

Under Milk Wood is not without its sounds; those natural sounds of footsteps, *Captain Cat hears Willy Nilly's feet heavy on the distant cobbles...*; the sounds of the church and school bells ringing; the sound of Organ Morgan's organ playing and the sounds of the village children at play etc. Perhaps the most distinctive use of sound is the way Thomas employs fragments of songs, nursery rhymes and bawdy pub vignettes in the play. Ackerman states that 'the use of song enables Thomas not only to evoke but quickly change mood and atmosphere, an innovative dramatic device in the early fifties. Of course Thomas well knew how Welsh pub singing easily moves from bawdy to hymn, aria to folk-song!'[19] The fragments of nursery rhymes and children's game rhymes range from the innocent 'Hushabye Baby' to the children's kissing game rhyme 'Gwennie, Gwennie, Give Her a Penny.' The three songs 'Johnnie Crack and Flossie Snail', 'Polly Garter's Song' and 'Mr. Waldo's Song' present themes from childish 'cruelty' rhymes to adult jocose eroticism.

Polly Garter's Song [20]

 I loved a man whose name was Tom

 He was strong as a bear and two yards long

 I loved a man whose name was Dick

 He was big as a barrel and three feet thick

 And I loved a man whose name was Harry

 Six feet tall and sweet as a cherry

 But the one I loved best awake or sleep

 Was little Willy Wee and he's six feet deep … etc.

Mr. Waldo's Song [21]

 Poor little chimbley sweep she said

 Black as the ace of spades

 Oh nobody's swept my chimbley

 Since my husband went his ways

 Come and sweep my chimbley

 Come and sweep my chimbley

 She sighed to me with a blush

 Come and sweep my chimbley

 Come and sweep my chimbley

 Bring along your chimbley brush!

'Johnnie Crack and Flossie Snail' is typical of many children's songs and is ideally suited to Thomas's use of sing-song linguistic writing in the play. The tempo is set as 'lively' which could range between 120 to 132 beats per minute. An interesting aspect of the song is that it is set in 2/4 time (2 beats to a bar) which reflects the single and double syllable words of the song e.g. Snail, Pail, John-nie, Floss-sie, etc. The sing-song (up-and-down) nature of the song is further emphasized by the stronger pulse or first beat falling after every second beat (e.g. | 1–2 | 1–2 | 1–2 | etc.) and by the rise and fall of the melody reflecting the natural syllabic inflection of the spoken words (e.g. $^{John}_{-ney}$, $^{Flos}_{-sie}$, etc.). I

have divided the lyrics into bar lengths of 2/4 time for the opening lines of the song as an example of the simplicity in the rhythmic structure.

<u>Johnnie Crack and Flossie Snail</u> [22] [The Children's Song]

All

Johnnie Crack and Flossie Snail

| *John-nie* | *Crack and* | *Flos-sie* | *Snail* |

Kept their baby in a milking pail

| *Kept their* | *ba-by in-a* | *milk-ing* | *pail* |

Flossie Snail and Johnnie Crack

| *Flos-sie* | *Snail and* | *John-nie* | *Crack* |

One would pull it out and one would put it back

| *One would* | *pull-it out-and* | *one would* | *put-it back* |

Girls

O it's my turn now said Flossie Snail

To take the baby from the milking pail

Boys

And it's my turn now said Johnnie Crack

To smack it on the head and put it back … etc.

The lives and loves of Llareggub continue unabated nestling dreamily 'Under Milk Wood' on that forever fine Spring day. But as the evening turns to dusk and dusk itself begins to slither under the cloak of night, the entire magical world that is Llareggub, begins to retire from the feverish activities of the day. The listener can imaginatively visualize the scene through Thomas's simple use of sounded narrative and crafted word play.

Under Milk Wood by Dylan Thomas

Now the town is dusk. Each cobble, donkey, goose and gooseberry is a thoroughfare of dusk…(p.56)

Mrs Ogmore-Pritchard, at the first drop of the dusk-shower, seals all her Sea View doors, draws the germ-free blinds, sits, erect as a dry dream on a highbacked hygenic chair and wills herself to cold, quick sleep…(p.56)

Llareggub is the capital of dusk…(p.56)

Dusk is drowned for ever until tomorrow. It is all at once night now…(p.59)

As the action recapitulates before dusk moves to night and peaceful contentment, the listener is once more imaginatively whisked through the familiar geography of Llareggub.

Under Milk Wood by Dylan Thomas

And at the doorway of Bethesda House, The Reverent Jenkins recites to Llareggub Hill his sunset poem (p. 57)…Jack Black prepares once more to meet his Satan in the Wood (p.58)…And Lily Smalls is up to Nogood Boyo in the wash house (p.58)…

A farmer's lantern glimmers, a spark on Llareggub hillside. Llareggub Hill, writes the Reverent Jenkins in his poem-room, that mystic tumulus, the memorial of peoples that dwelt in the region of Llareggub before the Celts left the Land of Summer and where the old wizards made themselves a wife out of flowers (pp.59/60)

…Mr Waldo, in his corner of the Sailors' Arms sings (p.60)…Organ Morgan goes to chapel to play the organ (p.61)…

…And Mr. Waldo drunk in Milk Wood smacks his live red lips. But it is not his name that Polly Garter whispers as she lies under the oak and loves him back. Six feet deep that name sings in the cold earth.

POLLY GARTER [Sings]

 But I always think as we tumble into bed

 Of little Willy Wee who is dead, dead, dead.

> The thin night darkens. A breeze from the creased water sighs the streets close under Milk waking Wood…the suddenly wind-shaken wood springs awake for the second dark time this one Spring day (p.62).

This is a palpable geography that breathes through the spoken narrative and in the voices of its surreal characters. Llareggub provides the physical geography from which Thomas craftily honed its characters, giving them a strangely identifiable, yet mystical place for their magical existence. If the action in *Under Milk Wood* could be described as a day in the life of a village, then the unity of action could be analysed as the exposition, development and recapitulation of Llareggub itself.

Under Milk Wood was not universally acclaimed and indeed attracted some vehement criticism with regard to its literary content.

> I have not yet come across any dramatic piece which when studied *as words on the page* can yield anything other than sentimentality. By this I mean that no defined artistic truth is employed to disturb and alter attitudes and perceptions – as art must alter them. Even our most 'realistic' drama, though it enacts arguments about human nature, social order, moral problems, does not seek to enlarge our sympathy. Essentially, it flatters our prejudices and inhibits our self-knowledge by a kind of self-righteous cosiness…Sex, boozing, eccentricity, cruelty, dirty behaviour, are enhanced by the implicit background of suburban respectability, the interest lying in the daring naughtiness of their revelation. The norms or the positives of living, expressed as the potentialities of human love, are absent: all is denigrated. Sometimes the denigration is relieved by humour, but only sometimes. And on the whole the breathless verbal patter is tedious.[23]

Holbrook's criticism is based upon some serious errors. First, he has fallen in to the common trap of analysing *Under Milk Wood* as a radio play, bringing to it a set of dramatic conventions which

are not applicable in this case. Accepting the ramifications of the first error, I reject his claim that any dramatic work should have as its basis the intention to 'disturb and alter attitudes and perceptions.' Here Holbrook employs an older Aristotelian concept founded upon the premise that all art should remain truthful to the greater ideal of individual and societal improvement. Second, in stating that 'on the whole the breathless verbal patter was tedious', Holbrook completely misses the most important point that the work was written specifically for the aural medium. Its 'verbal patter' is precisely what Thomas wrote to be spoken and it is through its sonic form that its aurality springs alive in the listener's imagination. On the lesser point of sentimentality – I believe that a listener's probable empathy with its language and its characters is drawn more from a humorous association, a form of remembered childhood fantasy spirited by the recognition of a form of linguistic chaos in a willy-nilly-nogood-boyo way.

I attended a performance of *Under Milk Wood* as an adapted stage play many years ago at the Olympia Theatre (Dublin) performed by a Welsh theatre company. The production was excellent as I remember it, but it reinforced my belief that *Under Milk Wood* is simply at its best in sound and aurally in the imaginations of its listeners. In this particular instance the visibility of the costumed characters, their movements in and out of 'constructed' scenes, the vocal projections from stage to audience which altered the emphasis of many of the more subtle and quietly spoken nuances, and the setting for Llareggub itself were a faded and disappointing realization of my previously imagined pictures gained from listening to its sonic realization.

Is it possible to categorize *Under Milk Wood* in modern broadcasting terms? Is it possible to categorize it in aural literary terms? Is it a radio drama, a radio feature or a radio poem? It is ironic that *Under Milk Wood* has come to be considered a 'classic' example of radio drama when in fact it was neither written for nor produced by the Radio Drama Department. Thomas wrote *Under Milk Wood* in a particular radio style he had grown to know best, influenced by those radio practitioners he knew most – the Features Department.

What if, for a point of argument, the BBC Radio Drama Department rather than the Features Department had commissioned *Under Milk Wood?* What if it had been given its first production not in 1954 but three years later in 1957, the year of *All That Fall* (Beckett) and the seminal beginnings of The BBC Radiophonic Workshop? And what if it were to be produced by a radio drama producer in deference to an esteemed features producer? Would Thomas's 'play for voices', or perhaps his earlier more incisive description of it as 'an impression for voices', have become radio drama's first full-length radiophonic poem? There is no doubting that a different approach, different advice and a different treatment would have yielded a different work from the *Under Milk Wood* we have come to know.

6 | *Krapp's Last Tape* (Samuel Beckett)

It is a truism that the essence of radio cannot be seen, it exists only in sound and in the imagination. Radio obviously has to be heard and in hearing it the possibility is that its listener may be imaginatively awakened, angered, elated, stimulated, shocked, saddened with every passing moment. The act of listening to the radio is essentially a private experience and it is not often that one can observe the private act of another who is *listening* and *reacts* to what is heard. Whereas *Under Milk Wood* naturally belongs in sound, Beckett's stage play *Krapp's Last Tape* (1958) can only belong in the visual context of the stage. *Krapp's Last Tape* is curiously significant to the exploration of sound perception and, by extension, radio drama. It can visibly do what radio never can, that is, allow an audience to watch the solitary, private listener caught in the imaginary world of 'hearing' visual memories evoked through sound.

The play's subtlety in demonstrating what cannot be shown otherwise in radio terms is an identifiable subplot in the play. One could argue that the interchange of plot and subplot in many of Beckett's works is dependent upon the perspective formed at any particular point. *Krapp's Last Tape* is much more than the simple dramatic scenario of an old man listening to the recordings of his past self or the more involved scenario of an old man coming to terms with his present through the recordings of his past. *Krapp's Last Tape* fundamentally demonstrates the profound effect of sound upon the aural imagination and the

intensity of active listening upon concentration. There are no sounds more intense, more acutely personal in a surreal sense than hearing the sound of one's own voice, and this can only be achieved objectively by recording the voice and playing it back as a past event brought into the present.

The play can be analysed from a number of different angles, but for me, the play is fundamentally about listening, hearing, listener reaction and imaginative aural realizations. For the purpose of this exploration I identify 'Krapp' as 'old-Krapp' and 'Tape' as 'young-Krapp.' My reason for altering their identities is to maintain and underline the biological link between the voice heard from the tape as the younger Krapp which is an earlier manifestation of the voice heard on stage of the visible actor playing the character of the present older Krapp. 'Young-Krapp' and 'old-Krapp' are clearly one and the same person in a physiological sense but, having been separated by time and life's experiences, they are now psychologically and philosophically two different persons. In this case the sound of listening to oneself separated by time creates a greater aural resonance in the perception of time where the past is brought into the present as a form of timeless objective memory.

In performance, the play turns the audience into voyeurs by placing them in the surreal situation of watching someone in the private act of 'actively' listening. In this process the play should also effectively alienate the audience as they peer over, under, around and through Beckett's brilliantly built psychological fourth wall, perhaps guilty and uncomfortable in the knowledge that this is a prolonged 'secret' observance, a peeping-Tom experience, they would not engage in in reality. Brater states that 'in the opening moments of 'Krapp's Last Tape', it's as though Beckett has almost succeeded in 'visualising' a radio play's 'soundscape' … When Krapp switches on his machine, the audience discovers him in a private act of listening.[1]

The dialectics of thought brought to bear on the use of the 'tape machine' are quite divergent. McMillan and Fehsenfeld state that 'at no time is it a symbol (of memory for example) but simply a machine possessing a faculty of replaying a recorded voice, becoming in this way the generator of the principal events of the

play.'[2] In a way this is a correct assessment in that the older reel-to-reel tape machine in itself is an inanimate object and therefore possesses no memory function. I would argue, therefore, that it is the reel of tape or more precisely the 'sound' magnetically recorded on the reel that acts as a symbol of 'old-Krapp's' memory while also functioning as an index of 'young-Krapp's' presence and altered existence. It is the sound that is replayed and heard from the tape and not the physical tape itself that stimulates 'old-Krapp's' memory. Rozik expresses a different opinion when he states that 'an example of a mechanical allegorical metaphor is the tape recorder in Beckett's *Krapp's Last Tape*. The tape recorder represents human memory. By listening to his old tapes, in which he also finds himself listening to yet older tapes, Krapp confronts various layers of his own past.'[3] In elevating the tape recorder as the means of playing-back the sound, Rozik accords it an omni-present symbolism representing 'old-Krapp's present memories of past events.' Both opinions, that is, those of McMillan/Fehsenfeld and Rozik, are arguable in relation to the symbolism of the physical objects, tape-recorder and reel of tape. Regretfully, they both neglect to consider the semiotic importance of the aurally invisible element, the sound magnetically encoded on the tape.

When 'old-Krapp' fantasizes expectantly over the words *spoooool*[4] it is in the knowledge that beyond the physicality of the spool and his tactile handling of it there exists the invisibility of sounded memories. The spool itself merely represents the prized silent record contained invisibly within it of a sonic or spoken past whose aural realization will engage him in imaginative memory recall. Another less probable theory is that the sound of the word 'spool' closely resembles the word 'stool' – *What's a year now? The sour cud and the iron stool*[5] where 'spool' may symbolize the silently contained and constipated sound of past memories that are painfully released by playing them out. Hearing the replayed voice and spoken words of 'young-Krapp' makes 'old-Krapp' at times angry, sad, impetuous and makes him grimace, smile, brood, become bemused and puzzled. It is the aural content of the invisible sound on tape that makes 'old-Krapp' react to what he hears by rewinding, fast-forwarding, repeating

parts of the story and eventually attempting to record his own voice. A curious recording, of his present interpretation of remote past memories now distanced by age, of more recent past memories by his former self distanced in time. That is where the concept of time is intangibly vague and where age is physiologically experienced, the gap wedged between time by age is irretrievably permanent.

I find the diverging opinions in relation to Beckett's initial concept of using a tape recorder and a recorded voice as the unseen second character in the play intriguing. Deirdre Bair states that 'Beckett claims he had never seen a tape recorder before writing Krapp and had no idea how one operated.' [6] Bair's restatement of Beckett's (unsubstantiated) claim is in stark contrast to Linda Ben-Zvi's assessment. 'Introduced to the recorder when he received a tape of his BBC radio play 'All That Fall', Beckett two years later wrote 'Krapps Last Tape' that employed its recollective properties.' [7] Brater's account of Beckett's meeting with BBC radio drama producer Donald McWhinnie is interesting in its detail:

> Beckett was in Paris on January 13, 1957, when Donald McWhinnie's BBC production [*All That Fall*] was broadcast on the Third Programme. He had hoped to hear the play on his short-wave radio. Disappointed by the fact that there was too much static on the wire, he wrote to BBC headquarters asking for a tape of *All That Fall*. The next week he wrote again, this time requesting a manual on how to operate a tape-recorder.[8]

Krapp's Last Tape was written in early 1958 the year after Beckett had received his tape, tape-recorder and the manual. There is little doubt that this new tape technology was influential in Beckett's decision to write a play about the recording properties of the machine and the abilities of its recorded voices to transcend time. It is purely conjecture but I believe that much of 'old-Krapp's' physical wrestling with the tape-recorder, his intense listening and physical positions adopted for listening, and his gestural reactions to what he hears from the tape may reflect Beckett's own experiences of listening to *All That Fall*. Consider for a moment the momentous occasion when Beckett finally

learned to thread the *spool* of tape properly onto the machine – which in itself requires a certain amount of dexterity and practice – switch it on and put the machine into play mode without the machine 'spilling' the tape onto the floor. This is not intended to be patronising of Beckett but, having witnessed this simple operation turn into disaster for many students, I can understand why Beckett requested a manual. ('Spilling' is a technical term, which occurs on reel-to-reel machines when set in edit mode. The take-up reel is disengaged therefore allowing the tape to 'spill' out or off the machine.)

Finally Beckett sits down to listen to *All That Fall* and, not having been able to attend either rehearsals or the recording, he is listening for the first time to himself – not his own voice of course but his own work in a way he has never done before. *All That Fall* had then become a 'live' work in Beckett's hearing and whether he liked or disliked parts of production/recording there was nothing he could do at that point to change it. *All That Fall* was broadcast and Beckett was now listening to the work being brought to life in his aural imagination for the first time. The only control he now had over the production tape was to play *[switches tape on]*, rewind *[winds tape back]*, fast forward *[winds tape forward]* and stop *[switches off]*. Beckett's first tape-recorder experiences both physical and aural, I believe, may well have ended up in part as character gestures in *Krapp's Last Tape*.

Krapp's Last Tape (Samuel Beckett)

Box three, spool five. [*He bends over machine, looks up. With relish.*] Spooool! [*Happy smile. He bends, loads spool on machine, rubs his hands.*] Ah!

[*He raises his head, broods, bends over machine, switches on and assumes listening position, i.e. leaning forward, elbows on table, hand cupping ear towards machine, face front.*]

[*Fit of coughing. He comes back into light, sits down, wipes his mouth, switches on, resumes listening posture.*]

TAPE: – back on the year that is gone, with what I hope is perhaps a glint of an old eye to come, there is of course the house on the canal where mother lay-a-dying, in the late autumn, after her long viduity [KRAPP *gives a start*] and the- [KRAPP *switches off, winds back tape a little, bends his ear closer to machine, switches on*] -a-dying, after her long viduity and the- [KRAPP *switches off, raises his head, stares blankly before him. His lips move in the syllables of 'viduity.' No sound. He gets up, goes backstage into darkness, comes back with an enormous dictionary, lays it on table, sits down and looks up the word.*]

Mary Bryden suggests that 'yoked within the acoustic domain, the twin functions of listening and speaking are in Beckett's writing given more weight as attestors of presence than is the function of seeing.'[9]

'Old-Krapp' listens as 'young-Krapp' speaks, where 'young-Krapp' is no longer physically present and has ceased to exist but is made aurally present through the physical manifestation of sound and imaginatively present through stimulated memory. Having listened, 'old-Krapp' now needs to speak but also to be listened to. Aware that what may need to be said cannot be listened to objectively at the same time by 'old-Krapp' himself, he instinctively turns to the tape recorder as the symbolic alter ego of his listening self and loads a new reel of tape, which symbolizes a new pair of ears as the electronic listener.

Krapp's Last Tape (Samuel Beckett)

KRAPP: Just been listening to that stupid bastard I took myself for thirty years ago, hard to believe I was ever as bad as that. Thank God that's all done with anyway. [*Pause*] The eyes she had! [*Broods, realizes he is recording silence, switches off, broods. Finally.*]

His attempts to say something new, to start from now in the present, are quickly frustrated as his mind is drawn back into past memories. But unlike the upbeat positive voice of 'young-Krapp'

relating memories separated by time, 'old-Krapp's' current thoughts have turned into dark, sombre, brooding recollections influenced by the passing of time. His irritation with himself and these moody ramblings becomes obvious.

Krapp's Last Tape (Samuel Beckett)

> KRAPP: Ah finish your booze now and get to your bed. Go on with this drivel in the morning. Or leave it at that. [*Pause*] Leave it at that. [*Pause.*]

Realising that he has totally lost the vivacity that accompanies pleasant memories, he switches off and throws the tape away. This act alone is significant as it symbolizes the abject rejection of his present self manifested as the reel of tape, his frustrated attempt to record his current self. Lulled by 'booze' and the sound of his former up-beat, positive self, 'old-Krapp' opts for the aurally imaginative world of his past existence as he listens with that sense of incredulity that this was him but in reality is no longer him.

Krapp's Last Tape (Samuel Beckett)

> KRAPP: ...Be again, be again. [*Pause.*] All that old misery. [*Pause.*] Once wasn't enough for you. [*Pause.*] Lie down across her. [*Long pause. He suddenly bends over machine, switches off, wrenches off tape, throws it away, puts on the other, winds it forward to the passage he wants, switches on, listens staring front.*]

Krapp's Last Tape deals with multiple levels of the same persona separated by the vague notion of time as the preservative of imaginative memory, that is, the physicality of age manifested as physical time and the fluctuating alternation and altercation of past and present. Above all it demonstrates the aural affects of sound as part of a neurological process in influencing behaviour. In a sense *Krapp's Last Tape* is in part a study in behavioural aural science.

7 | Radio and Language

In the modern broadcasting environment radio drama is somewhat protected in its niche market by its content and formats, but faces a major challenge if it is to develop beyond its current safety cage. The promotion of a positive prognosis for the development and wider dissemination of radio drama hinges upon a number of interrelated concerns: (i) the segmented and commercially driven radio industry; (ii) the unchanging and traditional structured format of existing radio drama; (iii) the accepted audience perception of radio drama as being an un-confrontational and unchallenging entertainment format; (iv) the accepted content of plays; and (v) the restricted use of language.

Radio drama, a unique dramatic genre encompassing all sounds, but where the spoken word is primarily the main sounding agent, finds a natural home on traditional speech radio and to a lesser extent on 'middle-of-the-road' radio. Radio drama's traditional formats (30 minutes, 60 minutes and 90 minutes) have become by default the acceptable time length for what is described as the short, medium and long play. The notable exceptions are the mini drama series and the radio soaps (10 to 15 minutes per episode). The longer time formats require a reasonably lengthy span of broadcasting time dedicated to them and an equal amount of aural concentration on behalf of the listener. Acknowledging that radio drama in its broadest definition can include the thirty second radio commercial to the three hour

classical drama, there may be an argument for developing new formats and content for audiences other than the identifiable radio drama listener. Contemporary themes and concerns dramatized through shorter time lengths, serialized episodes and pertinent language will always have a high degree of relevancy to any target audience while also training the ear to listen more acutely. The aural appeal of the spoken word, the good story and the dramatically imaginative event is a primal response in most humans regardless of age, social standing, education or cultural background. Radio drama, considered on its lateral plane, can provide an aural literature of immense richness in its diversity.

One of the arguments advanced against the development of more contemporary forms of radio drama is the broadcaster's reluctance to challenge their listener's perceived acceptance of radio drama as un-confrontational and unchallenging entertainment. P.M. Lewis undertook a survey through the *Radio Times* in 1986 in which he identified the key factors, which influenced listeners in their choice of play listening.

> Those who wrote to me repeatedly stressed that they looked to plays for relief and entertainment. This is the reaction of the listener who stays with a channel throughout the day and consequently looks to the drama slot to provide something different – i.e. 'not-news.' It is also the reaction of people whose work does not allow them to consume fiction in any other way … 'Problem plays' are likely to include the portrayal of strong emotions which in some listeners stir unwelcome echoes.[1]

P.M. Lewis here quotes from playwright Howard Barker's remarks:

> The bland question so often put to writers "Do you really need those words?" rings with false innocence. The hidden meaning of this question is, "Do you really need those feelings?" Attempts to restrict vocabulary are invariably attempts to restrict emotions. (BBC, 1988)[2]

P. M. Lewis continues:

> So threatening to some listeners are these emotions that
> they sometimes hear 'language' in a play when it is not
> there. For these listeners, and perhaps for those who are
> tired of news and current affairs and want their plays to
> be oases of supportive calm ('non-news'), 'language'
> becomes a typification that enables them to reject a
> play.[3]

This creates a dilemma for the development of new radio drama
writing that explores problematic contemporary life issues while
trying to maintain a semblance of the *status quo* with regard to the
listening audience.

> The readiness of the Drama Department [BBC], then,
> to accept new writers – indeed, the necessity of its doing
> so if it is to fill the schedules – carries with it the
> drawback that traditions and patterns are established
> among writers, producers and listeners which are
> exceedingly hard to shift.[4]

Perhaps the greatest concern expressed by the BBC into the
playwright's exploration of contemporary life in its dramatic
form on the radio is the one of language.

> 'Language' [means] those words and phrases which may
> potentially give offence to sections of our audience or
> indeed simply distract them from the main purpose of
> the play in question.[5]

There is a general broadcasting agreement which emanates from
the television sector that a censorial time-line (the '9 p.m.
watershed') should operate with regard to the broadcasting of
programmes which include strong language and potentially
offensive items. This is in addition to the industry's own code of
ethics governing the areas of taste, decency, and privacy and the
legal constraints on the depiction of sex, violence, and racial
prejudice. The '9 p.m. watershed' is a point in time where it is
assumed that children have gone to bed and only adults will be
listening or viewing from that time. That assumption has
operated for over thirty-five years, but it is interesting to note

that television stations bilaterally have moved the time-point later to 10 p.m, 10.30 p.m, 11.00 p.m. The '9 p.m. watershed' acts as a finite time-point where after that time television can broadcast programmes and films with the equivalent of an 'over-18' certificate. The '9 p.m. watershed' exists in principle for radio, but regrettably it is extremely rare in radio circles to hear a programme whose content invokes the 'watershed' rule. This may be explained in part by the very nature of the radio medium (the broadcaster-solo listener relationship); its unique aural penetration of the imaginative functions and its primary use of the voice and the spoken word; where spoken language alone, without the accompanying visual gestures made visible in stage, film and television could be considered as offensive (i.e. language-out-of-context). This fearful reverence of the potential power of radio has a very debilitating effect upon the development of new forms of radio drama in general. As regards BBC4 specifically, the problems of scheduling and repeat scheduling (the 9-10 p.m. broadcasts are scheduled for repeat broadcasts in the afternoons when children could be listening) act as convenient excuses for the maintenance of a 'clean' play policy which keeps the plays free from any potential controversy. It is therefore extremely rare indeed to hear the sonic equivalent in radio drama of an 'over-18' certified film.

> Just as the sense of personal involvement in radio makes violence, for example, more real and upsetting than it would be on stage or screen, so that same involvement makes the sense of outrage at a gross image more personal and upsetting. It is as if we had compelled the individual listener to utter a word or make concrete an image themselves which they would not normally allow to pass their lips or enter their minds.[6]

The BBC singled out one word in particular for specific mention. This word, whether right or wrong, has entered into the lexicon of language use and is heard frequently in films, on the stage and read in literature.

> There is only one BBC policy; it is that the word 'fuck' may not be used on any network without referral

through the Head of Department to the Network Controller.[7]

The RTE Writers Guide (1995), although warning against the use of profane language, adopts a more compromising and perhaps a more realistic stance.

Profanities:

> The writer should be aware that profanities – so-called offensive language – are not usually considered acceptable on radio unless the play is of such significant merit that realistic dialogue is justified. The medium's intimacy ensures that a profanity takes on an exaggerated significance. You should also bear in mind that radio cannot be geared to a selective audience…Radio by its nature is non-discriminatory. A radio play which is inoffensive to a car driver might embarrass a passenger. Radio characters are therefore noted for their 'Damns' and 'Blasts' rather than the more colourful equivalents.[8]

The series of plays by 'Rough Magic Theatre Company' adapted for radio and broadcast by RTE1 (Tuesday nights 9.00 – 10.00 p.m) were revelatory in their explicit use of language. For example, *Danti-Dan* by Gina Moxley, transmitted on 29 June 1999, revolves around the problems of growing up, intuitiveness, sexual exploration, and teenage pregnancy. Although there is much humour in the script there is also a tragic poignancy that is discretely interwoven through the play. The dramatis personae range in age from young to older teenagers, although the play was acted by adults in the original stage version and on the radio.

It should be noted that the play was originally written for the stage with a performance time of approximately one and three-quarter hours. The radio adaptation was made to fit a broadcasting slot of one hour. The transcodification of visual elements into aural elements is indicated in the extract by the use of italics and underlined, and any extra sonic/verbal additions to the original text are bracketed and underlined. I have used a strike-through to indicate deletions from the original text. In the extract quoted, these deletions/adaptations would be considered

a normal part of the transcodification process. The play was broadcast just after the '9 p.m. watershed' and was preceded by a presentation announcement which included a warning to listeners about the use of strong language.

> RTE CONTINUITY ANNOUNCER: … Tonight's play is the fourth of six broadcasts marking the publication of plays by Rough Magic Theatre Company. Tonight we present *Danti Dan* by Gina Moxley and we would like to advise listeners that this play contains some strong language.[9]

Danti-Dan by Gina Moxley [10]

Dramatis Personae:	
DAN:	(Danti-Dan), aged 14 with a functioning age of 8
BER:	aged 16
CACTUS:	aged 13
DOLORES:	aged 14, Ber's younger sister
NOEL:	aged 18, Ber's boyfriend
The action takes place in summer 1970, ten miles from Cork city.	

The following extract is taken from Act 2: scene ii. Ber, who strongly suspects that she is pregnant has bought herself a cheap ring in the vain attempt to pretend to her friends at work that she is engaged to Noel, her errant boyfriend. Noel is about to find out about the ring and much more besides.

Danti-Dan (Gina Moxley): Act 2: sc. ii (Radio adaptation) – Extract

Sfx:	*[Background sound throughout—sounds of the country side]*
CACTUS:	You're obviously not marrying him for his mind, Ber.
NOEL:	We're only talking about the poxy dog, who said anything about getting married?
CACTUS:	Oooops. Did I say something wrong? Am I not supposed to know, Ber? Sorry, sorreee.
NOEL:	Supposed to know what?
BER:	Don't mind her, she's talking through her arse.
DOLORES:	It's a lovely day today isn't it? We're haunted.
NOEL:	Hang on a minute, just hang on a ~~fucking~~ [feckin'] minute
CACTUS:	Oh God. Sorry sorry sorry. It's all my fault. I just thought since you were engaged, that you had the ring and everything…
[DOLORES:	I might even go for another swim.]
	~~DOLORES~~ [BER] *pinches Cactus's leg*
	Ouch [Ber]. What did you do that for? That hurt you know.
NOEL:	What load of shite have you been telling them? Answer me.
BER: *(To Cactus)*	Nothing Noelie boy. I swear. She's only making it up. Mind your own business or I'll give you a proper dig.
CACTUS:	You and whose army?
NOEL:	Ring? What fucking ring is she talking about? ~~What fucking ring?~~ I bought you no ring.
~~DOLORES:~~	~~Let her go you. Let my sister go.~~
	Ber ~~fumbles for the ring around her neck.~~
BER:	~~Here look~~ [Ah look Noelie]. It's only a stupid ol'thing I got myself. [I have it here on a chain.] It's only mock.

Danti-Dan (Gina Moxley): Act 2: sc. ii (Radio adaptation) - Extract

NOEL:	You dopey fuck, what did you do that for?

He reefs the chain from her neck.

Ouch. [Ah Noel] the girls at work…sorry Noelie.
I told them we were getting engaged…[ah! ouch]

Sfx: *[General commotion behind]*

[What do you think you're doing that for?
Give me the ring.]

He throws the ring into the field behind him.

Sfx: *[Sound of ring thrown on concrete]*

[What did you throw it into the river for?]
A bastard. That's all you are. Fuck you anyway.

He pushes her and she falls down the steps of the monument.

Sfx: *[Sounds of wrestling and commotion]*

[BER: Ouch …Ah Jesus no…]

[DOLORES: Let my sister go…Noel…no…don't hit her…]

Sfx: *[Sound of a smack]*

[BER: Umph!…]

There is silence. **Noel** *shakes his head, the others are stock still.*

DOLORES: *(Whispers)* The baby…*[Audible intake of breath]*

NOEL: Tell me I'm hearing things here. The what?

[BER: *Shocked sigh]* Oh…]

Nobody answers. **Noel** *lights a fag and walks around in a circle.*

Ber *edges her way back onto the steps.* **Dolores** *comforts her.*

NOEL: I said the what?

CACTUS: *[Off mic]* The baby! Are you deaf or something?

The baby. Alright. Did you hear that?

Noel *stares at* **Ber**. *She nods.* **Cactus** *is peeling the leaves off the wreaths.*

Danti-Dan (Gina Moxley): Act 2: sc. ii (Radio adaptation) - Extract

BER:	I think I'm up the pole.
NOEL:	You are in your hole.
BER:	I'm not sure yet like, I think I am though.
DOLORES:	She's three weeks late, is it? And her chest is killing her.
NOEL:	That's all I ~~fucking well~~ need. Jesus H Christ. Oh no, no no no, hang on a minute here. I get it now; you're only saying that so as to get married. *(Laughs)* What kind of an eejit do you take me for? ~~You can go and fuck yourself.~~
BER:	[Oh!] Jesus Noel. I swear. I wouldn't do that Noelie. I am, really.
NOEL:	You lying little pox bottle. I wouldn't believe daylight out of you. ~~Sweet lamb of divine fuck.~~ Even if you are, don't think I'm marrying any ol'flah bag who's after getting herself in trouble. Christ like t'would kill the fucking mother.
CACTUS:	*[Off mic]* That's lovely, that is.
NOEL:	And you [Cactus], shut your face if you know what's good for you.
	~~*Ber gets up and heads back to work, crying. Noel goes off in the opposite direction, shouting after her.*~~
Sfx:	[**Ber** *begins crying close to mic. and continues during and after Noel's exit.* **Noel** *moves off, exiting while shouting at her.*]
	And you needn't think I'm going to waste my ~~fucking~~ time making bubble gum either [Ber]. Fuck bubble gum. Do you hear me? I'm not having some bastaring Yank telling me what to do. They can stuff their jobs up their holes.

It could be argued that the stranglehold exerted by broadcasters on the use of language in broadcasting is a security measure for the preservation of societal norms and in respect of radio drama that it safeguards the established perception of the radio play as a form of benign entertainment. RTE received a total of ten phone

calls complaining about the excessive use of 'bad' language following the transmission of n insignificantly low response if it is compared to the number of people listening, however, a source in RTE Information considered that ten complaint calls in relation to any one programme constitutes quite a high response.

'You wouldn't hear that on the radio' is a well used euphemistic expression relating to radio's quasi-parental role as the preservative voice of language stability in society. P.M. Lewis refers to the growth of right-wing opinions during the Thatcher administration in Britain and in particular pressure groups such as The National Viewers' and Listeners' Association whose role he claims was 'monitoring broadcasting for signs of offence, occasioned not only by political bias, but in moral affronts to family (Christian) (*sic*) values, and social threats to the lower middle-class way of life.' [11] He continues:

> For such a constituency 'bad' language is symptomatic of a wider, deeper malaise. Together with other attacks on language such as incorrect usage and pronunciation, it is part of that unholy trinity: language, sex and violence. Each must be kept within bounds – the first two within the family, the last reserved for the state of war and the maintenance of law and order. The sight and sound in the media of lack of control in these areas signal 'the collapse of all values and standards, the spiritual rottenness of modernity.' [12]

It would appear that little has changed over the last eighty years when the broadcaster C.A. Lewis wrote about the BBC's first year of broadcasting.

> Lastly, broadcasting means the re-discovery of the home. In these days [1923], when house and hearth have been largely given up in favour of a multitude of other interests and activities outside, with the consequent disintegration of family ties and affections, it appears that this new persuasion may to some extent reinstate the parental roof in its old accustomed place,

for all will admit that this is, or should be, one of the greatest and best influences in life.[13]

It could be argued that the restriction on the use of language is in fact a constriction on the freedom of playwrights to explore hard-hitting contemporary themes. This constriction could be viewed as a highly strict form of overt censorship on what the listener is allowed to hear. If the dramatic exposition of the ills and tensions of contemporary society are to be sonically explored, is there not a compelling argument for the use of the language of modernity? Surely dramatic exploration in this case should be allowed expression in the language of the society that has bred the ills and fostered the tensions.

The restrictions on language use are applied across the board in radio broadcasting. But there is a case for considering radio drama separately from all other programme formats (news, documentaries, sports etc.). As radio drama is radio's highest level of creative output and as a dramatic art form in its own right, should it not be allowed to fluctuate within the bounds of 'artistic licence', as theatre, film and television drama can? The effect of censorship within the BBC was lamented by one anonymous BBC4 radio drama producer:

> Many of our major writers are not writing hard-hitting stuff for us. It's irrational, utterly enervating, removes their confidence in the medium, and makes them doubt our estimation of their work…We have a reputation for not doing the toughest plays around.[14]

There is undoubtedly a sizeable demand, which can not be overlooked, for radio plays purely as entertainment. However, the restriction on the use of language denies the development of a contemporary form of hard-hitting radio plays which could easily be scheduled after the '9 p.m. watershed.' On the one hand, theatre, film and television are fortunate in the degree of artistic licence they can enjoy. Radio, on the other hand, held to be the last bastion of language preservation tends to cocoon its creatively dramatic genre in an antique world of linguistic purity. RTE 1 have taken a brave and courageous step in moving outside the preservative norms by broadcasting the Rough Magic

series and other potentially controversial plays from time to time. The freshness in hearing something rarely heard on radio is an electrifying realization of how microscopically close a dramatic sonic exploration of 'real' life can actually be. It may sometimes be uncomfortable, unsettling, even shocking but so too are many of the problems facing today's society. Dramatic exploration of these themes through language and sound could more easily be facilitated. That, after all, is the purpose behind the '9 p.m. watershed'.

I neither condemn nor condone the use of 'bad' language in dramatic writing. I merely raise the greater concern regarding the overt control exerted on (radio) playwrights in what is considered suitable for broadcast and by extension the decision on what we, the listeners, are allowed to hear.

Part Two | Transitions

8 | Aspects of Radio Drama

Useful comparisons can be made between radio drama as a sonic dramatic performance genre and the other visually dramatic performance genres of theatre, film and television.

Paglia quotes from Lily Yeh, Professor of Painting and Art History, (University of Arts, Philadelphia):

> Western landscape is about measured space perceived by man's eye. Oriental landscape is a landscape of the mind. Illuminated from within, it is not disturbed by darkened shadows or sharp, foreshortened views. The unenlightened mind sees things in terms of form, but the enlightened mind sees the Void.[1]

Although not directly related to radio drama, this metaphoric reasoning highlights the crucial difference between the visual reality of stage, film and television drama and the 'invisible' virtual reality of radio drama. Paglia describes the unenlightened mind, which she associates with the Western Apollonian style, as seeing things in terms of form, structured within defined boundaries. In contrast she believes that the enlightened mind sees the Void whose darkness becomes illuminated from within the boundless form from which it emanates, the human imagination. Using an analogy of the Buddhist concept of 'Sunyata', (Sunyata = the Void), Paglia states that the Oriental philosophy of reality is 'about the all-encompassing and luminous

space…the space that holds all that happens. The ultimate reality is *sunyata,* voidness.[2] In radio drama this void exists in the space between the performer/performance and the audience/listener. Somewhere between the two the imaginations of its writers meet with the imaginations of the listeners through the performer/performance. As the listener hears the drama the void is continually filled with mental visualizations as real and as vivid as the listener's imagination allows them to be. Through the neurological functions of electro-chemical reactions in the brain triggered by aural stimulation, the willing listener enters into a state of individual 'virtual reality' as they engage with the sounds of the production.

Expressing this in the form of a simple equation it is easy to distinguish between two crucially important elements (i) the production with its associated elements and (ii) the 'active' or attentive listener. Both are interactive in the sense that both obviously have to be present.

Aural imagery: Radio drama's sonic and aural perception

ELEMENTS	
SONIC	Voices, words, music, sounds, silences etc.
	Intonation, tempo, dynamics, phrasing etc
+	
AURAL	'Active' listener
	Imagination
=	
PERCEPTION	Perceived virtual reality
	Individual and infinite

Here we can classify the 'active' listener as one who is deliberately engaged in listening and the 'passive' listener as one who may be aware of the presence of sound but is otherwise occupied or not concentrating on the sound. In our modern world, filled with numerous types of informational media and visual stimuli, the 'active' listener not only has to make a conscious decision to listen, but also has to apportion the time to listen. In so doing Andrew Hart rightly claims that radio

audiences are not passive and predictable but active and variable in their responses.[3]

The aural imagery formula is more akin to the older oral tradition of storytelling but in the case of radio drama the storyteller (or sound drama) is physically absent from the listener's presence, yet, is curiously present in the listener's aural imagination. Radio is capable of transmitting to greater numbers of people those elements which are fundamental to all oral based societies. These include [1] a heightened imaginary sensitivity through aural stimulation; [2] the common identity or bond associated with hearing the spoken voice as oral literature; and [3] an innate inquisitiveness towards the source and nature of sounds. Zumthor alludes to the anthropological primacy of oral literature, that is the speaker/listener relationship, using the example of a village or neighbourhood where groups of people would gather around a radio set to listen as once they gathered around the local 'reader' in order to listen to a book being read.[4] In much the same primal way that the listener's imagination is heightened by hearing the sound, words, inflections, dynamics etc., of the storyteller's voice, radio drama is using a combination of sound elements in a fundamentally similar way. Whereas the listener in the oral tradition may also share in the benefit of visual gestures e.g. the storyteller's facial, eye, and hand movements, yet, the primacy of the speech act (sound/hearing) is fundamental to oral literature. Radio as a specialized genre of communication carries no 'real' visual stimuli. It is *prima facie* an 'invisible' medium. Radio drama, as the creative exception of the genre, does promote an imaginary sense of visual illusion through its creative and carefully composed use of all sounds including verbal, non-verbal, music etc.

In using the sound/hearing principle, radio in general could be classified as a technological genre of oral literature. Where it cannot be denied that radio drama is a dramatic performance genre in its own right, it is through its combination and use of all sound elements as audible triggers for the imagination that radio drama becomes a new form of aural literature. Firmly based upon the principles of oral literature (speaking/hearing relationship), radio drama creates a fusion of disparate sound elements (words,

voices, sounds, music, and acoustic distances) which are presented to be heard as a perceptive entity. It may be a form of supra-oral literature, but I would prefer to describe it as an exclusive 'aural' literature and one which has not been explored in any depth through its performance medium.

Criticisms of radio drama are unjustly based upon prejudice and a misunderstanding of its medium, which leaves it cast aside as the impoverished and disabled relation of other dramatic genres. At best it is accepted for its experimental potential. Generally, however, it is considered to be either an embryonic precursor of television drama incapable of visual development, or an incapacitated vocal rendition of live stage drama. With the exception of mixed media art forms, every individual genre is handicapped to some degree by the physical constraints of the particular medium. On the surface, radio drama's main constraint is the radio medium. Radio is commonly and inaccurately referred to as being a 'blind' medium. In the modern 'seeing' world dominated by its graphic visibility, radio and radio drama can too easily be criticized as being handicapped by their own invisibility. It is an easy target for ridicule by those who require the pictures drawn for them or those who, like the biblical doubting 'Thomas', need to witness the action visibly performed. Guralnick's assertion that the usual charge against radio is that it is merely a 'crippled form of theatre' [5] derives from the misperception that radio is and can only ever be a blind medium. This misperception may prove in retrospect to be the prejudiced handicap of its critics and their particular inability simply to 'listen.' Radio may be invisible to the naked eye but it is neither blind nor handicapped to the *imaginative mind*. Its presence is experienced through sound and, as such, uses all sounds as the basis for its creations in a sonic art form. Radio drama is also a unique form of personalized aural art where the listener is given the basic materials in sound, but is then required to construct the imaginative reality surrounding those sounds. Radio's 'realities' are as infinitely variable as the imaginations of those who choose to listen. Its 'realities' are individually owned even if the single event (the radio play, short story etc.) is transmitted to a collective but disparate group (the listening audience).

Through the medium of radio the realities of sound can combine with the power of the listening imagination to transform the surreal images of the visible Void into virtual experiences. The radio audience is therefore drawn into a simulated world that is both 'real' and original where it remains instinctively memorable in the imaginations of those who experience it.

While the radio drama performance exists in time and begins and finishes within a specific time frame, its psychologically affective resonance continues to exist in the listener's reproductive imagination as memories where time boundaries evaporate. This is in sharp contrast to Birringer's assessment of the theatrical realities presented on the stage where the dialectics in the relationship between performance time and theatre space separates the theatre from itself.

> Unlike literature, film, painting, or the popular mass media, the theatre must show its physical, bodily existence and its 'liveness', the volatile progress of its human labor, the contingencies of the space in which it labors, and its schizophrenic awareness of its own unreality.

> This awareness results from the temporal structure of performance: the work on stage and the process of its creation are suspended and then disappear. This suspension of the time-space or 'world' of performance divides the theatre from itself. It cannot hold on to the reality it imagines and produces, and the lived body of work becomes a fiction the moment it vanishes.[6]

In radio drama the spoken-word, sound, music, silence, pause, aural distance and technical considerations are the acoustic elements of a sonic theatre that is isolated in sound and transmitted to where the 'suspension of the time-space world of performance' *unites* the drama with the individual self.

9 | Sound Images

Whereas radio itself is about sound, radio drama is immersed in a world of sounds—voices, spoken-words, music, sound effects, noises, silences, utterances, acoustic distances and electronic processing. Radio drama is the only form of radio broadcasting which consistently uses all of the elements of sound as being potentially creative. As such it is perhaps a more defined dramatic genre to analyse because the totality of all the elements it presents as an art form can singularly be described as 'absolute sound.' It composes with sound: therefore its compositions can only be fully experienced through listening. Whether it is listened to as a broadcast radio signal or from a recorded cassette/CD, what is constructed as a sound drama is complete and is only realized in its totality as an aural experience.

In 1881 the acoustician John Broadhouse began the first chapter of his book *Musical Acoustics or The Phenomena of Sound* with the simple and obvious statement that sound is 'something heard.' [1] It is accepted that all external parts of the human body and in particular nerve endings can also tangibly 'feel' sound through vibration. Also, given that the auditory mechanism itself functions solely on sound wave fluctuations and vibrating impulses, it is more commonly accepted that sound is something *heard*. In using the continuous past form of the verb 'to hear' it is understood that all sound heard by an individual is post-impulse sound. The sound has been caused to happen and is metaphorically dying, decaying or dead, before our brains have

identified or perceived what the sound is meant to be. In scientific analysis, particularly in relation to 'live' sound, this may count as only a matter of milliseconds but proves the conundrum that sound has happened before it is heard. The avant-garde composer John Cage believes that a sound in itself does not have a being, it cannot be sure of existing in the following second. 'What's strange is that it came to be there, this very second. And then it goes away. The riddle is the process.' [2] The Romanian theatre director Andrei Serban believes that:

> The word is written to be experienced at the moment it is spoken, in an immediate relationship with the sound, with an infinite possibility to create moods and situations as music does. It exists on its own. It comes from somewhere—and it goes away. We sense its vibration. We hold on to it. We can try to make it vibrate inside us. [3]

Broadhouse states that the ear is the organ by which what we call 'sound' is made palpable to the brain, or the channel through which the cause of sound is carried to that part of the organism in which we are made conscious of sound. [4] Published in the latter part of the last century and based upon the acoustic and physiological theories of H. L. F. Helmholtz, Broadhouse's work posed the central argument regarding the dialectics of sound perception. What is heard as 'sound' simply proves to what degree the auditory system functions, that is, the degree to which an individual can physiologically hear sound. However, what a 'sound' is perceived to be and individually interpreted to be defines the construction of 'interpretative meaning' through an individual's reactions to sound.

> The cause of sound is without us; the sensation of sound is within us; the ear is the medium which enables the external cause to become a sensation ... The sensation of sound is beyond our power to analyse. We know it because we experience it; but although we can trace the motions which produce it, and the machinery which transmits those motions from without to within, we cannot at present tell how the latter become a part of our consciousness. [5]

Written in the early stages of Freudian experimentation into psychology, Broadhouse's frustration at only being able to understand one half of the equation is obvious. Almost one hundred years later and in the latter part of our century, the scientific quest for the conscious 'meaning' of sound and how the human brain interprets sound continues. Research in this area of sound perception crosses different branches of science and now calls upon the inter-disciplinary approaches of audiology, neurology, psychology, musicology and psychiatry. A pioneering event occurred in 1973 when the first 'Workshop on the Physical and Neuropsychological Foundations of Music' (Austria) applied an inter-disciplinary approach to the subject.

> This event brought together leading musicians, neurobiologists, physicists, engineers, philosophers and psychologists to appraise a variety of controversial and *little-explored* subjects related to the understanding of how sound patterns are produced in musical instruments, how they propagate through and interact with the acoustical environment, and how they are perceived by the auditory system and interpreted by the human brain.[6]

The statement by Professor Manfred Clynes in 1981, following the third international workshop, that *'there is so much we do not yet know,*[7] is less an admission of failure with the many research programmes, but more an acknowledgement of the areas that await further exploration into the area of sound perception.

> Music differs from the sounds of speech and from other sounds, but only now do we find ourselves at the threshold of being able to find out how our brain processes musical sounds differently from other sounds. We are going through an exciting time when these questions and the question of how music moves us are being seriously investigated for the first time from the perspective of the co-ordinated functioning of the organism: the perspective of brain function, motor function as well as perception and experience ... Such knowledge of brain function eventually will weigh

alongside the knowledge of structure and energy in the universe.[8]

Research into the human perception of sound and the effects of sound upon the brain is not only exciting but is absolutely necessary. However, such research might be somewhat limited if it were confined to musical events as the source of sound stimulation in the investigation of the brain and its imaginative functions. I believe radio drama, as the only dramatic genre which uses a combination of all sound sources for the expressed intention of creating imaginary illusions, has an important contribution to make to such research; but as yet its potential for scientific research remains largely undiscovered or totally ignored. A detailed exploration into the potential areas for research is beyond the focus of this work; however, a brief and general consideration is appropriate at this point.

There is an accepted and simplified division of the human brain into two functioning regions where the left and right brain functions work separately in influencing the processing and assimilation of different forms of informational input, as illustrated below:

Left and right brain functions

LEFT Brain Functions	RIGHT Brain Functions
Written language	Art awareness
Spoken language	Music awareness
Number skills	3-D forms
Scientific skills	Imagination
Reasoning	Insight
Right hand control	Left hand control

Radio drama, functioning exclusively as an aural literature, consistently makes use of all sound stimuli including voices, spoken words, music, sound effects, silences/pauses, acoustic distances and technical sound manipulation (fades, cross-fades, electronic processing) etc. But as separate entities in themselves,

they are processed by different regions of the brain, for example, music and pitched related sounds by the right side and voices/words/inflections by the left side. Radio drama takes these separate elements of sound and composes or combines them into a contextualized and cohesive unit, the sound drama. In the process, the 'active' listener is constantly engaging multiple brain functions in the assimilation and perception of the sounds received by the auditory mechanism and reconstituting them in a 'personal' and heightened imaginary sense in a more complex way than, for example, listening to a piece of music.

Our ability to hear, recognize, categorize and ultimately contextualize sounds results in a process of aural imaging. Stephen McAdams asserts that 'the auditory system participates in the forming of images evoked by acoustic phenomena in the world around us. An important aspect of the imaging process is the distinguishing of different sound sources[9]. This process of aural imaging is a function of the neurological system which may be influenced by other innate mechanisms (a genetic pre-existent bank of categorized sounds) and mechanisms acquired through experience in the world (an expandable cognitive bank of categorized sounds).

The brain's ability to receive, filter and recognize a single sound heard in isolation is a relatively instantaneous and simple function, assuming that the sound (identified by its spectral components: frequency, timbre, intensity, rhythmic frequency etc.) has been previously recognized either by the innate or cognitive mechanisms. For example, hearing the sound of screeching tyres on the road would lead one immediately to imagine the picture of a car, speed, the frozen look of fright, a near accident, lack of concentration etc. Although complete in itself as a single sound the screech is somewhat incomplete as an aural image because it is missing other separate but what we generally consider associated sonic elements. A more complete image is created if the screech were to be immediately followed by a scream, a loud bang or the breaking of glass etc. These extra sonic elements which are associated or expected through cognizance support the aural image which the brain has already formed (i.e. screech + scream-bang-breaking glass = crash). The

completed sound we generally associate with a 'crash' is a complex sound made up of two or more separate sonic elements. By a process of cognitive recognition, the brain has in a way pre-programmed this set of sounds as an associated group, which now form the singular sound of a 'crash.' Aural imaging is, therefore, a process of collecting separate sounds which may or may not be naturally associated with each other, but following a sequential experiential pattern come to form a unitary sound by belonging together. Borrowing a conceptual tool originally invoked by the Gestalt psychologists, McAdams defines this process as one of 'belongingness.' 'The image emerges as a representation of this collection of the parts of a sounding body distributed across time and frequency.' [10]

In classifying the sounds individually, it can be shown that the formant signal of the crash sound (the screech) is alone sufficient to pre-empt the crash image. Therefore, when the initial sound of the screech is heard, the brain forms the completed image, naturally assuming the other sonic elements of the crash-sound will follow. What may at one moment be an 'object' of focus for a listener may at another moment be an element collected into a composite image, wherein the object loses its identity but contributes to the quality of the more embracing image.[11] A moment of confusion or uncertainty may follow if the associated sounds do not occur as the brain constructs a new and different image for the portion of sounds heard. Because of our natural aural inquisitiveness as to the source of sounds, new parameters of questionable assumptions are set as the original assumed image is proved false. The severity or otherwise of the crash can also be imagined as other acoustic spectral elements are deciphered by the brain e.g. loudness of sounds (intensity) x period length of sounds (time), where even the perception or quantity of speed can also be imagined; speed = (screech) intensity x time length. McAdams classifies this as a process of 'perceptual fusion' where sequential and/or simultaneous sonic events are grouped into single entities, but which in themselves separately account for a mosaic pattern of imagery and meaning.

As early as 1931 the psychologist T. H. Pear emphasized that hearing was a cognitive process and in a way was partly correct in

identifying the stimulatory properties of sound upon the imagination.

> Let us remember that we hear not with our ears but with our minds, and that, therefore, a radio play, must '*a fortiori*', be an individual as opposed to a group activity, whose effect depended upon the 'mental apparatus' of each listener.[12]

Although imagination or perception and memory employ essentially similar mental processes, there is a distinct difference in the source stimuli of both processes. Imagination/perception could be categorized as the conscious integration of sensory impressions of external objects and events 'outside' the person, whereas memory is the mental evocation of previous experiences and events which happened to and belong 'inside' the person. Psychologists occasionally distinguish between (i) imagination that is 'passive' and *reproductive*, by which mental images originally perceived by the senses are elicited; and (ii) imagination that is 'active' and *constructive* by which the mind produces images of events or objects that are either unrelated, or at the most, tenuously related to past and present reality. Radio drama can require that both forms of the imagination are used. As the drama is isolated in sound and has no real visual stimuli, it encourages a far greater use of the listener's 'constructive' imagination than other visual dramatic genres. Don Haworth's radio play *On a Day in a Garden in Summer* is one example of the total suspension of disbelief. It demonstrates radio drama's unique ability to transpose the surreal into the real, or at the very least, the imaginatively believable.

On a Day in a Garden in Summer (Don Haworth)[13]

Sfx:	*[Birds: a dawn chorus]*
DICK:	Nice morning.
JIM:	Grand.
Sfx:	*Bullocks low and sheep bleat in the distance. Birds near and far dive and tweet. The conversation is leisurely. These country sounds are heard behind it and during the quite long pauses.*

JIM:	Nippy though.
DICK:	Morning mist. Morning mist and morning dew. Going to be hot today young Jack.
JACK:	Is it, grandad?
DICK:	When the sun strikes through on a hot day, early summer, there's no better thing in creation than to be a dock plant in this garden...

What becomes obvious in the first few lines is that the play is about the surreal world of dock plants whose speech is 'ordinarily' human, neither 'put-on' nor electronically processed in any way. Within those opening lines it becomes clear that the very human-speaking characters are not two men and a boy, but two older dock plants and a younger one. As with the many forms of imaginative transition and illusion, the listener accepts the transformation from the surreal to the imaginatively 'real.' But the play cannot be heard merely as something experimental or something to be passed off as a form of whimsical farce. *On a Day in a Garden in Summer* confronts serious ethical and moral concerns such as bullying, control, selfishness, and power, ending in environmental destruction and death, something more akin to the concept of ethnic cleansing. The dock plants are initially happy, strong, and confidently in control of their corner of the garden where they exercise their dominance by choking other less dominant plant species.

On a Day in a Garden in Summer (Don Haworth)

DICK:	You're here, I'm here, young Jack's here. This is our patch of garden.
JIM:	We tried to teach them that.
DICK:	Well, then, it's finally sunk in.
JIM:	*[Laughs]* I don't think those daisies will come again.
JACK:	What's daisies?
DICK:	Surface leaf, white flower, close up at night. We throttled them.[14]

The docks, however, eventually face their own life threatening crises. Rooted in the ground with no means of escape, they face a greater form of ethnic cleansing – environmental control in the form of the gardener and a weed-killer spray resulting in the death of Jim. David Wade writing about the play states:

> The play is not reduced by its horticultural setting but gains stature from it. In short, it makes it perfectly plain that if there are things to be said requiring some kind of dramatic form, but which will be most acceptably, most persuasively, most penetratingly conveyed only if there is nothing to see, then among the media you either get them from radio or you do not get them at all...Abstractions are not visible. The world of the future is not visible. Fairy-stories, allegories, legends, myths, space odysseys—all these risk and usually receive reduction by sight. These then are *par excellence* the worlds of drama in which, if they are to act upon us as they might, radio holds a virtual monopoly...[15]

Another important aspect of radio drama's influence in the stimulation of the imagination is its process of transcodifying visual elements into aural equivalents. Certain types of 'transcodification' could be described as an example of the creative and imaginary use of what is otherwise referred to in clinical psychology as synesthesia.

Synesthesia is an experience in which the stimulation of one sense elicits a perception that ordinarily would be elicited had another sense been stimulated, such as a loud noise registering as a blinding light etc. This could be extended in a non-clinical sense describing certain processes in a radio drama as a creative form of synesthesia where tonal clusters and harmonies register as colour combinations, and constructed sound patterns register as extremes of heat, cold, hunger, thirst etc.

One of the sounds which Giles Cooper required for his radio play *Under the Loofah Tree* (1958) was the sound of a high hum of pure agony. This was realized for the play at the BBC Radiophonic Workshop. Cooper wrote later that 'part of the

attraction of writing for radio lies in the fact that for no other medium can one write pieces like this which are neither fact nor fiction, neither prose nor poetry, and which have no being except on air.' [16]

It is true that radio drama can incorporate almost all forms of imaginative dramatic scenarios. Crisell believes that 'it is capable of presenting naturalistic plays, psychological dramas whose action is largely internal and invisible, fantasies, and those blends of realism and fantasy which make up absurdist and surreal drama.' [17]

In recognizing its ability to transgress the physical and imaginative barriers, which hamper a stage realization of certain dramatic scenarios, radio drama should not be construed as a home for the weird, wonderful or fantastical. It certainly can be particularly good at exploring those surreal worlds but it is equally capable of producing Shakespeare, Chekhov, Shaw, Beckett, Pinter, Stoppard etc.

> No other medium could afford such a profusion of dramatic riches as appears in any one year's radio schedule. Aeschylus and Marlowe rub shoulders with Adamov and Fabbri, and distinguished actors come regularly to the studios to play Ibsen, Strindberg, Betti, Anouilh, Shakespeare, Molière, Shaw...In fact, it has provided a rich complement to the work of the 'live' theatre, and one which we should be unwise to underestimate.[18]

Whether a text is written specifically for the radio or adapted from another medium to the radio is a less important argument than whether the radio production has made good, creative and imaginative use of the sound elements that is radio drama in its various forms.

Radio drama has been inaccurately described as falling somewhere between conventional theatre and imaginative literature. It is a separate medium, which is neither a vocal form of stage drama without the visual stimuli nor a vocalized/ sounded form of silent literature. It is a dramatic genre in its own right where the juxtaposition of its sonic elements, precisely

calculated for their aurally perceptive affects, clearly defines it as an aural and imaginative literature and one that is complete in itself.

> As soon as we hear a word in a radio play, we are close to the experience it signifies; in fact the sound is literally inside us. To submit to this kind of invasion, to allow another's picture of the universe to enter and undermine our own, is to become vulnerable in a way we do not when we watch a film or a play, where the alien world is demonstrably outside.[19]

Radio drama is partly about that level of intimacy, which allows it to breathe gently into our ears, whisper to our imaginations and tingle our perceptions, and all through its use of sound.

10 | Silences | Pauses

To the composer, writer, philosopher and philanthropist John Cage, 'silence is always musical', and quoting from Henry Thoreau he added that 'sounds are merely bubbles on the surface of silence.' [1] In radio drama, silence and pause are important contextual elements in the composition of sound. As an external element to the play, silence is the point in time from where the play begins, the play's opening sounds break the broadcaster's silence and mark the outer extremity of the play's time frame. It is the first and equally important element that I wish to consider as one of the aspects of radio drama. McWhinnie states 'that as sound comes from it, sound returns to it, words have their meaning surrounded by it, it is the cloth on which the pattern is woven.' [2]

Silence on radio, defined as the absence of sound, is the broadcaster's greatest nightmare. The 'sound' of radio on the one hand, that is, the broadcasting or transmission signal, could be considered as an aural icon affirming the broadcaster's (radio station's) presence. Silence on the other hand becomes darkly symbolic of non-existence, a form of 'nothingness' which is heard as the broadcaster's inability to communicate. Technical silences such as transmitter loss and programme drop-out are tantamount to the involuntary loss or theft of the corporate voice. One is reminded of the numerous apologies given by both radio and television stations for being *'off the air'* during inadvertent breaks in programming due to probable transmitter

failure. In the contexts of radio drama and music, 'silence' is not feared, but embraced as a meaningful and creative element of composition.

Crisell classifies silence as having two distinct functions. 'It has both negative and positive functions which seem to be indexical.' [3] He defines silence in its negative role as the absence of sound, referred to as 'dead-air' in general broadcasting terms, where silence is perceived as a broadcasting void. 'In this function silence can resemble noise (that is, sounds, words and music) in acting as a framing mechanism, for it can signify the integrity of a programme or item by making a space around it.' [4] In this instance Crisell is suggesting an interesting reversal role for silence. If the sounds of radio can equate to noise, then silence is in a way a form of escape from that noise; where silence is heard as the absence of sound it can also be heard as a 'sound' that contains no noise. Silence as sound, just as invisibility as sight, therefore, would act upon and become contextualized and defined by our senses.

> The positive function of silence is to signify that something is happening which for one reason or another cannot be expressed in noise. Because radio silence is total (unlike film and theatrical silences, which are visually filled) it can be a potent stimulus to the listener, providing a gap in the noise for his imagination to work. [5]

Silences and pauses can suggest not only physical actions but abstract, dramatic qualities and even humour. Crisell asserts that 'they can generate pathos or irony by confirming or countering the words which surround them.' [6] Here he highlights the purposeful use of silence as a meaningful entity, and while silence contains no sound, the silence is inextricably linked to the current programme content, that is, the immediate past, present, or immediate future within the programme frame. I disagree with some of Crisell's descriptive terminology, particularly with his use of the term 'noise', which I believe to be somewhat misleading. Crisell describes noise as being the sonic/aural content of the signal being broadcast; however, noise both acoustically and musically is defined as 'unwanted' sound. In a radio drama every

breath can be accounted for to the extent that every 'sound' has a specific function as either icon, index or symbol depending upon its context. As such, radio drama has no place for 'noise' *per se*, unless it is intended and therefore has a precise meaning within the context of the dramatic action. In radio drama 'noise' can not exist on an involuntary basis. Deliberate silences separate and isolate sounds from themselves. Silence is not merely the absence of sound but can be a meaningful void defined by the context of its preceding sounds. Crisell agrees that 'silences are defined by their context; the context determines their functions'.[7]

The following example illustrates three different contexts where silence precedes a subsequent sound or action; silence that is verbally commanded, silence that is 'silently commanded' (a social/cultural protocol), and silence as an involuntary reaction to some unexpected occurrence.

<u>SILENCE</u>

<u>Sounds [events]</u>	*[Context]*	-- <u>(New) sounds/action</u>
Tennis match umpire:	*Command -*	
'Quiet, please.'	*response*	-- Serve taken
Concert soloist:	*Cultural -*	
composure/concentration	*social protocol*	-- Soloist begins playing
Unexpected fright/shock	*Psychological*	-- Emotional/physical
	(and/or) physiological	reactions

Therefore, the succeeding sound/action is the sound that breaks the silence that in itself belongs, or has been a reaction, to preceding sounds/events.

'Silence is golden, golden, but my eyes can see.' Those words from the 1960s song 'Silence Is Golden' draw an important distinction between theatrical silence and pause and radio silence and pause. Zilliacus states:

> Theatre practice can never by pause or silence effect a
> total cessation of impulses: only radio can. The stage is
> always observably there, a peopled milieu which
> projects stimuli into the auditorium ... Traditionally the
> stage, like nature, abhors vacua. [8]

While abhorring the silent void McCallion asserts that in the
theatre 'there's still a lot to see during a pause; on radio the
audience has to imagine what's going on, so the pause becomes a
greater builder of suspense.' [9]

There are different types of pause and silence and a brief
consideration of their differences highlights the dialectics of their
perception. Zilliacus devotes a complete chapter to the uses of
pause and silence in the broadcasting works of Beckett. As
Zilliacus does, I would also like to draw a distinction between
'silence' and 'pause' as being two separate entities. Silence is the
deliberate withdrawal of the sounding object, for example, one's
voice, yielding a sense of finality that can be measured across a
particular time span: 3, 5, 10 seconds etc. Whereas the 'silence' of
one character in the constructed aural acoustic may be objectively
filled by other sounds, it is implicit that the intended silence is a
subjective phenomenon and a deliberate cessation of sound.
Pause, conversely, is a momentary interruption of the sounding
object, deliberate or otherwise, but with the clear intention of
possible continuation and is generally measured over a shorter
time span of 1, 2, or 3 seconds. A pause may also contain non-
verbal utterances such as 'ems', 'umms', 'oohs', 'ahs' and
deliberate in-takes/out-takes of breath etc. as forms of reflective
thought or nervousness, involuntary agreement or disagreement,
surprise, elation, shock etc. In radio drama such non-verbal
utterances are deliberate within the dramatic framework and
impart a high level of contextual meaning to the listener. They
should not be interpreted as out of character hesitant speech or
faulty reading.

The silence which frames the outer extremities of a radio
drama—beginning and end—is an explicit form of institutional
silence. It can be that void of a second or two between the radio
announcer's introduction to a play and the listener hearing the
first sounds of the play. That form of silence is total and

absolute, it is meaningless in itself and does not perform any function within the dramatic structure, a moment of darkness whose content is a form of vast 'nothingness.' This form of silence, silence as nothing, silence as the theft of the corporate voice, silence as the theft of the writer's thoughts is, I believe, the alienating sense of silence that Beckett intends in *Cascando*.

Cascando (Samuel Beckett)[10]

VOICE:Woburn....same old coat....right the sea.....left the hills.... he has the choice.....he has only-
OPENER:	[*With* VOICE] And I close
	[*SILENCE*]
	I open the other
MUSIC:	...
OPENER:	[*With* MUSIC] And I close.
	[*SILENCE*]

Cascando never finishes, never draws to a conclusion. There is no resolution of VOICE's never-ending story or of MUSIC's never-ending pattern of notes. There is no climactic finality, no subtle fade-out signifying a 'controlled' decay. Beckett has skilfully played with that form of silence which neither the acting performance, technical production nor the broadcasting institution can alter. Instead he mercilessly plunges *Cascando* back into the void from whence it came, that form of ethereal 'nothingness'—absolute silence. As Zilliacus states, 'the play as it stands does not end. It is cut off[11] [by silence].

Cascando (Samuel Beckett)

VOICE: ⎤	-this time...it's the right one...finish...
MUSIC: ⎦ [*Together*]
	...no more stories...sleep...we're there...

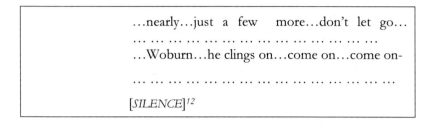

A similar form of Beckettian silence can be found in his plays, *Roughs I* and *II for Radio* and in *Words and Music*. Silence may also be implicit, demanded by the playwright as a constructive element in the play itself or indeed the point of 'nothingness' from where the play emanates and to which it ultimately recedes. Used in this sense, silence becomes an aural acoustic prop, as McWhinnie says: 'sound comes from it, sound returns to it, words have their being surrounded by it, it is the cloth on which the pattern is woven.' [13] Dylan Thomas, for example, specifically asks for 'silence' prior to the beginning of *Under Milk Wood*.

Under Milk Wood (Dylan Thomas)

> [Silence]
>
> *FIRST VOICE [Very softly]*
>
> To begin at the beginning:
>
> It is spring, moonless night in the small town, starless and bible black, the cobblestreets silent and the hunched, courters' and rabbits' wood limping invisible down to the sloeblack, slow, black, crowblack, fishingboat-bobbing sea.[14]

In Walford Davies's introduction to the Everyman edition of *Under Milk Wood* he believes that the very first word, 'Silence— threatens the world of sound by which a play for voices lives.' [15] I disagree with Davies's assessment because I believe in the first instance Thomas clearly required his play to emerge out of the silence of 'nothingness', in much the same way as the oral storyteller might begin: 'I'm going to tell you a story. *[Long pause to gain listener attention—then softly]*—To begin at the beginning.' In a similar way Thomas used silence to distance and protect the sound of FIRST VOICE's opening words from whatever voices or

sounds that may have been broadcast just prior to the beginning of the work. These unrelated sounds of whatever programme that might have been broadcast previously, e.g. a sports programme, music programme, news or presentation announcement, are obviously sound material which have no relevance and may even prove a distraction to the initial inception of the rhythmic and aural aspects of *Under Milk Wood*. (By using silence in this way Dylan Thomas is aware of an infinitely more effective aural equivalent than that of the visual blank page.) Thomas clearly wishes to separate by 'silent time' those sounds, which are external to the play and those which are internal. In so doing he is trying to achieve a space in time that will allow for a heightened and timeless aural event. This form of institutional silence also distances the previously heard vocal characteristics (tempo, intonation, inflection, accent etc.) of whatever radio programme from those the play wishes to establish.

Another use of silence is found in Tom Stoppard's radio play *'M' Is For Moon Among Other Things*. This play which explores the stagnancy of communication between a married couple begins out of silence. Here Stoppard clearly wants the silence to be heard and interpreted as a breakdown in aural communication, a sonic 'nothingness', before the first verbal sounds are uttered. This is further emphasized by the sounds of turning pages (first the lighter sound of a newspaper pages, second, the heavier sound of book pages) symbolizing the act of reading as a private engagement. The man's grunt and the woman's sigh aurally signify the presence of two individuals separately engaged in the silent act of private reading. The sounds of turning pages could further be described as an aural icon of non-communication. This nonchalant silence locks the couple into the play's interior world of apathetic consciousness.

'M' Is For Moon Among Other Things (Tom Stoppard)

> *Silence — a man grunts and shakes his paper — a woman flips over the pages of a book and sighs.*[16]

On radio, 'silence' has the ability to become a character, a co-presenter, an entity that takes on a shape within itself. Its potential effect upon the listener can be as great as visually seeing the fatal thrust of the duelling sword, the gun being fired, the body drop through the gallows trapdoor or, paraphrasing Hitchcock's *Psycho*, the knife blade raised behind the shower curtain. Silence is not necessarily a form of 'nothingness', on the contrary, it can be filled with meaningful intent. The fear that silence can evoke becomes an abyss whose physical proportions are framed only by time. It can be something created out of the unwillingness to speak but implicitly loaded with the willingness to act, as real but intangible, as that which lurks in the black of the darkest night. Silence's volume grows in intensity to almost explosive proportions in the imaginative anticipation of the listener's mind, its crescendo halted only by its succeeding sound, the sound that breaks the silence, the sound that gives way to that palpable sigh of relief, which releases one from silence's nightmarish entrapment, the imagination. The pregnant pause, that wordless time space filled with anticipation, silence, can sometimes allow us to sense what cannot possibly be shown.

11 | Voices

> The speaking voice is an extension of the self. It is the
> leading edge of individual identity—the audible
> expression of the personality.[1]

Jeffery Pittam believes that 'one reason to consider the voice
separately is that there are times when it is the only non-verbal
channel available in an interaction, or at least is the most
important.' [2] He considers 'telephone calls, talk-back radio and a
conversation where at least one of the interactants is blind as
examples of this. In such a case, the voice increases in
importance.' [3] Pittam regrettably excludes radio drama from his
analysis.

It is accepted in radio drama that sound effects (Sfx.) can aid a
voice by aurally depicting scenery e.g. driving rain, a violent
storm, quiet country-side sounds, seaside sounds etc. and music
can certainly help to create a particular mood. Whatever aural set
or acoustic is created as a backdrop, the vocal sense that is
imparted to a listener must be created by the actor's voice. Alan
Beck adds that many directors have stressed this to him, pointing
out that '70% of the acoustic is in the acting.' [4] It is accepted that
every actor must touch the character through language, through
the words given in the script and through the actor's voice
vocalizing and enlivening those words. Cicely Berry is correct
when she proposes that 'every actor wants to know that his voice
is carrying what is in his mind and imagination directly across to

the audience ... in the end it is the voice which sets up the main bond between him and his audience.' [5] In radio drama the voice is isolated in sound, stripped bare of those other supporting visual stimuli the stage actor can rely upon for character building, e.g. costume, movement, gesture, make-up and lighting. The disembodied voice in radio drama is vulnerable and even when sound effects and music surround it, the voice remains naked in an aurally transparent way. This calls for an intense and critical concentration on vocal performance beyond what may be required in the theatre or on film, because to the listener the actor's voice has to appear fully clothed and emotionally charged if it is to be a convincing character. The phrase 'it's all in the voice' is a chillingly poignant description of the most fundamental element in radio drama, the voice. Radio drama demands, but regretfully does not always achieve, that sense of vocal excellence, that transparency that can raise the hair on the backs of its listener's necks. This does not refer to the rarely heard 'super-voice', but more to the normal voice that can explore and fluidly use the variable elements of speech including pitch, tempo, articulation, inflection, intonation, pause etc.

A deeper exploration into the science of voice production would involve an interdisciplinary approach considering areas such as physiology, psycholinguistics, phonetics, audiology, and linguistics. For our purposes, at least a preliminary consideration of voice and vocal types is deemed necessary, particularly as they form a major component in radio drama.

Ingo Titze claims that 'the perception of voiced sounds is sometimes reduced to four dimensions: pitch, loudness, vowel (or voiced consonant) and quality.' [6] The last of these dimensions, 'quality', is a somewhat subjectively vague and poorly defined term which Titze states 'includes all the leftover perceptions after pitch, loudness and phonetic category have been identified.' [7] He also includes what Laver further identified as roughness, breathiness, creakiness, nasality and register[8] as being only a few descriptors that refer to voice quality. It is accepted that there are many differences of opinion regarding definition of voice quality. What is immediately obvious to a listener is that he/she will instantly warm to, empathize with,

turn-on to or be turned-off by a particular voice the moment the listener hears it.

It is said that we are born with the voice that we use, that is, its register and acoustic characteristics, the sound of one's voice. But like any organic element the voice is greatly influenced by the physiological changes and development experienced through life, where it can act as a reflection of health, ill health, trauma, depression, elation and the accident status of our bodies. The human voice is therefore a physiological and psychological indicator of an individual's state of being. Each voice has certain 'fixed' parameters, for example, we cannot alter the size of the larynx unless through radical invasive surgery and neither can we do much about the size and shape of our resonating chambers, mouth, nasal, head and chest cavities. There are also individually 'fixed' acoustic characteristics, which remain unchanged despite ageing or accent change. This phenomena is currently being researched in the U.S.A and elsewhere and presents itself as a system of 'voice-printing', akin to 'finger-printing', as a means of identity. Just as a finger print is unique to each individual so too, it is claimed, is a voice print. Already voice activated/recognition (v-a/v-r) electro-mechanical and software systems are in everyday use, for example, (v-a) computer commands, (v-r) word processing software, (v-a) telephone dialling, (v-r) security clearance etc.

Despite these fixed elements influencing vocal production, individuals can effect a dramatic change in their voice through appropriate voice training. Margaret Thatcher (former British Prime Minister) went through such a training programme to lower her vocal pitch. Scientific tape analysis showed that 'she reduced her pitch by 46 Hz, almost half the average difference between male and female voices. She also slowed down a bit, as we tend to reduce word speed when we lower pitch in talk.' [9]

Changing one's vocal register, which is essentially re-training the vocal muscles to perform differently, will certainly take time and effort. Whereas the effect is dramatically audible in such a prominent and public person, we may overlook the fact that the vocal actor may be expected to perform a number of vocal changes in the course of one production. The variety of vocal

changes required from an actor can involve alternating the pitch, inflection, emphasis, phrasing, breathing, tempo, accent and the voluntary restriction or relaxation of the vocal folds.

Electronic measurement of the acoustic signal has become one of the major ways of measuring voice and speech. Pittam claims that 'at a basic level these physical measures, the acoustic signals the voice emits, fall into three types. First, there are those underlying the perceptual feature of *loudness*, such as amplitude; second, there are measures underlying the perceptual feature of *pitch*, such as fundamental frequency; and third, those related to *time* as the duration of speech sounds.' [10] This is in broad agreement with Titze's claim at the outset that 'the perception of voiced sounds is sometimes reduced to four dimensions, loudness, pitch, vowel (voiced consonant) and quality. (Titze eliminates time—expressed as a rhythmic structure—as a possible dimension). [11]

Titze classifies the aural recognition of vocal registers (pitch) as the prominent indicator of voice recognition. The term 'register' has been used to describe perceptually distinct regions of vocal quality that can be maintained over some ranges and loudness. This applies to the fundamental frequency of a voice in any register where pitch variability *does not* adversely affect the sound quality of the voice in that particular register. He classifies these registers for the typical speaking voice as (1) PULSE, (2) MODAL and (3) FALSETTO; typical singing registers correspond as (i) chest, (ii) head and (iii) falsetto. It is generally assumed that modal (the normal or mode) register in speech, and the chest resister in singing (the one that produces vibratory sensations in the trachea and sternum) are similar. However, Titze warns that the terminology of vocal registers is not scientifically exact because of the different use of terminology employed by speech scientists and singing teachers. [12]

Adopting Titze's terminology, the vocal actor has the use of three distinct registers, pulse, modal and falsetto. The pulse register often sounds as a forced lower bass range of the normal or modal voice and without good execution can sound contrived and deliberately false. Examples of this can be heard in both the

male and female voice, although it is more pronounced in a male voice, which is forced lower to simulate the perceived sound of old age, seriousness, gravity, sexiness, evil, out-of-this-world voice etc. What it may gain in an artificial bass frequency range can be lost if strained breathing and vocal hoarseness leaves it with a lack of presence and power. These negative vocal effects can be compensated for electronically in the recording studio. With modern digital sampling techniques and pitch shifting devices a pulse or falsetto register can be electronically created from a modal register without the vocal necessity of the actor trying to achieve it. Another common example of the pulse voice is an actor trying to simulate Beckett's 'cracked' voice as exemplified by Patrick Magee. The falsetto register can be very effectively used by alto and soprano range voices in speech to simulate accurately the aural perception of children's voices. In addition to the use of different voice registers, vocal actors also have at their disposal a battery of voiced alternatives for creating contrast and change in tempo, pitch, inflection, rhythm flows, emphasis, pause, accent etc. Beck classifies five variable aspects, which he considers important for a good acting voice on radio.

1.	Pitch or range (also intonation = the notes of the voice)
2.	Volume or loudness (projection) and breathing
3.	Tempo or rate (with word strike)
4.	Voice qualities
5.	Dialect[13]

Johan Sundberg, suggests that one and the same sentence can be pronounced in a vast number of different ways, and the way it is pronounced reveals among other things the speaker's state of emotion.[14] Assuming that the acted voice should always contain contextualized 'acted' emotion the question of whether something 'rings-true' or 'rings-false' depends upon matching the correct emotional intensity with the spoken dialogue. In vocal acting, matching emotions to words can sometimes prove difficult. In proposing an answer to his own question: where in the sound of the voice do we find the information about the emotional state of the speaker? Sundberg suggests that 'one

possible parameter is the frequency pattern of the voice fundamental, i.e. <u>the phonation frequency pattern</u>, because the course of the phonation frequency can be varied within wide limits without encroaching on the information on the linguistic contents of a sentence.' [15] What Sundberg suggests is that the voice can be increased or decreased in pitch to suit an emotional state of mind <u>without</u> adversely affecting the sentence structure from either the intelligibility of its phonation—that is, the articulation of the spoken words—or the emotional content signifying its contextual meaning.

It may seem patently obvious that in radio one casts for voice and not appearance, but it is a principle that is often overlooked particularly where closer attention to the aural ramifications of vocal broadcasting are concerned. In a radio drama, what is essentially required for performance is not merely good intelligible voices but good vocal contrast.

> In the theatre one usually casts on an individual basis: such-and-such a player for such-and-such a part. In radio the over-all pattern of sound is nearly as important as the individual voices. Again, since listeners must be able to distinguish readily between one character and another, if there's no difference in accent, age or sex there must be a difference in pitch and timbre. So quite often you cast for vocal contrast. (As Lefeaux puts it, 'what one then needs is not the voice beautiful but the voice peculiar').[16]

Selecting voices that are 'peculiar' enough to be instantly and aurally different and therefore easily recognizable by a listener may be the ideal but it is not always practicable. A common problem in vocal casting is to have two voices with the same register and vocal characteristics, but where each voice is required to play different characters. There are natural elements in vocal performance that can create an aural difference between similar voice characteristics—for example, sharply contrasting tempos of delivery, intonation, inflections, speech rhythms, accents etc., but these may be restricted by the character's contextual role within the play. If these vocal differences are contextually impossible then there are production techniques

which may help to differentiate the voices such as acoustic distancing, electronic processing and vocal filtering, but again these are also dependent upon their use within the context of the play. These problems and their attempted resolutions are addressed in the performance analysis of the four *King Lear* radio productions.

Alan Beck is correct when he states that 'the world of radio drama is the world of language.' [17] And in radio drama that language is a spoken language—a language that resorts to that primal organ of communication—the voice. Horstmann's advice on writing for radio is that 'each character should have an aurally recognizable personality.' [18] Is that personality to be found in the words as text or in the voice as performance? Here, I restate part of my initial argument in relation to radio drama as aural literature. The creation of the art form goes beyond the textual aspirations of the playwright and manifests itself within the sonic realizations of the actor's vocal performance and the aural perception of the production as a whole.

Beck is also correct in his assumption that 'it is sometimes difficult for actor and playwright on radio to reach through to the lower levels of the mind, that is, to pre-formed speech, emotion and instinct.' [19] This offers only part of the possible answer to a dilemma, which confronts actors and producers in radio drama, that is, that if good vocal acting can at times mask poorly written dialogue, why then can well-written dialogue at times sound 'poorly'? Even with adequate vocal preparation, breathing, articulation, intonation, tempo, dynamics etc., together with technical direction in the studio, some voices just simply fail to connect with those lower levels of the emotional and instinctive mind.

Realizing that 'it is all in the voice', could be a dialectical challenge for some actors and a terrifying reality for others. Depending upon the complexity of the role and as the voice is always stripped of 'costume and make-up' on radio, the actor's character role has to be created from the naked intimacy of the actor's self, articulated and emotionally expressed through the voice.

12 | Words

In the radio medium, it is difficult to separate voices from words unless one focuses specifically upon the science and physiology of vocal production in the former and a purely textual and literary analysis in the latter. In stating that 'speech is inseparable from our consciousness'[1], Ong reaffirms the primacy of sound as central to the development of consciousness and imagination. In so doing he underlines the thesis of linguist, Henry Sweet, that 'words are made up not of letters but of functional sound units or phonemes.'[2]

In his essay 'The life in a Sound', the Romanian theatre director, Andrei Serban, extols the virtue of the sounded word, which he believes transforms the speech act in an innate way from being merely a vehicle for verbalizing text into a verbal expression of the human soul.

> We attempt to create a sound—a sound which grows and turns into a cry. We try to find the energy which produces this action and become aware of it. I see the sound as an image. I see what is enclosed in it—a column of air trying to break open. In the effort to produce the cry I attempt to replace heaviness with spontaneous vitality. The cry becomes either an expression of freedom and awakening or a sign of imprisonment; it depends on how the sound is controlled and directed from inside ... We all find ourselves faced with the same difficulty in this attempt,

which is to understand something that is very simple. The core of our search is to try to work as if the whole world existed in a single word and each word represented a fragment of life … Not only with words but with fragments of words, with each consonant and each vowel—every sound is charged with a particular activity and a specific colour…When we speak in ancient verse, it is not only the rhythm which comes alive but the entire imagination which begins to stir in many directions. We try *to see* the images in the sound … It is not only the imagination but our entire being which lives through the words. It is a matter of discovering the paradox that the head, the heart, and the voice are not separate but connected with each other.[3]

As radio is exclusively concerned with the production of sound, both voice and word are inseparable. In radio drama the spoken word is in reality the 'acted word.' Isolated in sound and devoid of any form of visual stimuli, the 'acted-word' is charged with a far greater responsibility for carrying emotional power, meaningful intent and the physical sense of character. Words, which will have to come alive through the actor's voice, need to be razor sharp and precise, yet colourful and evocative. They are merely the measured threads of the playwriting-weaver that will be passed on to the skilled tailor—the vocal actor.

The economy of words is something like a dramatic Occam's Razor, where simple wordless action is sufficient to indicate what is happening, words are redundant.[4]

Esslin's statement has particular relevance in the highly visible world of stagecraft where to use an oft-repeated metaphor, 'actions can [sometimes] speak louder than words.' That is, where words merely represent a verbal expression or intention to act upon something it is the ensuing action that becomes the tangible and believably physical fulfilment of such expressions. Therefore, where wordless actions on the stage can be clearly defined for what they mean, the visibly physical action and its consequence makes any stated intention to act redundant. For example:

CHARACTER A:	I'm going to shoot you.
	Takes a gun from his pocket.
[*ACTION*]	*Gun raised, pointed at character B and fired.*
[*SOUND*]	[BANG!]
[*CONSEQUENCE*]	*Character B falls to the floor - motionless.*

The visibility of the action and its consequence means that the audience in the theatre can instantly interpret the meaning intended [*A shoots B*] without the need for the intention to be verbally expressed.

CHARACTER A:	*Takes a gun from his pocket.*
[*ACTION*]	*Gun raised, pointed at character B and fired.*
[*SOUND*]	[BANG!]
[*CONSEQUENCE*]	*Character B falls to the floor - motionless.*

Whereas the second example can visibly work on the stage, in the invisible world of radio it is meaningless. In a radio play, the simple sound effect of a gunshot can be rendered meaningless unless it is verbally contextualized and made part of the dramatic action. On the level of sound recognition, the listener can easily identify the sound as a gun shot therefore an action has occurred, but it remains meaningless unless the intention and the consequence are also known. For example, the listener may need to know who fired the shot? why was the shot fired? at what or whom was the shot fired? and what was the consequence of the action (e.g. did the shot miss? was somebody injured or killed?) In the invisible world of radio drama certain actions and their consequences will always be required to be contextualized. The metaphor, '[visible] actions speak louder than words' cannot be easily applied to the radio play. Words in a radio drama, whether combined with silence and pause, sound effects or music, are the primary identifier of dramatic action but care must be taken that

stated intentions are neither naive nor linguistically so overstated as to sound farcical.

Timothy West's humorously 'skittish' one act radio play *This Gun That I Have In My Right Hand Is Loaded* [5] is a deliberate and excellent example of language redundancy and 'how-<u>NOT</u>-to write-a radio play.' His tongue-in-cheek play satirically exploits the deliberate over-use of meaningless descriptive dialogue, vocal accents and sound effects to farcical proportions. In this extract from the play the diamond smuggling OPPENHEIMER and his group of German cohorts have reached their escape submarine with CLIVE and GERDA (OPPENHEIMER's sister) as their prisoners.

This Gun That I Have In My Right Hand Is Loaded (Timothy West)

OPPEN:	Ach, Zehr gut. Tell me once more what you have done with the prisoners; my sister Gerda and that meddling fool Barrington.
LUDWIG:	Karl found them attempting to telephone Scotland Yard from the porter's lodge. They have been tied up and taken on board the submarine half an hour ago.
OPPEN:	That is gut. I will teach the fool Englishman to double-cross me. Achtung! Here we are at the submarine. Karl! Kurt! Lower a rope ladder!
KARL:	Ja, mein Kommandant.
Sfx:	*(FEET ON TIN TRAY)*
OPPEN:	It is four o'clock, We sail immediately.
Sfx:	*(CHANGE TO SUBMARINE INTERIOR ACOUSTIC)*
HEINZ:	The diamonds are safely locked in your cabin, mein Kommandant.
OPPEN:	Jawohl! Kurt! Heinz! Karl! Prepare to dive!
Sfx:	*(DIVING NOISES, KLAXON)*
	Set course for Amsterdam.
KURT:	Steer East North East eight degrees by north.
Sfx:	*(CRIES OF JAWOHL, ACHTUNG, MIDSHIPS etc.)*

OPPEN:	Ludwig!
LUDWIG:	Ja, mein Kommandant.
OPPEN:	Take me to the prisoners.
LUDWIG:	Ja, mein Kommandant.
Sfx:	(MORE FEET ON TIN TRAY)
	They are in the forward hydroplane compartment.
Sfx:	(DOOR OPENS, FORWARD HYDROPLANE COMPARTMENT NOISES)
OPPEN:	So, Herr Barrington, we meet again.
CLIVE:	You filthy swine, Oppenheimer, you won't get away with this.
OPPEN:	*(becoming slightly manic)* On the contrary, my friend, there is no power on earth that can stop me now. You, I'm afraid, will never reach Amsterdam. There will be an unfortunate…accident in the escape hatch.
GERDA:	*(a gasp)* Heinrich! You don't mean…
OPPEN:	As for you, my dear sister Gerda…
CLIVE:	Leave the girl out of it, Oppenheimer. She's done nothing to you.
OPPEN:	Charming chivalry, my English friend. But it is to no avail. Come.
CLIVE:	All right you swine, you asked for it!
Sfx:	(BLOW)
OPPEN:	Aargh. Himmel! Kurt, Kurt!
Sfx:	(RUNNING FOOTSTEPS)
CLIVE:	Ah, would you? Then try *this* for size.
Sfx:	(BLOW, GROAN)
	If *that's* the way you want it.
Sfx:	(BLOW, GROAN)

KURT: Get him, Hans.

CLIVE: Ah, no you don't. Take *that*.

Sfx: *(BLOW, GROAN. A CHAIR FALLS OVER)*

GERDA: Look out Clive. The one with the glasses behind
 you. He's got a gun.

Sfx: *(SHOT)*

CLIVE: (*Winces*)
Sfx: *(ANOTHER CHAIR FALLS OVER)*
 Phew! Close thing, that.

GERDA: Clive? What happened?

CLIVE: Just my luck; he got me in the arm. Luckily, he
 caught his foot on that bulkhead coaming; he must
 have stuck his head on that valve group between the
 depth gauge and the watertight torpedo door.

GERDA: Is he - ?

CLIVE: I'm afraid so. Right, now to get this thing surfaced.

The skill of radio acting while reading from a script is called
'lifting-it-off-the-page.' This is a term to describe the vocal
actor's mental process as it goes from page-to-mind, and from
mind through voice-to-microphone into the listener's
consciousness. But the actor requires the correct balance of
words, a finely crafted balance of quality and quantity, which can
vocally transform words into verbalized thoughts thereby aiding
the stimulation of aurally imaginative pictures. Dylan Thomas
recognized this finely tuned balance where the act of seeing
evoked through spoken words cannot be taken for granted.
Davies states in his introduction to *Under Milk Wood* that 'in one
section Thomas considered teasing our very dependence on
words, by evoking their opposites in the wordlessness of
dreams.' [6] But a sequence of words of unrelated descriptive
nouns may not in themselves evoke an imaginative aural picture.

Under Milk Wood (Dylan Thomas)

SECOND VOICE:	Mrs Rose-Cottage's eldest, Mae, is dreaming of dreaming of tall, tower, white furnace, cave, flower, ferret, waterfall, sigh, without any words at all.[7]

This is an example where the poet's economy of words may be textually meaningful and visually revealing, but proves too little in the auditory domain. Davies believes that 'Thomas must have recognized that those staccato words would have come through as mere words, not brisk pictures. He rewrote the passage so that we are led through the discrete words into a delightfully indiscreet picture.[8] Thomas adds active verbs giving a sense of identifiable forward movement and anticipated intention.

Under Milk Wood (Dylan Thomas)

SECOND VOICE:	Mrs Rose-Cottage's eldest, Mae, peels off her pink-and-white skin in a furnace in a tower in a cave in a waterfall in a wood and waits there raw as an onion for Mister Right to leap up the burning tall hollow splashes of leaves like a brilliantined trout.[9]

This rewritten passage with its extra contextual words turns the passage into a sensual and erotic sound picture. But is it necessary to hear these words spoken aloud by another in order for this imaginary picture to be drawn? Or can a picture be formed by simply reading the words to oneself? At this point one enters the dialectical debate concerning the eminence the performance text over the pre-eminence of the dramatic text as vocal characteristics, nuance, emphasis, and meaning are aurally realized.

The 'acted' or 'spoken word' is a complex unit that contains semiotic functions that can be both symbolic and indexical. Written words on the page are generally interpreted as symbolic signs, that is, symbols of objects which in their written form do not physically resemble the object. Yet, their symbolism is the

basis of radio's imaginative appeal, for if the word-sign or spoken word does not resemble its object, the listener has to imagine or imaginatively visualize the object in a very direct and personal way. It is accepted that both the listener to the spoken word and the reader of the written word each use a form of aural imagination for mental visualization. The aural experience in the former is influenced by a third party sounded interpretation and in the latter by the individual or personally read form. This acceptance is supported by Ong's assertion that 'written texts all have to be related somehow, directly or indirectly, to the world of sound, the natural habitat of language, to yield their meanings.' [10]

As individuals, we spend most of our waking hours interpreting 'meaning' on both conscious and sub-conscious levels from a variety of sources including sounds, written texts, and visual stimuli. But 'meaning' itself could be described as operating on at least two independent levels simultaneously. On the first level 'meaning' is generally initiated as a subjective idea (belonging to, for example, the 'artist') and is aimed at an objective receptor (the consumer). That is, some other person or thing tries to denote, to signify, to convey, or to indicate a meaning to me as a consumer; examples of this include actors acting, advertisements, films, literature, the visual arts etc.

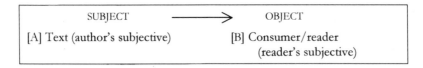

SUBJECT	\longrightarrow	OBJECT
[A] Text (author's subjective)		[B] Consumer/reader (reader's subjective)

On the second level, 'meaning' undergoes a metamorphosis. [A] is assimilated as an object by the consumer as the interpreter of 'meaning' who internalizes it subjectively.' On this level the 'meaning' is interpreted by subjective deconstruction (I use the verb to 'interpret' in preference to 'understand' as something 'understood' can imply a cloned or replicated understanding of the original subjective idea or message at level 1). The author's text is subjective to the author where its objective target is the reader; but to the reader the objective text is internalized where its 'meaning(s)', knowledge etc., becomes 'owned' by its

interpreter. In doing so, the 'owned interpretation' alters to some degree the original subjective message of its author. As the reader's interpretative subjectivity will never be the same as the author's original subjectivity, an inverted or reconstructed meaning is produced as an outcome. While the line of communication is direct, author --- reader, the accuracy of the interpretation will be as infinitely variable as the number of readers, modified by the subjective assimilation or interpretative abilities of each reader. Consideration needs to be given to the communicative process in its extended form where the reader becomes an audient reader of a performed interpretation of a text , e.g. author --- actor --- audient reader.

Whether the actor is more accurate or not in decoding the author's meaning from a text is not in question. The fact remains though, that the listener/audience is presented and influenced by a single interpretation of the text which for many is perhaps the only interpretation they will experience.

Radio's sonic invisibility creates a *de facto* axiom that words on radio do not exist unless they are spoken; this however, introduces a variable link in the chain of communicating meaning. The initial relationship of author- [TEXT] -reader *(subjective interpretation)*, is now transacted as, author- [TEXT - 3rd party interpretation - PERFORMED TEXT] -audient reader *(pre-formed objective interpretation)*. The listener now transposed as an 'aural reader' more readily accepts the spoken words as the author's implied subjective meaning and hears the audio text as the first assumed subjective interpretation. This assumption does not apply only to radio drama but can also be extended to film, television, and the theatre, where the audio-visual spectators are primarily interested in and influenced by the spectacle they are attending. As with radio, the assessment of an author's work will be influenced in a positive or a negative way by the strengths or weaknesses of a particular production.

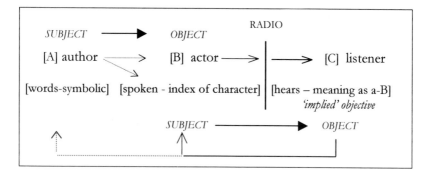

Crisell states that 'spoken-words constitute a binary code in which the words themselves are symbols of what they represent, while the voice in which they are heard is an index of the person or "character" who is speaking.'[11] The human voice is the only vehicle by which words can come into being and be experienced solely by being heard. 'Radio reproduces most effectively the experience of human interaction through its reference to the code of the spoken word.'[12]

It is true that what the listener hears in a radio play is the completed radio drama production where voices may be given extra contextual meaning by the production's associated elements of silences, pauses, sound effects, music and acoustic distances. The aural interpretation of the enlarged sonic text returns to the physiology and psychology of sound perception and the influence of sound upon the imagination and ultimately upon thought processes. This is not to imply that radio drama thinks for its listeners, on the contrary, good radio drama can be a potent stimulus that activates the listener's own imagination from where interpretative thoughts and thinking derive.

It is also true that the invisibility of the radio medium releases language from additional visual communication considerations such as gesture, movement, costume, make-up, set, props, lighting etc. The absence of physical visibility could be argued as having a positive, or a negative, influence on language, depending upon one's critical opinions of radio drama. The loss of additional visual signifiers could be argued in the negative that it impoverishes language and dilutes meaning by isolating the

speech-act to the solo role of attempting to communicate information and emotional content. However, I would argue that the loss of additional visual signifiers positively heightens the role and primacy of language, particularly in the nuances of its vocal delivery, as an acute and incisive means of communication. This ostensibly reiterates Ong's assertion that 'all written texts have to be related somehow, directly or indirectly, to the world of sound, the natural habitat of language, to yield their meanings.' [13]

13 | Utterances

In radio drama vocal utterances, as distinct from complete spoken-words or speech, play a critically important role. In a sound only medium, for example, radio drama and telephone conversations, utterances such as audible breathing, sighs, grunts, groans, cries, incomplete words, verbal exclamations etc., have a heightened significance over their use in visual communications, such as face-to-face conversation, theatre, film and television. In the visual communication genres verbal utterances are to an extent minimized by visible gesture signs including facial, eye, hand and body movements, and combined with other visual stimuli such as costume, make-up, sound, lighting, props etc., supersede vocal utterances in creating the predominant level of signification. In the theatre, for example, these visual gesture signs replace the vocal utterance as primary signifiers. A case where the hands thrown up in the air in silent despair is immediately more demonstrative and easier to achieve than finding the right tone and pitch for an angry vocalized 'Ah!' Whereas complete words are easier to act vocally, vocal utterances and the various degrees of crying, laughing, sighing etc., are the most difficult to reproduce convincingly. Because the vocal utterance is a sonic affirmation of an instantaneous emotional reaction or response, the major difficulty for the vocal actor is in creating a pseudo-emotional feeling for the utterance so that it sounds 'genuine' and convincing to the listener. In radio

drama the vocalized utterance receives an elevated significance, which results directly from its isolation in sound.

Their importance within the radio drama frame as character-laden insights can help to contextualize the dialogue by supporting the spoken-word with a more direct primal iconic system of communication. Eli Rozik states that iconic communication is non-verbal by definition, since it operates within a different mode of signification. His reasoning being that 'real speech acts are conventional indexes of actions, that are 'categorized' by the hearers. Iconic speech acts are motivated signs that are 'decoded' on the grounds of their similarity to real speech acts and the natural ability of the hearers to categorize them.' [1]

'Ahs', 'ahas', 'emms', 'umms', 'errs', audible inhales and exhales of breath etc., have a close affinity to the ear of a listener. They are part of a universal vocabulary drawn from an instinctively primal and pre-verbal utterance language with a shared use and understanding. Linguistically it is perhaps more correct to define them as a paralanguage within the language of the text, a paralanguage which has its importance in everyday speech, but is often over-looked, sanitized or deliberately omitted in stage performances. Alan Beck suggests that there are two forms of this paralanguage within radio drama. 'First they may be additions which are made to a script to express subtext and to give colour. Second they may be reactions that characters make while other characters are speaking'[2], a vocal affirmation, rejection or exclamation to a controversial statement or issue.

In Stephen Dunstone's 'Giles Cooper Award Winning' radio play *Who is Sylvia?* MICHAEL (a Ph.D. research graduate) under the supervision of SIR ARCHIBALD SOPWITH-PLACKETT are both biological scientists undertaking investigative—or ruthless—experiments on the other cast members, ANGELA, HENRY, SYLVIA and their off-spring who happen to be cockroaches. Fear, trust, betrayal and love are some of the themes that are explored in the play from both sides of the laboratory glass by both species. In this extract PLACKETT enters the laboratory preoccupied with family matters concerning his wife's illness and their human daughter Sylvia.

Who is Sylvia? (Stephen Dunstone)[3]

	Silence. MICHAEL *checks various sheets of paper at his desk.*
MICHAEL:	*(To himself)* Yes, yes…yep, yep…yer…yer…Yer, Doive. *(Then, in a high pitched, nasal parody of himself.)* Hello, Sylvia, it's Michael, I've come to see you. *(Falsetto, as* SYLVIA.) Mickey…!! Oh Mickey, I'd like you to meet Dave. *(As himself.)* Hello, Dave! *(As* DAVE.) Uhh. Uhh. *(He makes noises of boredom and annoyance.)* Doive. Yer.
	Distant sounds of PLACKETT *arriving.*
PLACKETT:	*(From the office.)* Michael?
MICHAEL:	In here.
PLACKETT:	*(Coming through.)* Ah.
MICHAEL:	What news? Any?
PLACKETT:	*(Obviously utterly depressed.)* Er…no. No, nothing. Not yet. No.
MICHAEL:	Ah.
	Pause.
PLACKETT:	Er…everything all right, is it?
MICHAEL:	Yes. Er, yes, fine.
	Pause.
PLACKETT:	Good. *(Pause.)* Er…what…um, what do we…er, what do we have to take care of today, Michael?

Deleting the various utterances from this extract would inevitably change both the intentional interrupted rhythmic flow and the emotional sense of the piece. For example:

	Distant sounds of PLACKETT *arriving.*
PLACKETT:	*(From the office - coming through.)* Michael?
MICHAEL:	In here.

MICHAEL:	What news? Any?
PLACKETT:	(*Obviously utterly depressed.*) No. No, nothing. Not yet. No.
	Pause.
PLACKETT:	Everything all right, is it?
MICHAEL:	Yes. Yes, fine.
	Pause.
PLACKETT:	Good. (*Pause.*) What…what do we…what do we have to take care of today, Michael?

Another form of utterance is the vocalized whisper whether in the form of vocalized thoughts or *sotto voce* conversation. An example of this can be found in David Campton's radio play *Boo!* This is a horror play, a theme which radio does particularly well as the gruesome shape that haunts is materialized by the listener's imagination.

Boo! (David Campton)

BILL:	*[In panting whisper]* Damn fool place to hide – behind spare room curtains. Bound to show. Panic, of course. Should have cheated. Slip out through back door, and come back when they give up. Too late now, though. On their way. Mustn't breathe so hard. They can hear a heart beating…etc.
Sfx:	*[Door opens. Scuffling of tiny feet. A whisper which is shushed. Heavy breathing]*
CHILD:	*[In a low whisper]* The curtains.
Sfx:	*[The whisper is taken up by the others. 'The curtain, curtain, curtain …]*
TONY:	Sssh
Sfx:	*[The curtains are drawn - Bill gasps, then laughs uneasily]*
BILL:	I give up. *[There is no sound from the children]*[4]

Scripted utterances are always contextual. 'Ah', is an exclamation expressive of various emotions, according to the manner in which it is uttered, for example, 'sorrow, regret, fatigue, relief, surprise, admiration, appeal, remonstrance, aversion, contempt, mockery'. [5] Whereas, 'aha', is an exclamation of 'surprise, triumph or mockery'. [6] As with any word, the utterance is given a particular meaning by its context and vocalization.

14 | Sound Effects (Sound fx.)

As important as the acted or spoken word is to radio drama, the sounds and sound fx. which surround the words also perform a vital and closely interrelated function. In the theatre, whether the curtain or lights rise on a scene or the scene is fully visible from the beginning, that visibility gives the audience important contextual information about the play and its setting. McLeish states that in radio drama 'the equivalent of the theatre's backdrop are those sounds which run throughout a scene—for example, rain, conversation at a party, traffic noise or the sounds of battle.' [1] All of the sounds in a radio drama are specifically chosen for their contextual value. Unlike words, which are a human invention, sound is 'natural', it is a form of signification which exists 'out there' in the real world. Crisell suggests that 'sounds, whether in the world or on radio, are generally indexical,[2] that is, that the sound one hears is directly linked to its object, but is clearly not the object itself. It can also be argued that 'natural' sounds on radio are iconic, 'that is to say that a recorded sound can represent an aural icon or image of the original sound, or that a sound in a radio play is an icon of a sound in the real world.' [3] Further extrapolation of this theory inevitably leads to an exploration of the science of aural/sonic semasiology. However, if a sound is to be accepted as an aural icon then two questions need to be answered (i) what does the

sound 'signify'? and (ii) from what physical source is the sound made?

Sound fx. can be divided into three broad categories, (i) pre-recorded and sounds from nature, (ii) 'live' or spot fx. and (iii) complex composed sounds. The obvious sounds in the pre-recorded category are identifiable as natural sounding phenomena, which are generally used as background sounds. For example, the use of general sounds, especially those that are not specific to an identifiable location or object, such as the exterior sounds of the country side, cityscapes, seascapes, traffic, various sporting fixtures etc., and general interiors such as concert hall applause, people in churches, restaurants, pubs etc. In certain circumstances where identifiable or local sound is required for a play then this will need to be specifically recorded. For example, the street sounds of Henry Street, Dublin, which would include the sounds of pedestrian hustle and bustle, but more importantly the defining sound would include the voices, accents and sale banter of the street sellers. The unique 'Dublin-accented' sound of the street sellers, therefore, becomes the identifiable sound of Henry Street.

Sounds in the second category—'live' or spot fx—could also be described as natural sounds but rather than functioning as a general background, they may be more specific and individual to the sounds a character makes in the play. These sound effects are usually created in real time by spot effects as the play is being recorded. There are a number of ways to create the sound of something or some object that the listener will aurally recognize as the sound resembling that object but the means of making the sound may bear no relationship to the object. These types of sounds may need to be contextualized by some degree of verbal prompting in the dialogue. This form of sound creation, anything from the clinking of glasses to walking through leaves, is common in radio drama and is most likely to be executed as spot effects in real time.

There are numerous stock-in-trade methods of creating spot effects, and whereas the final sound may be said aurally to signify the action or object intended, the means and materials of its creation may bear no relationship whatsoever to its form in

reality. This can not be seen as any form of deception but merely highlights the impact of sound as an assumed identity and as a focused identifier in the aural imaginative process. It also partly illustrates one of the physical processes of transcodification. This process of transcodification not only recodifies certain visual elements into sound representations, but also transforms unrelated materials into a cohesive and identifiable sonic object.

Examples of 'spot' sound fx creation.[4]

1. *Walking through undergrowth or jungle* – a bundle of recording tape rustled in the hands [or walked upon on the floor].

2. *Walking through snow* – a roll of cotton wool squeezed and twisted in the hands, or two blocks of salt rubbed together.

3. *Horses' hooves* – halved coconut shells are still the best from pawing the ground to a full gallop. They take practice though. A bunch of keys will produce the jingle of harness.

4. *Pouring a drink* - put a little water into the glass first so that the sound starts immediately the pouring begins.

5. *Opening champagne* - any good sound assistant ought to be able to make a convincing 'pop' with their mouth, otherwise blow a cork from a sawn-off bicycle pump. A little water poured on to Alka-Seltzer tablets or fruit salts close on-mic. should do the rest.

6. *A building on fire* – cellophane from a cigarette packet rustled on-mic. plus the breaking of small sticks.

7. *Marching troops* - a marching box is simply a cardboard box approximately 20 x 10 x 5cm, containing some small gravel. Held between the hands and shaken with precision, it can execute drill movements to order.

8. *Creaks* - rusty bolts, chains or other hardware are worth saving for the appropriate aural occasion. A little resin put on a cloth and pulled tightly along a piece of string fastened to a resonator is worth trying.

 * In the case of costume drama some silk or taffeta material rustled near the mic occasionally is a great help in suggesting movement.

These 'spot' effects are created by studio 'technicians' or members of the cast, depending upon the requirements of the production. I use the term technician to differentiate the work of a spot effects person from that of the vocal actor. As actors are primarily concerned with 'lifting-the-words-off-the-page' and physically moving around the acoustic set, it should also be noted that the actors are holding a script in their hands and performing to a microphone. The performance of radio drama is not memorized as it is in stage theatre, and no matter how much vocal preparation an actor does on a script before its production, the play is performed, or more precisely, vocally acted at the point of recording. The actors neither have their hands free nor the time to create their own or the play's spot effects. The work of the spot-effects person(s) is an integral part of any radio drama production where they are relied upon to create some or all of the contextual sounds necessary for the production. These include ordinary and simple sounds such as walking, footsteps, closing doors, jangling keys or money, stirring cups of tea, rattling cutlery, pouring drinks, 'slurping' or drinking liquids etc. The majority of the sounds that 'spot' makes could be described as 'quasi-naturalistic' sounds and are generally identified by the listener as contextual sounds 'made ·by or belonging to' a character. Spot effects should sound aurally convincing. In part this means creating the precise type of sound, for example, the clink of crystal glasses—high pitched, delicately thin, ringing type of glass sound—is a completely different sound to the clink of ordinary mass produced glasses; or the sound of a china cup being stirred is utterly different from that of an ordinary delf cup or mug. Care also needs to be taken with the placement of sounds within the aural perspective. Taylor cautions that 'great care must be taken with spot effects to ensure that they are in the same position and perspective as the associated voice.' [5]

This is a process of 'thinking-in-sound', which forms an important part of the transcodification system necessary for successful radio drama production. An extension of this form of sound creation leads to the third category of sound effects—the complex composed sounds. These types of sounds can be explored through the work of the BBC Radiophonic Workshop,

which specialized in the composition of sounds and music, perhaps more correctly termed, radiophonic sound.

Sound can also be symbolic in the sense that it does not represent the physical object that makes the sound but a disparate idea, thought or situation that is only vaguely associated with the sound. For example, whether in real life or in a radio play what possible aural images might be suggested or signified by hearing the distant sound of the slow ringing of a church bell?

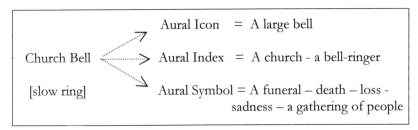

In radio drama as with life, any sound can act as a simple or complex signifier. Its function may be one of singular signification (iconic) or extended signification framed within the context of referential words (indexical or symbolic). The sonic significance of the church bell—beyond its simple identification as the sound of a church bell—is framed within the context of the words ascribed to it. In the following examples the same sound of the ringing bell can be ascribed completely different meanings depending upon the scripted context.

Ex 1 (Icon)	*Sfx.*	*Slow ring of church bell* (hold under)
Object - a church bell	Voice:	Shissh…listen! *(pause)* They're ringing the new bell. Doesn't it have a lovely sound!

Ex 2-a (Index)	*Sfx.*	*Slow ring of church bell* (hold under)
A place - the church	Voice 1:	Have you been inside the church before?
	Voice 2:	No *(pause)* but I'm told its quite amazing – an excellent example of Gothic architecture.

Ex 2-b (<u>Index</u>)	*Sfx.*	<u>*Slow ring of church bell*</u> (hold <u>under</u>)
A character - (the bell-ringer)	Voice:	Night after night I have to listen to him. I wish that new priest would find a different hobby and give up bell ringing.
Ex 3-a (<u>Symbol</u>)	*Sfx.*	<u>*Slow ring of church bell*</u> (hold <u>under</u>)
(Death – funeral)	Voice:	Poor Jack. He fought it to the very end.
Ex 3-b (<u>Symbol</u>)	*Sfx.*	<u>*Slow ring of church bell*</u> (hold <u>under</u>)
(Death – mystery)	Voice:	Not another one. That's the tenth in three months. They'll have to investigate that chemical plant now.
Ex 3-c (<u>Symbol</u>)	*Sfx.*	<u>*Speeded-up slow ring of church bell*</u> (hold <u>under</u>)
(Death – cautionary)	Voice:	You like the excitement, the thrill, the challenge, the buzz, the power, the on-the-edge-of-your-seat sensation of blood pulsating through your veins, that white knuckled grasp on reality!
	Sfx.	<u>*Vari-speed down to slow ring of church bell*</u> (hold under)
	Voice:	*(during vari-speed)* Slow down *[pause]*.... While you can still take a breath.
	Sfx.	<u>*Slow ring of church bell (hold under)*</u>
	Voice:	Speeding, can stop <u>you</u> breathing - permanently
	Sfx.	<u>*Fade up sfx and out*</u>

An example of the dual semiotic function of sound can be found in Tom Stoppard's radio play *If You're Glad I'll Be Frank*. The play creates a structural shift in the listener's perception of voice as sound. Here GLADYS's voice is both the human-mechanized non-emotional speaking clock, while at times the same mechanical voice transmogrifies into a human-like, emotional and thought-provoking being. In the play the central character GLADYS is ostensibly the speaking clock 'TIM' while at times she is also

GLADYS a disembodied voice who thinks deeply about life. As Stoppard states in the introduction to the play: *From her first words it is apparent that Gladys is the 'TIM' girl, and always has been...*Until the introduction of STD in Britain the Speaking Clock was reached by dialling TIM.[6] Stoppard divides GLADYS's two separate roles, GLADYS the speaking clock as an aural icon of that object and GLADYS the expressively thoughtful entity as an index of her personality. The play revolves around a number of other characters, notably FRANK, who thinks he recognizes the voice of TIM as that of his absent wife Gladys. This leads him to believe that the telephone corporation have imprisoned her and brainwashed her into being TIM. Stoppard requires that the play revolves around 'real' time in that TIM should deliver her time checks as near accurate as the elapsed 'real' time. For example, the number of seconds indicated should elapse before the next time check pips are sounded. GLADYS (TIM) also has control of the time frame as she is required to operate the time pips. In this way, Stoppard uses the passing of time as the main structuring agent.

In scene one, FRANK is heard dialling TIM. It is clear that neither FRANK nor GLADYS can actually speak to each other. TIM after all is the talking clock, an inanimate recorded voice continuously announcing the time but to FRANK it is the voice of his GLADYS that he hears at the end of the phone.

If You're Glad I'll Be Frank (Tom Stoppard) [7]

SCENE 1

FRANK, *who turns out to be a bus driver, is heard dialling 'TIM.'*

GLADYS: *(Through phone):* At the third stroke it will be eight fifty-nine precisely.

FRANK: *(amazed disbelief):* It can't be (PIP – PIP - PIP)

... At the third stroke it will be eight fifty-nine and ten seconds...

(Fearful hope): It's not...? (PIP - PIP - PIP)

	...At the third stroke it will be eight fifty nine and twenty seconds...
(Joy): It is!...*Gladys!* It's my Gladys!	(PIP - PIP - PIP)
(Fade.)	

In scene three, GLADYS, the TIM girl, continues the mechanically precise job of announcing the time, but the listener is now also introduced to GLADYS the thinking, soulful being behind the clock. This is a talking clock that thinks 'aloud' during the lapses between announcing the time. These longer sustained passages are forms of interior monologue which in vocal performance are intended to be more rhythmically poetic than ponderously psychological. Stoppard states in the introduction to the play:

> ...Some of GLADYS's sustained passages fall into something halfway between prose and verse, and I have gone some way to indicate the rhythms by line-endings, but of course the effect should not be declamatory...

> ...The right-hand column is for the Speaking Clock, and as such it is ostensibly continuous. But of course we hear her voice direct, not through a telephone unless otherwise indicated. The left-hand column is for her unspoken thoughts, and of course this one has the dominant value. It should be obvious in the script when her 'TIM' voice is needed in the background as counterpoint, and when it should be drowned altogether by the rising dominance of her thoughts.[8]

If You're Glad I'll Be Frank (Tom Stoppard)

SCENE 3

Follows straight on with the Time signal (PIP – PIP - PIP)

Heard direct, i.e. not through the phone, as is GLADYS *now.*

GLADYS:	...At the third stroke it will be nine two and fifty seconds...
	(PIP - PIP - PIP)

...At the third stroke it will be nine three precisely.

(PIP – PIP - PIP)

Or to put it another way,
three minutes past nine,
precisely, though which
nine in particular, I don't
say, so what's precise
about that?...

...nine three and ten seconds...

(PIP – PIP - PIP)

The point is beginning to be
 lost on me.
Or rather it is becoming a
 different point.
Or rather I am beginning to
 see through it.
Because they think that
 time is something they
 invented,
for their own convenience,
and divided up into ticks
 and tocks
and sixties and twelves
and twenty-fours...
so that they'd know when
 the Olympic record has
 been broken
and when to stop serving
 dinner in second class
 hotels,
when the season opens and
 when the betting closes,
when to retire... etc.[9]

Sounds can also be specifically composed to create the aural illusion of something which is ascribed a sound within a context. For example, the sound of an abstract object or event that the listener may not have previously imagined had an identifiable sound in itself, but within the play's context and with dramatic auto-suggestion the listener accepts the sound as being associated with the object. Categories into which these composed and

ascribed sounds fall include the worlds of science, medicine, disaster, horror, interior worlds, science-fiction etc. An example of this type of sound effect is taken from some of my own work in the field of illustrative composition.

In composing the sound track for the radio drama-documentary *Shame on the Titanic* (RTE 1), one of the sound effects I had to create was the imagined sound of the iceberg ripping asunder the side of the Titanic. This involved recording separate sound events, which were then multitracked, mixed and balanced for their overall effect as a new complete sound. I initially recorded 'real' and disparate sound sources and together with electronic sound and processing composed the completed abstract sound montage that, when transcodified and contextualized, became the aurally imaginative sound of the event. I used sound items such as slowly scraping my finger-nails down the bass strings of a piano, (used in normal mode but also reversed and slowed down). The resultant sound was a slow bass metallic rip, which created the sound of metal plates being slowly forced apart under intense pressure. Added to that was the sound of the iceberg, not the benign visible part above the water, but the dark invisible object lurking beneath the surface. This was represented as a synthesized slow pulsating bass tonal cluster representing the solid, jagged object floating in the dark icy cold North Atlantic sea. Combined with that was the sound of the icy sea gushing in and filling up the Titanic's hull. This was represented by the sound of water emptying from a bath, which was pitch-shifted downwards, and mixed with similar higher pitched sounds in reversed form. The sounds of synthesized white noise was also used as representing the moment of ripping apart and rupture to the water tight compartments. Amongst other sound elements and electronic processing (reverbs, delays etc.), this complex sound became the single sound of the Titanic ripping itself apart against the jagged edges of the almost immovable iceberg.

This process of sound creation is similar to that of music composition, whether the resultant sound is a simple sound effect, a complex sound montage or a musical event within the score.

15 | Music

Music simply defined is the 'art or science of arranging sounds in notes and rhythms to give a desired pattern or effect.' [1] It could be argued that the final part of this definition conveniently divides all music into two generalized categories, (i) 'pure music' as represented by the *desired pattern* and (ii) 'programme music' as represented by the *desired effect*. Maintaining this broad definition, music can therefore fluctuate between two categories of consciousness; (i) *'pure music'*, that is, music which is composed, arranged and played for its purely musical content and entertainment value (e.g. a Bach Prelude and Fugue, a Mozart String Quartet, a symphony by Brahms etc.); and (ii) *'programme music'*, music which is composed, arranged and played that contains some descriptive or illustrative purpose. This descriptive purpose may evoke real or imaginary psychological states of mind, visual enhancement or pictures in sound. Programme music however encompasses a diverse spectrum of categories e.g. film music, music for the theatre, advertising, all forms of dance music etc., where in these categories music plays a supporting role to a more prominent visual event. In the strictly 'classical' understanding of the term, that is, where music is composed/played alone for its musical content without external visual stimulus, for example, as a concert piece, then 'programme' music is understood to contain some internal imaginary concept programmed into it by its composer. Examples of this type of programme music include Vivaldi's *Four*

Seasons, Mussorgsky's *Pictures At An Exhibition*, Holst's *The Planets*
Smetana's *Ma Vlast*, Penderecki's *Threnody to the Victims of
Hiroshima*, etc.

The absolute boundaries between 'pure' and 'programme' music
can become somewhat blurred either because of the nature of
musical composition or the illustrative use the music is used for
after its composition as pure music. Both types of music have to
be composed, conceived, thought about and worked into a
finished piece by first developing an architectural framework (the
musical structure of the piece); and then applying the tools of
musical composition (the creation of melodies, rhythms,
harmonies, tempos, repetition, development, instrumentation,
dynamic structures etc.). Whether a composer is composing 'pure
music' or 'programme music' of whatever time length, the rules
applying to the craft of musical composition remain basically the
same.

The impact of sound on the human ear coupled with the
psychological power of suggestion is enormous. Schubert's *Trout
Quintet* for example is less about the plight of a female trout
battling its way up-stream against the prevailing flow of water
and more about a superbly refined sonata-form piano quintet, in
which only the fourth movement consists of variations on
Schubert's song, *The Trout*. Yet, the Quintet as a whole is
recognizably famous by the fourth movement with its ascending
triplet form melody played over a rippling arpeggiated
accompaniment. The impact of sound combined with suggestion
creates a strong mental picture or illusion of a trout battling its
way up-stream. Through the power of auto-suggestion (in this
case Schubert's song title, *The Trout*), those triplets and arpeggios
recognizably symbolize all trout battling their way up all streams,
yet, in reality the triplets and arpeggios coldly remain just figures
of musical syntax. 'Pure music', that is music with no authorial
suggestion of meaning can subsequently have suggestion applied
to it by a third party other than the composer thereby removing
it from its preserve of musical purity. For better or for worse this
creates a new and sometimes lasting artificial association with the
music. Common examples of this would include Bach's second
movement from the third orchestral suite in D, more famously

known as 'Air on a G string' and its now more common association with Hamlet cigars and restfulness. Or, his Toccata from the *Toccata and Fugue in D minor,* now more commonly associated with the 'Phantom of the Opera' and other horror and suspense genres. Examples of this form of transcodification of music abound in the film, television and advertising genres and to a lesser extent in the theatre and radio drama. Whether such transcodification in some way violates the original purity of the music is an interesting debate.

An in-depth exploration of musical structures and meaning is beyond the focus of this particular work. However, for illustrative purposes, I will use the general and simplified division of music into 'pure' and 'programme' as a starting point for an initial consideration of music as portraying meaning. In the widespread use of transcodified music a curious anomaly can be said to exist. I delineate three forms of 'programme music', (i) music which is specially composed for the programme content (that is, new or original music composed to illustrate a particular event, dramatic tension, mood, character etc); (ii) programme music which is further transcodified for a different illustrative purpose than its original concept. The omnipresent artistic danger in this is that the music, particularly if it is well known, has been associated with a different meaning entirely from that of its secondary programme use. This can have the detrimental effect of destroying the message the music was intended to illustrate and in Brechtian style lays bare the illusion of what is being attempted; (iii) The third form of programme music, that is, existing and well known 'programme' music, which is re-transcodified for a different programme compounds the dangers of the latter and can only amount to a form of artistic suicide for the production. Consideration of these issues will be undertaken in relation to the performance analysis of the four *King Lear* radio productions.

As mentioned earlier, radio drama is a composition in sound. The totality of the composition is the product of the effective and creative use of the sound elements available to it (words, voices, sound fx., pauses/silences, utterances, acoustic distances and music). All of these elements perform a variety of semiotic

functions within a production. Sound elements in a radio drama neither occur by coincidence or by random selection. They are specifically chosen, composed or created for the value of meaning they bring to the drama. Music, therefore, can be expected to play roles ranging from simple symbolic significance to those of complex extended signification. A major dialectical problem concerning music and one which is the focus of continuous investigation through diverse branches of science is whether music alone can impart meaning.

> Music resembles language in the sense that it is a temporal sequence of articulated sounds, which are more than just sounds. They say something, often something human. The better the music the more forcefully they say it. The succession of sounds is like logic: it can be right or wrong. But what has been said cannot be detached from the music. Music creates no semiotic system.[2]

Adorno's theoretical paradox is that music resembles a language as a 'temporal sequence of articulated sounds that say something', where language is understood to be 'voiced' meaning and where music is understood to consist of performed (played) sounds. That is, where language = a temporal sequence of articulated sounds which say something (sequential phonemes [making] words [making] sentences [making] meaning) whose structural syntax is semiotically linked to its shared use and understanding. Yet, according to Adorno, 'music creates no semiotic system', the paradox being that meaning can be construed where no semiotic structure of meaning exists. That is, where music has the ability to speak and impart meaning on one level it remains devoid of semiotic analysis of its meaning on the level of the actual thing itself, the piece of music, the interplay of the musical elements and structures. If this is the case, then any individual state of emotional response to music can only be by some vague or arbitrary association with the external or overall sound and not with the internal elements of the composition. This reduces the art of music composition, the carefully planned internal sequence of alternating pitches, melodies, rhythms, harmonies, instrumentation, dynamics etc., to an act of merely

assembling an arbitrarily 'temporal sequence of articulated sounds.'

Adorno's categorical assertion that 'music creates no semiotic system' may have been influenced by an older and narrower definition of music as 'the art of combining vocal and instrumental tones in a rhythmic form for the expression of emotion under the *laws of beauty*.' [3] Drawn from the theories of Aristotelian poetics, the act of composing or making music was relegated to the level of craftsmanship and as such is subservient to the higher goal of the imitation of beauty or perfection. 'In the arts I have spoken of, the imitation is produced by means of rhythm, language, and music, these being used separately or in combination.' [4]

The concept that 'music is the imitation of natural beauty' as the eighteenth-century theorist Charles Batteux expressed it, considered any form of dissonance, erratic interval leaps, and contrapuntal rhythms as an anathema to beauty. How could the tragic dissonant and strident poignancy of Penderecki's *Threnody to the Victims of Hiroshima*, or the violent rhythmic and harmonic birth of Spring in Stravinsky's *Rite of Spring* be described if one held with the eighteenth-century definition of music as the imitation of natural 'beauty'? Centuries before, Vivaldi's *Four Seasons* pushed the Baroque concept of harmonic 'beauty' towards dissonant acceptance. This is particularly so in the *Allegro non molto* movement of Winter, where its pulsating repetitive crotchet rhythm and its stark harmonic structure create a chilly sense of dissonant bleakness. A dominant bass note *(F)* is repeatedly played, over which a disparate triad of notes *(G, Db, Bb)* slowly build to form an E diminished chord *(the F bass note resolves to E)*. The E diminished chord creates the sound of anticipation and tension which is subsequently resolved by moving to F minor—the subdominant in the movement's key of C minor. Beauty may be said to be in the eye of the beholder, in these instances the stark dissonance in the harmonic and rhythmic structures of the music were a deliberate attempt to depict aurally the starkness of winter through the ears of its composer.

Echoing W. B. Yeats's phrase 'a terrible beauty is born', music has always had the ability to summon up the images of beauty and horror in their many guises. Through music the listener is sometimes sonically thrown into a world of raw emotion which is at times uncertain, confrontational, unsettling and decidedly uncomfortable. A lexicon of musical meaning does exist but not in the formal sense of a structured grammar of musical composition. Its existence is now thought to form part of the innate human response to the elements of sound and by extension to music as a combined and heightened process of sound communication.

Music can emotionally affect the listener in two ways, objectively as the piece of music and subjectively as our individual responses to its sounds. Hegel's theory that 'audible things are sensed not as things out there, but rather as events surrounding us and invading us, instead of keeping their distance from us' [5], expands the concept of objectivity and subjectivity. When sound is heard it is objective in the sense that an individual who hears a sound may not be the person or 'thing' responsible for making the sound. Further, we have little or no control over whether we want to hear sound or not. It is accepted that sound heard is post-impulse sound, that is, any sound that is heard has already existed, perhaps only a fraction of a second earlier, before it is heard. The human auditory system has no natural mechanism to block out sound once sound vibrations are received by the ears, whereas closing one's eyes can block out sight, refusing to physically touch something can block the sense of touch and even holding one's breath can block out smell. There is no similar natural mechanism to control or block-out sound short of clinical 'deafness.' Hearing sound in the objective sense (that is, sounds out there) is also hearing sound subjectively, for once sound is heard it has entered into our consciousness through the auditory mechanism, deciphered by the brain and pictured by the imagination. Certain sounds in life will immediately and innately elicit different emotional responses in humans, for example, hearing a baby cry may produce a concerned protective response, whereas hearing unexpected or unidentified footsteps behind one in the dark will most likely produce a sense of fear and

apprehension. Both examples are obviously dependent upon the context of their hearing which helps to explain why sounds heard are owned individually by each listener and where the perception of what those sounds mean is an individual imaginative function.

Dahlhaus states that 'tones, understood as stimuli in a physiological-psychological sense, release reflexes; they stimulate feelings that a listener does not objectify but rather feels immediately as his own, as invasions of his heart.' [6] Where music is concerned, therefore, the listener who is exposed to music externally has little option but to internalize it where it becomes 'owned' in a subjective process of realization, rather than beholding it from an aesthetic distance. This may possibly explain why some types of music, sounds, and voices instantly 'grate-on-the-nerves' while others produce intrinsic feelings of calmness, euphoria, and belonging.

As early as the seventh century the philosopher, Isidor of Seville proclaimed that 'music moves affections and calls forth feelings into a different disposition.' [7] The German musicologist Kurt Huber considered the perceptual response to particular events in a piece of music:

> Involuntarily, listeners attribute an impression of something serious, sad, or dull to the tonal structure itself as one of its characteristics. In unprejudiced perception, a melodic motive does not express dullness and transport one into a dull mood, but rather it seems dull in itself. Only later, if at all, will anyone experience the objective emotional impression as a mere condition or interpret the impression as a sign. [8]

Huber's argument claims that musical listening is in the first instance that of experiencing emotional traits objectively, as properties of the music itself, and only as a secondary consequence transferring those properties into, and influencing, the listener's own mood. His rationale is that in order to recognize the affective meanings in a piece of music, one need not, oneself, be affected or stirred.

Music is a structured language and like its closest relative, verbal language (speech), its structures and vocabulary have developed

through its usage across time and cultural divergence. Whether music just as speech (words, sentence structure and syntax) is an acquired language or something that is instinctively primal is currently the focus of scientific research. Current thoughts on the subject would now tend to agree that 'music' and in particular, early vocalizations in infants, combining the use of alternating dynamics in rhythmic and melodic patterns, may form the basis for what is being considered as a primal structure of language communications in sound. Both music and speech require realization through sound. Indeed I would argue that their presence and 'real' meaning only exists in their sounded forms where elements of extended signification infuse them with 'human' meaning as distinct from 'representational' meaning. However, it can also be argued that, as 'representational' meaning, both music and speech exist as an acquired language in their written forms. The system and need for musical notation was historically a much later phenomenon than that of writing down language. In their written forms both systems also impart meaning to the reader through silent reading. In music's written form, which is an acquired language of representation, the perception of meaning in the notation is obviously lost to a reader without the musical literacy skills to decipher the notation. The same premise holds true for the reader of literature who does not possess the necessary literary and linguistic skills required for a particular language in its written form. Dahlhaus asserts that there is a distinct difference between the two written forms, as written speech represents speech to a greater extent than notated music represents music.

> To grasp the meaning of a literary work, a reader need
> not bring to mind the phonetic form of the words, nor
> even know that form ... Musical meaning, in contrast to
> linguistic meaning, is only to a slight extent, if at all,
> detachable from the sounding phenomena.[9]

If one accepts the probability that music has the capability of communicating with us where 'we' the listeners can deduce or interpret 'meaning' from it—particularly so if 'what has been said cannot be detached from the music'—then music does not merely resemble a language. It becomes a language. Just as with

other forms of communication languages e.g. the language of colour, the language of gesture, non-verbal language, sign-language etc., meaning is encoded and communicated by the sender(s) and decoded and interpreted by the receiver(s) through a recognized and shared syntax of semiotic codes. Although music has been described with monotonous regularity as a language of the emotions, it is undeniable that it can in certain contexts convey a greater sense of imaginative and emotional clarity than literary, verbal or visual languages. But has music the ability to speak to us on its own purely through its tones? Or does it require some form of auto-suggestion e.g. the title of a piece or the illustrative purpose of the piece? The search for meaning in music is certainly not a new phenomenon. According to Nicola Vicentino (1555) and Gioseffo Zarlino (1558) 'the movements of the animal spirits are the reason for the effects of musical intervals, major stretched intervals of the second, third, sixth attune to joy, while minor contracted intervals on the contrary attune to sadness.' [10] Such delineation of musical events into linguistic or descriptive equivalents is an example of 'suggestive' or conjectural meaning, but it is not scientific. One thing is certain and, to express it in Adorno's words, music can say something, often something human, but why and how we come to understand music's message remains for the time being a mystery. Perhaps in the future the results of scientific research into the area of human sound perception will provide some of the answers.

Crisell states that 'music on the radio, as on television, seems to perform two main functions. It is an object of aesthetic pleasure in its own right, in record shows, concerts, recitals and so on; and either by itself or in combination with words and/or sounds it performs an ancillary function in signifying something outside itself.' [11] There is no doubting that music is a most powerful carrier of messages—as pure sound, absent of any verbal language. It is directed straight to the seat of human consciousness. When contextualized, that is, placed within a dramatic scenario—particularly so in radio drama and film but also to a lesser extent in the theatre—the appropriate music, whether it is specially composed or pre-existing, can concentrate

and pressurize the audience's emotional response to a particular message. McWhinnie asserts that 'in all dramatic media its prime use is to heighten or resolve the immediate tension, by underlining, by contrast, or by completing a cadence.' [12] But if the music is not appropriate to the 'action', then the magic of the illusion becomes transparently false and the emotional message of the scenario, far from being increased, is utterly destroyed. The correct music is a translucent illuminator to the scenario, the wrong music draws a thick fog of confusion, sometimes, even farcical alienation.

Elwyn Evans (Former Head of the Radio Training Section, BBC.) defines two types of music in relation to radio drama and documentary making:

> (1) *Objective Music*—the kind of music that goes into a documentary because it's the kind of music being reported on, or in a play because it is an integral part of the scene (as when characters are talking in a discotheque). (2) *Subjective Music*—(background music, incidental music, mood music) is used to create or heighten an atmosphere. Subjective music can give a tremendous lift to a production; increase the emotional charge. It can suggest a period or a place. It can offer oblique and witty comment on a scene. Or, in the old-fashioned way, it can provide inter-scene punctuation or modulation—the so-called music link. [13]

Evans's division of music into two constituent groups, objective music and subjective music, I believe over-simplifies the roles played by music in radio drama. Erving Goffman expands the roles, believing that 'syntactically there are at least three radically different kinds of music in radio drama.' [14] (1) Background music—the music of everyday life or 'muzak' as he prefers to call it. (2) The musical bridge—music used as part of the radio drama frame which serves as a bridge, a signal that the scene is changing. Goffman considers this type of music as being to radio drama in part what the curtain drops are to staged drama. (3) Foretelling or mood music—music that serves to foretell then mark the dramatic action, a sort of aural version of subtitles. In a

footnote Goffman acknowledges a fourth type of music belonging to a different dramatic genre—the musical.

> The form of scripted drama called a musical provides a fourth role for music. A character may not only enact a performance of a song or music (this having the same realm status as background music, merely a more prominent place), but may also 'break-into' musical expression as though this could be interposed in the flow of action without requiring a formal shift into the performer role … Here, then, is the Nelson Eddy syndrome.[15]

Other writers on radio since Goffman have basically adopted his categorizations for music. For example McLeish also defines three similar types of music. (1) As a 'leitmotif' to create an overall style. Opening and closing music plus its use within the play as links between some of the scenes (Goffman's 'bridge' music). (2) Music simply chosen to create mood and establish the atmosphere of a scene (Goffman's 'foretelling' music). (3) Reiterative or relentless music can be used to mark the passage of time.[16] (Goffman's everyday 'muzak').

Crisell, in examining radio signs and codes extends the categorizations of music a further step. His first three categories are similar to those identified by Goffman; (1) 'framing' or 'boundary' mechanism; (2) music as a link; and (3) 'mood' music. Crisell also introduces two new categories: (4) music as a stylized sound effect, and (5) music as an indexical function. He states that (4) music as a stylized sound effect 'is part of the stock-in-trade of radio drama, where it is used to simulate sounds that occur in the real world—storms or battles, for instance.' [17] Such music he believes has an imitative function and therefore becomes a type of iconic index. He considers (5) music as an indexical function 'as part of the ordinary sounds of the world which radio portrays. These sounds are usually known collectively as 'actuality'. [18] Crisell gives an example from the world of reality radio where music plays an actuality role in a probable news item.

Sfx:	*FADE IN SOUND OF BAGPIPES AND DRUMS*
Presenter:	The Band of the Argyll and Sutherland Highlanders, who today were granted the freedom of Aldershot.[19]

He states that the semiotic function of the music would be the same whether it were 'live' actuality from the Freedom Ceremony, or a recording of the actuality, or simply the sound taken from a gramophone record which leads Crisell to assume that radio producers often 'cheat.' [20] He states that in the first instance—'live' reporting/actuality—the music would be considered as indexical, (that is, the musicians + its sounds = the band's physical presence). In the other two instances—a recording of the actuality or a commercial record/CD—he claims that the recordings represent icons of the sounds the band made and where those iconic sounds subsequently represent an index of the band's presence at the event. Crisell refers to the later two instances as iconic indexes. However, I have reservations concerning his classification of the third instance (a record/CD) as an iconic index. This may certainly be true if the recording is that of the current members of the band but if the band membership had changed since the recording (e.g. retired, deceased members etc.), it would be more correct to classify it as a symbolic icon.

The writer Edgar E. Wallis lists six ways in which music can be meaningfully used in radio and television.[21]

1. As a signature or theme for a drama series or for a particular drama in a series *[this could be interpreted as either an outer frame marking or as a musical identification of the thematic content.]*

2. As a transition between scenes, acting as a curtain for the scene that is ending and as an introduction to the scene that is about to begin.

3. As a background to a scene or to a sequence of narration.

4. As part of the action itself, an example being the orchestra music in a night club setting.

5. As a 'stab' or 'sting' *[a very short interval of music e.g. 2 to 6 seconds]* to point up critical stages in the dramatic development.

6. As a symbolic effect to suggest such ideas as a soft, spring day or the churning of angry emotions.

The role of music in a radio drama can be complex and should not be heard as objective unconnected sounds or incidental scene fillers to the drama proper. Music can have as real a function as sound fx. that is, in the way that sound fx. (footsteps, banging doors etc.) are not objective, unconnected or random sounds but are very much part of the dramatic fabric of the play. Music, as part of the dramatic action in a radio play should never be a form of decorative 'wallpaper' or merely a time filler.

Music at its simplest may perform a structural role in the overall framing mechanism of the play where it could be used for scene breakers and as a pointer to new actions or events. For example, a sudden illogical shift of key at the end of a phrase could denote a change of scene or direction. Upward modulation could mean that a new dramatic tension will be introduced, downward modulation can bring the storyline back to a previously unresolved tension; and placing dissonant notes in the melody can denote an altered state or dysfunctional tension. Music's complexity grows when it is used as a descriptive means for character(s), object(s) or events. In these roles the actual structure of the music, its notes, harmonies, instruments, tempos etc., hold the keys to its extended semiotic meaning(s). The fact that music is used is an acknowledgement of its presence as sound, but its greater importance lies within the structure of the music and its connectivity to the structure of the drama through its storylines and characterization.

Aaron Copland's comments on the effects of music in film originally printed in *The New York Times*, November 6, 1949 and quoted by Roy Prendergast[22], further underlines the important meaning-laden value music can bring to dramatic situations.

However, further research needs to be done on the semiotic functions of the structure of music itself:

> Music can create a more convincing atmosphere of time and place. [23]

This alludes to musical colour. In a broad sense, musical colour may be taken to represent the exotic or sensuous aspects of music, as distinct from the musical structure, or line, which might be considered the intellectual side.

> Music can be used to underline or create psychological refinements—the unspoken thoughts of a character or the unseen implications of a situation.[24]

Music can frequently imply a psychological element far better than dialogue can. Copland observed that music can play upon the emotions of the spectator, sometimes counterpointing the thing seen with an aural image that implies the contrary of the thing seen.

Copland also recognized the use of music as a 'neutral' background filler and to provide the underpinning for the theatrical build-up of a scene and then round it off with a sense of finality. Composer Leonard Rosenman also recognized the intrinsic psychological value of music within a film:

> Film music has the power to change naturalism into reality. Actually, the musical contribution to the film should be ideally to create a 'supra-reality', a condition wherein the elements of literary naturalism are perceptually altered ... Film music must thus enter directly into the 'plot' of the film, adding a third dimension to the images and words. [25]

Although related to film music, the arguments of Copland and Rosenman attest to the power of music in the field of dramatic representation. The over-riding caveat would appear to be that if music is to be used, either specially composed or chosen from pre-existing recordings, then the music should have an integral and functional role to play in support of the dramatic action or dialogue. It would be an artistic anathema to use music simply as an aural 'space filler' or because the music 'sounds nice.'

McWhinnie also derived the same conclusion in relation to radio drama where in some instances music is used not simply as a primitive adjunct to the text but as an integral component. It is not a substitute for speech, but a co-equal. In believing that words must always be predominant in radio and music subservient, he recognized that the music/speech complex should always be conceived as a unity, if it is to appear inevitable.

> It is only too easy to dress up a text with musical decoration, without any artistic justification whatsoever; music as a genuine ingredient in radio communication is always demanded, not simply allowed.[26]

Reiterating, therefore, that radio drama is a sound only medium: music, sounds, silences and words carry the extra burden of 'meaningful betrayal' which may not be as critical in other dramatic genres. All sounds in a radio drama coalesce to form the structural syntax which when produced and heard form the analytical basis for radio drama as an aural literature.

Evans's categorization of music in radio drama as being either 'subjective' or 'objective' is too broad to be meaningful. Goffman's categorization of music into 'background', 'musical bridging' and 'foretelling' is too narrowly defined and prescriptive. Crisell on the other hand had begun to open out the possible roles that music can play.

In writing/recording the musical score for the RTE radio drama-documentary *'Shame On The Titanic'*, the challenge presented to me was to compose sounds and music which illustrated the great ship's ill-fated maiden voyage. The documentary about the infamous voyage and subsequent trial of its owner, Bruce Ismay, told the poignant tale of human error and intransigence that ultimately led to the human catastrophe. Howard Kinley reviewing the programme in the *Irish Times* wrote that the music, 'composed by Dermot Rattigan, expressed more than anything else, the awful mood of haunted gloom that lay about the man and his ill-fated ship.' [27] (The word music in this context also incorporates its broader definition encompassing 'radiophonic sound'). The music score was an element in the overall production and as such was surrounded by the context of words

and verbal language. Whether the music alone without the accompanying script would express that exact same awful mood of haunted gloom is debatable. Parts of the music certainly sounded awesome in the positive sense; however, I believe it required the context set by the dialogue and the dramatic action for its appropriate meaning to be realized. The music in this production was playing a supportive role to the dramatic dialogue, not as a substitute but as a co-equal. What this example illustrates is the potential power of music particularly within radio drama or drama-documentaries that can evoke an internal emotional response far sharper than words alone.

Whatever about Crisell's assertion that music is an object of aesthetic pleasure in its own right, I have certain reservations about his assertion that it merely performs an ancillary function to words. I favour McWhinnie's belief that, depending upon the context of the drama and specifically in what context a piece of music is chosen to be used (specifically composed or pre-existing), the sense of being 'outside itself' should be understood as a powerful adjunct to words. Not as a replacement for words or as an abstract ancillary function to words but as a co-equal in the creation of meaning. The astute use of music as a signifying element should be aimed directly at the 'inside' of the listener's consciousness.

> Indeed, unless the musical score has its own shape, corresponding to the poetic or dramatic shape of the text, it will positively get in the way of the artistic illusion; it, too, must have diversity in unity, it must march hand in hand with the words.[28]

Music can perform other functions in radio drama than being merely a structural framing device. Beckett used music as an explicit character in *Words and Music* and *Cascando,* but it can also have a more subtle use in depicting various levels of intended meaning, that is, where it is not elevated in the Beckett sense but is enmeshed within the dramatic structure of the play. In such instance I refer to music specifically chosen for the degree to which it is intended to signify dramatic meaning as itself.

While not all radio drama requires the use of music in any form, either externally as a framing device or internally as a dramatic device, the following diagram illustrates some of the simple and extended functions music can perform in radio drama.

MUSICAL CONTEXT

Within a play, a scene, individual characterization.

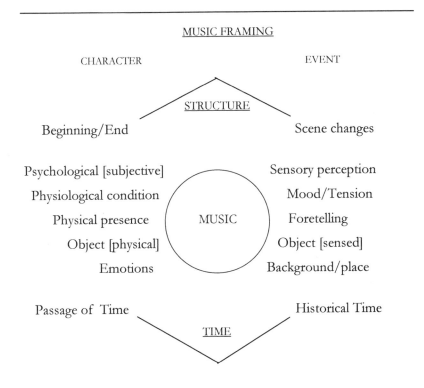

MUSIC FRAMING

CHARACTER EVENT

STRUCTURE

Beginning/End Scene changes

Psychological [subjective] Sensory perception

Physiological condition Mood/Tension

Physical presence MUSIC Foretelling

Object [physical] Object [sensed]

Emotions Background/place

Passage of Time Historical Time

TIME

16 | Technical

General acoustics - Distances - Movement/Perspectives - Fades

Once a text/script has been accepted for production (either specifically written for radio or adapted from another source) then a number of technical and performance aspects need to be considered during the pre-production, production and post-production phases of a radio drama. Some are specifically in the area of sound engineering e.g. settings for the equipment to be used (levels, balance, frequency equalization, choice and placement of microphones, external sound processing, creation and management of the acoustic spaces etc.). Many of these aspects of sound engineering and recording are quite specific and constitute a technical study in their own right. For example, the effectiveness of a particular microphone such as its electronic design, frequency response(s), polar pick-up pattern(s), sound pressure levels, sensitivity in both close and variable-distance microphone use etc., would need to be considered. These electronic performance criteria involve a different level of technical consideration that is considered unnecessary for an exploration of the more general technical and operational aspects of a radio drama production.

Other aspects of the production process are performance related e.g. choice of voices, vocal deliveries, distances, blocking, co-ordination of sound and spot fx. etc. I have already delineated and considered in isolation certain performance aspects in the

previous sections. In this section, I will draw together some of the general technical and performance elements that are both interactive and interdependent parts of the production process. This fluctuating combination of production and performance elements forms the completed sound the listener hears as the radio play. They also form the basis for the third section of this work, the performance analysis as a working example from an extract of four radio productions of *King Lear*.

My consideration of what I term the general technical aspects of a production involves a considerable overlap between what has been delineated as purely performance elements and those involving the use of electronic and acoustic devices. Good radio drama is only possible when the actors are confidently aware of both the technical elements and the studio techniques of radio drama production. This awareness is as critical to the actor's performance as that of the vocal performance of the text. The methods and mechanics of production should be as 'visible' to the actors in terms of the overall radio drama process as those of sets, props, costumes, lighting and make-up are to the stage performance. A sound working knowledge of radio drama production techniques is, I believe, a prerequisite for the actor's preparation of both characterization and vocal deliveries. It should also be understood that these performance elements are intrinsically linked to all technical aspects. For example, acoustic distances (as, static distance) can only be realized by the listener if voices are heard speaking at different distances from a microphone's pick-up range. Vocal or spatial movement (as, variable distance) will only be realized if a voice is heard speaking *while* moving away from/or into a microphone's pick-up range.

Radio drama is the only form of radio broadcasting that makes use of a pseudo three-dimensional sound concept as an intrinsic part of its production process. This spatial sound dimension is constructed primarily by using acoustic distancing to create the desired aural effect. Indeed spatial sound drama could also be said to invoke the use of a fourth dimension in the way the production is listened to, analysed, and internalized upon its reception by the listener. The variables of the restructured drama in the fourth dimension would appear to be incalculable, the

fourth dimension itself being as infinitely variable and as numerous as the imaginations of its listeners.

General acoustics

The study of acoustics is the study of the science of sound, its properties, emission, transmission and reception. 'Acoustic(-ical)' as an adjective is simply defined as 'pertaining to the ear, constituting part of the physical apparatus for hearing, sound or acoustics.' [1] Acoustics as a noun is defined as the science of sound and its phenomena, and the phenomena of hearing, where the plural noun is defined as the 'properties of a room or building that determine sound quality.' [2] All strands of the definition are correct if initially they appear somewhat confusing. Acoustics in the scientific world is the mathematical measurement of the properties of sound. Acoustics in general human perception is also like a type of measurement (sounds that are loud or quiet—high pitched or low pitched—quick or slow—close or far etc.); a measurement of sound 'heard' by an individual and which can possibly be identified.

Acoustics in a very general sense could be described as a sound which we can hear and identify as being something, someone or someplace. Radio drama as opposed to most other forms of radio broadcasting (with the exception of certain types of documentaries, 'on-the-scene' reporting, 'live' or recorded OB [outside broadcast] of music concerts and sporting events) consistently makes use to a greater or lesser extent of a real and contextualized soundscape. These broadcasting categories make effective use of 'actuality' sound (also referred to as 'atmos' [atmosphere] or 'wild-track'), the extraneous sound of the event, environment or place in which the broadcast or recording was made. For example, a report from the scene of an accident where the sounds of people, ambulance sirens, emergency service traffic etc., form a sound backdrop that is naturally connected to the report and in most instances intensifies the gravity of the verbal report. In a similar way, hearing the sounds made by either a 'live' audience at a concert event (applause, movement, coughing etc.) or the sounds made by spectators at a sporting event (cheers, roars, applause etc.) provide important aural elements of immediacy, 'liveness', reaction, and a 'believable' reality to the

broadcast. These extraneous sounds on a simple level add atmosphere but more importantly they may psychologically represent a form of extended significance by contributing important extra contextual information. For example, the sounds of weak or reluctant applause following an item from a 'live' concert broadcast may indicate to a listener that either the music was not well appreciated by the audience or that the concert was not well attended. It is also the case that when extraneous sounds are heard out of context or unexpected, such as, disturbances during the 'live' broadcast of a speech, the listener may be left temporarily confused e.g. [WHAT is happening?]—[WHY is it happening?]—[WHERE is it happening?]—[WHO is involved?] etc.

Whereas the extraneous/actuality sounds in a news report are real in that they belong within the context of the report, similar sounds in a radio drama are fabricated and are therefore false in a 'real' sense but 'real' within the fabric of the drama. (I refer back to Orson Welles and the 1938 broadcast of *The War of the Worlds*). Playing against or perhaps more correctly playing in a sonically constructed sound space contextualizes most verbal dramas. Whole plays, scenes and sections of scenes can be placed in dramatically 'real', fantasy or imaginary sound spaces. Some sound spaces are pre-recorded and played from a CD or tape, for example, exterior scenes such as the seaside, countryside, busy streets etc., while others of a more interior nature may be created in the studio by spot effects and/or pre-recorded sounds.

At this point it should be noted that the radio drama studio is a 'controlled' acoustic environment. It is controlled in the sense that the acoustic environment can be altered and new acoustic settings created depending upon the requirements of the play such as an interior scene in a reverberant kitchen or bathroom to a non-reverberant scene in a bedroom or the 'boxy' interior of a car. Most radio drama studios are constructed to provide for smaller dedicated 'fixed' acoustic areas and frequency responses. The illustration [*Example of microphone positions* - page 206] is one such studio. This studio has three recording areas two smaller dedicated or fixed areas and the larger main studio. The whole complex is a self-contained drama unit with access to each of the studio areas.

The 'live' room sounds like a reverberant kitchen or bathroom and is used for recording scenes that require a livelier acoustic sound. This acoustic is achieved by designing a room with reflective surfaces (tiled walls, solid floor etc.,) and containing no sound absorption material (drapes, curtains, soft furnishings etc.,). The 'dead' room is, in fact, the exact acoustic opposite of the 'live' room. The 'dead' room is constructed to give the highest possible level of sound absorption with no reverberation or sound reflection characteristics. Although not scientifically an anechoic chamber, the 'dead' room would sound more akin to speaking under a well-padded duvet. As its name suggests, the purpose of the 'dead' room is to absorb or kill any reflected sounds. The main studio is the largest recording area, which should be large enough in height and depth to allow for distance perspective recording. It should also be large enough to incorporate at least one reasonable length flight of steps, preferably two, one constructed in concrete and one in wood— for the sound of ascending/descending footsteps—plus a myriad of sound fx props and a cast of actors. The general acoustic in the main studio is similar to that of a carpeted living room with curtains and soft furnishings. With the use of extra sound absorption or reflection panels and possible cyclorama curtains the overall acoustics in the main studio, or specific areas in the studio, can be altered to suit the acoustic requirements of the recording. The control room, which contains the mixing desk, recording and technical equipment, is totally separate and sound isolated for the studio areas. There is visual contact between the production team in the control room and the actors in the studio through a large soundproofed window and voice contact is maintained through a talk-back system.

McLeish classifies four basic acoustic settings, which are appropriate for most general types of scenes, comprising combinations of the quality and duration of the reflected sound. Other particular types of scenes may require a specifically tailored type of acoustic.

McLeish: acoustic settings[3]

REVERBERATION	SCENE	CONSTRUCTION
(1) No reverberation	*Outdoor*	Created by fully absorbent 'dead' studio
(2) Little reverberation but long reverberation time	*Library or well furnished room*	Bright acoustic or a little reverberation added to normal studio
(3) Much reverberation but short reverberation time	*Telephone box, bathroom*	Small enclosed space of reflective surfaces – 'boxy acoustic'
(4) Much reverberation and long reverberation time	*Cave, concert hall 'Royal Palace'*	Artificial echo added to normal studio output

Electronic processing may sometimes replace or be added to enhance natural acoustic settings. Equalization is a fundamental piece of processing which is designed to manipulate the frequency spectrum of sounds passed through the equalizer. This has the effect of giving prominence to selected frequencies or frequency bands and reducing the amplitude or prominence of others. As the audio spectrum is related to the range of human hearing at best 20hz to 20Khz, any change in the frequency spectrum should be aurally detected. An example of dramatic equalization (also referred to as eq) is simulating the sound of a voice on the telephone where all frequencies below 800hz are reduced while frequencies in the 1 Khz to 1.5 Khz range are considerably increased. This equates to the rather poor quality of the telephone's electronics and the land line in use where the natural bass presence in voice, primarily generated by the body's resonating chambers, is lost. The resulting sound is more distant and harmonically thinner because of the dominance of higher frequencies and the lack of bass frequencies.

Time-delay-effects are perhaps the most commonly used pieces of electronic processing in radio drama. Time-delay-effects range from a definite echo, that is, a repeat of the sound being

processed to various types of reverberation. Numerous types of delay or echo can be easily created from a single repeat to multiple repeats. Two important factors which influence the quality and type of repeat(s) are (i) the delayed time of the first repeat called <u>attack</u> time (e.g. a half second delay, or otherwise, between the direct signal and its repeated signal; and (ii) the <u>decay</u> time of the repeat which governs the number of repeats generated. Generally a quick decay time is used for a single repeat and longer decay times for multiple repeats.

[Delay Time e.g. 0.5 sec]

DIRECT SIGNAL	REPEATED SIGNAL
VOICE: Hello	Hello *[single repeat with a very short decay time]*
Or	*[Multiple repeats by increasing the decay time]*
VOICE: Hello	Hello Hello Hello Hello Hello etc. etc.

The most commonly used and abused time delay is reverb. There are different types, qualities, and sizes of reverb ranging from simulating the acoustics in a large cathedral to a roadside phone-box. Reverb is similar to the repeat but with the important difference that it is not just one repeat but thousands of repeats piled on top of each other and measured in milli-seconds. Choosing the appropriate attack and decay times (early and multiple reflections) is critically important to the effective setting of a reverb unit. Reverb, though, is not especially kind to the spoken voice where both the overuse of reverb (euphemistically referred to as the voice 'swimming-in-reverb') and the inappropriate type of reverb adversely colouring the vocal frequencies (too rich or too thin) can be heard in some radio drama productions.

Distances – Movements - Perspectives

Distance is created by different degrees of a voice's proximity to or from a microphone. An appropriate analogy to understanding aural distancing can be explained using the example of a still camera or video camera with a zoom facility. At its furthest level away from the zoom (minus zoom), the camera will show a picture in a panoramic view, that is, a wide picture where individual details or specific objects are distant to the eye but correctly in proportion with the overall picture. With the use of various levels of zoom, certain objects in the picture can be brought closer to the eye (in technical terms brought into focus), where at maximum zoom (plus zoom) individual objects may be viewed in detail, but in distance terms they would be out of proportion and perspective within the overall picture. Similar aural events occur when using acoustic distances and microphones. It is often stated that the microphone represents the point of the listener's ear. Therefore the actor's voice (including spot fx. etc.) can be placed either closer to or further away from the listener depending upon the actor's distance from the microphone and the particular dramatic context.

There are five basic microphone positions that allow for an infinite number of aural distancing combinations. These are illustrated in the diagram on page 207.

Position 1: Closest to the microphone
[distance from mic. e.g. 2 to 3 inches]

Position 1 is used for interiorizing, intimate dialogue, asides and whispered thoughts—this may require 'working across' the microphone rather than directly to the microphone. Working across the microphone can greatly minimize 'popping', 'blasting' and 'sibilance' problems. Music presenters and particularly commercial radio DJs often move forward into position 1 as Beck suggests 'to give a sexier impression of themselves. It is one of their tricks of the trade, because it brings out the lower, more masculine tones, through bass tip-up.[4]

Position 2: The mouth max half an arm's length away
[distance from mic. e.g. 6 to 10 inches]

Position 2 is used for close and intimate dialogue, conspiracy, secrets, narrator's and storyteller's position. Position 2 is also the accepted position for all general presentation work on radio e.g. news reading, magazine presentation, voice-overs etc.

Position 3: The mouth about an arm's length away
[distance from mic. e.g. 1½ – 3 feet]

Position 3 is used for normal conversation between characters. This position places the characters' voices in a natural perspective within the aural setting of the scene, e.g. a living-room, an office, a prison cell etc.

Position 4: Moves-off (or -on) and halfway across the 'room' (studio)
[distance from mic. e.g. 5 to 10 feet]

Position 4 is placed up to halfway across the studio from the microphone and is used to create greater spatial distances between characters. Beck adds that actors are often 'placed in position 4 to open out the picture a bit more and it could be that the action is set in a larger space, such as a factory or hospital ward.' [5] Positions 4 and 5 (as representing off/far and distant), take on a heightened relative significance particularly when heard against other voices at closer positions (e.g. 1 or 2). Positions 1 and 2 establish one end of the aural perspective (very close and close) by which the other end of the aural perspective (off/far and distant) can be realized spatially, for example:

MIC-LISTENER | 1 2 3 4 5
 | <---------------------------------->
 v.close close near off/far distant

The aural combination of character's voices at close and distant microphone positions creates an interesting and natural spatial perspective and gives a sense of aural depth and space to the scene setting.

Position 5: Moves-off (moves-on) but further away e.g. at the 'door' of the room, for voices outside the room and greater distances in an exterior setting (e.g. the other side of a street or garden)
[distance from mic. e.g. 15 feet +]

Position 5 gathers together all of the 'moves-off, including exiting away from a scene, entering a scene from a distance, going behind a screen, going up the stairs and into the corners of a studio. Positions 4 and 5 are also used for static distances, which do not involve aural movement. There are two ways of achieving this either through movement (moving-off or -on the microphone) and static distance. In the first instance the actor is heard speaking the text while physically moving from one microphone position to another (e.g. mic. position 3 to 4 to 5 or visa versa). Hearing the voice either moving away from or towards the microphone clearly creates a sense of aural distancing and movement. Static distances where no movement is involved and combined with closer microphone positions by other characters creates a sense of spaciousness and distance. Beck adds that the biggest technical demands made upon an actor using positions 4 and 5 are 'adjusting the level or volume of your voice as you move away and shift the relations of your head, and the line of your voice, to the microphone.' [6]

Example of mic. positions:

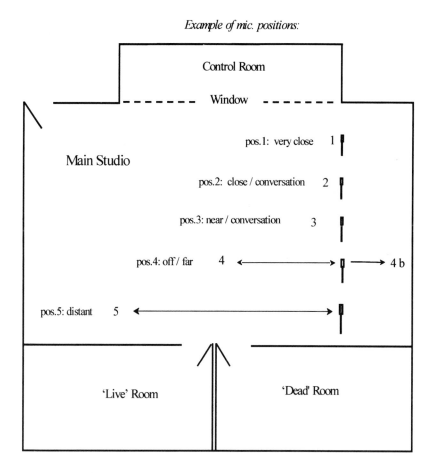

The following example illustrates the movement of two voices using different microphone positions played against the static distance of the sound of a party in progress.

In this example the party atmosphere is established at mic. position 4 (stereo) giving a sense of distance and space. Some moments later a male voice is heard from the party atmosphere calling-out a girl's name (BARRY-1). SHARON comes to life initially as verbalized thoughts (SHARON-2), her voice placed as close as possible to the listener at mic position 1 (centre-right) and possibly placed in reverb. This has the effect of bringing the listener into the head of SHARON and encouraging the imaginative

visualisation of the party and its event through her eyes and feelings—her thoughts also colour the listener's perception about BARRY. The party and its ensuing event is now placed in a new and distant perspective as experienced by SHARON. BARRY-3 emerges out of the party crowd at mic position 4 (left) and moves forward invading SHARON's space—uninvited—as his voice moves closer. The visual illusion of the emerging party bore and chauvinist pick-up is brought sharply into focus with BARRY's approaching voice.

SHARON's feeling of entrapment and overpowering sense of close proximity is heightened when BARRY moves to mic. position 2 (centre) and smugly suggests they both leave the party together. SHARON-4 (centre) maintains this close proximity perspective for her retort. SHARON-5 angrily replies to BARRY as she moves back into the safety of the party crowd from mic. position 3 to 4 (centre-right to right), using the opposite direction from where BARRY approached. In a stereo recording this movement in an opposite direction gives a sense of width and space. SHARON's movement reverses the listener's visual illusion without the listener necessarily realizing it, from initially imagining the physicality of BARRY's approach through the eyes of SHARON, to now imagining the physicality of SHARON's departure through the eyes of BARRY who is left, metaphorically, standing beside the ear of the listener [mic. pos 2]. As SHARON moves away from BARRY (mic. position 3 to 4), she also moves away from the listener who is now fixed in the same position as BARRY. The listener is psychologically placed at the most recent closest point of aural contact, mic. position 2.

The Party Scene

<u>Mic. pos. 4 [L-R]</u>	*Sfx:*	*Clinking of glasses, chatter and laughter, music played low from speaker. Party atmosphere - maintained throughout - held at mic. position 4.*
<u>Mic. pos. 4 [L]</u>	B'ARRY-1:	*[Raised excited voice attempting to speak over the crowd]* Hey Sharon ...Sharon.
<u>Mic. pos. 1 [C-r]</u>	<u>SHARON-2:</u>	*[Interior monologue/in reverb]* Oh no! That insufferable chauvinist bore has spotted me. How did he get invited here?
<u>Mic. pos.4</u> [Moving to mic. pos. 3] [Moving to mic. pos. 2] [Mic. pos.2 [C]	<u>BARRY-3:</u>	Hey Sharon...Hey!...Over here!. It's great to see ye'...I heard you were coming tonight. When the cat's away eh?... *[Mock Hollywood accent]* What's a pretty girl like you doing all alone at a party like this *(Sneer)*...eh? *[Intimately]* What do yeh say to the two of us splitting this scene and going somewhere a little quieter?
<u>Mic. pos. 2 [C]</u>	<u>SHARON-4:</u>	Barry...piss off!
<u>Mic. pos. 3 [L]</u> [Moving to mic. pos 4]	<u>SHARON-5:</u>	*[Angry]* I wouldn't be seen dead going out with a creep like you... ...You can take your beady eyes off of me and leave me alone.
	<u>*Sfx::*</u>	*[Slow fade of party atmosphere]*

It is acknowledged that the hearing mechanism is individual to each listener but each listener can only hear sound from a fixed point—that is the position of the individual relative to any sound perspective. In other words as humans we perceive sound as either coming towards us or moving away from us, where we as individuals are the fixed point of hearing contact. This reiterates the earlier assumption that sound either invades our being or, conversely, escapes our being by an involuntary process. This example may be somewhat exaggerated, yet, it illustrates the influence of sounds, words, movement and context upon the

imagination of the listener and their combined importance within the construction of radio drama.

The following is an illustration of the scene's movement in sound, a type of sound map. Similar sound maps will be used later for the same purpose in the performance analysis of the four *King Lear* radio productions. The sound map also illustrates simple panoramic positioning for stereophonic recording. That is, whether voices are placed extreme left, centre-left, centre, centre-right or extreme right in the stereo field. The juxtaposition of contrasting positions in the stereo field combined with aural distancing greatly heightens the spatial dimension of the soundscape and increases the overall sense of space and dramatic intensity.

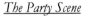

The Party Scene

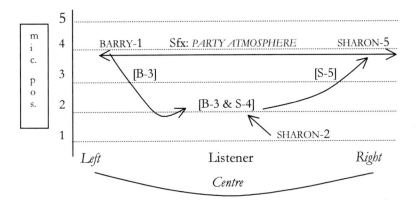

Elwyn Evans adds that 'in any scene all the speakers, plus the sound effects, should be in a recognizable spatial relationship to one another, and to the listener, who is the fixed point.' [7] The construction of a spatial soundscape is the realization on the one hand of working with the physical properties and probabilities of sound. On the other hand, it is the colourful and creative use of aural perspectives analogous to that of the visual artist's use of colour, line and perspective in painting. Whereas a finished painting can be considered 'fixed' as a static perspective, radio drama consistently shifts and alters its aural perspectives throughout a production. The interweaving mix of its elements

(voices, sound effects, music, pauses, silences etc.) combine to make a form of sonic/aural hologram.

Fades & cross-fades

The volume fade (fade-in, fade-out, and cross-fade) performs the same types of function in sonic terms as the curtain(s) and lighting cues do in the theatre and the picture dissolve in television and video production.

In its simplest form the technical fade (fade-in and fade-out) sonically represents the beginning or end of a scene creating a smooth aural transition to a subsequent sonic event. A fade is an increase or decrease in volume output and is measured in time—for example, long fades and short fades, which are also referred to as slow and quick fades.

[FADE]

Quick:	1 - 2 seconds
Short - medium:	2 - 5 seconds
Long:	6 - 10+ seconds

The fade-out is generally longer than the fade-in where in some instances fade-outs for the end of plays, particularly where music is played, can last as long as fifteen seconds (0' 15"). Quick fades are used more as a technique of smooth editing than an audibly graduated increase/decrease in volume. Greater care needs to be taken with the execution of quick fades, for example, a fade-out lasting one second could be easily interpreted as a 'pot-cut', a sudden loss of volume, or a very tight edit. In the following illustrations volume is represented as 0% to 100% of programme output volume, that is, where 100% = optimum programme output level. However, it is important to note that the wider range of volume dynamics inherent in 'classical' music and radio drama where sound levels can fluctuate between very loud (*fortissimo*) and very quiet (*pianissimo*), notionally means: 100% = sound at its loudest; 50% = sound at its quietest; and 0% = SILENCE.

Illustration of a fade-in and fade-out using a variable time frame.

Scene 1

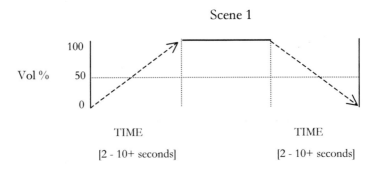

TIME TIME

[2 - 10+ seconds] [2 - 10+ seconds]

The cross-fade is a technique of mixing two fades together (a fade-out and a fade-in) which sonically links two scenes or separate events in an almost aurally imperceptible or seamless link. Cross-fades can also be either long or short but use a different time frame structure than the fade-out/fade-in.

[CROSS-FADE]

Short 3 - 6 seconds

Long 6 - 12 seconds

Illustration of a cross-fade using a variable time frame.

Scene 1 [exterior] Scene 2 [interior]

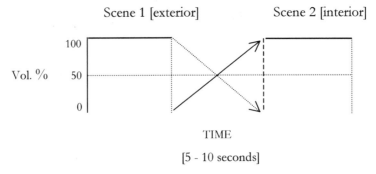

TIME

[5 - 10 seconds]

There are variations in the technical operation of fades, for example, the fade-in may have a slower start but a quicker finish to 100% of programme volume where the fade-out may be

similar in reverse. The cross-fade may begin initially with a fade-out followed a second or two later by the accompanying fade-in. These decisions are governed less by the personal choice of sound operators and more by the sound requirements for a particular production.

In radio drama fades and cross-fades can be used to great affect in creating an almost aural psychological believability in moving between different time periods—past, present, and future time. They also provide excellent ways of moving the dramatic action between exterior and interior scenes or vice versa as the following extract from John Arden's radio play *Pearl* demonstrates.

Pearl (John Arden)[8]

Scene Three [Interior]

GRIP: ...And we must climb it, clamber, storm the bloodstained wall. And fight to death its keepers. I promise you we will. Hallelujah!

Cries of 'Hallelujah'

GRIP *leads the singing of a hymn.*

GRIP (*singing*) 'The lord's Good Guide will walk before
His people on their Holy Road:
The fire by night, the smoke by day
We follow with our heavy load...'

The shouts and singing recede.

Scene Four *[Exterior]*

Fade out singing into exterior sounds of rain falling and rapid footsteps Splashing down a wet street.

PEARL: (*to herself - speech begins over end of hymn*). Myself with three terrified Courtesans am hustled by Mother Bumroll into the dark street outside and the rain pouring down...

MOTHER BUMROLL: We tek the short cut down the ginnel, we don't stop till we get to the house - run for it, run -!
Oh this town has been taken out of the hands of our Lord and master and given over to its own low rabble,

> we shall never again never be allowed our sweet
> pleasuring in decency and peace...
>
> *Cross fade to...* *Interior. Rain heard faintly perhaps on window or roof.*
>
> PEARL: *(to herself).* We go in, we make all safe -
>
> > *Door slamming.*
>
> We're not in her house scarce five minutes nor six
> when who comes but that damned clergyman...

There is an important distinction to be made between the
technical fade-out/fade-in and that of aural distancing on the
microphone. For example, a fade-out on an actor speaking at
microphone position 2 is not aurally the same as the actor
speaking as he/she moves away from mic. position 2 to another
mic. position e.g. 4 or 5.—the comparison remains true in
reverse for the fade-in. Goffman highlights this point in his
article 'The radio drama frame', where he chooses to describe the
technical fade as the broad fade:

> The attenuation of sound is used in the radio frame as a
> means of signalling the termination of a scene or
> episode, leading to the re-establishment of the drama at
> what is taken to be a different time or place, or an
> 'instalment' termination—again, something handled on
> the stage by means of a curtain drop. This is done by a
> 'broad fade', that is, a reduction of transmission power.
> But reduction in sound level can also be achieved by
> having an actor or other sound source move away from
> the microphone. Attenuation of sound created by
> moving away from the microphone can be aurally
> distinguished from a broad fade and is used *within* a
> scene to indicate that an actor is leaving the scene.[9]

The importance of sonic accuracy, that is, the decision between
technical fades and aural distancing, is even more critical when
dealing with music in a scene, particularly music that is a
contextual part of the dramatic frame. A fade-down of sound
that is held-under dialogue does not necessarily create the sense
of aural distance. The acuteness in aural perception will easily

differentiate between an instrument or a voice that is recorded with a relatively close microphone position but whose sound is merely faded-down and that of the same instrument or voice recorded at a further off microphone position. These problems of sonic perspectives and aural perception are encountered in Louis MacNeice's radio play *The Dark Tower*. In the first instance GAVIN is being coached in trumpet playing while at times he is also part of the scene's dialogue. In the second instance GAVIN's trumpet playing (and by inference GAVIN himself) are not intended to be as close as the scene's dialogue but more distant creating an interesting spatial relationship as a background.

The Dark Tower (Louis MacNeice)[10]

(A trumpet plays through the Challenge Call)

SERGEANT-TRUMPETER: There now, that's the challenge. And mark this: Always hold the note at the end.

GAVIN: Yes, Sergeant-Trumpeter, yes.

ROLAND: *(as a boy)* Why need Gavin hold the note at the end?

SERGEANT-TRUMPETER: Ach, ye're too young to know. It's all tradition.

ROLAND: What's tradition, Sergeant-Trumpeter?

GAVIN: Ask Mother that one. She knows.

SERGEANT-TRUMPETER: Aye, *she* knows. But run along, sonny. Leave your brother to practice.

(The trumpet begins - but breaks off)

SERGEANT-TRUMPETER: No. Again.

(The trumpet re-begins - breaks off)

SERGEANT-TRUMPETER: Again.

(The trumpet begins and is sustained)

SERGEANT-TRUMPETER: That's it now. But hold that last note - hold it!

(On the long last note the trumpet fades into the distance)...

[A little later in the scene]

ROLAND: …And did they all die the same way?

MOTHER: They did, Roland. And now I've answered your
 question.

ROLAND: Question…? What question, Mother?

 (The trumpet call is heard in the distance and held behind.)

 Ah, there's Gavin practising.
 He's got it right at last.

 (The trumpet call sounds, still distant, and closes.)

17 | Text | Script | Aural Literature

Text | Script

There are basically only two forms of media texts, (a) the text specifically written for a particular medium and (b) a text adapted from another medium e.g. a stage play adapted for radio, a novel adapted for a film or a radio drama adapted for the stage as in the case of Dylan Thomas's *Under Milk Wood*. Beyond the simple categorization of a text, issues of intertextuality and transformations of a text through whatever medium is the subject for a different line of investigation and is beyond the focus of this book. However, a brief consideration of the broader parameters of dramatic representation as applied to the reader/spectator-listener relationship is considered necessary.

Whether audio-visually on the stage or aurally on the radio, every performed text becomes a new rendition of that work, that is to say its realization becomes a transformation of its source text. This is particularly the case where separate performances by different actors of the same source text are involved, even if meticulous attention is paid to the author's dramatic directions (e.g. scenery, props, costume, lighting, movement etc.). Where the macro visible elements of stage presentation may achieve as near 'cloned' replication from one production to another, the micro invisible or less obvious elements of human performance (e.g. voice quality-pitch-inflection-intonation-phrasing-tempo etc.) will always vary. These differences in themselves create new

realizations of the source text where it can also be argued that every additional performance of the same text by the same actor also creates a new and different realization of the text. By the physical laws of nature a repeat performance can never be a 'cloned' replica of the original performance—to repeat is to do-again, to do-again is to re-enact. The distinction between the 'source' text experienced by a reader and the 'performance' text experienced by the spectator/listener continues to be a subject for research and debate (Ubersfeld, Pavis, De Marinis, Elam, Rozik, Tornqvist and De Toro). De Toro acknowledges that the 'semiological nature of the theatre 'object' is complex in that its greatest complexity comes from the fact that, unlike other artistic practices, theatre is not comprised of a single signifying system but, rather, a multitude of signifying systems that each have a dual function: as a literary practice and as a performance practice.' [1]

One cannot deny the logic of the argument where the theatre's 'multitude' of signifying systems have not only been delineated, classified and explored by numerous semioticians but adapted and extended as tools of analysis for other visual performance genres, notably film and television. De Toro's assertion that not only is the theatre object a *dramatic text*, it is also a *performance text*, with both a literary and a performance dimension, [2] could be applied to any dramatic art form. I hold that it is particularly relevant to radio drama.

Tornqvist poses a more contentious question: is transposing drama from any medium to another medium desirable? In his attempt to answer the question, Tornqvist believes that 'disclaiming the value of transformation is like repudiating that of translation.' [3] Whether transformation is desirable or not, the fundamental question is whether a work lends itself to transposition? In radio drama such transposition involves the process of transcodifying the visual elements of a play into aural equivalents. This has been viewed by some playwrights and critics as rewriting the play and moving it away from its original form. Beckett for example was notorious in preserving the artistic integrity of his works believing that works written for a specific medium (with a few exceptions) should only be realized

through that medium. No matter how ingenious an adaptation might be, or how potentially pictorial—for example, *All That Fall*—it might appear from the page, Beckett was adamant that it was to remain a sound play for voices.

> *All That Fall* is a specifically radio play, or rather, radio text, for voices, not bodies. I have already refused to have it 'staged' and I cannot think of it in such terms …
> I am absolutely opposed to any form of adaptation with a view to its conversion into 'theatre.' It is no more theatre than *'End-Game'* is radio and to 'act' it is to kill it.[4]

The affinity between stage drama and radio drama is at best superficial. The only real common denominator in both is the important element of dialogue. The stage play has its own fully wrought dramatic structure and shape which depends essentially on a counterpoint of sound and vision. The radio play also has a fully wrought dramatic structure which depends upon a counterpoint of words, voices, sounds and music encapsulated into the single entity, sound. On the face of it therefore, the stage play could probably be only palely rendered in terms of sound alone unless careful and sympathetic transcodification transforms the stage play into a new realization, a new perspective on the work. To use the appropriate distinction between '*radio*-drama' (plays *written* for radio) and 'radio-*drama*' (plays *adapted* for radio), the stage play (or, indeed, the novel) should not sound like a play-to-microphone but a play-for-microphone. Such a transformation does not change the play but presents a new perspective on the play and something that may not be easily realized in its former medium.

> The problems of 'adaptation' are necessarily difficult; even the word is misleading … I simply mean that 'adaptation' is, or should be, interpretation, restatement in a different form, in terms of a different medium. This kind of restatement is likely to provoke antagonism among purists, but can hardly be dismissed for that reason. The final judgement must depend on the act of re-creation, not on the principle involved.[5]

Aural Literature

Great radio drama does not belong to a static medium. It is as infinitely variable and as artistically creative as great music. Its creative elements are perhaps more easily delineated than that of music, but they are essentially the same as the 'abstract' qualities the music composer composes with and that is, sound. Whereas the music composer may use different instruments, rhythms, melodies and harmonies to create line, dramatic shape, movement, contrast and colour, the radio drama playwright and the production process use words, voices, rhythms, sounds, music and the other production elements to form an orchestrated aural harmony to the same effect. The very best of radio drama involves its creators (playwrights, directors, actors and composers) in a process of thinking *in* sound and not merely *about* sound. There is something about the sound of well-written radio drama that allows the best to stand apart, imbuing its productions and most especially its playwrights with an almost timeless quality of greatness. Mediocre radio drama, of which there is more than there should be, plays in that sonically safe and static form that refuses to challenge and seldom invents in the imaginative world of sound. Here, most especially at a production level, sound is used purely as a means to an end and not as a means of artistic expression.

In comparing our world of electronic orality to older oral cultures, Ong believes that the former, electronic orality has brought us into the age of 'secondary orality.' This new communicative level of human consciousness should not be viewed as a replacement for 'primary orality', but more as an evolution in human communications made possible by the advent of electronics. 'The electronic transformation of verbal expression has both deepened the commitment of the word to space initiated by writing and intensified by print and has brought consciousness to a new age of secondary orality.' [6] Zumthor expands this point by stating that 'orality interiorizes memory, the same as it spatializes it: voice is deployed in a space whose dimensions are measured at its acoustic range, whether expanded or not by mechanical means, but that it never exceeds.' [7]

The constituent elements discussed in this chapter form the main sonic materials from which radio drama creates its exclusive sonic art form. It is its total reliance upon sound and its compositions in sound that are specifically unique to the genre. Whereas Ong and Zumthor allude to a sonically spatial orality that has at its roots the fundamental need of ancient oral based cultures to communicate, radio and most especially radio drama, enshrines the highest artistic form of dramatic orality in the electronic sense.

The script of a radio play is clearly not a 'radio play' in its printed form, in so far that printed music is not music. At best the script is the written aspiration of a playwright's aural inception affirming its need to be sounded. Accepting Ong's belief that written texts have to be related somehow to the world of sound to yield their meanings[8], the radio play in its performed medium provides the sonic transformation of the script into a dramatic entity that can be aurally realized. The following illustration summarizes some of the most important aspects in this transformation process. Finally, it is my belief that if the dramatic text is read as visible dramatic literature, then, it follows that the performance text, realized as radio drama, is heard as an aural dramatic literature.

Radio drama as Aural Literature

D- (minus sonic realization) represents the dramatic text

D+ (plus sonic realization) represents the performance text

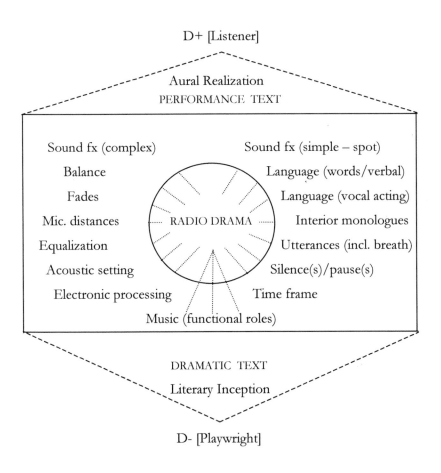

D+ [Listener]

Aural Realization
PERFORMANCE TEXT

Sound fx (complex) Sound fx (simple – spot)

Balance Language (words/verbal)

Fades Language (vocal acting)

Mic. distances RADIO DRAMA Interior monologues

Equalization Utterances (incl. breath)

Acoustic setting Silence(s)/pause(s)

Electronic processing Time frame

Music (functional roles)

DRAMATIC TEXT

Literary Inception

D- [Playwright]

Part Three | Transmissions

> An actor approaching the role of King Lear must first
> look past the word 'King' and search for the human
> being. What I have missed in most performances of
> King Lear is this human being in Lear. The man I can
> identify with. The person I know.[1]

Radio drama is unique among other dramatic art forms in its
ability to scrape at the nerve of human consciousness. Guralnick
suggests that there are those who would say that we all live in
consciousness, that the world as we know it is a product of
perception and that save for our perceptions nothing exists[2]. On
stage and in film the realities of the picture are created for the
audience, a near complete tableau with moving figures, but a
mere directorial breath away from the command 'freeze' before
the spectator is presented with a *tableau vivant*. We, the audience –
a collective of individuals – are invited to view these moving
'paintings' with collective objectivity, as voyeurs of spectacle, as
passive audient spectators. We know what we see is the fusion of
a professionally manufactured reality influenced by fantasy and
enclosed within the bounds of spectacle. On radio, conversely,
the audience – also a collective of individuals – knows only what
each individual has experience of or can perceive something to
be, in the sense that as no optical/visual information is trans-
mitted, what constitutes spectacle becomes purely imaginary. As

a consequence, radio drama requires its audience to favour the action of the mind above the actuality of matter.

Holbrook's dilemma at the outset in identifying on stage the human being that is Lear extends itself to any complex character and is rooted in the improbability of trying to show what cannot easily be seen. The nuances of utterance, including pauses and silences expressed as the outward vocalization of interior thoughts, are highly significant for triggering sensory emotional responses. These nuances are heard and sensed by the attentive listener. In acting just as much as in 'real' life they can betray the sub-conscious thinking of a character and when interpreted by their listeners can manifest themselves as vivid and sometimes frightening realities through the illuminations of our imagin-ations. This degree of emotional response requires a connectivity between actor and audience intimately closer than the physical distance between stage and audience or the fixed inanimate distance between projection screen/television set and its viewer. Radio's distance between itself and its audience is one of perception. For its active or attentive listeners it can be as intimate as being literally inside one's head. Its very fluidity evaporates its boundaries of fictional time and space blending perfectly into a fusion of perceptive reality. Ultimately, the aural fantasy world including its characters whether benign or malign that each individual creates in their imagination is more personally real and comforting or disturbing than the manu-factured visual illusion presented by a third party.

In so far as the eyes are said to be the mirror of the soul, the voice, including its silence, must surely be the soul's outward sounding expression. How poignantly redundant yet charged with emotional meaning can the word 'nothing' impart when uttered? When qualified by silence – verbal 'nothingness' – its significance becomes electrifying and its effects unpredictable. Cordelia's aside/interior monologue (*King Lear* Act 1:i – line 64) – 'What shall Cordelia speak?' – prompted by Goneril's exaggerated speech highlights Cordelia's psychological dilemma. How can she find the words, let alone the voice, to express her love publicly for her father? Her solution – 'Love, and be Silent' – charges Cordelia's utterance of the word 'nothing', together

with its inherent silence, with emotional intent quite different from Lear's expectations and understanding.

King Lear *Act 1:i [Lines 83-91]*

LEAR:	…Now our Joy, Although our Last and Least; to whose young Love the Vines of France and Milk of Burgundy Strive to be Interest. What can you say, to draw a Third more opilent than your Sisters? Speak.
CORDELIA:	Nothing, my Lord.
LEAR:	Nothing?
CORDELIA:	Nothing.
LEAR:	Nothing will come of Nothing, speak again. [3]

In these lines Shakespeare dissembles the function of language, and at a highly dramatic moment chooses words whose inanimate emptiness demands human enlightenment. Here Shakespeare strikes at the truth hiding in the absence of completed phrases, that temporal space between words, which contains the conscious mind of unspoken thoughts. Its rhythmic structure becomes one of paused consciousness, not mere silence; something that cannot be illustrated spatially upon the page but can be aurally experienced through time. The hidden silences between Cordelia and Lear, those character-laden insights (fear, anticipation, disappointment, anger, truth etc.) are embedded in the pauses of interrupted narrative. Words alone cannot carry the emotional charge neither can the emotional content be realized through space upon the printed page. The emotional impact in this passage is aurally sensed across time where the pauses/silences counterpoint the utterances as intimate human responses. The silence of Lear's disappointment sharply contrasts with the silence of Cordelia's truth. The minutiae of such non-verbal utterances can often be lost in the spatial perspective upon the stage as they can be visually negated in the choice of images presented upon the screen (close-ups, wide shots, cut-aways etc.).

The words of immobilized actors convince nobody, except of the pathos of words without action, the pathos of fantasy.[4] Hughes argues that truth can only be made visible to an audience through mobilising the actors into meaningful actions. But what actions accompany truth and by what actions can truth be recognized? These are not the visibly physical actions of movement or broad gestures, but the actions of language as an action itself. Elam posits that the difference between 'sentence-meaning' and 'utterer's meaning' is one of the crucial concerns in any 'reading' of a play[5]. He argues that it is language-as-action-theory that holds the key to understanding the proairetic functions of discourse in the drama. The very essence of the human character hidden behind the words and expressed as utterance impregnates the silences with inner meaning creating its own rhythmic stream of consciousness.

Hughes's descriptive use of the word 'fantasy' is one allied to that of the visual spectacle, something accepted as being 'unreal' and in itself a fantasy. Therefore, is it capable of 'truth'? The silent truth of Divine Love he suggests cannot be dramatized at all, except as a creature suffering in a world where the egomaniac voices of the tragic error reject it, violate it, exploit it[6]. The profane expressions of love by Goneril and Regan resound as mere verbal phrases whose disjointed and alienated meanings are in stark contrast to Cordelia's conscious silence. On radio, truth and silence are delivered by the voice and by its absence of words, they are in a sense 'invisible' of action being the products of individual consciousness. When rendered in a sound medium, Shakespeare's combination of words together with the unseen utterances and silences can create sharp contrasting rhythms of consciousness. They are, in essence, a radiophonic stream of consciousness whose striking and chilling poignancy can only be 'truthfully' experienced aurally from within. The imaginative juxtaposition of what is unseen-but-heard sharply focuses our attention upon the dramatic nuances, which are part of the complex intricacies of what it is to be human. When conscious visible actions and gestures such as smiling, hand-waving, applauding etc., can sometimes hide the essence of the truthful 'self', only then, in the sub-conscious link between mind and

body expressed through the spoken voice, do we begin to identify the person, whom we think we know. The dutiful father who is also King and absolute contrasts with the demanding King who now, in the public arena, wrestles with his ability to be an understanding father. The human consequences where truth is overruled and rejected sets a departure point not only for the tragedy of *King Lear* but for the tragic frailty of mankind itself.

Titze's statement that the 'voice is our primary means of expression'[7] underlines the claim that one's voice can ultimately be a truthful expression of oneself. 'Expression of *emotion* is highly vocal. Six primary emotions – fear, anger, joy, sadness, surprise, and disgust – are all expressible vocally.'[8] The actor in a radio drama is charged with the critical responsibility for the communication of emotional meaning exclusively through the voice. As such, the well-acted radio play offers an excellent vehicle for the exploration of spoken language as an emotional communicator. The philosophies of language and linguistics pertaining to speech-act theories are, however, beyond the focus of this particular work and will not, therefore, be explored. However, the broad principles underlying the theories of language as action inevitably form a basis for the investigation of radio drama as aural literature.

In analysing the following four radio productions of *King Lear*, I acknowledge the volume of academic research and scholarship brought to bear upon the literary text and its performance on stage and in film. This investigation will not examine (unless where relevant in terms of radio production techniques) the broader issues of psychological entanglements and sub-plots in the play; the shifting balances between gender and power; or the dialectics of stability (matriarchal v patriarchal society). I acknowledge the literary concerns with regard to the editorial chronology of Shakespeare's printed works particularly the many drafts and revisions of his plays as evidenced in the numerous quarto and folio editions. I have selected as a source text the Everyman Shakespeare[9] (1993) which uses the First Folio (1623) as a control copy, but which also includes a separate analysis of the additions and alterations made to the First Quarto (1608).

Although there are minor textual differences between the Shakespeare Recording Society (SRS), BBC3, and BBC4 productions in their use of the complete literary text, there is a significant difference in RTE's adaptation. It is a radically modified and shortened adaptation of the play, leaving virtually no scene untouched or uncut. The following analysis will not examine these textual differences *per se*, as a discussion on textual editing is not the focus of the analysis. All four radio productions present radiophonic adaptations of the play and in so doing make artistic use of additional verbal and non-verbal utterances not published in the source text. These additions can be rightly justified as being medium specific where they sonically illustrate the *modus operandi* for contextualising certain otherwise visual elements in an aurally transparent way. Such additions and their contrasting uses by each production are annotated in the performance analysis. As a focus for the analysis, I propose to explore each production's use of important radiophonic elements such as: voices (including pitch, timbre, tempo, vocal hierarchies etc.), utterances, music, sound effects (sound fx.), silences/ pauses, acoustic spatiality, and technical considerations. It is the way in which these elements are used and combined together which shapes a production's individual approach to the play in sound.

Radio productions are planned from the accepted premise of a 'one-pass-hearing.' It is assumed that the listener has only one chance of hearing the production and that is, as a general rule, as it is being broadcast. This reaffirms the unbounded parameters of radio transmissions as existing only in time and space. On the level of a practical interpretation this can mean that a radio transmission is broadcast between two fixed points in time but is received in an infinite number of personal spaces, for example, where and how each listener hears the transmission. The possible exceptions to the 'one-pass-hearing' theory could be argued as human intervention into radio's passing time and space frame, either through repetition or prolongation. One could either hear a repeat broadcast by the radio station, which for some listeners offers a second chance hearing, but for those who had not already heard the broadcast, it remains the first 'one-pass-

hearing.' Alternatively an individual may record a broadcast or obtain a commercial release of a broadcast, which gives the listener a degree of control not envisaged by the original production. Controls such as the choice of when, where, and for how long one chooses to listen, stop/start, rewind, and fast-forward offer personalized control over repeated and selective listening in much the same way as one might read, re-read and analyse a text.

The immediacy element that forms part of the 'one-pass-hearing' theory is a major part of radio's appeal and influences all of its broadcasting output including that of planned and recorded radio drama productions. The *raison d'être* for any artistic radio work is a radiophonic production capable of creating the impact desired in a 'one-pass-hearing.' As Laurence Gilliam claims, radio is the art of communicating meaning at first hearing.[10] This poses a certain dilemma and raises the recurring uneasiness between practitioners of the performing arts and academic research into the performing arts. I readily accept the criticism that an in-depth analysis of any radio production runs contrary to Gilliam's claim and in a sense violates the spirit in which the production was intended to be heard. As with any deconstruction theory regarding theatre, film, music, and radio, an examination of the working intricacies of a genre's elements can only be extrapolated by repeated, close, and attentive study. One must accept the objectivity of the exercise and move beyond the bias of any initial emotional attitude that sees the product of any creative activity as sacrosanct, as if an analysis of its process and craft defiles the sanctity of its creation.

Any radio production (incorporated as writer/adapter, producer and actors) has to create a sonic environment, an aural sound stage (voices, music, sound fx., acoustics, etc.) convincing enough to stimulate the listener into sustained listening while also trying to express the quintessence of the play.

In listing the four radio productions of *King Lear* at this point, I will only credit the character playing Lear together with the director/producer of the play and the composer of the music (if acknowledged). I will also list the mode of recording, date of production and the overall timing of the production. A model

radio analysis script for Act 1: Scene i is presented in appendix i and the complete cast list for each production is included in appendix ii.

Note: in expressing lengths of time in the analysis I use the following structure. [00:00:00] means:

[00: 00: 00:]

zero [hours: minutes: seconds]

where: [00:01:35] should be read as:

zero hours: one minutes: thirty-five seconds

The four radio productions of *King Lear* under consideration are:

(1) *King Lear* by The Shakespeare Recording Society [11] (1965)

Paul Scofield as *Lear*. Directed by Howard Sackler

Music composed by: n.a.

Original Mono Recording remastered in simulated stereo for

Harper Collins release: (4 cassettes) [Time: 03:06:00:00]

[From here on referred to as the SRS production]

(2) *King Lear* by R.T.E. (Radio 1) [12] (1988)

Seamus Forde as *Lear* : Directed by Laurence Foster

Music composed by: n.a.

Stereo recording: (2 cassettes) [Time: 02:02:00:00]

[From here on referred to as the RTE production]

(3) *King Lear* by B.B.C. Radio 4 [13] (1988)

With Alec Guinness as Lear: Directed by John Tydeman

Music composed and conducted by: Christopher Whelan

Stereo recording : (2 cassettes) [Time: 02: 52: 00:00]

[From here on referred to as the BBC4 production]

(4) <u>*King Lear* by The Renaissance Theatre Company</u>[14] (1994)

In association with BBC Radio 3

With Sir John Gielgud as Lear: Directed by John Dearman

Music composed by Patrick Doyle

Stereo recording : (3 cassettes) [Time: 03:13:00:00:]

[*From here on referred to as the* <u>BBC3</u> *production*]

The four radio productions of *King Lear* span a period of thirty years (1965–1994) and cross a major development in radio technology, the replacement of monophonic recording and broadcasting with stereophonic. The strengths and weaknesses of both modes of recording, particularly when applied to radio drama, are points of technical and artistic preferences and will not be dealt with here. It is accepted that both modes of recording (mono and stereo) can each offer different and interesting perspectives separately within the realm of sonic/aural space.

19 | Music Preludes

The musical use of the term prelude usually refers to a short introductory piece of music played prior to the main work, such as prelude and fugue or the introductory movement to a solo instrumental or orchestral suite. Its more elaborate form in terms of composition and orchestration, the overture, precedes an opera, oratorio, operetta, some stage plays and virtually all films (where it is commonly referred to as the opening or theme music). The accepted use of prelude/introductory music in these visual performance genres ranges from the functionally practical, an aural cue to the audience that the main performance is about to begin, or as an evocative mood setting, music which captures the emotive levels of the play/film. In the case of opera, more complex compositions are composed which can interweave fragments of the main melodic/rhythmic material to be heard later in the work. In a non-visual performance genre such as radio drama, where the reliance is totally upon sound, any music, including prelude/theme music, carries with it far greater responsibility.

The dramatic importance of the opening sequence or prelude to a radio play before any words are spoken is enormous, and unlike its mirrored form, the postlude, the prelude performs particular radiophonic functions, which could be deemed essential to the production. It has to be noted that music is not a prerequisite for a radio drama production. Indeed, many radio dramas begin with

a montage of sounds, sound fx, voices etc. However, the golden rule still applies that the use of any sound in the sound medium should have referential intent. The prelude music in these productions is first and foremost used as a framing device where it marks one of the outer extremities of the time frame in which the play will be performed. The opening bar of music denotes the beginning of the production's time frame in much the same way as raising the curtain or the fading up of a lighting cue do for stage productions. The renowned American composer, Aaron Copland, once stated that music could create a more convincing atmosphere of time and place[1]. In doing so, the prelude's 'sounds' (whether music or sound fx, separately or combined) create the first aural clues for the listener's development of an imaginary aural landscape in terms of place and fictional time. The correct choice of music can heighten a play's imaginary physicality of place and its immediate position within an era of time (past – present – future). Copland also believed that music could be used to underline or create psychological refinements – the unspoken thoughts of a character or the unseen implications of a situation[2]. Music as a medium of communication can sometimes imply a psychological element in sharper focus than that of dialogue. However, if music alone is the prelude cue, then it is critically important that it is both <u>sympathetically</u> and <u>artistically</u> 'in-tune' with the plot and/or characterization in the play. If it is, then music can powerfully create the evocative and emotive mood and even underscore the tempo of the opening action. More importantly, the prelude music can engage the listener's attention by crystallising the point of tension from where the verbal language of the play emerges.

SRS Production: Music Prelude

The SRS production prelude is a short orchestral motif, eighteen seconds in total [00:00:18] and played by members of the woodwind and string section of the orchestra. The tempo of the piece is extremely slow-moving at Largo tempo (c. 44 b.p.m.) and whereas the piece is centred around the key of A minor its two melodies, melody 1 played by flutes/clarinets and melody 2 the counter melody played by oboes/violins, are chromatically contrapuntal. After a minor 3rd rise in the first interval (a to c),

both melodies weave their way downward through a series of falling chromatic intervals in close counterpoint. The combination of both melodies played against each other, at times one melody rising while the other falls, creates a wandering modal sense of tonality. The modality of the piece temporarily destroys any sense of key structure, but its key centre of A minor is re-established when both melodies arrive independently and hold on the final note *(E)*, a 4th below the tonic and the dominant in the key (A–e). The key centre and the end of the prelude is further signified by two pianissimo half rolls on a low tonic note *(A)* played by the timpani. The overall aural dynamics of the prelude are soft and quiet *(p)* and it concludes with a rallentando coupled with a diminuendo to *(pp)*.

This short prelude suggests a code of meaning through its use of generally accepted musical metaphors; however, the degree to which a listener interprets its meaning remains subjective and unscientific. It is questionable if this music or its implied meanings are indicative of the general mood of the play or more especially of the main protagonist, Lear. However, it does help to set up a powerful, evocative, and atmospheric introduction to *King Lear*. For example, the slow largo tempo might be expressed as an aural icon of old age, whereas, the minor key tonality could conceivably be an index of sadness or pain. Whereas other identifiable metaphors could be classified as being symbolic of certain states of being or event happenings, the timpani roll should be clearly recognizable as an icon of doom. Since the 19th century, the timpani roll in conjunction with other instrumentation has been used in orchestral music as a most effective sonic builder of climactic tension. Its most obvious performance role is underpinning a crescendo to fortissimo *(ff)* or even *fff* dynamics, but when used to play entirely different dynamics e.g. quiet *(p)* or a diminuendo to very quiet *(pp)*, the timpani roll can create the aural illusion of a most darkly sinister sound.

The music metaphors in the SRS prelude are expressed in a signifier–signified relationship in the following illustration.

SRS – Production Prelude: *King Lear*

SIGNIFIER [Musical]	SIGNIFIED *[Meaning]*
Tempo - (largo) very slow	*Old age, elderly, nearing the end*
Tonality -minor key	*Sadness, separation, pain,* *unrequited love*
Descending intervals	*Loss of power, loss of hope,* *downward spiral*
Modal or chromaticism	*Wandering, loss of focus, confusion*
Quiet dynamics	*Lacking energy, reserved, elderly*
Timpani roll (*pp*)	*Impending or foreshadowed doom,* *suspense, despair*
Final note (E) [dominant in the tonic]	*Unfinished, waiting, hesitant,* *expectation, unresolved*

The musical metaphors in the SRS production prelude are different from those used by the other productions. The other preludes use more typical musical idioms and instrumental groupings to denote time, place and personage. SRS's prelude music does however create a greater sense of 'timelessness' rather than 'historic-time' and a greater sense of personal 'emptiness' than public 'fulfilment' (e.g. royalty/power). In focusing the mind upon the more penetrable feeling of foreboding and timelessness, the music is suited to Shakespeare's pre-Christian setting for the play.

RTE Production: Music Prelude

The RTE, BBC3 and BBC4 production preludes use musical idioms which have become accepted as musical conventions for denoting historical time and personage. Although the RTE prelude observes the general 'rules' of these conventions, there are choices of instrumentation in the orchestration, which gives

the piece a more Oriental connotation than Western and certainly does little to create the aural illusion of historical Britain.

The orchestral prelude is forty-six seconds [00:00:46] in total but is faded down at fourteen seconds [00:00:14] to facilitate a verbal introduction to the play (title, author and main cast). It is faded up again at twenty-seven seconds [00:00:27] where the musical motif plays out to a rather abrupt and sudden fade-out at forty-six seconds [00:00:46]. As with the SRS prelude no composer was credited, which leaves me to believe that the music was selected from a pre-existing recording or copyright free library music. The prelude is set in the key centre of B*b* minor and is played at a slightly slower pace than moderate tempo (72 bpm). The key centre of B*b* is a particularly suitable key for brass instruments, taking account of the transposing nature, fingering and natural resonance of the instruments. The use of the minor key in music is also significant, as composers have tended to use this key combined with a generally slow tempo for depiction of sadness, loss, doom, or death[3].

The prelude consists of two short musical phrases. The first phrase, repeated once with a slight melodic variation, is a bold, regal sounding statement played by trumpets and horns in parallel 5th intervals. The use of parallel 5[ths] creates a stark sounding harmonic structure, where the absence of the 3rd interval throughout negates any formation of completed chords. The ends of the phrases are marked by a curious choice of instrumentation creating percussion-like chords with a far-Eastern sound connotation. The instruments used for these chords at the end of the first phrase are violins holding the 5th in the tonic over two beats played by a (Chinese) gong accompanied by two soft mallet beats on a crash symbol. The same instruments are used at the end of the repeated phrase with the addition of a bass clarinet playing the tonic/key note. The same percussion/instrumental chord (with the exception of the bass clarinet) is repeated at the end of the second contrapuntal phrase, this time played by trumpets and horns.

The use of identifiable instruments and melodic and harmonic groupings to signify place or geographical regions is a common musical idiom. For example, the sounds of the Spanish guitar are

indicative of Spain, the bagpipes of Scotland, the cor anglais of rustic England, the bongos of deepest Africa, the sitar of India and the harp or possibly the tin whistle with that of Ireland. It is worth noting that the national symbol of Ireland is that of the harp. In the case of the RTE prelude the use of the gong and crash cymbal combination has a symbolic connotation denoting the Orient. The gong/cymbal combination associated with Oriental sound appears to be out of context for an aural imaginative landscape depicting historic Britain of any era.

The prelude, with the exception of the reservations spoken of above, makes use of accepted musical conventions for aurally depicting historical time and personage in three ways (i) instrumentation, (ii) melodic structure and (iii) harmonic structure. The sounds of brass instruments[4] particularly trumpets and horns, playing both the main melody and fanfares, has for centuries been associated with the depiction of royalty, power, or military endeavours (land and sea) in programmatic tone poems and symphonies. In religious music these instruments are associated with the power of God, heaven, and planetary systems (consider the choice of instrumentation and orchestration in *The Planets Suite* by Gustav Holst).

There is a further sub-division of depiction and meaning that can be applied to horns and trumpets. However, an exploration of their use in descriptive music is beyond the focus of this work. In brief, the trumpet has a sharper, more abrasive metallic and an immediate type of sound compared to the horn The trumpet has generally been used and accepted as a heralding instrument playing fanfares, voluntaries, military, and ceremonial calls. The power of breath required to produce a note on the trumpet creates a degree of difficulty in executing pianissimo dynamics. As such the trumpet is used for brash depiction of royalty as an institutional position, for the overt power of royalty and for the depiction of God's power in heaven. The horn on the other hand has a softer sound, a lower register and the ability to use a wider dynamic range. It is particularly suited to playing piano/- pianissimo dynamics and is, therefore, better at depicting royalty as a person or the character who is royal. In RTE's production prelude, the trumpets and horns play the melody in 5^{th} intervals

The melodic structure of the first phrase and its repetition is a straightforward linear construction more reminiscent of a hunting or herald type call. The second phrase played by the trumpets and horns is an interesting contrapuntal phrase sounding more like a fugal exposition. The melody moves downward in a sequential pattern ending on the dominant (f) in the tonic key of *Bb*. The harmonic structure makes use of a commonly used musical convention for denoting historical time, in this case, time typical of the medieval period. The use of moving parallel 5ths and the absence of the 3rd creates a bare, stark sounding harmony. The harmonic structure relates to the movement of intervals found in the music of the medieval and early renaissance periods. This style of music, organum, is a form of medieval polyphony (circa 11th to 13th centuries) and marks a cross-over point in musical history between purely monophonic music (e.g. plainchant) and the complex polyphony of renaissance music. This stark harmony based on consecutive intervals of 4ths, 5ths, and octaves formed the seminal beginnings of tonal consonant harmony developed through the renaissance period (1400–1600). The use of such harmonic devices clearly gives the piece a medieval sound.

The music metaphors in the RTE prelude are expressed in a signifier–signified relationship in the following illustration. As the piece was not specifically composed for the production any insights into the play itself are difficult to determine.

RTE – Production Prelude *King Lear*

SIGNIFIER	SIGNIFIED
[Musical]	*[Meaning]*
Brass instruments (trumpets) (horn)	*Royalty, powerful, institutional* *Regal personage*
Percussion instruments (gong and cymbals)	*Oriental*
Melody (linear/military call)	*Heralding, summoning, entrance*
Harmony (parallel 5ths)	*Historical time (medieval)*

| Contrapuntal (2nd phrase) | *Double agenda, conflicting personality* |
| Sequential movement (down) | *Loss of power, regression, negativity* |

The fact that the music was suddenly faded out at forty-six seconds [00:00:46] is an indication that the music continued as a piece in its own right beyond the last notes faded on tape. This gives the impression that the music was considered as a secondary element to the production and was selected as being merely a suitable sounding piece within the overall framing context of the production e.g. curtain raiser and time depiction. Whereas the music sounds regal and is aurally effective at creating the illusion of a particular historical point in time, it conveys little information about the play itself (e.g. plot, characters, tension etc.). This in itself is not necessarily a fault but it does underline the difference between music that is composed specifically for a production and music which pre-exists but has no embryonic link with the concepts of the production.

BBC 4 Production: Music Prelude

BBC 4's prelude is quite a dramatic piece composed for the production by Christopher Whelan. The piece is relatively short at one minute and seventeen seconds [00:01:17] and is divided into three musical sections. Section 1 – introduction, section 2 – which includes a verbal introduction to the play (title, author, and main cast), and section 3 – a short refrain of 1 ending with a crescendo followed directly by a diminuendo leading to scene one. The tempo of the piece is slow and deliberate (Adagio @ 54 bpm).

Section 1 (Introduction) is stark and tense and uses a highly effective instrumental grouping. The opening sounds are made up of low pitched unison notes played at mezzo-forte by the trombones, a unison bass note on the piano and timpani. This instrumental group play a single note bass 'chord' (the relative lack of definition due to the 'spreading' nature of dominant low frequencies helps to create a sense of chord from what is otherwise unison notes). Played as a repeated downbeat, this chord punctuates the silence creating a strong rhythmic pulse

with the aural impression of a low growl and suppressed anger. After the third beat the horns introduce a fragmentary hunting-like call that weaves around the main rhythmic pulse. At twenty five seconds [00:00:25] the music is interrupted by a syncopated 5th interval, the first note played by a tubular bell followed immediately by a bass note on the piano leading to section 2.

The music from this point (section 2) changes and is characteristically different from section 1. The prominent under-lying instrument in this section is the concert harp playing a rolling arpeggiated 6th + 9th chord over which the brass section (horns, trumpets and trombones) continue to weave a downward moving melody culminating in upward moving 5th interval held chords. The division in the brass section is interesting at this point. The trombones play the downward moving melody at *forte*, creating a deliberately harsh sound, ending on an upward 5th interval. They are joined at the end of their phrase by the trumpets playing upward 5th interval chords at a softer *mezzo-forte*, which is further imitated by the even softer horns repeating the 5th interval chords. The aural illusion created by the music at this point is one of mystery, suspense and anticipation. This is further reinforced by the harp's 6th + 9th arpeggiated chord where the addition of the extra notes (6 and 9) in the chord creates a whole tone consonant chord lacking definite harmonic identity within a key structure, but adding to the sense of mystery and suspense. The quieter and rolling nature of this section provides an excellent 'music-bed' for the super-imposed verbal introduction.

Section 3 is a short refrain with slight variations of the opening rhythmic growling music culminating in a single note brass chord sustained through a forceful crescendo followed immediately by its diminuendo to scene 1.

Christopher Whelan has used common musical metaphors for describing personage and historic time in this piece. The brass signifies royalty and the 5th interval harmonies signify remote past or historic time. He has also used interesting tonal clusters, which underscore these metaphors and help to signify the doomed mood of the play. The slow deliberate tempo together with the use of minor tonality helps to highlight the gravity of the situation. The sustained single note crescendo-diminuendo effect

(< >) at the close creates a tremendous sense of drawing or sucking the listener through a time warp into meeting Kent's first words, *'I thought the King had more affected the Duke of Albany than Cornwall.'*

The music metaphors in the BBC4 prelude are expressed in a signifier–signified relationship in the following illustration.

BBC 4 – Production Prelude *King Lear*

SIGNIFIER	SIGNIFIED
[Musical]	*[Meaning]*
Tempo (slow) – together with	*Serious, stately*
Key – minor key	*Gravity, sorrow, death, doom, darkness*
Low 'groaning' bass chord	*Anger, danger, unfriendly, protagonist?*
Horns (hunting theme)	*Royalty as institutional, power over vast lands and peoples (ref. hunting theme)*
Tubular Bell/Piano – 5th interval	*Interruption, sudden change, signal*
Arpeggiated Harp chord	*Soft, feminine, consonant sounding against the harsher brass sound creating a sense of mystery, suspense or anticipation*
Brass instruments	*Royalty*
– Trombones (downward movement-harsh)	*Descent, fall, powerfully ungraceful*
- Trumpets/horns	*Royalty, historical time, maintenance*
(5th interval chords-upward)	*of the upward illusion of power, comparison between falling down from above.*
Final crescendo + diminuendo	*Marks a dramatic point of tension and integrates music with verbal action*

BBC 3 Production: Music Prelude

BBC 3's prelude is an orchestral war-like piece composed for the production by Patrick Doyle. The prelude is longer than the other three preludes at one minute and fifty-one seconds [00:01:51] in total, that is [00:01:40] for the main body of the prelude followed by an eleven second [00:00:11] sustained diminuendo on a low pitched orchestral chord. The production uses this sustain to great radiophonic effect as the orchestral diminuendo is composed to cross-fade naturally to the opening action of the play. This sustained chord diminuendos to silence under the faded-in sound of approaching footsteps (spot effects, leather on concrete) followed by the approaching voices of Kent and Gloucester.

This cross-fade is significant on three levels. First, it integrates the music directly into the opening action of the play. Second, the pitch range and timbre of the orchestral chord is in sympathy with the pitch and timbre of the footsteps. Third, and perhaps most importantly, there is a high degree of co-ordination between the rhythmic structures of the prelude and that of the opening footsteps and vocal delivery. These are not just any set of footsteps taken from a sound fx. disc, but well performed 'spot' effects producing a steady, unhurried rhythm in sympathy with both the pulse of the music and the opening vocal delivery. This creates an integrated and seamless extension of the dramatic pulse of the music into the opening dramatic action of the scene.

Patrick Doyle has composed a highly dramatic piece of music using a combination of melodic simplicity surrounded by clever yet stirring orchestration. The piece plays at an Andante tempo of circa 66 bpm (4/4 time), which is significantly close to the natural average human heartbeat rate of circa 70 bpm. and to that of a casual ponderous walk (ref: Gloucester & Kent's entrance). This underlying andante pulse beat creates an instinctively human rhythmic compatibility with the music, while also laying a natural rhythmic foundation facilitating the seamless integration of the opening sounds with the music.

The piece is in the key of C# minor and again the minor key is used to signify an air of sadness and gravity. The melody is tonal throughout and is a straightforward linear construction in A/B

form spanning one octave in a downward movement across
seven bars. The melodic phrase repeats itself three times on the
8th, 16th and 24th bars with each repeat introducing variations in
the orchestration. The piece is faded down at bar 8 (1st repeat) to
facilitate a dramatic verbal introduction to the play (title, author
and main cast).

On the third time repeat the melody is interrupted midway by a
prominently sustained G# (the dominant in the tonic) played by
the horns, while the double basses sustain the tonic note (C#) a
5th lower supported on the initial beat by the timpani. There are
two points of interest about this final chord. First, the two notes
tonic and dominant played together create a bare 5th interval
spoken of earlier as possibly signifying historic time. Second, in
this particular case the aural prominence and dynamics of the
dominant over the tonic gives the chord a disturbingly
'unfinished' or interrupted sound in the sense of displacing the
tonic as bass note and ending on a 2nd inversion. This
'unfinished' interruption creates a perfect aural cue from which
footsteps and voices rhythmically emerge as if being an extension
of the music itself.

The strong pulsating rhythmic structure of the piece (played four
crotchets in the bar throughout) is created predominantly by the
double basses and timpani (playing a low C# tonic note)
supported by other percussion instruments such as snare drum
and cymbals. Its steady four in the bar pulse is given a sense of
movement by timpani rolls across beats one and two and crochet
soft mallet beats on three and four. The melody played by the
lower brass section (trombones etc.) moves with a strong sense
of the prevailing pulse beat. Instrumental variations in the
orchestration include the alternating use of high single note
sustained semi-quaver bowing on violins and middle-upper
register trumpets playing the melody in a higher octave.

There are two interesting aspects about the melody. First, it
begins with a minor second interval (e to d#) as two quavers on
the first beat and second, the note d# is repeated with emphasis
on the second beat and sustained for over two beats. In the first
instance the use of the minor 2nd interval as the opening notes of
the melody dramatically reinforces the minor key tonality as

signifying gravity, sadness etc. In the second instance, the prominent dissonant clash in a tonal piece of a major 2nd interval played together (C# and D#) creates a tremendous sense of melodic unease. It is as if the melody is tonally at variance with the sense of key maintained by the double basses and timpani playing the tonic bass note (C#). The dissonance is less pronounced in this instance as the major 2nd clash is played in the bass region and due to the broader nature of low frequency sounds, this major 2nd clash appears less strident than if it occurred in the higher frequencies. As the tonic chord and its bass note performs the aural function of anchoring or rooting the ear to a sense of 'home' key, then the variant nature of this melody gives the feeling of tonal unease and removal from the 'home' key. The 'home' key of C# minor played by double basses and timpani could be said to signify Lear's Kingdom, the seat of power and root of stability. The variant tonal melody played by the brass might signify the main protagonist, Lear, as being one tonally removed from that establishment, a type of dissonant dissident. Placing the melody in the bass region as signifying older age further reinforces this.

The music metaphors in the BBC3 prelude are expressed in a signifier–signified relationship in the following illustration.

BBC 3 – Production Prelude *King Lear*

SIGNIFIER	SIGNIFIED
[Musical]	*[Meaning]*
Tempo (slow) – combined with	*Serious, stately*
Key – minor key	*Gravity, sorrow, death, doom, darkness*
Steady strong pulse beat	*Slow ponderous heartbeat,*

(Timpani/D.basses)	*Old age, infirmity; powerful, immovable – hard to fight against rhythmically (could this represent the main protagonist or the power associated with the protagonist?)*
Melody (March like – dead march)	*Processional*
Combined with: snare drum rolls	*Military*
Brass	*Royalty*
Repetition (including variations)	*The constancy of the status quo*
Final sustained 5th chord	*Historical time but also facilitates the integration of music to action*
Combined with prominent 5th	*Sense of in-completion, continuation into the ensuing verbal action.*
Melody (bass region)	*Older age, powerful or serious personage*

The following table summarizes the main external elements of the four production preludes. There are some interestingly similar production choices made for the use of music. These similarities highlight a certain commonality in the perception of music as the sonic evocator of mood, feeling, and suspense. For example, all four productions chose music in the sadder sounding minor key. While the tempos were generally slow with the exception of RTE's at moderate tempo, all four productions again chose the more formal orchestral instrumentation in either full or partial use. The predominant melodic instruments were brass with the exception of the SRS prelude, which used the more lonesome sounding woodwind instruments. The melodic pitch centre for each of the preludes fluctuated between mid and low pitch where the pitch centre is essentially governed by the choice of instruments. It is also interesting to note that the two preludes specifically written for their productions (BBC3 and BBC4) were both the longest in time and were integrated into the opening action of the play either partially or fully. Their extended time length helped to create a greater build-up of dramatic tension when compared to the shorter preludes.

Summary of External Elements in the Music Preludes *King Lear*

	SRS	RTE	BBC4	BBC3
Specifically composed	X	X	✓	✓
Time	0' 18"	0' 46"	1' 17"	1' 51"
Tempo	Largo	Moderate	Adagio	Andante
(Bpm - beats per minute)	[c.44]	[c.72]	[c.54]	[c.66]
Key	Minor/modal	Minor	Minor	Minor
Orchestral	Part	Full	Full	Full
Melodic pitch region	Mid	Mid	Mid/low	Low
Melodic instruments	Woodwind	Brass	Brass	Brass
Music integrated to Sc.1	X	X	Partial	Full

I propose to present the analysis of the four radio drama productions in the following way. First, by offering a brief discussion on some of the general points common to each production as raised in the numbered references from the radio analysis script [appendix i]. Second, I will offer an analysis of each production's approach to the points raised. It must be noted that each production separately does not necessarily address all of the points raised. Neither can it be inferred that lack of consideration for certain points by whichever production is tantamount to either poor judgement or faulty production, particularly in relation to music, voice, sound effects or spatial (acoustic) distances. I hope it will become clear to the reader through the analysis those production approaches which proved to be more 'radiophonically' successful in resolving some of the points raised.

This analysis, therefore, should not be read as a qualitative or comparative analysis on the basis of which production is best, but more as an explorative analysis into the practical application of just some of the aspects of radio drama's unique genre. For the purposes of analysis and to enable a clear focus on specific 'radiophonic' aspects, I have divided the analysis section of the scene into four aurally apparent sections. [A] – the entry of Kent, Gloucester and Edmund; [B] – from the entry of Lear (the court scene) to the exit of Kent; [C] – the re-entry of Gloucester with France and Burgundy to the exit of Lear; and [D] – Cordelia's

parting words with her sisters to the end of Goneril and Regan's imminent plans.

As these radio productions are in themselves individually adapted radio performance texts, I have included examples of such radiophonic additions using underlined *italics* as an addition to the Everyman source text of the play. These examples should be heard as 'sound' additions, a form of aural transcodification into the medium of radio, and not to be read as textual additions. In a way it is similar to the imaginative process of aurally 'hearing' the sounds from reading music notation. An example of textual additions is given here:

BBC 3 Production *King Lear* Act 1:i

> LEAR: Know that we have divided In three our Kingdom...
>
> *Sfx: (Crowd) [Brief] Quiet shuffling and murmurs*
>
> LEAR: ...and 'tis our fast Intent To shake all Cares and
> Business from our Age, Conferring them on
> Younger Strengths, while we Unburthen'd crawl
> towards Death.
>
> *Sfx: (Crowd) [Brief] Light laughter, words of disagreement 'No, no'*
>
> LEAR: Our Son of Cornwall, And you, our no less loving
> Son of Albany, We have this Hour a constant Wish to
> publish Our Daughter's several Dowers, that future
> Strife May be prevented now. The Princes, France
> and Burgundy, Great Rivals in our youngest
> Daughter's Love, Long in our Court made their
> amorous Sojourn, And here are to be answer'd.
> - Tell me, my Daughters, (Since now we will divest us
> both of Rule, Interest of Territory, Cares of State),
> Which of you shall we say doth love us most - *[Pause]*
>
> *Sfx: (crowd + Goneril) Brief, nervous laughter*
>
> LEAR: - That we our largest Bounty may extend Where
> Nature doth with Merit challenge. – Goneril, Our
> eldest borne, speak first.
>
> *Sfx: (crowd) [0' 02"] Surprised - murmuring and muttering*

In a similar way I have constructed a visual illustration of the effect of aural distancing. Aural distancing is an important and integral part of the *modus operandi* in radio drama production. This is radio drama's use of spatial sound, which differentiates it from all other types of radio broadcasting in creating an aural perspective. This is the construction of spatial soundscape environments facilitating the aural sense of movement and contextualized spatial relationships between characters. In trying to construct a visual illustration of spatial sound, I am aware that a reader needs aurally to imagine the positions and movement of sound from a visual impression in much the same way as aurally realising the performance text example above.

The visual illustration of aural distancing is constructed as follows with reference to the illustrated example following. The listener is placed in front of the stereo sound field and whether listening to the sound on a set of speakers or on headphones, the aural realization of the sonic setting can be illustrated. In studying the diagram it will be easy to visualize the contextualized sound and placement of characters e.g. which character(s) are prominent, less prominent etc. Such placement in sound is akin to kinetic blocking on the stage and is not randomly chosen by the actors but is planned in advance by the production. Mic. positions 1 to 5, where 1 is closest and 5 is furthest, illustrates the aural effect of proximity and distance as the listener would perceive it. It is important to note that mic. position 2, (that is, close but not very close), is the type of proximity sound heard by listeners from generally all other types of radio broadcasting e.g. news reading, presentation, book readings, magazine pro-grammes etc. This is also referred to as the 'presence effect', a type of closeness effect between presenter and listener that is similar to someone speaking to a person while standing close to them. The directions and spatial variations in which the voice moves in the stereo field is indicated by a directional line. To whom the voice is directed, that is, which character is being addressed, is indicated by the letters A, B, C, D etc. as per the radio analysis script [appendix i].

Example of sonic movement within a stereophonic field displaying spatial depth and proximity when aurally realized.

SRS Production *King Lear* Act 1: i

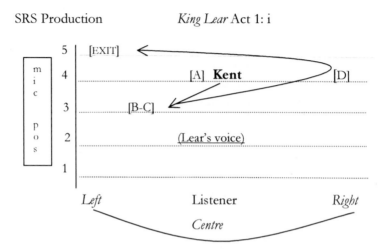

[With reference to Radio Analysis Script - appendix i]

Ref. A.1–2 : appendix i *King Lear* Act 1:i

> A.1 *Is there a sense of place established (interior or exterior)?*
>
> A.2 *What type of aural place is created? A corridor leading to an assembly hall [movement]; an assembly hall with voices/people in it [fixed]; an exterior (garden/gravel path) leading to an interior (hall) [movement]?*

Creating a sense of place, an aural sound stage however short in time, before the first words are spoken provides an important aural bridge into the production for the listener. Firstly, it allows for smooth transition (cross-fade) of the prelude music into this imaginary sonic space before words are spoken. This can create the seamless co-existence of 'music' as character, commentator or emotive provocateur out of which the aural sound stage emerges. Secondly, it opens a histrionic window into a world first alluded to by music but then encountered by its sounds, thereby tuning the listener's ears and providing an aural reference point from where speech can naturally emerge. Intrinsically linked to the creation of an aural landscape is the question of where Kent and Gloucester are meant to be in acoustic terms? Are they intended to be voices fixed at a particular microphone position in a dry studio acoustic? a room in a medieval castle? a garden in springtime? a windswept moor? or a desolate landscape on some

remote planet? Whatever aural space is created, voices need to move initially to create aural interest and to establish distance and perceptual space, whether it is wholly interior, or an exterior leading to an interior or vice versa, is a point of artistic preference drawn from the acoustic setting of the play. The acoustic space created becomes a critical backdrop providing a sound stage, which will be visually completed by the listener with imaginary scenery.

Creating different and therefore identifiable aural spaces or sonic scenery throughout the play is important for generating an imaginative realization of *King Lear* in any radio production. Charles Lamb's opinion that Lear is essentially impossible to be represented on a stage[1], does not immediately mean that it is necessarily better suited to radio. The play's dramatic improbabilities as discussed by A. C. Bradley pose obvious problems for the stage director but are also problematic for the radio producer – it is merely an emphasis on the scale of resolution. In recognising *King Lear* as one of Shakespeare's greatest plays, Bradley, however, considers that as a stage representation it is, from a dramatical point of view, imperfect, and there is something in its very essence which is at war with the senses, and demands a purely imaginative realization.[2] Part of Bradley's criticism on the spatial structure of the play as being ill-suited to a straightforward dramatic visual representation is the relatively fast moving, non-linear and geographically unidentifiable locations of many of its scenes. Yet, by implication, the play espouses a 'vast' physical geography. Lear after all rules over an enormous geographical Kingdom spanning Britain and France, which is signified initially in the play by the map of the territory.

There are also other practical but elemental parameters, including the storm and the gouging of Gloucester's eyes, which pose difficulties in realization for any stage production. Not so with sound – the tools available to the sound (radio) producer can lay bare the fragile pulse of dying emotions as easily as conjuring up the most violent throbbing of unpredictable nature. Through sound the listener can be instantly transported from the warmth and security of the boudoir to the cold rejection of a dungeon, or

from a world with which we may in some way identify to a world we hope never to encounter. Each landscape is so completely different in itself but when imaginatively constructed it can be instantly recognized in a personally aural way in the listener's imagination.

Ref. A.3–appendix i *King Lear* Act 1:i

> *A.3* *Are the characters to enter on mic creating a sense of movement or are they stationary on mic. (fixed position)?*

Should the characters, Kent and Gloucester, move into the microphone pickup range, speaking as they move, or should they remain fixed in a relatively close position from the start? Kent's opening statement, *I thought the King had more affected the Duke of Albany than Cornwall*, followed by Gloucester's reply, proves significant on two accounts. First, for the light it throws upon the characters of these two pivotal opposites (Albany and Cornwall) in the development of the play. Second, it pre-empts the summoning of this royal gathering, the council of state in which Lear announces his 'abdication' and *the Division of the Kingdom*. The physicality of moving-while-speaking has to be carefully considered lest this line, the first spoken words in the play, sound faded-in and possibly lost to the listener. It is accepted that the microphone is euphemistically the listener's psycho-acoustic point of hearing in the sense that the microphone(s) represents to the actor the ear(s) of the listener. Hence, different microphone positions represent variable proximity effects to the listener's ear. The either/or, move or fixed position creates two different aural sensations for a listener. The move scenario brings the action to the listener by gradually moving into his/her hearing range, psychologically creating a moment of inquisitiveness, thereby inviting the listener to engage with the action. The opening moments of a radio play are critical in attracting the listener's attention, stimulating the imagination, and creating aural interest.

For the listener, the sound of actors moving on microphone creates a greater aural awareness of varying acoustic distances.

The fixed position suitable for some occasions drops the listener into a pre-existent level of conversation as if 'uninvited', but with possibly no point of aural reference it can lead to moments of confusion as to the sense and intent of the words spoken. With regard to the actors, speaking-while-moving can encourage a more positive fluidity in vocal 'acting', minimising the dangers of vocal 'reading.' This is a particularly important point when dealing with a broadcast version of Shakespeare. To misinterpret what should sound as character dialogue for the sound of character reading is an obvious acting fault, as is the more traditional sound associated with the declamatory style of Shakespearean acting. In acknowledging that Shakespeare is first and foremost a dramatist and 'not some rarefied literary poet', Andrew Rissik is critical of the loftier vocal style of the Stratford Voice in Shakespearean acting.

> My primary complaint against the Stratford voice and its
> ludicrous elevation of the art of delivery is that it turns
> the acting of Shakespeare into something monotonous,
> arid and cerebral...The Stratford voice – with its
> inverted rhythms, its caesuras that have nothing to do
> with sense, its elevated stress on minor syllables – is
> fundamentally an academic self-indulgence.[3]

That formal and declamatory style of vocal acting, which beset the early BBC radio productions of Shakespeare, is clearly not what is required for good broadcast acting.

Ref. A.4 : appendix i *King Lear* Act 1:i

A.4 Consideration of vocal pitch, timbre and tempo of delivery between characters.

Enter Kent, Gloucester, and Edmund.

KENT: I thought the King had more affected the Duke of
 Albany than Cornwall.

GLOUCESTER: It did always seem so to us; but now in the Division
 of the Kingdom it appears not which of the Dukes
 he values most, for Qualities are so weigh'd that
 Curiosity in neither can make Choice of either's
 Moi'ty...

The selection of appropriate voices to play Kent, Gloucester and Edmund would be an important consideration at this early point in the play. In the first instance they are the first triumvirate of voices to be heard in the play and therefore have the extra responsibility of engaging the listener's attention. Secondly, this introductory section informs us of important pieces of character information and more especially it builds towards the first climactic cadenza, the arrival of Lear. We are quickly informed of the immediate course of events, Lear's abdication and the division of the Kingdom. This later creates an interesting sub-plot (matriarchal v patriarchal – who exercises the power of action?), and is further contrasted between the relative blandness of Albany and Cornwall with the cunning and ruthlessness of Goneril and Regan.

We are also informed of a further family division as we are introduced to the character background of Gloucester's illegitimate and 'knavish' son Edmund while also being made aware of a more valued elder legitimate son *'by order of Law.'* Is Gloucester's confirmation of Edgar's older age any subtle insight into Gloucester's character as being possibly manipulative but unreliable, more impetuous than shrewd? The choice of voice to play Gloucester and Kent is important. They are both Earls in Lear's Kingdom where they have attained positions of respect and relative authority. They are also older than Edmund. One of the more common ways of aurally depicting relative ages is through vocal pitch combined with tempo of delivery. Taking the male voice range as an example, if the modal voice is a lower pitch (bass/tenor) combined with a slow to moderate tempo of delivery (including phraseology, pause and hesitancy), it can create the illusion of older age. A younger modal voice, though not a child's voice, will in comparison be generally a higher pitch (high baritone – tenor) combined with a quicker tempo of delivery. Although this is a general rule-of-thumb, it must be noted that there are other important physiological factors, which can effect an actor's vocal production including the choice of words and the context of the spoken text. To borrow a simplified extract from a method of understanding orchestration through colour visualization, different instruments according to their

pitch ranges are assigned different colours from the spectrum. For example, brighter tones = higher pitches [yellow = flute]; mid tones = medium pitches [blue = clarinet]; deeper tones = lower pitches [brown = cello]; dark tones = lowest pitches [black = double bass]. The appreciation of orchestration can then be approached from the visual concept of painting in sound and aurally realized as instrumental colours, collages of alternating colours/pitches/instruments. Radio drama is also a form of orchestration, the orchestrated sound of voices, music, sound effects etc. This colour concept can also be applied to radio drama's individual elements but particularly so to those of its voices where the approach should always be one of vocal orchestration.

The consideration of all voices in a production is of the utmost importance especially that of its main protagonist. Lear is the elder statesman, he is the King, a powerful God-like figure controlling his own kingdom. But he is also elderly and on the point of abdication. What type of voice (pitch, tempo, rhythm and phrasing) should Lear have? From his natural position of dominance over the lives of his subjects one might expect his voice to exude power, power that is elderly but power that is also respected and possibly feared. Not the type of power that can be achieved by merely increasing the dynamic range (e.g. raising the volume) or delivering the voice in a pulse register.

Ref. A.5–7: appendix i *King Lear* Act 1:i

<u>A.5</u> *Is Edmund audible in the scene before Kent's question?*

KENT: <u>Is this not your Son, my Lord?</u>

<u>A.6</u> *Who leads the humour from this point? Is Edmund intended to overhear the conversation?*

GLOUCESTER: His Breeding, Sir, hath been at my Charge. I have So Often blush'd to acknowledge him that now I am braz'd to't.

KENT: I cannot conceive you.

GLOUCESTER:	Sir, this young Fellow's Mother could, wereupon She grew Round-womb'd, and had indeed, Sir, a Son for her Cradle ere she had a Husband for her Bed. Do you smell a Fault?
KENT:	I cannot wish the Fault undone, the Issue of it being so proper.
GLOUCESTER.:	But I have a Son, Sir, by order of Law, some year elder than this, who yet is no Dearer in my account, though this Knave came something saucily to the World before he was sent for: yet was his Mother fair, there was good Sport at his Making, and the Whoreson must be acknowledged. – <u>Do you know this Noble Gentleman, Edmund?</u>

<u>A.7</u> *Where is Edmund spatially to G & K? is Edmund fixed, with G & K moving towards E or vice versa?*

A character does not exist for the listener in a radio drama unless he/she is referred to in some way or can be identified through sound. The problem arises in the beginning of *King Lear* of trying to create an aural visibility for the silent and as such aurally invisible Edmund. What sound is aurally present for the listener that naturally gives rise to Kent's question, *Is this not your Son, my Lord?* Should Edmund audibly walk into the scene behind Kent and Gloucester? Or should he be audible from the beginning where Kent and Gloucester walk into his space? Either scenario would yield a more natural prompt to Kent's question. These points of artistic choice are just two possible approaches to the problem of the silent character and either may prove acceptable. On stage and in film the three characters can be made visible and therefore no aural clue to Edmund's presence is necessary; he can remain a silent but visible character, but not so on radio. It would appear from Shakespeare's text that Gloucester is the more flippant in his account of Edmund's conception and birth than Kent is from his more reserved replies. It is perhaps a subtle point, but is Edmund intended to overhear Gloucester's account

and therefore be privy to the conversation between Gloucester
and Kent? [4]

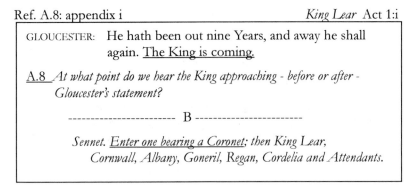

Ref. A.8: appendix i *King Lear* Act 1:i

> GLOUCESTER: He hath been out nine Years, and away he shall
> again. <u>The King is coming.</u>
>
> <u>A.8</u> *At what point do we hear the King approaching - before or after -*
> *Gloucester's statement?*
>
> ----------------------- B -----------------------
>
> *Sennet. <u>Enter one bearing a Coronet</u>; then King Lear,*
> *Cornwall, Albany, Goneril, Regan, Cordelia and Attendants.*

Shakespeare signifies Lear's entrance with the visual symbolism
of *one bearing a coronet*, followed by Lear and his entourage. The
coronet signifies Kingship or the seat of power. Why it is a
coronet and not a crown is perhaps questionable, [*coronet ;* a little
crown, an inferior crown worn by princes and noblemen[5]]. A
sound or aural signifier is required to replace that of the visual
coronet and would most likely be a fanfare played by brass
instruments. The use of brass instruments (trumpet, the older
cornet/post horn and the hunting horn) has long been accepted
as signifying royalty, power, even great events and in religious
music those of God and God's power in heaven and on earth.
The Old Testament is peppered with references to the use of
trumpets and cornets as signifying heavenly power. The walls of
Jericho were brought down to the clamorous sounds of trumpets
and voices … 'And when the voice of the trumpet shall give a
longer and broken tune, and shall sound in your ears, all the
people shall shout together with a very great shout, and the walls
of the city shall fall to the ground.' [6] And Asa's covenant with
God was sealed to the sound of voices and brass instruments.
'And they swore to the Lord with a loud voice with joyful
shouting, and with sound of trumpet, and sound of cornets.' [7]
Perhaps the most identifiable use of the trumpet is to be found in
Handel's *Messiah*, the famous trumpet air followed by the bass
aria, *The Trumpet shall sound, and the dead shall be raised.*[8]

Isabelle Cazeaux states that the arrival of Kings or other notable personages into a town was the occasion for much music-making. When Charles VI arrived into Paris on 13 October 1414, the people began to make bonfires and to sound their horns more than had ever been seen for the past one hundred years. The Duke of Bedford made a solemn entry into Paris in 1424, preceded by his four trumpeters, and Louis XI's cortege upon his return to Paris after his coronation included fifty-four trumpets[9]. Public proclamations, such as the announcement of peace, were made to the sound of the trumpet. Other outdoor activities accompanied by that instrument may have included executions, or public torture. Its use in this instance concurs with the sound of the trumpet (or brass instruments in general) as signifying the sound or indeed the voice of authority and power.

SRS Production Analysis – [Section A: 1–8]

The SRS production does not provide an aural link between the prelude music and scene 1, neither is there any attempt at creating a sense of place. The prelude music fades to Kent's opening line where Kent and Gloucester remain fixed at mic position 3 in a dry studio atmosphere. SRS's production is lack-lustre and unconvincing in radiophonic terms. There is good vocal articulation throughout but very little vocal characterization with the exception of Lear (Paul Scofield). Kent's voice (Andrew Keir), is a lower register/richer timbre voice (baritone) and he speaks with a slower measured tempo compared to Gloucester's (Cyril Cusack) lighter timbre (tenor), faster tempo and at times erratic phrasing. These differences in vocal delivery, deliberate or not, create separate impressions of both courtiers, Kent, as being measured, honest and sure of himself while Gloucester, although also honest, is perhaps less sure of himself and more prone to the winds of change. Edmund is not audibly in the scene, so in sound terms does not exist until his first line, *No, my Lord.* He is placed further back at mic position 4, creating the initial impression that he is not just a minor character but a minor character of little importance or potential threat. Lear's entrance music plays for thirty seconds [00:00:30] and is quite dramatic. It begins with a distant timpani roll before Gloucester's statement

and builds into a stately brass fanfare at andante pace moving in downward melodic intervals. The trumpets dominate the instrumental sound and are accompanied by two timpani beats playing the dominant and tonic notes. Timpani rolls are used at phrase ends creating an effective and dramatic sounding piece.

SRS Production *King Lear* Act 1:i

GLOUCESTER:	He hath been out nine Years, and away he shall again. *[pause]*
MUSIC:	*Timpani roll [00: 00: 02:00]*
GLOUCESTER:	The King is coming.
MUSIC:	*Brass fanfare [00: 00:28:00]*

SRS Production *King Lear* Act 1:i

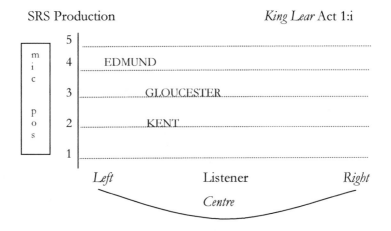

RTE Production Analysis – [Section A: 1–8]

The RTE production does not make use of an aural link between the prelude music and scene 1. The music is abruptly faded-out before the short preamble to scene 1 is faded-in. The production uses an interesting preamble where the sounds of approaching footsteps (spot fx.) and light laughter (Kent and Gloucester) are heard before Kent speaks. This sets the tone for section A as being lighter and allows for playing-up the potential humour over Edmund's illegitimacy, particularly by Gloucester. The

combination of fading-in (spot fx. and laughter) with voices moving towards the microphone creates the illusion that the characters have walked into the scene from somewhere else and had been speaking about, or reacting to, something said before Kent's first line, *I thought the King had more affected the Duke of Albany than Cornwall.* This illustrates Basil Maine's point that laughter is a cadenza of speech and in this case it creates the sense of an immediate past to the scene. A past which in itself holds no importance of content to the play, but a past nonetheless that through its non-verbal utterance (laughter) creates a sense of immediacy or inquisitive present for Kent's first words. Kent and Gloucester move from mic. positions 4 to 2 across speeches 1 to 3. The sense of place (an interior reverberant hallway) is well established from the start by placing the voices in a deep rich reverb. It is curious though that the footsteps (leather on wood) were recorded dry (no reverb), creating the aural impression that the footsteps do not belong to either the characters or the acoustic setting. The footsteps were performed by spot fx., but the realization that footsteps reverberate, just as voices do in a reverberant acoustic space, was overlooked by the production. I would also query the choice of footsteps sound, e.g. leather-on-wood, as being tonally subdued for a stone castle acoustic. (I refer to the BBC 3 analysis following, where the footsteps sound was created by leather-on-stone + reverb). The choice of voices was particularly suitable for the characters, Kent (Aiden Grennell) and Gloucester's (Peter Dix) both have low pitch/rich timbre voices (baritone) with equally effective dynamic stress, however, Gloucester's voice employs a greater use of upward pitch variation in his phraseology making it somewhat more animated. As both performers use a similar moderate tempo in delivery, the vocal contrast between them is less strikingly obvious than in the SRS production.

The RTE adaptation uses a good example of 'character identity' within a scene when Kent adds the name 'Gloucester' to his question, *Is this not your Son, my Lord <u>Gloucester</u>?* The addition of well-chosen and subtle identity tags in a radio play can prove an important counteraction to potential listener confusion over who

is speaking or to whom a question is directed. This is evident with voices of the same gender and especially between voices that are similar in pitch, timbre and tempo of delivery, unless the written dialogue (syntax and grammar), accent or vocal inflections are in themselves contrasting enough to create obvious differences. Edmund is not aurally in the scene until his first line, *No, my Lord,* and when he does speak he is equal in spatial terms (mic position 2) to Kent and Gloucester creating the impression that they may have walked up to this silent character!

A brass fanfare (horns, trumpets and trombones) is faded by using a slow fade (also referred to as a long fade) behind Gloucester's line, *He hath been out nine Years…*etc. The piece lasts fifteen seconds (00:00:15) in total and moves at a lively or allegro pace. It is obvious that the piece was faded in on the final phrase of a longer piece, which destroys any sense of completed identity (beginning-middle-end). The music functions as an external element in the production, its choice and use being one of expediency rather than consideration. This brass fanfare was an unfortunate production choice. It is the final cadence of a well-associated signature tune for the RTE Radio 1 programme, 'Sunday Miscellany.' Using an identifiable piece of music such as this, especially associated with a different context, not only mixes metaphors but casts an element of doubt upon the credibility of the production choice.

RTE Production	*King Lear* Act 1:i
MUSIC:	*[Fade in over Gloucester]*
GLOUCESTER:	He hath been out nine Years, and away he shall again. The King is coming.
MUSIC:	*[Fade up to end]*

Gloucester's phrasing in these lines is somewhat peculiar. He disregards the full stop/pause at the end of the first sentence and connects *The King is coming* to the sentence, making it the final clause of one sentence ending in a downward inflection. For example, *He hath been out nine Years, and away he shall again, the King*

is coming. This fails to create a sense of anticipation about the King's arrival and does not make any vocal association with the music as an internal element in the scene signifying the King's approach. The illusion created by interrupted dialogue, pause, or non-verbal utterance as Gloucester becomes 'aware' of the fanfare's significance would recognize the music's indexical and symbolic meaning.

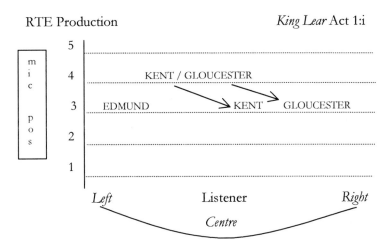

BBC4 Production Analysis – [Section A: 1–8]

The BBC 4 production is quite similar in many ways to the SRS production. BBC 4 created no sense of place and, therefore, no aural link between the prelude music and the scene, the music being closely faded into Kent's opening words. BBC4 use a dry studio acoustic with Kent and Gloucester fixed at mic position 3 from the start. As with the SRS production, Gloucester is played by Cyril Cusack. Although there is a gap of twenty-three years between the two recordings Cusack's vocal performance in both productions is remarkably similar (pitch and timbre) but a little more characterized and animated (tempo and phraseology) in the BBC 4 production. A study of Cusack's two Gloucesters would prove to be an interesting analysis in vocal performance technique, particularly in his contrasting use of phrasing, emphasis, inflection, and pauses. There is a sharper contrast between the voices of Kent and Gloucester in this production. Kent's voice (Trevor Martin) is pitched bass voice yielding a dark

rich timbre that produces a powerful magnetic presence on microphone. Gloucester's (Cyril Cusack) has a lighter tenor quality and when spoken at a quicker tempo creates the illusion of a younger less secure and possibly even lower ranking courtier than Kent. BBC 4's adaptation makes excellent use of non-verbal utterances, e.g. laughs, chuckles etc., at different points between the text. This has the dramatic effect for the listener of bringing Shakespeare's text alive by creating a sense of spontaneous conversation between the characters. These non-verbal utterances create a more natural sense of rhythm, which gives Shakespeare's words a conversational flow rather than a textual recitation. It also underscores aurally, in this case better than words alone can, the humour implied in Shakespeare's text. BBC 4 has Kent leading the humour in response to Gloucester's explanation of Edmund's illegitimacy.

BBC4 Production *King Lear* Act 1:i

GLOUCESTER: *(jokingly)* Sir, this young Fellow's Mother could…	
KENT: _(Laughs)_	
GLOUCESTER:	…whereupon she grew Round womb'd, and had indeed, Sir, a Son for her Cradle ere she had a Husband for her Bed.
KENT: _(Heartier laugh)_	
GLOUCESTER: _(Joins_ KENT _with a chuckle)_ Do you smell a Fault?	

Edmund is not audibly in the scene before his first line, *No, my Lord.* He is introduced spatially behind the voices of Gloucester and Kent at mic. position 4 but moves into position 3 across his lines. A short variation of the prelude music (00:00:10) is played after Gloucester announces *The King is coming.*

BBC4 Production *King Lear* Act 1:i

GLOUCESTER:	He hath been out nine Years, and away he shall again. The King is coming.
[MUSIC:	_Fade in]_
SFX:	_Footsteps and rattling of chains_

The music in this instance is used as a music-bed over which the sounds of movement and metallic clinking are heard (see B.1 Appendix i). The music concludes with two slightly out of tune notes played a major 2^{nd} apart on the tubular bells. The inclusion of the tubular bells in the score at this point is somewhat unfortunate as they sound in context more like modern door chimes. There is no character awareness in the BBC 4 production that the music belongs as an internal element within the scene. Instead it appears as an external element that has little or no aural impact upon the speaking characters. The perception of music as an external element in this instance negates the role of music as either an index or symbolic function within the *mise-en-scène*.

BBC 4 Production *King Lear* Act 1:i

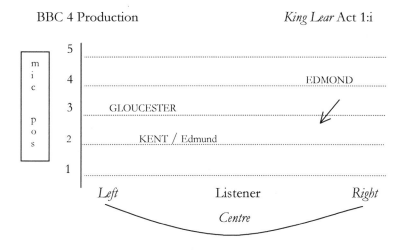

BBC3 Production Analysis – [Section A: 1–8]

The BBC3 production is the most dramatic of the four productions in its exploitation of radiophonic techniques. As mentioned earlier in the analysis of its prelude music, BBC 3 cross-fades its music to the sound of walking footsteps. The footsteps use the same tempo established by the music and unlike RTE's footsteps (leather on wood), BBC3's are leather-on-stone with added reverb. This is a subtle but important sonic difference as BBC3 creates a sound that is more aurally sympathetic to the illusion of the interior of a medieval stone built castle. A sense of place, a castle interior, is well established

by placing the voices of Kent and Gloucester and the footsteps in a lighter more natural sounding reverb than that used by RTE. BBC 3 use a reverb setting that has a slower attack and faster decay producing a shorter time length of approximately two seconds. The slow attack, which uses slower early reflections, creates a greater sense of spatial depth while the illusion of an interior/enclosed space is maintained by the faster decay. The footsteps are faded in to create sympathetic movement to Kent and Gloucester's move from mic positions 4 to 3 across their opening lines. The voices of Kent (Keith Michell) and Gloucester (Richard Briers) are very similar in pitch and timbre (baritone range) and tempo of delivery, giving the impression that both men are of similar age, position, and experience. The tone of vocal delivery is somewhat older and positively stately. BBC 3 is the only production that sonically places Edmund in the scene before Kent's question at speech 3. Acknowledging that in a radio drama a character can only be aurally visible if he/she is in some way sonically present, Edmund interrupts Kent with a verbal interjection, *Ah*. This both signals his presence in the scene and gives rise to Kent's question, *Is this not your Son, my Lord?*

BBC3 Production *King Lear* Act 1:i

GLOUCESTER:	It did always seem so to us; but now in the Division of the Kingdom it appears not which of the Dukes he values most, for Qualities are so weigh'd that Curiosity in neither can make Choice of either's Moit'y.
Sfx:	*[Sounds of movement — shoes shuffle to a halt]*
EDMUND:	*Ah!*
KENT:	*[off-mic]* Is this not your Son, my Lord?
GLOUCESTER:	His Breeding, Sir, hath been at my Charge. I have so often blush'd to acknowledge him that now I am braz'd to't.
EDMUND *followed by* GLOUCESTER *Light laughter*	

Edmund is maintained in the scene from this point by vocally joining in the humorous non-verbal utterances (chuckles and laughs) of Gloucester and Kent during Gloucester's account of his making. In this production Edmund is clearly meant to hear Gloucester's account of his conception/birth and confirmation of his illegitimacy. The mixture of three male voices, which could generate a confusion of identity for the listener, is avoided here by the choice of Edmund's voice (Kenneth Branagh), a younger, lighter, tenor voice compared with the voices of Kent and Gloucester. The approach of the King is signalled during Edmund's line, *Sir, I shall study deserving,* by the distant sound of two timpani playing intervals of a 5^{th} apart in a slow deliberate tempo. This slow tempo together with the repeated 5^{th} intervals creates the peculiar association of one laboured in movement and breath, the pronounced inhale and the slow exhale of life's breath itself. The timpani grow to a crescendo accompanied by sound fx. (movement, light chatter, people in the background, light laughter), which is brought to an abrupt end by the sound of two mace beats announcing Lear's arrival. This section is sonically very dramatic and effective and provides an interesting radiophonic alternative to the stock symbolism of 'regal' trumpets.

BBC3 Production *King Lear* Act 1:i

EDMUND:	Sir, I shall study deserving
MUSIC:	*[Fade-in timpani beats – slow crescendo to mace beats]*
GLOUCESTER *followed by* KENT *Light chuckle + Ah!*	
GLOUCESTER:	He hath been out nine Years, and away he shall again.
Sfx:	*[Fade-in movement, light chatter (background), light laughter]*
GLOUCESTER:	The King is coming.
MUSIC / Sfx:	*[…continue crescendo – 00:00:05]*
Sfx:	*[Two mace beats – on stone]*

BBC3 Production *King Lear* Act 1:i

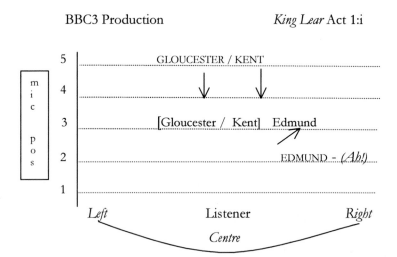

22 | *King Lear* | Discussion | Analysis–B

<u>[With reference to Radio Analysis Script - appendix i]</u>

[Ref. B.1–2 : appendix i]

Sennet. <u>Enter one bearing a Coronet</u>; then King Lear, Cornwall, Albany, Goneril, Regan, Cordelia and Attendants.

<u>B.1</u> *Are there sound fx surrounding Lear's entrance?*

<u>B.2</u> *Consideration of Lear's vocal pitch, timbre and tempo of delivery*

LEAR: Attend the Lords of France and Burgundy, Gloucester.

Section B poses greater problems for aural transcodification. On the stage the entrance of Lear and his entourage is visibly apparent and when combined with costume, make-up, movement, and voice delivery, his elderly, domineering stature can be readily shown. On radio, aural clues are the only clues available e.g. music, words, sounds, etc. Music, particularly the use of brass instruments, has been referred to as being a symbolism of royalty. Words also take on a symbolic meaning in this case, as with Gloucester's line *The King is coming*. Separately or together, music and words create little dramatic impact but when combined with sound fx. and verbal silence the impact is significantly heightened. The verbal silence I refer to here is the time lapse between Gloucester's last line *The King is coming* and Lear's first line, *Attend the Lords of France and Burgundy, Gloucester.*

This time lapse is not silent in itself, it is filled with the sounds of movement but it is silent of words. This helps to create both an aural perception of spaciousness and an anxious anticipation of Lear. The sounds of movement cannot be so general as to be meaningless. This is not the movement of ordinary people; it is the movement of a powerful King entering into his own domain. In this context the sounds may need to be further qualified if they are to signify the movements of a King.

We have up to this point been introduced to the voices of three characters in the play, (Kent, Gloucester, and Edmund). The choice of voice to play Lear as the main protagonist (vocal pitch, timbre and tempo of delivery) is highly significant. What we can learn of Lear, the person, his possible age, his character, his temperament, will all be contained within his voice and revealed within the first moments of his speech. Lear commands not just as King but as an absolute right. His first sentence in the play is a command to Gloucester, which is speedily obeyed. He further commands his daughters to verbally express their love for him, commands that Cordelia be disinherited and disowned, and commands that Kent be exiled. He is at the outset one who is used to giving commands and commanding absolute obedience. Wherever Lear's sense of cruelty lies, either in his heart as an emotive impulse or his mind as a cognitive response, it is expressed verbally through his voice. He, the Royal Institution, commands through his voice; he, the slighted monarch, is cruel through his voice; and he, the human being and father is also kind and forgiving through his voice. Lear is a complex character whose complexities in a sound drama are more stridently enunciated through his vocal responses. It is here in the voice that we begin to explore the intricacies of Lear's humanity; or, to express it in Holbrook's words, to identify the person with whom we think we know.

[Ref. B.3–4–8: appendix i]

LEAR:	Attend the Lords of France and Burgundy, Gloucester.	
GLOUCESTER:	I shall, my Lord.	*Exit.*
<u>B.3</u> *Does Gloucester audibly exit the scene?*		

> LEAR: Mean time we shall express our darker Purpose.
> <u>Give me the Map there.</u>
>
> **B.4** *How is the significance of the map dealt with aurally (sounds, movement, pauses etc.)?*
>
> **B.8** *How are these maps lines signified aurally?*
>
> LEAR: Of all these Bounds, even <u>from this Line to this</u>,
> With shadowy Forests, and with Champains rich'd…

There are elements throughout this [B] section of the scene both visual and vocal which require a careful process of transcodification lest inappropriate sonic/aural signs are given/received.

Why does Gloucester need to exit the scene at this point? Is it as simple as obeying Lear's command to *Attend the Lords of France and Burgundy* or is there a reason why Shakespeare does not want him to witness the division of the Kingdom, the ensuing cruel act of disinheriting Cordelia and the impetuous act of banishing Kent? Granville Barker claims that Gloucester 'is the play's nearest approach to the sensual man.' [1] The civilized world may indeed be full of people like Gloucester, and Gloucester himself, like so many sensual men, is good nature itself, as long as things go their easy, natural way; but when they fail to be, he is upset, rattled.' [2] Shakespeare cleverly avoids answering the question of whether Gloucester would be rattled enough to challenge Lear over his act of disinheriting Cordelia. Kent on the other hand, forthright, honest, and fearless does challenge Lear and is offered banishment or the threat of death as a consequence. But Gloucester was not present to witness this row either! His exit from the scene preserves his gullible neutrality and heightens our emotional response towards the later deceptions and cruelty played out against him. In a radio version how do we aurally know that Gloucester has exited the scene? In the theatre Gloucester's exit presents no problem, he just visibly leaves the stage and therefore is not part of the ensuing action. In sound Lear's verbal command to *Attend the Lords of France and Burgundy* will not in itself prove sufficient.

The map in this scene is of particular interest because it functions as a signifier on two levels: in the first instance as a symbol and in the second as an index. The symbolism of the map as signifying Lear's kingdom is testimony to power and spatial ownership, stretching far beyond the confines of Lear's 'throne room.' This symbolism can be exaggerated or diminished to an extent through visual illusion depending on the relative size of the map displayed. [An interesting alternative to a paper map was used in Peter Brook's film *King Lear* starring Paul Scofield as Lear. Lear draws his Kingdom with a stick in the sand of the floor and divides it up roughly with similar 'accuracy'! Whatever medium is used by the visual performance genres, radio is presented with a very different type of problem. What is the sound of a map? It may be that the map only exists in sound as it is being unfolded – the silent folded-out map being no more present in sound than a silent character. Its unfolding 'sound' however, is not just a simple matter of rustling paper in front of a microphone – it clearly has to have a 'map' sound other than that of plain paper, or else it will sound like a horrendous paper rustle. The time taken to 'unfold' the map may also be somewhat analogous to the visual illusion of size spoken of above. This refers back to the concept of radio's structuring form of time and space, where the time frame of any one-event structures our perception of space within it, that is, the illusion created by the sounds heard within the given time frame. It could be argued that the sound of the 'actual' lines drawn on the map by Lear [ref. B8] are the signifying index of his abdication of control, whereas the sound of the unfolding map symbolizes the geographical Kingdom.

The physical act of drawing these divisional lines on the map is the visible witnessing of Lear's abdication. Lear's perceptive attempt to *publish our Daughters' several Dowers, that future Strife may be prevented* divides the stability of the established whole into three new potentially rivalling ownerships. The fact that Cordelia was to be disinherited of her share within minutes of the division did not necessitate a redrawing of the map into two halves. By slight of hand or psychological illusion the division into three remains dominant as Cordelia's portion moves imperceptibly, from being one of physical and geographical proportions, into one of intense

psychological drama – her banishment, the loss of her father's love and their eventual reuniting.

[Ref. B.6–9 + (B.7–10 – Cordelia): appendix i]

B.6 Consideration of Goneril and Regan's vocal deliveries

GONERIL: Sir, I love you more than Word can wield the Matter, Dearer than Eyesight, Space and Liberty…

B.9 Similar to B.6 above.

REGAN: I am made of that self Mettle as my Sister, And prize me at her Worth. In my true Heart I find she names…

[B.6–9] Consideration of the style, phrasing and intonation of Goneril and Regan's vocal deliveries is important. Here Shakespeare dissembles the function of language as being symbolically truthful. He writes the words for the sisters' declaration of their love for Lear, but in an almost Brechtian style of alienation we are required to hear the falsehood in the delivery of these words through their voices. This is a good example of the possible redundancy of words, their symbolic meaning immediately changed and twisted out of recognition by an opposing vocal intonation. It would be wrong to hear these words spoken as passionately truthful because this would negate the more palpable truth lying in Cordelia's absence of words. It may be somewhat easier to voice falsehoods in verse form, e.g. deliberate straight reading or poor recitation where the words are clearly not those of the speaker. But we are left under no illusions as to their true characters when they drop from verse to prose at the end of the scene. Should Goneril and Regan be presented from the beginning as cold, hardhearted, even wicked individuals? Characters who are pre-formed rather than evolutionary. As Granville Barker posits, 'we may see, then, in Goneril and Regan, evil triumphant, self-degrading and self-destructive.' [3]

[B.7–10 – Cordelia]

B.7 *If Cordelia's line is written as an aside how is it produced in interior monologue?*

CORDELIA: What shall Cordelia speak? Love, and be Silent.

B.10 *Cordelia's line similar to B.7 above.*

CORDELIA: - Then poor Cordelia, And yet not so, since I am
 sure my Love's More ponderous than my Tongue.

[B.7–10] Cordelia's two lines are typical examples of the Shakespearian 'aside.' The 'aside' is in reality the un-voiced interior thoughts of an individual. Whatever difficulty this might pose on the stage, on radio it is a completely natural extension of the medium that favours interior perception. Interior thoughts can be presented different ways but obviously have to be voiced. Two of the common approaches include a voice-whispered thought using a close mic. position or a low vocalized thought placed in a suitable reverb. The latter may be the preferred option as the reverb spatially distances the voice from other non-reverbed voices creating the aural illusion of cavernous sound – the thoughts reverberating inside the speaker's head. Whatever method is chosen, it should not distract from the importance of Cordelia's vocal character. These asides are the listener's aural introduction to who Cordelia really is. Barker suggests 'it will be a fatal error to present Cordelia as a meek saint.' [4] She is young, possibly sweet and innocent but she also is her father's daughter! She is as proud and as obstinate as he is and Barker believes that, 'to miss this likeness between the two is to miss Shakespeare's first dramatic effect; the mighty old man and the frail child, confronted, and each unyielding.' [5]

[Ref. B.5 (Lear) – 14 (Kent) + B.11 (Lear): appendix 1]

> <u>B.5</u> *Does Lear's vocal delivery reflect the fact that he is addressing three*
> *different groups of people [A] assembled courtiers, [B] Albany &*
> *Cornwall, [C] his daughters?*
>
> [A]　LEAR:　- Know that we have divided In three our Kingdom;
> 　　　　　and 'tis our fast Intent To shake all Cares and Business
> 　　　　　from our Age, Conferring them on Younger Strengths,
> 　　　　　while we Unburthen'd crawl toward Death.
>
> [B]　　　- Our Son of Cornwall, And you, our no less loving
> 　　　　　Son of Albany, We have this Hour a constant Wish
> 　　　　　to publish Our Daughters' several Dowers, that future
> 　　　　　Strife May be prevented now. The Princes, France and
> 　　　　　Burgundy, Great Rivals in our youngest Daughter's
> 　　　　　Love, Long in our Court have made their amorous
> 　　　　　Sojourn, And here are to be answer'd.
>
> [C]　　　- <u>Tell me, my Daughters,</u> (Since now we will divest us
> 　　　　　both of Rule, Interest of Territory, Cares of State),
> 　　　　　Which of you shall we say doth love us most, That we
> 　　　　　our largest Bounty may extend Where Nature doth
> 　　　　　with Merit challenge.
>
> 　　　– Goneril, Our eldest borne, speak first.

Lear's address at B.5 and Kent's address at B.14 pose similar aural considerations. Lear is directly addressing three separate groups of people within the assembled courtiers: [A] everybody in general, [B] Albany and Cornwall and [C] his daughters. With stereophonic recording, the aural realization of directing the voice towards different directions is easily achieved by having the speaker move from a centre position on mic. to a centre left or centre right position. This has the same aural effect as somebody physically turning their head to speak to different people, thereby creating a sense of acoustic space and sonic directivity. But simply moving the voice in different directions may not be convincing enough. This may need to be combined with a perceptible change in the vocal intonation of the speaker indicating a direct address to a different character, in order to heighten the contextual intent of the address. Similar considerations apply to Kent's lines at B.14 and Lear's lines at

B.11 where Lear has finished addressing Regan and fondly turns to Cordelia *Now our Joy, Although our Last and Least....*

B 14 (Kent)

<div style="border:1px solid">

<u>B.14</u> *Is there an indication in Kent's vocal delivery that he is addressing four different sets of people : (A) Lear; (B) Cordelia; (C) Goneril & Regan; and (D) the assembled court?*

[A] KENT: - Fare thee well King, sith thus thou wilt appear,
 Freedom lives hence, and Banishment is here.

[B] - The Gods to their dear Shelter take thee, Maid,
 That justly thinkst and hast most rightly said.

[C] - And your large Speeches may your Deeds
 approve, that Good Effects may spring from
 Words of Love.

[D] - Thus Kent, O Princes, bids you all adew;
 He'll shape his Old Course in a Country New.

 Exit.

</div>

B.11 (Lear)

<div style="border:1px solid">

<u>B.11</u> *Is there any vocal indication (change in intonation) of Lear's fondness towards Cordelia over Goneril & Regan?*

LEAR: To thee and thine hereditary ever Remain this ample
 Third of our fair Kingdom, No less in Space, Validity,
 and Pleasure than that conferr'd on Goneril.

 – Now our Joy, Although our Last and Least; to
 whose young Love the Vines of France and Milk
 of Burgundy Strive to be of Interest. What can you
 say, to draw A Third more opilent than your Sisters? Speak.

<u>B.12</u> *How is the tension at this dramatic point realized and sustained across the following lines?*

CORDELIA: Nothing, my Lord.

LEAR: Nothing?

CORDELIA: Nothing.

LEAR: Nothing will come of Nothing, speak again.

</div>

> CORDELIA: Unhappy that I am, I cannot heave My Heart into my Mouth: I love your Majesty according to my Bond, no more nor less.
>
> LEAR: How, now, Cordelia? Mend your speech a little, Least you may mar your Fortunes.

[Ref. B.12: appendix i]

B.12 is Shakespeare's point of dramatic modulation in scene one. Just as in a Mahler symphony, this transition brings about a change of key and a radically new direction is taken. It is suspended in a bi-tonal form of slow interweaving tonal clusters heaving with palpable tension. The obstinate dominance of both characters, as restrained as one walking on rice paper, is powerfully un-demonstrative. It can be sensed in listening to the faltering rhythmic patterns of interrupted dialogue where if it were a piece of music it would be marked *sustenuto con gravita*. It is a slow crescendo of nervous anticipation, not one of merely explosive sound. I have referred earlier to Shakespeare's use of dissembling the function of language in this passage supported by the 'unseen' use of silence and pause. The use of silence here is not that of 'absolute' silence – the Beckettian silence of the void – but a silence that is filled with intent. Here the silences and pauses are owned individually by Lear and Cordelia but are also shared with the assembled courtiers. They are as different in their intent as those of the two consciences that posses them, as different as truth is from pretence. The vocal utterances and verbal exclamations of the assembled courtiers (any oohs, ahas and audible intakes of breath) sharply focus this aural sense of *sustenuto con gravita*.

In contrast to a possibly stunned, restrained and incredulous Lear during this transition Shakespeare explodes the play's key change with a radical alteration in Lear's character resulting from these events. Lear's sforzando like character now sets the play's ultimate direction with a pounding sense of rhythm. As a premonition of Lear's own battle both with himself and the elements, he whips up an unnatural storm of vengeance against those who dare to disobey.

[Ref. B. 13: appendix i]

B.13 *To what degree does Lear's personality change from this point?*

LEAR: Let it be so, thy Truth then be thy Dow'r : For by the sacred Radiance of the Sun, The Miseries of Hecat and the Night, By all the Operation of the Orbs, From whom we do exist, and cease to be, Here I disclaim all my Paternal Care, Propinquity and Property of Blood, And as a Stranger to my Heart and me Hold thee from this for ever. The barbarous Scythian, Or he that makes his Generation Messes To gorge his Appetite, shall to my Bosom Be as well neighbour'd, pitied, and reliev'd As thou my sometime Daughter.

Kent's exit coincides with Gloucester's 'flourished' re-entry with France, Burgundy and Attendants [C.1]. Kent must create the aural illusion of physically leaving the company, but his is no ordinary exit. It is coupled with the vocal sense of seething resignation towards the fate that has fallen upon him and a determination that he will *shape his Old Course in a Country New.*

[Ref B.15: appendix i]

KENT: - Thus Kent, O Princes, bids you all adew;
He'll shape his Old Course in a Country New.

Exit

B.15 *How is Kent's exit aurally achieved?*

SRS Production Analysis – [Section B: 1–15]

There is a three second [00:00:03] silent delay between the end of the music announcing the arrival of the King and Lear's first words. Paul Scofield's voice is a deep rich bass voice that exudes power and presence. His slow rhythmic flow, combined with its fluctuating dynamic articulation, gives his voice a sense of age and seriousness. Lear is stationary at mic. position 3 from the beginning, so no sense of movement or entry into the scene is created. While there is an attempt aurally to distance Gloucester from Lear, placing him at mic. position 5, it does not create a

sense of the movement of exiting. Scofield chooses an interesting vocal delivery for the line, *Give me the map there*. He quivers on the two words, *map there*, signifying the enormity or fear of what will be revealed as the *darker purpose*. The map is not aurally signified although there is a pause of three seconds between asking for the map and Lear's first words. The scene is recorded in a dry studio atmosphere with no sound fx. The acoustic is so dry that there is no aural awareness of anyone else being present until Goneril speaks (save for Gloucester who did not sonically exit). Scofield delivers Lear's proclamation in a slow deliberate way. His overall timing for this speech is one minute and fifteen seconds [00:01:15] slow enough to underline the gravity of his abdication intent. Lear gives little physical indication that he is addressing different people, as there is no aural concept of others being present. However, his vocal dynamics and use of emphasis on certain words go some way in making up for what is otherwise a stationary centred delivery. One example of his interesting use of vocal phrasing is contained in the line, *We have this Hour / a constant <u>Wish</u> / to publish our Daughter's several Dowers / that future Strife / may be // prevented (pause) <u>NOW</u>.*

The voices of Goneril, Regan and Cordelia are aptly suited to their respective characters. Goneril has a more mature alto voice and uses a slower tempo of delivery than Regan's quicker and younger sounding soprano voice. Cordelia's voice is similar to Regan's, but timbre differences together with slight variations between accents and inflections makes it easier to distinguish the voices as two different characters. Goneril and Regan are placed at mic. position 4 on the extreme right which creates an aural distance further away from Lear's centre left – mic. 3 position. Cordelia's two asides are vocalized as very quiet-spoken whispers at centre-right mic. position 1 level. Lear's powerful dominating voice holds the centre ground but a little distant at mic. position 3, while Goneril and Regan are further distanced in sound by being placed on the extreme right and at mic. position 4. This creates the sense of not only being distanced from Lear himself but also both Goneril and Regan being distanced/alienated from the words they speak. Cordelia's worry over the truth of spoken language *What shall Cordelia speak? Love, and be Silent* is given a

position in the foreground and prominently if quietly placed at centre-right mic. position 1. This position places Cordelia in a different aural perspective closer to the listener than to either her sisters or Lear.

SRS Production *King Lear* Act 1:i

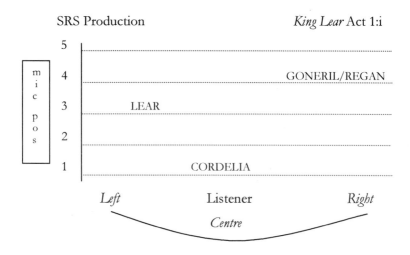

The map lines were not aurally signified in this production. Lear takes a two second pause before addressing Cordelia. When he does his tempo is initially much slower with a quieter voice indicating a perceptual change in his fondness for Cordelia, *Now / our joy*. Although Scofield changes the vocal dynamics (higher pitch and greater emphasis) for *the Vines of France and the Milk of Burgundy*, his greatest change in vocal delivery is in the phrasing of the final line. *What can you say / to draw a Third / more / opilent / than your Sisters?*

The structure of the production at this point is interesting. The tension between Cordelia and Lear is maintained through pauses and silences. In this production the pauses and silences are empty of any other sounds and are therefore what they are: pauses and silences. This is due to the nature of the production and particularly the dry studio atmosphere. The production makes good use of artistic licence by transposing Cordelia's line, *Unhappy that I am, I cannot heave My Heart into my Mouth,* into a form of interior monologue.

> LEAR: ...Now / our Joy / Although our Last and Least; to
> whose young Love The <u>Vines</u> of France and <u>Milk</u>
> of Burgundy Strive to be Interest. What can you
> say / to draw a <u>Third</u> / <u>more</u> / <u>opilent</u> / <u>than your</u>
> <u>Sisters</u>? – *[Pause - 00:00:03]* - Speak.
>
> CORDELIA: Nothing, my Lord.
>
> *** *[Silence – 00:00:04]*
>
> LEAR: Nothing?
>
> *** *[Silence – 00:00:02]*
>
> CORDELIA: Nothing.
>
> *** *[Silence – 00:00:02]*
>
> LEAR: Nothing / *[Pause]* / will come of Nothing.
> *[Pause – 00:00:02]* Speak again.
>
> CORDELIA: *[Interior monologue – mic. pos.2]* <u>Unhappy that I</u>
> <u>am, I cannot heave My Heart into my Mouth.</u>
> *[Pause...Determined/defiant speech – mic. pos 3]*
> I love your Majesty According to my Bond, no
> more nor less.

Throughout this section (B.12: appendix i), Scofield's voice is
one of increasing but controlled anger displayed in the hesitancy
of his questions to Cordelia. Cordelia's voice is one of confident
defiance. The use of interior monologue for Cordelia's line,
spoken of above, diminishes the apologetic tone of the sentence
by removing the voice from the external 'public' arena into the
internal thoughts of the character. Inwardly perhaps Cordelia is
unsure, certainly she is unhappy that she *cannot heave her heart into
her mouth.* In public and as an outward expression of herself she is
confident and defiant as she expresses her love for her Majesty
according to her bond, no more nor less. The complete Lear/Cordelia
passage referred to as B.12 in appendix i takes one minute and
five seconds [00:01:05] in performance time.

Lear's explosion of uncontrollable rage at B.13 makes a dramatic contrast to Cordelia's previous confident and measured delivery. Scofield's voice exudes power, anger, and a frightening sense of action as he disinherits Cordelia. Lear's rage is heightened and increases in dynamic range following Kent's repeated intrusions. Scofield's emotive and at times cracked voice with its varying wild rhythms and vocal pitches creates the aural illusion of the King as an omnipotent Institution reduced to a human figurehead whose vunerability has now been betrayed through his very irrational human behaviour. Lear's incessant rage encompasses Kent's banishment not as a separate and considered decision in itself, but as the unfortunate overflow of Lear's rash anger with Cordelia.

One interesting example of Scofield's vocal use of alternating pitch and rhythm is heard in his delivery of the final line which seals his proclamation, *By Jupiter, This shall not be revok'd*. His delivery of this line is decidedly musical in its use of melodic and rhythmic phrasing. It is not spoken but intoned, closer in a way to singing than speech. The pitch rises from the middle range of his modal voice in a three step stage to the highest point of the modal voice (that is before the range crosses into falsetto voice) and is maintained for the end word of the phrase, *revok'd*. There is no falling inflection at the end of this sentence as one might expect in normal dialogue, instead his voice gives the aural illusion of rising on the second syllable of the word 'revok'd', because of a slight downward inflection on the first syllable. Although Scofield was not pitching his voice as a singer would in the sense that he was not singing the phrase, he creates a G minor triad (G, Bb, D) with the emphasis on the note D, the 5th interval from G. This imparts a tremendous sense of power to the sentence and in a verbal/aural way it makes the sentence sound more like a judgement being passed down not by Lear as man, but by the institutional power recognized as Lear the King. Could this form of intoning and reversed dialogue patterns of up-inflected phrase endings for the annunciation of momentous decisions be ritualistic? It certainly distances the human being from the spoken words in the sense that what cannot be revoked

is the sentence which has now passed beyond 'man' and into 'law', where the 'law' in any despotic regime is always absolute.

D
Bb
G

By Ju-pi-ter this shall not be re - vok'd

Kent's exiting speech at B.14 was effectively enacted. Lear had finished his speech at centre–mic. position 2. This is followed by Kent at centre left–mic. position 4 while addressing Lear [A], and then moves to centre left–mic. position 3 while addressing Cordelia [B] and remains so while addressing Goneril and Regan [C]. Kent then moves to right–mic. position 4 while addressing all [D] and moves straight across to left–mic. position 5 for his final words. [Right –4] *He'll shape his Old Course –* [Left –5] *in a Country New*. It is important to note that there are no sounds of movement, the acoustic distances are achieved solely by the voice. This leads me to suspect that the hurried move from right to left on the last line was achieved by panning the voice electronically and not by the physical movement of the actor.

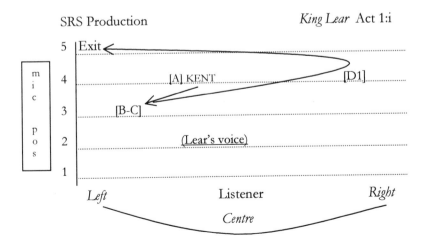

SRS Production *King Lear* Act 1:i

RTE Production Analysis – [Section B: 1–15]

[B.1–2-3] I have already referred to the unfortunate choice of music at this point [section A]. Lear's first words, the command to Gloucester to *Attend the Lords of France and Burgundy*, is shouted with a robust dynamic from mic. position left 4. There is no aural sense of entry by Lear, no movement to indicate his approach, he is just there from the start of this section. The voice of Lear (Seamus Forde) is sharp, powerful and immediate. He has a baritone voice which, when combined with its dominant nasal tonality, creates a sustained ringing quality. His fast tempo and delivery together with his loud volume gives the impression of a King who knows exactly what he is about and wastes no time in getting on with it. But such a combination of vocal characteristics gives the impression of a younger King, certainly not one who is elderly and on the point of abdication. Gloucester's voice (Peter Dix) is a similar baritone voice, but has more mellow and rounded tones and is spoken in a slower tempo which gives the aural impression of the character being older than Lear. Although this is not a fault in itself, it does however shift the illusion of seniority (the elder statesman) from Lear to Gloucester. Perhaps more importantly, Lear's strident delivery, his choice of a fast tempo and robust dynamics certainly does not give the impression of one who is about to *crawl toward Death*. Gloucester does not aurally exit the scene.

[B.4] The sound of the map is created by the rustle of heavy quality paper and is repeated intermittently during the first half of Lear's speech. Although the map is aurally present in sound, the significance of what it represents is suppressed, even lost altogether. The map is given no time (e.g. two or three seconds) to establish itself as a map because Lear creates no space between his request for the map and beginning his proclamation. The RTE production therefore removed the significance of the map as being a symbol of Lear's geographic kingdom.

RTE Production *King Lear* Act 1:i

| LEAR: | Mean time we shall express our darker Purpose. Give me the Map there. *[Sfx – slight rustle of paper]* Know that we have divided in three our Kingdom… |

As mentioned earlier in the A section there is no aural awareness of a group presence and this is further confirmed as Lear in B.5 gives little spatial or verbal indication that he is addressing specific individuals within the group. However, there is a good use of vocal interjection when specifically Goneril (supported by Regan's wordless utterances) expresses surprise throughout Lear's speech. RTE's textual editing is indicated by a strike-through in the text. Why Lear's words of abdication are omitted from the sentence is unclear. Surely these words in part explain the reason behind Lear's *'darker purpose'*, that being the public expression of his daughters' love for him in exchange for land, wealth and power. A form of oral contract publicly uttered by his daughters binding them to provide for Lear's welfare in his elder years.

RTE Production *King Lear* Act 1:i

LEAR: Tell me, my Daughters, (~~Since now we will divest us both of Rule, Interest of Territory, Cares of State~~), Which of you shall say doth love us most, That we Our largest Bounty may extend Where ... *[Goneril and Regan with Lear: intakes breath (eager anticipation) - voiced whispers etc.]* ... Nature doth with Merit challenge. [GONERIL: *Oh your Highness !*] LEAR: Goneril, Our eldest borne, speak first.

[B.6-9] The vocal deliveries of Goneril (Collette Proctor), Regan (Kate Minogue) and Cordelia (Cathryn Brennan) appear considerably slower when heard against the rapid-fire voice of Lear. Goneril's voice is placed in the mid soprano range and projects a mellow timbre. The script is delivered with excellent enunciation, diction and dynamic variety and there is also good use of melodic and rhythmic variations between words and phrases. Goneril gives the aural impression of 'truthfulness' in her expression of love for Lear. Whether this is a deliberate choice for the character is unclear, but it fails to separate or alienate the meaning of the voiced words from the intention of the character. Regan's voice is quite similar to Goneril except that

it is placed in the low soprano range and spoken with a slightly slower tempo. The same criticism of the over expression of 'truthfulness' in the voice can also be applied to Regan. In essence the two voices are almost too good in the sense that their warm and mellow timbre fails to strike at the cruel and deceptive nature of both the textual characters. Goneril's voice (mid soprano combined with a quicker tempo) gives the impression of a younger character than that of Regan (low soprano and a slower tempo).

[B7-10] Cordelia's asides are spoken in quiet, voiced whispers using a low falsetto register, which is very effective in creating the illusion of worried childlike innocence. She is placed at left–mic. position 1 but the sense of her lines being heard by the listener as interior monologue is somewhat negated. First, by sharply increasing her volume level both destroys the overall balance between voices and places her too far forward in the mix (a type of forced artificiality). And second, by using the same type of reverb setting for Cordelia that is used for all other voices destroys any aural illusion of division between what is internal (interior voiced thoughts) and what is external (normal character dialogue).

[B.11] Although Seamus Forde makes no directional change in terms of acoustic space as he addresses Cordelia, his voice performs quite a dramatic transformation. His tempo slows immediately to almost half that of its previous rate and his new rhythm of speech is quietly flowing. His intonation, phrasing and dynamics are contained within a voice that exudes tenderness and love. In using musical terminology to describe Lear's two voices so far, voice 1 could be described as *fortissimo agitato* and voice 2 as *piano amoroso*.

[B.12] The RTE production seriously underscores the palpable tension that is inherent in the Lear/Cordelia section. The section takes one minute and seven seconds [00:01:07] to perform which is similar in time to the SRS production at one minute and five seconds [00:01:05], but achieves a completely different dramatic effect. RTE does not make any use of silence or extended pauses but instead Cordelia's slow, quivering, youthful soprano voice, played against the previously heard dominating, agitated voice of

Lear, creates an entirely different mood and tension. Cordelia immediately answers Lear's demand to speak with only an audible intake of breath as the separation in time between her interior thoughts and her vocalized words. It is as though she really had nothing to say and just got on and said it. Apart from failing to build dramatic tension at this point, Cordelia's rush to speak is somewhat at variance with her previous interior thoughtful question/answer, *What shall Cordelia speak? Love and be Silent.* There is good use of extra contextual sounds during the section, but unfortunately they only highlight Cordelia's voice as being young with a slightly jocose delivery. This section, deliberately or otherwise, creates the aural illusion of adolescent defiance with a propensity to jeer.

RTE Production *King Lear* Act 1:i

LEAR:	Nothing will come of Nothing.
Sfx:	*[Goneril/Regan + others] Light sniggers and chuckles.*
LEAR:	*(over sfx)* Speak again,

[B.13] Lear's defiant and angry outburst follows within a split second of Cordelia's last words, *so Young my Lord, and True.* Because there is little or no time allowed for Lear's rash thoughts to percolate through before he verbalizes them, the dramatic change in the course of ensuing events is negated. The time required for a listener's aural comprehension between the dramatic shift from the voice of Lear 2, *piano amoroso*, back to Lear 1, *fortissimo agitato*, was not seriously considered. There is considerable editing in the following section between Lear and Kent. An example of this can be seen in Lear's response to Cordelia. Again a strike-through is used for the omitted text in the production.

RTE Production *King Lear* Act 1:i

LEAR:	Let it be so, thy Truth then be thy Dow'r: ~~For by the sacred Radiance of the Sun. The Miseries of Hecat and the Night, By all the Operation of the Orbs, From whom we do exist, and cease to be,~~ Here I disclaim all

> my Parental Care, Propinquity and Property of Blood,
> And as a Stranger to my Heart and me, Hold thee
> from this for ever. ~~The barbarous Scythian, Or he that~~
> ~~makes his Generation Messes to gorge his Appetite,~~
> ~~shall to my Bosom Be as well neighbour'd, pitied, and~~
> ~~reliev'd as thou my sometime Daughter.~~
>
> KENT: Good my Liege.

There is a sharp contrast between the voices of Lear (Seamus Forde) and Kent (Aiden Grennell) in this section. Two reasons account for this: first, Kent is placed at centre left–mic. position 2 while Lear remains at slightly left of centre–mic. position 3 throughout the scene. Second, and more importantly, the two voices have very different vocal characteristics and when they are heard successively together the aural impression is given that they may have been miscast for their character roles. Lear's voice is in the tenor range but its natural proneness towards nasality creates a dominance of mid frequencies in the 300 Hz–500 Hz range. Linklater states:

> Nasality can be heard in deep voices, high voices and middle-register voices and means that the pall of a single resonating quality hangs over all utterance. When a deep voice is nasal it tends to be richly adenoidal and monotonous; when a medium-pitched voice is nasal it tends to be aggressively strident and monotonous, and when a high-pitched voice is nasal it is piercingly monotonous.[6]

Although the voice of Seamus Forde is far from monotonous, on the contrary he uses a wide range of pitch, rhythmic and dynamic variety in his performance – it is in his higher pitch range that his voice sounds strident, particularly when heard against Kent's bass voice (Aiden Grennell). The dominance of mid frequency harmonics over a lower fundamental note (F_0) in the voice results in a highly resonant speaking voice which Titze refers to as 'call' and Lessac (1967) terms the 'Y-buzz' effect. 'Call is often employed by orators and actors who require stage speech. In speaking, the fundamental frequency is not

prescribed; F_0 can therefore be raised (or lowered) so that certain preferred harmonics (typically the second or third) fall into the first formant region.'[7] This consideration combined with a faster tempo of delivery and wider range of vocal dynamics gives Lear's voice a lighter, more strident sound than that of Kent's. Kent's voice (Grennell) is in the bass range and when combined with a richer timbre and a perceived slower tempo of delivery creates a greater sense of authority over that of Lear's (Forde).

[B.14] Kent makes good use of acoustic distances in this section and exits in a similar way to the SRS production. However, Kent is more prominent from the beginning at centre–mic. position 2 where there are the almost imperceptible sounds of movement (footsteps) before he addresses Lear [A]. He begins his exiting pattern across [B] to mic. position 3 which is sustained for [C], and at [D] moves through positions 4 and 5, finally exiting at mic. position 5 on his final words, *He'll shape his Old Course in a Country New.*

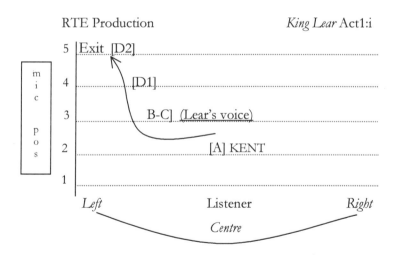

RTE Production *King Lear* Act1:i

BBC 4 Production Analysis – [Section B: 1–15]

BBC4 makes good use of sound fx. cross-faded with the decaying notes of the music signifying Lear's arrival. The sound of movement (a crowd of footsteps with jangling chains) creates the aural illusion of a crowd of people entering the scene, while the jangling chains helps to signify historical time (swords, armour etc.). What is more significant is Lear's entry into the stereo sound field. While the music has already been mentioned e.g. the use of brass instruments denoting royalty etc., it is the use and position within the mix of the two tubular bell notes and Lear's opening words which scores high on production values. The two tubular notes are placed on the extreme left of the music stereo mix and as their notes decay in their natural sustain, Lear's voice is heard coming also from the same extreme left in the drama stereo mix. In matching the decaying (diminuendo) sound of the bells, Lear's voice is also placed at left–mic. position 5, which creates a natural form of cross-fade between music and character. This arrangement of the sound pattern is not a coincidence, it did not just randomly happen this way, instead the positioning demonstrates a level of craftsmanship in sound. This is just one example of a radio drama production that not only thinks in sound but uses sound in both a creative and sensitive way.

On signification: the notes on the tubular bells followed closely by Lear's voice could be seen as signifying the person (Lear) who is royal where the brass instruments might signify royalty as an institution. Lear moves while speaking his opening lines from left–mic. position 5 through to centre/2 and finally slightly right of centre–mic. position 4 for B.5, his proclamation. This creates a tremendous aural illusion of acoustic space as Lear enters the room/hall from the furthest position in sound and then passes in front of the listener at mic. position 2 and moves further up the room/hall to his final position. Gloucester is placed at left centre–mic. position 3 but does not create the sense that he is exiting the scene.

BBC4 Production *King Lear* Act 1:i

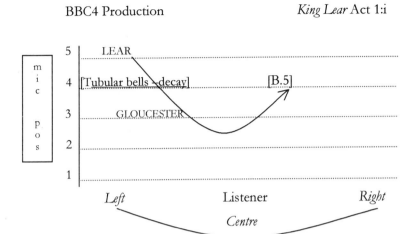

The production makes use of a natural 'room' sounding reverb (approximately 1 to 1.25 seconds), which is created not electronically as with other reverbs but simply by the careful positioning of reflective surface screens. Again this demonstrates a good use of 'natural' sound, but more importantly it creates a more convincing aural illusion of a medium to large room which makes it easier to pin-point and focus upon the sound fx. and voices. One of the dangers of using electronic reverbs for vocal work (with the exception of singing), particularly where a factory pre-set is selected rather than programming the reverb for the specific sound it is meant to emulate, is that a voice can sound un-naturally cavernous. This error, which is purely a lack of attention to sounds, can be heard too often in radio dramas where voices are placed in the proverbial large room or church sounding reverb and where interior monologues can sound as if they are being whispered in the Grand Canyon.

[B.4–5] The map at B.4 and the drawn map lines at B.8 are given no sonic significance in this production. Lear's voice (Alec Guinness) is placed in the baritone range and has a slightly strident timbre. His tempo of delivery is at a moderate pace but, combined with his phrasing and use of vocal inflections, it sounds faster and therefore younger than one would associate with an elderly Lear. In this sense Lear appears from the beginning as a man who is powerful, confident, sure of himself

and in control. He is not presented, as one might expect, as an elderly Lear on the point of abdication and possibly on the verge of madness. Lear gives no spatial or verbal indication that he is speaking to specific individuals within the assembled group until he commands Goneril to speak. His vocal delivery for the proclamation sounds more as one reading a written document than one conversing in dialogue. This creates the sense of a prepared speech, a King's address to his subjects, and helps to underline the 'official' nature of the gathering. The aural sense of the crowd being present is well maintained throughout Lear's proclamation. This is achieved by the intermittent jangle of chains and especially by the vocal interjections of the crowd.

BBC4 Production	*King Lear* Act 1:i

LEAR:	... while we Unburthen'd crawl toward Death. *[Pause]*
Sfx (crowd)	*Short light laughter and chuckles*
LEAR:	*[With sfx]* - Our Son of Cornwall...etc.

[B.6–7 – 9 –10] The voices of Goneril, Regan and Cordelia are very similar in their vocal range and are only slightly different in timbre and tone. All of the voices are in alto range where Goneril (Jill Bennett) and Cordelia (Sarah Badel) have full or warmer timbres than Regan's (Eileen Atkins) which is harsher. This is particularly contrasted in Bennett's rounder vowel sounds and Atkins's harder consonants. All three performers use very different tempos for their vocal deliveries. This immediately creates an identifiable difference between the three otherwise similar voices. Goneril, the older sister, chooses a slow deliberate tempo with a slow but flowing, gentle rhythm of speech; Regan conversely chooses a slightly quicker tempo and a more strict rhythm of speech. Cordelia, the youngest sister, uses a fast tempo but employs good dynamic use of *rubato* and *accelerando,* creating an alternating rhythmic flow which, when combined with her phrasing, gives a sense of urgency to her speech. The production also creates another interesting aural difference between the voices. Goneril is placed at right–mic. position 2 which gives the voice more presence and a warmer sounding tone. Regan is

placed at right–mic. position 3 which first of all creates a greater sense of distance; secondly, when spoken at that distance the voice blends more easily into the reverberant setting of the production. Cordelia's interior monologues [B.7/10] are deliberately slower than her external speech. They are placed at right–mic. position 1 and voiced in a spoken whisper.

The production makes good radiophonic use of both contextualized sound effects and spatial acoustic distances. When Lear commands Goneril to speak, there is a filled silence of five seconds before she speaks where the listener hears the sounds of a single pair of footsteps approaching the microphone, (or, theatrically approaching the King). These footsteps isolated in sound signify the as yet verbally silent character's presence and create an anxious air of expectancy for the listener; what is Goneril going to say? what does she sound like? They also help to maintain the production's sense of acoustic space, we can hear somebody walking from a point over there to a point closer to our ears. At the end of Goneril's speech there is a short round of quiet applause at mic. position 3 where the sound is spread evenly across the stereo spectrum, left to right, creating the illusion of people all around. This applause both maintains and reminds the listener of the aural presence of the assembled crowd in the scene. Cordelia voices her interior monologue over the applause and although this could cause level problems, in this case it is avoided by the more distant and quieter level of applause against Cordelia's prominent level at mic. position 1. The same pattern of silence-footsteps-applause is applied to Regan's speech at B.8 but not to Cordelia's at B.12.

BBC4 Production	*King Lear* Act 1:i

LEAR:	Goneril, Our eldest borne, speak first.
Sxf:	*[00:00: 05] Single pair of footsteps walk towards right–mic. pos 2*
GONERIL:	Sir, I love you more than Word can wield the Matter...etc. ...A Love that makes Breath poor, and Speech unable, Beyond all manner of so much I love you.

Sfx:	*[00:00: 04] Short quiet round of applause*
CORDELIA:	*[With sfx]* What shall Cordelia speak? Love and be Silent

BBC4 Production *King Lear* Act 1:i

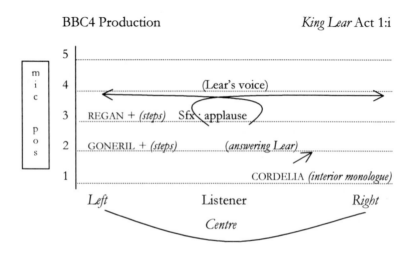

[B.11–12] Lear's fondness for Cordelia is reflected in his deliberate change to a slower tempo, a decrease in vocal intensity and more flowing speech rhythms as he is addressing Cordelia. There is a slight pause before Lear commands Cordelia to speak. During this pause three slow and reluctant footsteps are heard approaching.

BBC4 Production *King Lear* Act 1:i

LEAR:	What can you say, to draw a Third more opilent than Your Sisters? *(Pause)*
Sfx:	*[00:00:03] Three footsteps to right–mic. position 2*
LEAR:	Speak
CORDELIA:	Nothing - *[hesitates]* – my Lord.
LEAR:	Nothing?

BBC4 maintains the dramatic tension in the first part of this sequence by using a very slow delivery tempo (almost *adagio*). They do not use deliberate pauses/silences, just that even, measured, slow tempo which Lear and Cordelia adopt. The tempo quickens in the second half of the sequence from Cordelia's line, *Unhappy that I am, I cannot heave my Heart into my Mouth*. As in the RTE production, Cordelia gives the aural impression of confident defiance, which in a way weakens the effect of Lear's violent outburst. I would agree that Cordelia in character is not a pitiful, timid, frightened human being who cannot defend her own conscience, but she is, however, to be pitied for what she represents in the play as innocent truthfulness. The 'loving' Lear as man and father turns into an enraged, frightening ogre as Lear the all-powerful King when he disinherits and disowns his own daughter. Lear's violent vocal outburst at Cordelia is the sonic and aural realization of the play's first mortal blow on truth and as such needs to be carefully planned and executed. Like the RTE production, I believe that BBC4 could have made more of the dramatic tension in this sequence which sets the turning point for the play's departure into a spiral of evil versus good events.

[B.13] Although Lear violently erupts, his rage and his act of disinheriting and disclaiming Cordelia has less dramatic impact in this production. This is partly due to a lack of prepared and sustained tension leading to his outburst, but also due to his restrained use of vocal dynamics in performance, a lack in the variations of pitch, rhythm and emphasis. The production makes good radiophonic sense of Lear's command, *call France, who stirs? Call Burgundy*, by using vocal interjections in the form of answers to Lear's commands followed by footsteps walking off. These are additional un-named character voices, which are positioned to create spatial acoustic distances both to differentiate the voices and maintain the overall sense of space within the scene. They are placed at centre–mic. positions 4 and 5.

BBC4 Production	*King Lear* Act 1:i

LEAR:	*[Forcibly]* Call France. *[Pause – shouts]* Who stirs?
VOICE 1:	*[Centre–mic. pos. 5]* My Lord.

> LEAR: *[Pause – less forcibly]* Call Burgundy.
>
> <u>VOICE 2:</u> *[Centre–mic. pos. 4]* <u>My Lord.</u>
>
> <u>*Sfx:*</u> <u>*Footsteps walking off*</u>
>
> LEAR: *[With footsteps]* Cornwall and Albany, With my
> two Daughters' Dow'rs, digest the Third...etc.

[B.14] BBC 4 uses an unusual and somewhat unreal spatial acoustic distancing pattern for Kent's final speech in this section. Lear's verbal sentencing of Kent is quite adamant. I have indicated this by underlining the stress or emphasis Lear places on the words of this sentence. *By Jupiter, This shall not be revok'd.*

Lear's voice has remained at the same mic. position within the stereo field since issuing his proclamation, centre–mic. position 4. Kent addresses Lear at [A] from slightly right of centre–mic. position 4. There is a slight pause which allows Kent to move 'silently' to centre–mic. position 1 from where he now addresses Cordelia in a much softer, quieter voice, not quite a vocalized whisper, but very close, musically expressed as *sotto voce*. He returns to centre–mic. position 4 to address Goneril and Regan at [C]. His final address to all at [D] is voiced from centre left–mic. position 5 with his final words moving to left–mic. position 5. What is unusual and unreal about this distancing sequence is that there is actually no sound of movement or of footsteps. The listener is presented with the voice in different spatial locations, but how Kent's voice gets to these locations is not aurally apparent. This may be a minor point in the overall scheme of things. However, whether the voice was recorded separately at different microphone positions and finally edited together is not the question. But it must be realized that a voice cannot fly about in silent movement here and there at will even if the illusion of movement or spatial distance is the intended outcome. The voice of a character playing a 'real' character in a radio drama within the perceived time frame of spatial movement really needs to be aurally moved through some supporting sound of bodily movement.

BBC4 Production *King Lear* Act 1:i

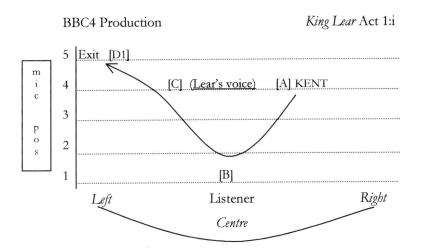

BBC 3 Production Analysis – [Section B: 1–15]

[B.1–2-3] The two mace beats draw the entrance procession to silence when Lear commands Gloucester to *Attend the Lords of France and Burgundy.* Lear is immediately in the scene placed at centre–mic. position 2. Lear's voice (John Gielgud) is in the low alto – high baritone range with a warm sounding rich timbre, but with a leaning towards dentality that can produce an increase in sibilant articulation. His tempo of delivery is moderately slow, but his interesting use of alternating speech rhythms gives his voice a sense of excelerated pace on some phrases while being deliberately slower on others. This creates a kind of formalized speech delivery more ponderously dramatic than naturally conversant. Gielgud projects the image of a King who is elderly and perhaps slightly infirm in his advancing years but one whose voice at the outset exudes kindness, stability, and a reluctant weariness of the power he has carried for so long. Gloucester exits the scene with a sense of urgency, his voice and hurried footsteps moving quickly from left centre–mic. position 3 to left–mic. position 5 on the words, *I shall, my Lord.*

[B.4–8] The map is particularly well signified in this production. It is given its own time of six seconds in which to be unfolded, thereby establishing its signifying importance. The presentation of the map to Lear following his command, *Give me the map there,*

is preceded by the sound of footsteps approaching Lear's microphone position where the sound of the map (heavy paper or parchment type) is folded-out in front of Lear. Referring to the earlier discussion on the map, this is a good example of transcodification of a visual symbol into a sonic/aural symbol, but its sonic exactness depends upon the weight or sound of the paper and the time given for the effect to be realized. Since a map in itself has no distinguishing sound except the sound it makes while being unfolded, it is important to consider the quality and time of that unfolded sound. The lines drawn on the map are also aurally signified with two lines drawn in a heavy upward and downward movement over Lear's words, *all these Bounds, even from this Line* ↓ *to this.* ↑

[B.5] Lear gives some indication that he is addressing separate individuals within the assembled group through the use of inflection and emphasis. His proclamation is made more as a prepared speech than spoken as dialogue. The presence of the crowd is aurally well maintained throughout Lear's speech, at times expressing surprise at what Lear proposes while at other times just nervously acknowledging that the King is speaking. This creates a heightened aural awareness of the stately significance of the gathering and puts Lear's decision of division and abdication into a human context.

BBC3 Production *King Lear* Act 1:i

LEAR: Know that we have divided In three our Kingdom…
Sfx: (Crowd) [Brief] Quiet shuffling and murmurs
LEAR: …and 'tis our fast Intent to shake all Cares and Business from our Age, Conferring them on Younger Strengths, while we Unburthen'd crawl toward Death.
Sfx: (Crowd) [Brief] Light laughter, words of disagreement 'No, no'
LEAR: Our Son of Cornwall, And you, our no less loving Son of Albany… etc. …Tell me, my Daughters, (Since now we will divest us both of Rule, Interest of Territory, Cares of State), Which of you shall we say doth love us most - *[Pause]*
Sfx (crowd + Goneril) Brief nervous laughter

> LEAR: - That we our largest Bounty may extend Where
> Nature doth with Merit challenge.
> - Goneril, Our eldest borne, speak first.
>
> *Sfx: (crowd) [00:00:02] Surprised - murmuring and muttering*

[B.6-8] The voices of Goneril (Judi Dench) and Regan (Eileen Atkins) are very close in vocal characteristics. Both of their voices are in the same alto range, both speak with a similar slow tempo of delivery, similar vocal inflections and phrasing, and similar heightened accent and articulation. This degree of similarity between voices can cause major problems of character recognition for the listener. This is even more the case when the voices are separated by other dissimilar/different voices than when the two voices are heard one after the other (e.g. GONERIL > CORDELIA > LEAR > REGAN as against GONERIL > REGAN > GONERIL > REGAN). Hearing similar voices successively allows the listener's ear to 'fine tune' to the subtle but audible differences between them. However, my argument here is that even the 'active' listener may not have the time in a 'one-pass-hearing' – or should not be expected to listen with such intensity – to decipher such differences. Creating audible differences with voices of such close similarity falls within the realm of the production and the techniques employed to create these differences. I refer back to BBC4's solution to the same problem in acoustically distancing the similar voices of Goneril (Jill Bennett) and Regan (Eileen Atkins). Again it would prove an interesting study to analyse both of Atkins's vocal performances of Regan, BBC 3 and BBC 4, but it is beyond the focus of this work.

The subtle difference in this production between the two voices (Dench and Atkins) is chiefly in the area of timbre. In vocal analysis, timbre has to do with the size, shape and musculature of the larynx and the effect on sound produced by the shape and use of the resonating chambers. Dench's timbre is mellower and somewhat richer than Atkins's which is conversely a sharper, slightly thinner sound, producing an increase in mid-frequency response, especially on consonant sounds. This timbral difference could be equated in musical terms to identifying which

similar but subtly different instrument played the same pitched note with the same intensity and time length. For example, an orchestral flute [metal construction] or a traditional flute [wooden construction]. Identifying the difference in that comparison may be relatively easy to hear. But for a listener of a radio play, hearing similar voices playing different characters can often be a futile and a frustrating exercise. In theatrical terms it is akin to identifying the difference between two identical twins in similar costumes (e.g. a uniform) with each playing a different character.

Another fundamental vocal difference is Dench's tendency to 'crack' her voice on higher pitched notes and Atkins's tendency towards slight sibilance problems with splashed 'sss.' Vocal similarities apart, Goneril and Regan deliver their speeches in a deceivingly 'truthful' fashion. Both actresses use a steady measured tempo of delivery with an emphasized up-inflection on the beginning of each phrase and a rallentando combined with a deliberate down-inflection at the end of each phrase. Their steady rhythm, measured phrases, and the absence of emotional dynamics – given that the words imply an expression of love – properly alienate the textual meaning of the spoken words from the implied meaning of the speakers.

[B.7-10] It is peculiar that Cordelia's two lines are not performed as interior monologue, instead they are quietly spoken and placed at right–mic. position 1. There is no attempt at distancing Cordelia's voice, either as a voiced whisper or placed in reverb, to create the impression that these are internal thoughts and not externally spoken words.

The BBC3 production, in a similar way to the BBC4 production, makes good use of extra contextual vocal sounds. These are placed at a number of points throughout this section and maintain the crowd in the scene creating a human response within the context of the spoken words.

BBC3 Production *King Lear* Act 1:i

GONERIL: ...A Love that makes Breath poor, and Speech
 unable, Beyond all manner of so much I love you.

Sfx: (crowd) Short round of applause, sound of laughs and ah's

CORDELIA: What shall Cordelia speak? Love, and be Silent

LEAR: Of all these Bonds, even from this Line *[/]* to

 this *[/\]* To thine and Albany's Issues, be this

 perpetual.

Sfx: (crowd + Goneril) [Goneril –'My Lord'] *applause; laughs and ah's*

LEAR: - What says our Second daughter?
 Our dearest Regan, Wife to Cornwall.

Sfx: (crowd) Murmurs and mutterings

REGAN: *[With sfx]* I am made of that self Mettle as my
 Sister, And prize me at her Worth. In my true Heart I
 find she names my very Deed of Love: onely she
 comes too short... *[pause]*

Sfx: (crowd) Laughs

REGAN: ...that I profess My self an Enemy to all other Joys
 Which the most precious Square of Sense professes,
 And find I am alone felicitate In your dear Highness'
 Love.

Sfx: (crowd) Applause, laughs, ah's, mutterings etc.

[B.11-12] Lear's fondness for Cordelia is very obvious in this section. His tempo slows considerably and both his phrasing and use of up-inflections on certain words creates an impression of almost prayer like quality in his address to Cordelia. Lear's command to Cordelia to speak is almost a crying plea. The B.12 section between Lear and Cordelia is filled with dramatic tension. The silences and pauses used in this section are highly dramatic and create an overwhelming sense of disbelief, disappointment and almost utter dejection on the part of Lear. What Cordelia

cannot say or will not say is painfully heart-wrenching for Lear.
The additional use of contextual sounds from the crowd
heightens the deliberately serious tone of the section.

BBC3 Production *King Lear* Act 1:i

LEAR:	….No less in Space, Validity, and Pleasure Than That conferr'd on Goneril. *[Pause]*

Sfx: (crowd) Applause and vocal ah's etc.

LEAR:	- Now our Joy, Although our Last and Least; to whose young Love The Vines of France and Milk of Burgundy Strive to be Interest. What can you say, to draw a Third more opilent than your Sisters <u>ah</u>? *[with a cry]* Speak. *[Silence 00:00:02]*

CORDELIA:	*[Very quietly]* Nothing, my Lord.

Sfx: (crowd) Surprised whispers [00:00:02]

LEAR:	Nothing? *[pause 00:00:02]*

CORDELIA:	Nothing *[silence 00:00:03]*

LEAR:	*[Restrained]* Nothing will come of Nothing, speak again.

[B.12] Lear's reaction to Cordelia is superbly enacted. Unlike the
other three productions (SRS, RTE and BBC4), Lear does not
immediately fly into a vocal rage. Instead his anger is a controlled
slow rage that grows like a long crescendo and accelerates until it
reaches its climax when he disinherits Cordelia. Gielgud's
opening line, *Let it be so, thy Truth be thy Dow'r,* is a good example
of a pulse register voice. Lear's hatred and venom is obvious in
the forced, extended bass range of his voice, although in volume
terms it is both quiet and restrained. Again there is good use of
contextual sounds from the crowd which point up the surprise
and awesomeness of Lear's reactions. Similar contextualized
sounds are maintained at different points throughout the
Lear/Kent section.

BBC3 Production *King Lear* Act 1:i

LEAR: ...Here I disclaim all my Parental Care *[pause]*

Sfx: (crowd + Cordelia) [Cor; right –mic. pos. 1] sharp intake of breath

LEAR: Propinquity and Property of Blood, And as a Stranger
 to my Heart and me, Hold thee from this for ever.
 [Pause]

Sfx: (crowd + Cordelia) [Cor; sighing cry] crowd; surprised oh's and ah's

LEAR: The barbarous Scythian, Or he that his Generation
 Messes To gorge his Appetite, shall to my Bosom Be as
 Well neighbour'd, pitied, and reliev'd As thou my
 Sometime Daughter.

KENT: *[With crowd similar to above; surprised oh's and ah's*
 [Kent; right–mic. pos. 4 excited voice] <u>Good my Liege!</u>

Another example of good aural transformation, not transcodification as such, is found in Kent's excited and forceful address to Lear, particularly when Kent accuses Lear of being mad and old. Here Lear vocally reacts to Kent's preposterous accusations and his bold effrontery in challenging the King. This helps to sustain the dramatic tension in this section and builds towards a more natural climactic point, Kent's banishment. The crowd support the overall sense of tension by surprised murmuring and mutterings throughout.

BBC3 Production *King Lear* Act 1:i

Sfx: (crowd) Low murmuring and muttering [sustained throughout]

KENT: *[Pleading]* Royal Lear, Whom I have ever honour'd as my
 King, Lov'd as my Father, as my Master follow'd, As my
 Great Patron thought on in my Prayers.

LEAR: *[Low and sustained]* The Bow is bent and drawn, make
 from the Shaft.

KENT: *[Becoming excited]* Let it fall rather, though the Fork
 invade the Region of My Heart ; be Kent unmannerly
 when Lear is mad...*[pause]*

LEAR: *[Surprised and loud]* Emmm!

KENT: *[More excited]* …What wouldest thou do, Old Man?

LEAR: *[Raging]* Ahhhhh!

Sfx: (crowd) [Raised - surprised voices of the crowd]

KENT: *[With sfx- forceful]* Thinkst thou that Duty shall have
 dread to speak when Power to Flattery bows?…etc.

[B.14] Kent's exit is highly dramatic and aurally very well
executed. Kent's voice (Keith Michell) is a tenor range voice and
across this section crescendoes to a loud, excited, angry pitch.
His tempo alternates between moderate and fast which reflects
his interesting use of vocal phrasing. He is placed initially for [A]
addressing Lear at centre–mic. position 3, moving to [B]
Cordelia, centre–mic. position 4. He moves for [C] Goneril and
Regan to left centre–mic. position 4 and exits on [D] the crowd,
by moving back to centre–mic. position 4 and then to 5 for his
exit. There is also good use of extra contextual sounds in this
section.

BBC3 Production *King Lear* Act 1:i

KENT: *[centre–mic. pos. 3]* Fare thee well, King, sith thus thou
 wilt appear, Freedom lives hence, and Banishment is here.
 [pause]

Sfx. Quick movement – footsteps

KENT: *[centre–mic. pos. 4]* - The Gods to their dear Shelter take
 thee, Maid, That justly thinkst and hast most rightly said.
 [pause]

CORDELIA: *[right–mic. pos. 2] [Pleadingly]* Sir!

KENT: *[left centre–mic. pos. 4]* - And your large Speeches may your
 Deeds approve, that Good Effects may spring from
 Words of Love. *[pause]*

Sfx: (Goneril/Regan + crowd) Light chuckles.

KENT: *[centre–mic. pos. 4]* - Thus Kent, O Princes, bids you all adew; *[while speaking to centre / mic. pos. 5]* He'll shape his Old Course in a Country New.

Sfx: (crowd) *Quiet murmuring and muttering*

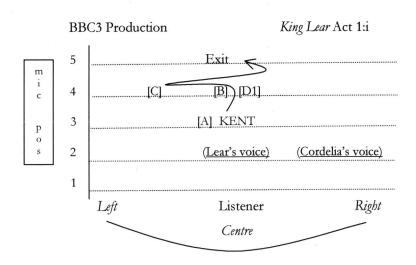

BBC3 Production *King Lear* Act 1:i

23 | *King Lear* | Discussion | Analysis–C

[With reference to Radio Analysis Script - appendix i]

[Ref. C.1–2 : appendix i]

Flourish. Enter Gloucester with France, Burgundy, and Attendants.

C. 1 *How is it indicated that Gloucester is (re-)entering the scene with France and Burgundy?*

CORNWALL: Here's France and Burgundy, my noble Lord.

LEAR: My Lord of Burgundy, We first address toward you, who with this King Have rivall'd for our Daughter; what in the least Will you require in present Dower with her Or cease your Quest of Love?

C. 2 *Is there any attempt to distinguish France and Burgundy as being foreigners visiting the English Court?*

BURGUNDY: Most royal Majesty, I crave no more than hath your Highness offer'd, Nor will you tender less?

LEAR: Right noble Burgundy, When she was Dear to us, We did hold her so, But now her Price is fallen, Sir, there she stands...

Following the exit of Kent it is important to establish two new aural perspectives. First, that Gloucester is re-entering the scene having attended to *the Lords of France and Burgundy,* and second, that the two characters, Burgundy and France, although referred to by name in the previous section, are only now entering the scene for the first time. It is of interest to note that Gloucester, Burgundy, and France were not present for the preceding section of the play, so they should be unaware of the present course of events, notably Lear's act of disinheriting Cordelia. Gloucester together with France, Burgundy and Attendants are intended to enter following a 'flourish.' It is generally accepted that a flourish refers to a musical passage played for display, a fanfare of trumpets etc. Cassells refers to a 'flourish' as the sounding of trumpets when receiving any person of distinction; an ostentatious announcement.[1] Whether a musical flourish is used or not, it is clear that in a sound medium the listener should hear the sounds of people entering the sound space. These sounds/flourish will make aural sense of Cornwall's statement, *Here's France and Burgundy, my noble Lord.*

The appearance of France and Burgundy at this point is less important to the overall dramatic structure of the play, but nonetheless their appearance is valuable in the framing structure of the play. They offer an interesting aside in the study of contrasting minor characterization, where Burgundy puts wealth and status above love, while France, responding to Cordelia's obvious integrity, finds his love increased by her outcast state. In a Saint Paul like conversion France's affirmation is in stark contrast to Burgundy's rejection. [FRANCE] *Gods, Gods! — 'Tis strange that from their cold'st Neglect, My Love should kindle to emflam'd Respect.* Their presence also gives a release from the tension built up in section B and the new marriage terms in relation to Cordelia offer an excellent means of reaffirming Lear's harsh and rash act of disinheriting her. Most importantly Shakespeare uses them as a structural solution to the problem of Cordelia's continuing presence in the play even in exile. As Kent has been banished by Lear we are aware at this point that he will remain present in his exiled form, shaping his *old Course in a Country New.* But what about Cordelia now disinherited and with no place to go?

France's acceptance of Cordelia under the new terms of marriage conveniently solves Shakespeare's dilemma of retaining a character for later retrieval.

If France and Burgundy are foreigners visiting the English Court, is there any attempt to distinguish this fact in the use of voice and accents signifying geographical differences? And in an act of extended signification, is there any attempt to distinguish vocally any psychological differences between both characters?

[Ref. C.3: appendix i]

BURGUNDY: Pardon me, Royal Sir, Election makes not up in such Conditions.

C.3 Is there any attempt to distinguish that Lear is addressing (A) Burgundy and (B) France?

[A] LEAR: Then leave her, Sir, for by the Powre that made me, I tell you all her Wealth.

[B] - For you, great King, I would not from your Love make such a Stray To match you where I hate, therefore beseech...

C3 poses similar aural problems of vocal intonation and direction as those found in the previous section [B.4 – 14]. In C.3 Lear has finished addressing Burgundy at [A] and begins addressing France at [B]. Is the listener made sufficiently aware from Lear's line *For you, great King...*that he is now advising or addressing France and not Burgundy?

[Ref. C.4 : appendix i]

C.4 How are these words delivered?

FRANCE: Gods, Gods! – 'Tis strange that from their cold'st Neglect, My Love should kindle to enflam'd Respect.

This is a most difficult line to interpret. Is France speaking as an aside or in radio terms as interior monologue? Or, is the line intended to be heard by all present? or addressed only to Cordelia? Whatever solution is chosen, the greater difficulty is with the intonation of the line itself, particularly with the two

words, *Gods, Gods!* If this is a sudden realization by France, a form of lightning inspiration offered by the Gods, in which case it may be uttered as a form of thank-you or acknowledgement, but, it may also be uttered as an evocation of Godly intervention followed by a pause. Either way requires a degree of thought and preparation on the part of the actor, as different forms of intonation may need to be employed. This line has proved to be one of the more vocally difficult lines to achieve in a convincing way.

[Ref. C.6 : appendix i]

LEAR:	Come, noble Burgundy.
C.5	*How is the 'exeunt' sonically realized?*
	Flourish. Exeunt [all but France, Cordelia, Goneril, and Regan]

How is the exit of Lear and his entourage aurally achieved? And while realising that some are leaving the scene, the listener must also be made aware that others (France, Cordelia, Goneril and Regan) remain present and that the scene is continuing. This exit may be a 'grand' exit but it should not be climactic in the sense that it signifies the end of the scene.

SRS Production Analysis – [Section C: 1–6]

[C.1-2] The SRS production prelude signals the entrance of France and Burgundy with a short brass fanfare lasting eight seconds [00:00:08], culminating with a snare drum roll. This is played over Cornwall's rather urgent announcement to Lear *Here's France and Burgundy, my noble Lord.* Neither France, Burgundy, Attendants nor indeed Gloucester is heard entering. As Gloucester has no spoken parts for the remainder of the scene and is not referred to by any other character, the listener is left aurally unaware of his 'resumed' presence or its possible significance.

The SRS production does not make any attempt to signify aurally that France and Burgundy are in fact visitors from different countries in Lear's geographical kingdom. Scofield's vocal delivery is excellent throughout. His declaration to Burgundy,

...but now her Price is fallen, Sir, there she stands, is resolutely cold and deliberate as if Cordelia was nothing more than unwanted chattel. Cordelia is made to appear as a dispensable individual upon whom an irreversible death sentence has been passed; she has lost her dignity, status and – most of all – paternal love. Cordelia's final plea to Lear, *...I yet beseech your Majesty...*draws Scofield's chillingly measured and deliberate reply, *Better thou Hadst not been borne than not t'have pleas'd me better.*

[C.3-6] There is no deliberate attempt by Lear to indicate sonically that he has finished addressing Burgundy and is now addressing France. The vocal delivery of France's line at C.5 *(Gods, Gods!...)* is interesting in the way he tries to create a sonic difference. He reduces his spoken volume considerably without moving from his microphone position. Although it does not sound as if he intended this line as an aside/interior monologue, yet he tries to give the aural impression of a vocalized thought that is directed at no one in particular. This is forcibly contrasted by a sudden increase in vocal projection when France is addressing Lear in the lines immediately following. *Thy Dow'rless Daughter, King, thrown to my Chance, is Queen of us, of ours, and our fair France.*

The exit of Lear and Burgundy is the only sonic movement so far in the SRS production. Lear's voice moves from centre mic. position 2 to left mic. position 3 across his final line – *Come, noble Burgundy.* This is followed by a short refrain of the previous brass fanfare but this time without the finality of the snare drum roll.

SRS Production *King Lear* Act 1:i

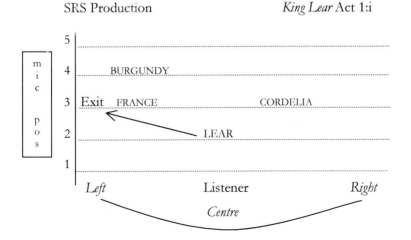

RTE Production Analysis – [Section C: 1–6]

[C.1-5] The RTE production signals the entrance of France and Burgundy by a very short single trumpet call lasting just four seconds [00:00:04], played over 'Cornwall's' announcement, *Here's France and Burgundy, my noble Lord.* However, the most interesting point here is that it is not the voice of Cornwall who speaks the line but the voice of Gloucester. This is a good example of just one of the possibilities of judicious adaptation. As Cornwall had nothing to say but a minor vocal interjection in the scene so far, his voice had not become prominent enough to be now vocally recognizable as that of Cornwall. Gloucester, on the other hand, had been quite prominent in the early part of the scene until his exit to *attend the Lords of France and Burgundy,* therefore, his voice should still remain recognizable. Using the voice of Gloucester to announce the arrival of France and Burgundy conveniently re-introduces him back into the scene. The RTE production cleverly places him at centre-right mic. position 4, giving the aural impression of the character entering the room from the far end. This creates an excellent stereophonic contrast to Kent's previous exit to left mic. position 5 and Gloucester's entry from centre-right mic. position 4. This left to right stereophonic design gives a realistic impression of greater aural spaciousness where Kent exits from one end of a spacious room while Gloucester enters from the opposite end.

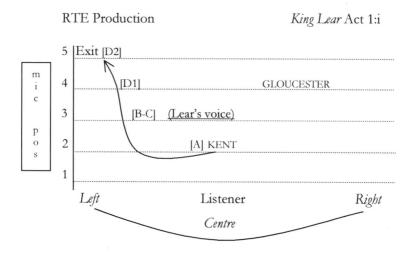

RTE Production *King Lear* Act 1:i

From this point the RTE production employs quite a radical adaptation of the text. I include the complete text of the RTE adaptation for section C and can be compared with the Everyman edition of the scene in appendix i.

RTE Production – adapted text section C *King Lear* Act 1:i

GLOUCESTER: Here's France and Burgundy, my noble Lord.

LEAR: Right noble Princes. When she was Dear to us, we
 did hold her so, But now her Price is fallen.
 Sirs, there she stands: Will you with those Infirmities
 she owes, Unfriended, new adopted to our Hate,
 Dow'r'd with our Curse, and stranger'd with our
 Oath, Take her or leave her.

CORDELIA: I yet beseech your Majesty. It is no vicious Blot,
 Murther, or Foulness, No Unchased Action or
 Dishonoured Step, That hath depriv'd me of your
 Grace and Favour.

LEAR: Better thou
 Hadst not been born, than not t' have pleas'd me better.

FRANCE: Is it but this? A Tardiness in Nature, Which often
 leaves the History unspoke, That it intends to do?
 [Pause]
 Fairest Cordelia, that art most Rich being Poor.
 Thee and thy Virtues here I seize upon,
 Be it lawful I take up what's cast away.

LEAR: Thou hast her, France, let her be thine, for we
 Have no such Daughter, or shall ever see
 That Face of hers again; therefore be gone,
 Without our Grace, our Love, our Benzion.
 Come, away.

This adaptation raises a number of production concerns. Whereas it was a good transition to use the voice of Gloucester in deference to that of Cornwall at C.1, Gloucester announces the arrival of France *and* Burgundy, but Burgundy does not sonically appear in the scene and remains silent during the short ensuing discourse. In this instance the listener will be left wondering what is Burgundy's role in Lear's hastened auction of

Cordelia? And which character is speaking in favour of Cordelia? The listener is made aware by Lear that it was France that was speaking only *after* France had finished speaking. By not aurally identifying *new* voices or characters before they speak can greatly weaken the role or relative significance of what that character has to say. The two characters, France and Burgundy, may be insignificant as character roles in the overall dramatic structure of the play, but their presence at this point as part of Lear's auctioning of Cordelia is important in highlighting Lear's ruthlessness and blind rejection of Cordelia. In fact, Lear's callous paternal disregard for his daughter is greatly understated in this production.

France's acceptance of Cordelia as his wife conveniently provides a point of exit or omnipresent exile for Cordelia, which retains her as an absent but living character in the play. The RTE production does not highlight France as being a foreign visitor to the English Court.

[C. 6] Lear's exit is symbolized by a single set of footsteps heard together with Lear's voice as it moves quickly from centre mic. position 3 to left mic. position 4 on his line, *Come, away*. This is clearly the exit of one character and one set of footsteps and not the *exeunt* of all! If France, Cordelia, Goneril and Regan are the only characters intended to remain after the *exeunt*, Lear and others should be heard leaving the soundspace. In the RTE production there is, however, only one set of exiting footsteps which signify that perhaps Lear is the only one to have exited. This leaves the rest of the assembled court aurally present for the remainder of the scene!

BBC4 Production Analysis – [Section C: 1–6]

BBC 4 use a repeated short brass chordal phrase of 5^{th} interval chords punctuated at the phrase ends by timpani beats lasting thirteen seconds in total [00:00:13]. Towards the end of the final phrase the voice of Gloucester is heard announcing the arrival of France and Burgundy from centre mic. position 4. This is immediately followed by the sound of footsteps, movement and

jangling chains. Lear is placed at centre mic. position 3 and Burgundy at left mic. position 4. This creates an interesting spatial perspective which makes Lear more prominent and closer to the listener, even though both characters are 'off-mic.' or spatially distant from the microphone. This creates the ambient sound of a large room where if one considers that the point of contact with the listener's ear is the microphone, this spatial sound aurally places the listener 'somewhere' in the room listening as a collective member of the assembled court. Lear's delivery in this section is considerably calmer and more constrained when compared to section B and particularly when compared to his confrontation with Kent.

[C.3] Lear signals that he has begun to address France in deference to Burgundy in two ways. First, he slows both his vocal pitch and tempo of delivery slightly and second, and perhaps more directly, he addresses France by his name, *For you, great France* etc. France is placed at right mic. position 3 in stereophonic contrast to Burgundy's left mic. position 4. France moves to centre-right mic. position 2 towards the end of his first speech. The importance of this move only becomes aurally apparent when Cordelia pleads to Lear at right mic. position 2. Cordelia's vocal plea is delivered in a hasty, urgent and slightly fearful voice. [C.2] The BBC4 production does not sonically distinguish France and Burgundy as being foreigners visiting the English court.

At C.5 France deliberately reduces his vocal attack and slows the overall tempo of delivery. He produces quite an odd phrasing on the words *Gods, Gods!*, which imparts little meaning or intent to the words. However, his more powerful and faster staccato rhythmic address to Lear immediately after the line, aurally dispels the concept of C.5 as being spoken thoughts, interior monologue or the classical aside.

The first two notes of Christopher Whelan's short brass flourish are played before Lear issues his command at C.6, *Come, noble Burgundy*. This simple, upward-moving musical motif played by trombones and horns fits as a rhythmic counterpoint to Lear's command. This is not a performance coincidence but more a

performance decision to counterpoint vocally the rhythmic sense
of the music.

TEXT:	*Come* *noble* *Bur-- gun--dy*
MUSIC:	*// // /// / //*

The brass motif is accompanied by the sound of multiple
footsteps, general movement and the jangles of chains moving
away out of the scene to left mic. positions 4–5.

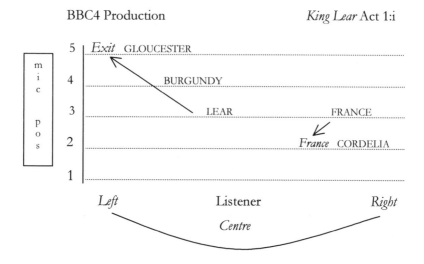

BBC4 Production *King Lear* Act 1:i

BBC3 Production Analysis – [Section C: 1–6]

As Kent exits the court in section B he is accompanied by the
sounds of mumbling, indecipherable chatter, general movement
and shuffling as affirmations of surprise and shock. This is
maintained over a very brief arpeggiated unison note octave
'chord' played octaves apart. This brass fanfare-like 'chord'
heralds the voice of Gloucester as he announces the arrival of
France and Burgundy. Gloucester, accompanied by the sounds of
shuffling and movement, calls his line *Here's France and Burgundy,*

my noble Lord, as he moves from left mic. position 5 to left-centre mic. position 3. Lear is placed at centre mic. position 2, giving him the most prominent position in this section. Lear's vocal delivery throughout is slow and deliberate where it is counterpointed at the end of each of his addresses by surprised mutterings and vocal utterings from the assembled court. Similarly to the BBC4 production, here Lear slows his tempo slightly and decreases his volume when he begins to address France at C.3. (*For you, great France...*)

France is placed at centre-right mic. position 3 in stereophonic contrast to Burgundy at left mic. position 3. Cordelia's aural position is interesting within the hierarchical structure of the section. She is placed at centre mic. position 2 as if she is literally beside Lear almost as if on her knees pleading in an ever increasing frightful crying voice. [C.2] BBC3 differentiate France and Burgundy as foreigners by giving them rather overdone typecast French accents. The difficulty for an English speaking actor to transfer the correct enunciation and articulation for Shakespeare's rhythmic language into an acquired foreign accent accentuates the sense of typecasting. However, BBC3 is the only production to attempt this transition which in itself adds variety, colour and linguistic contrast.

[C.5] France's delivery of the line *Gods, Gods!* ... is a complete contrast to any of the other vocal deliveries of this line (SRS, BBC4 or RTE). Here, France does certainly not intend this line to sound as spoken thoughts, interior monologue or an aside. He delivers a vocal outburst of sudden and overwhelming realization. France is not only about to do something noble by taking up *what's cast away,* but he also suddenly realizes that in Cordelia's *cold'st neglect* he has found love for Cordelia that *should kindle to enflam'd respect.*

[C.6] Following Lear's command, *Come, noble Burgundy,* the exeunt of Lear and his entourage is accompanied by the sounds of movement, multiple footsteps, indecipherable chatter and the ominous sound of two timpani beats, repeatedly playing a fourth apart at a slow 60 b.p.m. tempo.

BBC3 Production *King Lear* Act 1:i

[With reference to Radio Analysis Script – appendix i]

Ref. D.1: appendix i

FRANCE: Come, my fair Cordelia.

> *Exit with Cordelia*

D.1 *How is the exit aurally realized?*

The short exchange between Cordelia and her sisters is one of muted acceptance of her changed fate. If anything Goneril and Regan's callous replies to Cordelia seal the now irreversible family division. [REGAN] *Prescribe not us our Duty,* and [GONERIL] *Let your Study be to content your Lord, who hath receiv'd you At Fortune's Alms.* The exit of France and Cordelia is well signposted by France's request; *Come, my fair Cordelia.*

Ref. D.2: appendix i

D.2 *Is there any perceptible change in Goneril and Regan's vocal delivery reflecting (i) they are speaking in prose (conversation)? And (ii) given the content of their conversation, is it intended to be hushed and devious or normal and open?*

> GONERIL: Sister, it is not little I have to say Of what most nearly
> appertains to us both. I think our Father will hence to
> night.
>
> REGAN: That's most certain, and with you; next Month with us.
>
> GONERIL: You see how full of Changes his Age is. The
> Observation we have made of it hath been little; he
> always lov'd our Sister most, and with what poor
> Judgement he hath now cast her off appears too grossly.

Shakespeare reverts to prose for the conspiratorial dialogue between Goneril and Regan. This conversational section is in sharp contrast to their earlier and lofty affirmations of love for Lear. How can the devious nature of the sisters be best realized in an aural setting? Is it through normal and open conversation? or through a quieter, hushed, *sotto voce* delivery?

Ref. D.3 : appendix i

> REGAN: We shall further think of it.
>
> GONERIL: We must do something, and i'th' Heat.
>
> *Exeunt*
>
> *D.3 How is the 'exeunt' aurally realized?*

How does the scene conclude? In a radio production it may not be necessary that Goneril and Regan aurally exit the scene, particularly if consideration is given to D.4. One radiophonic approach might involve a relatively slow cross-fade of Goneril's final words with a suitably constructed aural link in D.4

Ref. D.4: appendix i

> *D.4 Is there an aural link between scene 1 and scene 2 denoting a passage of
> time? (given that scene 2 is set in Gloucester's castle and time has elapsed!)*

Scenes i and ii are separated and distanced by a sense of geographical space and elapsed time (scene i: Lear's castle and scene ii: Gloucester's castle). The period of elapsed time is relatively unimportant whether it is a matter of days or weeks. The dramatic action must however remain within the relevant 'present' of the play, but the sense that some time has elapsed would be an important consideration for the dramatic structure and impetus of the play. This could be achieved through the use of music or a combination of music and sound fx. depicting a change of place. The use of a brass fanfare for example, would be entirely inappropriate as it was earlier identified as signifying Lear or Lear's kingship (power). Its use as an introduction to Gloucester's scene (sc. ii) would aurally signify something other than what the scene is really about. Likewise the use of music or sounds merely as 'breakers' between scenes without due consideration of their sonic relevance, is not just careless, but could destroy the dramatic unity of a production. Further, the use of spurious music outside the internal frame of the production could seriously violate the aural integrity of the production.

SRS Production Analysis – [Section D: 1–4]

The SRS production constructs a slight distant aural perspective. Cordelia and France are placed at left mic. position 3 for the opening section. Regan is initially placed at right mic. position 2, but later at D.2 she silently moves across to left-centre mic. position 2. Goneril begins at right-centre mic. position 3 but moves to position 2 for her conversation with Regan. Cordelia and France do not aurally exit the scene at D.1 and neither do Goneril and Regan at D.3. There is little sense of finality in the scene, although a short orchestral motif closes the scene and creates the aural link to scene ii. While Goneril and Regan move to a prose style of delivery for D.2, it remains somewhat stiff and stultified and not as natural as with the other productions.

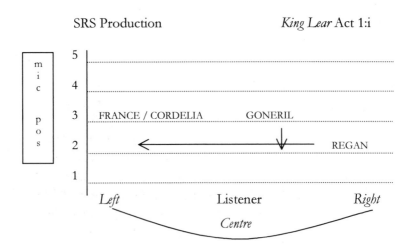

SRS Production *King Lear* Act 1:i

RTE Production Analysis – [Section D: 1–4]

The RTE production maintains a left exit aural perspective where France and Cordelia are placed on the left at mic. position 3. Cordelia moves forward to centre mic. position 2 to speak to her sisters but it is interesting that both Goneril and Regan remain back at left-centre and right-centre mic. position 3. The static distancing of Goneril and Regan heard against the moving distance of Cordelia creates a peculiar aural perspective. Why does Cordelia need to move? And what does the move signify? [D.1] France and Cordelia do not sonically exit the scene but France's line, *Come, my fair Cordelia,* spoken at left mic. position 3 as he turns from the microphone, does give the aural illusion of exiting particularly when heard with the strongly suggested context of the text.

[D.2-4] Goneril and Regan speak in a natural prose style with some interesting phrasing, vocal inflections and emphasis. This helps to create the more natural sense of two individuals who are not happy with the situation they find themselves in and are plotting to do something about it. Goneril's resolute and emphasized vocal delivery on her final line, *We must do something, and i'th' Heat,* displays their urgency and determination. Goneril and Regan do not exit the scene and neither is there a suitable aural link between scenes i and ii. [There is the rather curious

and Regan do not exit the scene and neither is there a suitable aural link between scenes i and ii. [There is the rather curious sound of an explosion presumably intended to sound as a clap of thunder heard immediately after Goneril's final words. This has no aural relevance to the preceding action of scene i, and when heard in isolation (and out of context), it has no aural significance as a link to the ensuing scene].

The RTE adaptation of section D (as per the Everyman edition) is less radical than section C, yet, the choice of the two omissions is curious for the information they leave out. In the first instance, Cordelia's wish to be with Lear and back in his grace is her obvious preference to going away to *a better place* with France. In the second instance, Goneril's affirmation informs the listener that Lear's rashness is borne out of his *long ingraffed Condition … that Infirm and Choleric years bring with them.* Again, I use a strike through to indicate deleted text.

RTE Production *King Lear* Act 1:i

FRANCE: Bid farewell to your sisters.

CORDELIA: The Jewels of our Father, with wash'd Eyes
 Cordelia leaves you. I know you what you are,
 And like a Sister [I] am most loath to call Your
 Faults as they are named. Love well our Father:
 To your professed Bosoms I commit him, ~~But yet
 alas, stood I within his Grace, I would prefer him
 to a better Place. So farewell to you both.~~

REGAN: Prescribe not us our Duty.

GONERIL: The Best and Soundest of his Time hath been but
 Rash; ~~then Must we look from his Age to receive
 not alone the Imperfections of long ingraffed
 Condition, but therewithal the unruly Way-wardness
 that Infirm and Choleric years bring with them.~~

REGAN: Such Unconstant Starts are we like to have from
 him as this of Kent's Banishment.

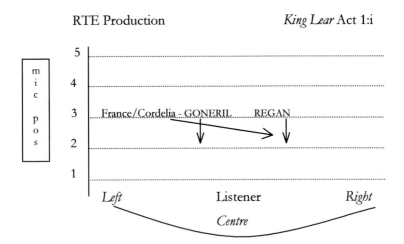

RTE Production *King Lear* Act 1:i

BBC4 Production Analysis – [Section D: 1–4]

BBC4 moves the aural perspective closer by initially placing Goneril at left mic. position 3 and Regan at left-centre mic. position 3 giving the aural impression of Goneril and Regan being relatively close together or at least on the same side or area of the room. Cordelia is placed at centre mic. position 3 while France is placed further back at centre mic. position 4. The exit of France and Cordelia [D.1] is simply achieved by footsteps moving away into the distance at centre mic. position 5. At [D.2] Goneril and Regan move closer for a slightly lower volume and intimate conversation spoken in natural prose style. Goneril is placed at left-centre mic. position 2 while Regan moves to right-centre mic. position 2. Both actresses effectively exit the scene by moving backwards on their final lines to mic. position 4. This creates a form of natural fade-out of the scene. There is no aural link into scene ii. The BASTARD begins his lines *Thou, Nature, art my Goddess...*in a dry studio acoustic and in a close microphone position directly following the 'faded' exit of Goneril and Regan.

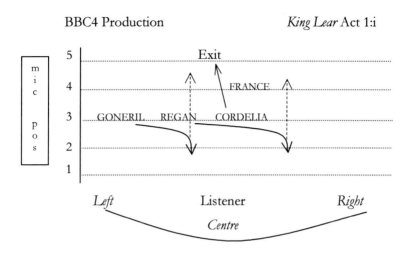

BBC4 Production *King Lear* Act 1:i

BBC3 Production Analysis – [Section D: 1–4]

BBC3 constructs a close and intimately interesting aural perspective between the three sisters while keeping France out of the intimacy by placing him further back. Similarly to the BBC4 production, Goneril and Regan are aurally placed close together with Regan at left mic. position 2 and Goneril at left-centre mic. position 2 while Cordelia is placed at right-centre mic. position 2. France is placed a little further back at centre mic. position 3. The exit of Cordelia and France at [D.1] is very effectively achieved by the sounds of footsteps walking away into the distance from centre mic. position 3 to 5. As the footsteps move away Goneril moves to centre mic. position 2 while Regan moves to a close left-centre mic. position 2.

Goneril and Regan speak in a rather urgent natural prose style with a good use of vocal dynamics, pause, inflection, pacing, and volume variation. There is no sonic exeunt at D.3 following Goneril's final words, *We must do something, and i'th' Heat.* BBC3 follow immediately with a dramatic orchestral music interlude lasting twenty seconds [00:00:20] leading directly to scene two on the music's natural decay.

BBC3 Production *King Lear* Act 1:i

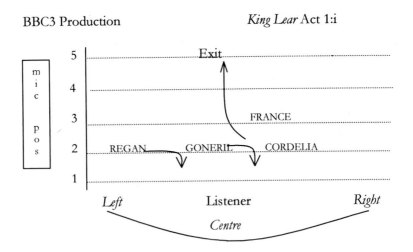

The following table includes a synopsis of the main points considered in the four productions:

* All times are expressed in minutes:seconds

	SRS	RTE	BBC4	BBC3
A.1 - Is there a sense of place established?	x	✓	✓	✓
A.2 - Is there a sense of movement (acoustic distance)?	x	✓	✓	✓
A.5 - Is Edmund audible in the scene before his first words are spoken?	x	x	x	✓
B.1 - Are sound fx used for Lear's entry?	x	x	✓	✓
B.5 - Time taken for Lear's proclamation	1:15	0:52	0:58	1:09
B.4 - Is the map sonically signified?	x	✓	x	✓
B.8 - Are the map lines sonically signified?	x	x	x	✓
B.12- Time taken between Lear and Cordelia	1:05	0:52	0:58	1:10
C.1 - Is Gloucester heard re-entering the scene?	x	✓	✓	✓
C.2 - Are France & Burgundy presented as foreigners?	x	x	x	✓

	SRS	RTE	BBC4	BBC3
foreigners?	x	x	x	✓

	SRS	RTE	BBC4	BBC3
C.6 - Does Lear audibly exit the scene?	✓	✓	✓	✓
D.1 - Do France and Cordelia audibly exit the scene?	x	✓	✓	✓
D.2 - Do Goneril and Regan audibly exit the scene?	x	x	✓	✓
D.4 - Is there an aural link between scenes one and two?	✓	x	x	✓
• Does Lear sound older (o) or younger (y) compared to other characters?	o	y	y	o

Overall times for sections expressed in minutes and seconds:

	SRS	RTE	BBC4	BBC3
[A]	1:38	1:40	1:28	1:32
[B]	8:50	7:28	8:28	9:12
[C]	4:30	1:10	4:10	5:10
[D]	1:54	1:43	1:58	2:00
Total	16:52	12:01	16:04	17:54

Conclusion

There has been scant academic and critical analysis devoted to radio drama in the past. Two reasons can be identified as probable causes. In the first instance, the dearth of published radio plays and academic literary criticism in print form has fostered a belief that the genre is too ephemeral to warrant serious consideration. In the second instance, the analysis of radio drama as a performance genre has been virtually non-existent owing substantially to the lack of suitable analytical tools specific to the radio drama medium. The methods of analysis that have existed have been inadequately adapted from other visual dramatic genres, most notably the theatre, film, and television, where they have awkwardly been made to fit a non-visual and specifically aural medium.

In this book I have primarily addressed the latter problem by developing a set of analytical tools specific to the medium of radio drama, thus providing a seminal approach to the analysis of radio drama in its ultimate form as a dramatic performance genre. In what I believe is the first formulated and structured analytical approach to performance-based radio drama, this study uncovers and scrutinizes the rudiments of a *modus operandi* that concretizes the uniqueness and separateness of radio drama as a dramatic aural art form.

The recognition from the beginning by its practitioners was that the oral/sonic nature of radio drama demanded through its medium a form of writing and performance that was uniquely and decidedly different from that of the theatre. Whereas many classical dramas were successfully broadcast, there was an early and growing awareness of the need to develop both a style of vocal performance and a method of production practice that would capture the 'actual radio effect' in deference to the more stylised theatrical stage performances presented to the microphone. Whereas it became the stated policy of the BBC as early as 1929 to develop a 'national theatre of the air', with a predominant emphasis upon past British dramatic literature, it was the playwrights who were newer to the medium who spearheaded the dramatic quest for the actual radio effect. The attempts of playwrights such as Guthrie, MacNeice, Cooper, Beckett and others to exploit the radiophonic uniqueness of the medium through dialogue, plot, sound, and silence more closely defined the 'actual' sound of radio drama. Their styles of radio plays could not have been performed successfully in any other medium but through pure sound. These plays encouraged the formation of a unique sound laboratory, the BBC Radiophonic Workshop, which was dedicated to the composition of new abstract radiophonic sounds. In many ways those playwrights helped to define the quintessential difference between the visual play for stage and the sound play for the ears.

The essential difference between radio drama and live theatre, with the now rare exceptions of 'live' broadcast plays, is the definitive existence of the radio play in its pre-recorded or taped form. Radio drama already exists, recorded in its entirety before the listener hears it as a broadcast or as a pre-recorded tape. Though the stage play will have gone through its pre-production phase which the audience will be able to view in the production, it is the production itself that is actually created live for the audience. Every subsequent performance is therefore a new production, which can randomly alter the production values as the play is reproduced and re-enacted. The radio drama listener may be termed the audient reader of a particular definitive production where the theatre audience may be described as

viewing a potential version of a finality that can never be definitive.[1]

The sounds of radio drama may indeed generate innate resonances in the aural imagination, but it is only when they are clearly delineated and scrutinised for what they mean within the sound drama that they gain a credible critical status. In a simple analogy: only by knowing what to listen for is one empowered to be a critical judge of what has been heard. This knowledge generates a heightened awareness of the medium together with a deeper appreciation of its value, and it is hoped it will promote ongoing academic and critical evaluation of a currently neglected dramatic performance genre. Essentially, knowing what is good is tantamount to knowing what could have been better. This alone could prove an electrifying influence upon the future direction of radio drama production and writing.

Radio drama's 'reality' is as unique and infinitely variable as that of its collective audience. It is an intimately experienced 'reality' whose ownership belongs to each individual listener and not to any one production. Owing to the nature of its medium, radio consistently surrenders ownership of its imagined physicality. Radio drama can never present a pre-formed visible picture, but neither can it turn its disparate audience into a captive voyeuristic collective. It is a magical genre where, as individual listeners, we choose to allow its 'sounds' to invade our inner being, stimulate our imaginations and draw us into being mindful and sharing participants in its creations.

> It's a magic place, radio. For the price of a sound effect, a little music, and a few words, the flying carpet can take the listener to remote jungles, the top of a mountain, the dangerous backstreets of a big city, inside the palace and the hovel, into the murderer's head. And that is just Act One.[2]

Unfortunately, not all radio drama is good radio drama - but there is no reason why it cannot be. Fundamentally a radio drama is produced and broadcast for listeners to hear where the individual listener retains the control of choosing to listen. The listener, therefore, is a voluntary participant in the dramatic event

and a voluntary creator of the drama's imaginary visualisations. It is critically imperative in this scenario that both writing and production strive to attain the highest level of artistic integrity in the knowledge that imaginative aural stimulus is dependent upon a highly creative approach to dramatic radiophonics. The qualitative scale of produced radio drama runs from the brilliantly artistic to the mediocre and the atrocious. If one accepts that a good production sets a minimum artistic standard for acceptance as a professional radio drama broadcast, then on the plus side of the equation a great many productions could be categorized as being excellent and brilliant. However, on the minus side, productions have regretfully dipped badly. Whereas atrocious warrants no comment, mediocre is professionally inexcusable. There can be no excuse for a mediocre approach to producing radio drama whether it is a full-length play, a serial, a 'soap' or a short dramatic advertisement.

I firmly believe in the enormous potential of radio, particularly in its creative and dramatic arts areas. It is here that radio exemplifies the very best in dramatic sound composition whether in the form of *radio*-drama or radio-*drama*, docudramas, dramatised stories, features or even the well made radio advertisement.

The radio industry in general is most definitely on the move where the opportunities soon to be realised by the advent of digital broadcasting technology will certainly introduce new sonic possibilities not currently available to either broadcaster or listener. However, as radio's technical form is set for a revolutionary re-invention, concerns are being seriously voiced regarding its increasingly soporific and inane content and the quality of programming formats generally. The reservation currently being expressed is that the emphasis on the development of new broadcasting technologies may be at the expense of creative programme making. To the listener it may well be marketed as the new sound of radio, or to be more accurate, the new visual sound of radio with side-band frequencies allocated to text, graphics, and pictures.

I believe that new technologies will always bring new possibilities for sound creation; however, it is imperative that radio's most creative identities, those of dramas, documentaries and features, are not threatened from less expensive 'live' programming formats. Because of the pragmatics of programme financing, money remains the all-important catalyst for converting ideas into broadcasting realities. Given that the comparative production cost per hour for radio drama is minuscule when compared to drama production for film, television and the theatre, it is curiously ironic that greater use is not made of radio's dramatic medium. As a dramatic format, radio drama is productively economic when compared to other dramatic genres but it should not be 'cheap', particularly where content, artistic merit and cultural values are concerned. It is a genre that I believe offers as yet unrealized riches as a means of dramatic expression, and while market share competitiveness and profit conversion economics appear to be the basic tenants for any successful business – including radio – 'managing-in' profit should not be at the expense of 'managing-out' creativity.

In the commercial reality of radio broadcasting, producing a greater audience share of the listening market inevitably takes precedence over producing artistic excellence. The two aspirations are neither irreconcilable nor mutually exclusive. There already exists a sizeable audience for radio drama and it is my belief that an existing untapped and under-developed audience can be grown, given the right incentives and productive environments. It may require encouragement or at least support for experimentation with new contemporary forms of drama, shorter formats, serialised forms, children's drama, and adult theme dramas broadcast after the '9 p.m. watershed.'

Radio drama's flexibility in invisibly projecting an infinite number of imaginatively aural visualisations makes it unique and decidedly more powerful than other dramatic genres. It is a unique genre where as individual listeners, even eavesdroppers, we choose to allow its 'sounds' to invade our inner being and resonate those interior worlds we might never have realised we were capable of imagining.

Appendix One | *King Lear*, Act 1 : Scene 1

PRELUDE MUSIC: **Theme, tempo, historical time, personage, climatic tension, transition of music to speech (X fades etc.)**

<u>A.1</u> *Is there a sense of place established (interior or exterior)?*

<u>A.2</u> *What type of aural place is created? A corridor leading to an assembly hall [movement]; an assembly hall with voices/people in it [fixed]; an exterior (garden/gravel path) leading to an interior (hall) [movement]?*

<u>A.3</u> *Are the characters to enter on mic. creating a sense of movement or are they stationary on mic. (fixed position)?*

<u>A.4</u> *Consideration of vocal pitch, timbre, and tempo of delivery between characters.*

Enter Kent, Gloucester, and Edmund.

KENT: I thought the King had more affected the Duke of Albany than Cornwall.

GLOUCESTER: It did always seem so to us; but now in the Division of the Kingdom it appears not which of the Dukes he values most, for Qualities are so weigh'd that Curiosity in neither can make Choice of either's Moi'ty

<u>A.5</u> *Is Edmund audible in the scene before Kent's question?*

KENT: Is this not your Son, my Lord?

<u>A.6</u> *Who leads the humour from this point? Is Edmund intended to overhear the conversation?*

GLOUCESTER: His Breeding, Sir, hath been at my Charge. I have so often blush'd to acknowledge him that now I am braz'd to't.

KENT: I cannot conceive you.

GLOUCESTER: Sir, this young Fellow's Mother could, whereupon she grew Round-womb'd, and had indeed, Sir, a Son for her Cradle ere she had a Husband for her Bed. Do you smell a Fault?

KENT: I cannot wish the Fault undone, the Issue of it being so proper.

GLOUCESTER: But I have a Son, Sir, by order of Law, some Year elder than this, who yet is no Dearer in my Account, though this Knave came something saucily to the World before he was sent for: yet was his Mother fair, there was good Sport at his Making, and the Whoreson must be acknowledged. – <u>Do you know this Noble Gentleman, Edmund?</u>

A.7 *Where is Edmund spatially to G & K? Is Edmund fixed with G & K moving towards E or vice versa?*

EDMUND: No, my Lord.

GLOUCESTER: My Lord of Kent: remember him hereafter as my Honourable Friend.

EDMUND: My Services to your Lordship.

KENT: I must love you, and sue to know you better.

EDMUND: Sir, I shall study Deserving.

GLOUCESTER: He hath been out nine Years, and away he shall again. <u>The King is coming.</u>

A.8 *At what point do we hear the King approaching - before or after Gloucester's statement?*

B

Sennet. <u>Enter one bearing a Coronet</u>; then King Lear, Cornwall, Albany, Goneril, Regan, Cordelia and Attendants.

B.1 *Are there sound fx. surrounding Lear's entrance?*

B.2 *Consideration of Lear's vocal pitch, timbre, and tempo of delivery*

LEAR: Attend the Lords of France and Burgundy,
 Gloucester.
GLOUCESTER: I shall, my Lord.
 Exit

B.3 *Does Gloucester audibly exit the scene?*

LEAR: Mean time we shall express our darker Purpose.
 <u>Give me the Map there.</u>

B.4 *How is the significance of the map dealt with aurally (sounds, movement, pauses etc.)?*

B.5 *Does Lear's vocal delivery reflect the fact that he is addressing three different groups of people [A] assembled courtiers, [B] Albany & Cornwall, [C] his daughters?*

LEAR: Know that we have divided
 In three our Kingdom; and 'tis our fast Intent
 To shake all Cares and Business from our Age,
 Conferring them on Younger Strengths, while we
 Unburthen'd crawl toward Death. – Our Son of
 Cornwall,
 And you, our no less loving Son of Albany,
 We have this Hour a constant Wish to publish
 Our Daughters' several Dowers, that future Strife
 May be prevented now. The Princes, France and
 Burgundy,
 Great Rivals in our youngest Daughter's Love,
 Long in our Court have made their amorous Sojourn,
 And here are to be answer'd. – <u>Tell me, my Daughters,</u>
 (Since now we will divest us both of Rule,
 Interest of Territory, Cares of State),
 Which Of you shall we say doth love us most,
 That we our largest Bounty may extend
 Where Nature doth with Merit challenge. – Goneril,
 Our eldest borne, speak first.

B.6 *Consideration of Goneril and Regan's vocal deliveries*

GONERIL: Sir,
 I love you more than Word can wield the Matter,
 Dearer than Eyesight, Space and Liberty,
 Beyond what can be valued, rich or rare,

No less than Life, with Grace, Health, Beauty, Honour;
As much as Child ere lov'd, or Father found.
A Love that makes Breath poor, and Speech unable,
Beyond all manner of so much I love you.

B.7 *If Cordelia's line is written as an aside how is it produced in interior monologue?*

CORDELIA: <u>What shall Cordelia speak? Love, and be Silent.</u>

B.8 *How are these maps lines signified aurally?*

LEAR: Of all these Bounds, even <u>from this Line to this,</u>
With shadowy Forests, and with Champains rich'd,
With plenteous Rivers and wide-skirted Meads,
We make thee Lady. To thine and Albany's Issues
Be this perpetual. – What says our Second Daughter?
Our dearest Regan, Wife of Cornwall? Speak.

B.9 *Similar to B.6 above.*

REGAN: I am made of that self Mettle as my Sister,
And prize me at her Worth. In my true Heart
I find she names my very Deed of Love:
Onely she comes too short, that I profess
My self an Enemy to all other Joys
Which the most precious Square of Sense professes,
And find I am alone felicitate
In your dear Highness' Love.

B.10 *Cordelia's line similar to B.7 above.*

CORDELIA: – Then poor Cordelia,
And yet not so, since I am sure my Love's
More ponderous than my Tongue.

B.11 *Is there any vocal indication (change in intonation) of Lear's fondness towards Cordelia over Goneril & Regan?*

LEAR: To thee and thine hereditary ever
Remain this ample Third of our fair Kingdom,
No less in Space, Validity, and Pleasure
Than that conferr'd on Goneril. – Now our Joy,
Although our Last and Least; to whose young Love
The Vines of France and Milk of Burgundy

Strive to be of Interest. What can you say, to draw
A Third more opilent than your Sisters? Speak.

B.12 *How is the tension at this dramatic point realised and sustained across the following lines?*

CORDELIA: Nothing, my Lord.
LEAR: Nothing?
CORDELIA: Nothing.
LEAR: Nothing will come of Nothing, speak again.
CORDELIA: Unhappy that I am, I cannot heave
My Heart into my Mouth: I love your Majesty
According to my Bond, no more nor less.
LEAR: How, now, Cordelia? Mend your speech a little,
Lest you may mar your Fortunes.
CORDELIA: Good my Lord,
You have begot me, bred me, lov'd me: I
Return those Duties back as are right Fit,
Obey you, Love you, and most Honour you.
Why have my Sisters Husbands, if they say
They love you all? Happily when I shall wed,
That Lord whose Hand must take my Plight shall carry
Half my Love with him, half my Care and Duty;
Sure I shall never marry like my Sisters,
To love my Father all.
LEAR: But goes thy Heart with this?
CORDELIA: I, my good Lord.
LEAR: So Young, and so Untender?
CORDELIA: So Young, my Lord, and True.

B.13 *To what degree does Lear's personality change from this point?*

LEAR: Let it be so, thy Truth then be thy Dow'r:
For by the sacred Radiance of the Sun,
The Miseries of Hecat and the Night,
By all the Operation of the Orbs,
From whom we do exist, and cease to be,
Here I disclaim all my Paternal Care,
Propinquity and Property of Blood,
And as a Stranger to my Heart and me
Hold thee from this for ever. The barbarous Scythian,
Or he that makes his Generation Messes
To gorge his Appetite, shall to my Bosom
Be as well neighbour'd, pitied, and reliev'd

	As thou my sometime Daughter.
KENT:	Good my Liege –
LEAR:	Peace, Kent!
	Come not between the Dragon and his Wrath;
	I lov'd her most, and thought to set my Rest
	On her kind Nursery. Hence and avoid my Sight:
	So be my Grave my Peace, as here I give
	Her Father's Heart from her. – Call France, who stirs?
	Call Burgundy. – Cornwall, and Albany,
	With my two Daughters' Dow'rs Digest the third.
	Let Pride, which she calls Plainness, marry her:
	I do invest you jointly with my Power,
	Pre-eminence, and all large Effects
	That troop with Majesty. Our self by Monthly Course,
	With Reservation of an hundred Knights,
	By you to be sustain'd, shall our Abode
	Make with you by due Turn; onely we shall retain
	The Name and all th' Addition to a King;
	The Sway, Revenue, Execution of the rest,
	Beloved Sons, be yours, which to confirm
	This Coronet part between you.
KENT:	Royal Lear,
	Whom I have ever honour'd as my King,
	Lov'd as my Father, as my Master follow'd,
	As my great Patron thought on in my Prayers –
LEAR:	The Bow is bent and drawn, make from the Shaft.
KENT:	Let it fall rather, though the Fork invade
	The Region of my Heart; be Kent unmannerly
	When Lear is mad. What wouldst thou do, Old Man?
	Think'st thou that Duty shall have dread to speak
	When Power to Flattery bows?
	To Plainness Honour's bound
	When Majesty falls to Folly. Reserve thy State;
	And, in thy best Consideration, check
	This hideous Rashness: answer my Life my Judgment,
	Thy Youngest Daughter does not love thee least;
	Nor are those Empty-hearted whose Low Sounds
	Reverb no hollowness.
LEAR:	Kent, on thy Life no more.
KENT:	My Life I never held but as a Pawn
	To wage against thine Enemies, nere fear to loose it,
	Thy Safety being Motive.
LEAR:	Out of my Sight.

KENT: See better, Lear, and let me still remain
The true Blank of thine Eye.

LEAR: Now by Apollo –

KENT: Now by Apollo, King,
Thou swear'st thy Gods in vain.

LEAR: O Vassal! Miscreant.

ALBANY, CORNWALL: Dear Sir, forbear.

KENT: Kill thy Physician, and thy Fee bestow
Upon the foul Disease. Revoke thy Gift,
Or whilst I can vent Clamour from my Throat
I'll tell thee thou dost Evil.

LEAR: Hear me, Recreant,
On thine Allegiance hear me;
That thou hast sought to make us break our Vows,
Which we durst never yet, and with strain'd Pride
To come betwixt our Sentences and our Power,
Which nor our Nature nor our Place can bear,
Our Potency made good, take thy Reward.
Five Days we do allot thee for Provision,
To shield thee from Disasters of the World,
And on the Sixt to turn thy hated Back
Upon our Kingdom; if on the Tenth Day following
Thy banish'd Trunk be found in our Dominions
The Moment is thy Death, away. By Jupiter,
This shall not be revok'd.

B.14 *Is there an indication in Kent's vocal delivery that he is addressing four different sets of people : (A) Lear (B) Cordelia (C) Goneril & Regan and (D) the assembled court?*

KENT: Fare thee well King, sith thus thou wilt appear,
Freedom lives hence, and Banishment is here.
– The Gods to their dear Shelter take thee, Maid,
That justly thinkst and hast most rightly said.
– And your large Speeches may your Deeds approve,
ThatGood Effects may spring from Words of Love.
– Thus Kent, O Princes, bids you all adew;
He'll shape his Old Course in a Country New.
Exit

B.15 *How is Kent's exit aurally achieved?*

C

Flourish. Enter Gloucester with France and Burgundy, Attendants.

C.1 *How is it indicated that Gloucester is (re-)entering the scene with France and Burgundy?*

CORNWALL: Here's France and Burgundy, my noble Lord.
LEAR: My Lord of Burgundy,
 We first address toward you, who with this King
 Have rivall'd for our Daughter; what in the least
 Will you require in present Dower with her
 Or cease your Quest of Love?

C.2 *Is there any attempt to distinguish France and Burgundy as being foreigners visiting the English Court?*

BURGUNDY: Most royal Majesty,
 I crave no more than hath your Highness offer'd,
 Nor will you tender less?
LEAR: Right noble Burgundy,
 When she was Dear to us, we did hold her so,
 But now her Price is fallen, Sir, there she stands:
 If ought within that little seeming Substance,
 Or all of it, with our Displeasure piec'd,
 And nothing more, may fitly like your Grace,
 She's there, and she is yours.
BURGUNDY: I know no Answer.
LEAR: Will you with those Infirmities she owes,
 Unfriended, new adopted to our Hate,
 Dow'r'd with our Curse, and stranger'd with our Oath,
 Take her or leave her?
BURGUNDY: Pardon me, Royal Sir,
 Election makes not up in such Conditions.

C.3 *Is there any attempt to distinguish that Lear is addressing (A) Burgundy and (B) France*

LEAR: Then leave her, Sir, for by the Powre that made me,
 I tell you all her Wealth. - For you, great King,
 I would not from your Love make such a Stray
 To match you where I hate, therefore beseech you
 T'avert your Liking a more worthier Way,
 Than on a Wretch whom Nature is asham'd
 Almost t'acknowledge hers.

FRANCE: This is most Strange,
That she whom even but now was your best Object,
The Argument of your Praise, Balm of your Age,
The Best, the Dearest, should in this Trice of Time
Commit a thing So monstrous, to dismantle
So many Folds of Favour. Sure her Offence
Must be of such Unnatural Degree
That monsters it, or your fore-vouch'd Affection
Fall into Taint, which to believe of her
Must be a Faith that Reason without Miracle
Should never plant in me.

CORDELIA: I yet beseech your Majesty,
If for I want that glib and oily Art
To speak and purpose not, since what I will intend
I'll do't before I speak, that you make known
It is no vicious Blot, Murther, or Foulness,
No Unchaste Action or Dishonoured Step,
That hath depriv'd me of your Grace and Favour,
But even for want of that for which I am richer,
A still soliciting Eye, and such a Tongue,
That I am glad I have not, though not to have it
Hath lost me in your Liking.

LEAR: Better thou
Hadst not been borne than not t'have pleas'd me better.

FRANCE: Is it but this? A Tardiness in Nature,
Which often leaves the History unspoke
That it intends to do? – My Lord of Burgundy,
What say you to the Lady? Love's not Love
When it is mingled with Regards that stands
Aloof from th'entire Point. Will you have her?
She is herself a Dowry.

BURGUNDY: Royal King,
Give but that Portion which your self propos'd,
And here I take Cordelia by the Hand,
Duchess of Burgundy.

LEAR: Nothing, I have sworn, I am firm.

BURGUNDY: I am sorry then you have so lost a Father
That you must loose a Husband.

CORDELIA: Peace be with Burgundy:
Since that Respect and Fortunes are his Love,
I shall not be his Wife.

C.4 *Similar aural problem of France addressing different people [ref. B.5 – 14]*

FRANCE: Fairest Cordelia, that art most Rich being Poor,
 Most Choice Forsaken, and most Lov'd Despis'd,
 Thee and thy Virtues here I seize upon,
 Be it lawful I take up what's cast away.

C.5 *How are these words delivered?*

 – Gods, Gods! – 'Tis strange that from their cold'st
 Neglect,
 My Love should kindle to enflam'd Respect.
 – Thy Dow'rless Daughter, King, thrown to my Chance,
 Is Queen of us, of ours, and our fair France:
 Not all the Dukes of wat'rish Burgundy
 Can buy this unpriz'd precious Maid of me.
 – Bid them farewell, Cordelia, though unkind,
 Thou loosest here a better where to find.
LEAR: Thou hast her, France, let her be thine, for we
 Have no such Daughter, nor shall ever see
 That Face of hers again; therefore be gone,
 Without our Grace, our Love, our Benizon.
 – Come, noble Burgundy.

C.6 *How is the 'exeunt' sonically realised?*
Flourish. Exeunt [all but France, Cordelia, Goneril, and Regan]

D

FRANCE: Bid farewell to your Sisters.
CORDELIA: The Jewels of our Father, with wash'd Eyes
 Cordelia leaves you. I know you what you are,
 And like a Sister am most loath to call
 Your Faults as they are named. Love well our Father:
 To your professed Bosoms I commit him,
 But yet alas, stood I within his Grace,
 I would prefer him to a better Place.
 So fare well to you both.
REGAN: Prescribe not us our Duty.
GONERIL: Let your Study
 Be to content your Lord, who hath receiv'd you
 At Fortune's Alms. You have Obedience scanted,
 And well are worth the Want that you have wanted.
CORDELIA: Time shall unfold what plighted Cunning hides,

Who covers Faults, at last with Shame derides:
Well may you prosper.

FRANCE: Come, my fair Cordelia.

Exit with Cordelia

D.1 *How is the exit aurally realised?*

D.2 *Is there any perceptible change in Goneril and Regan's vocal delivery reflecting (i) they are speaking in prose/conversation? And (ii) given the content of their conversation, is it intended to be hushed and devious or normal and open?*

GONERIL: Sister, it is not little I have to say
 Of what most nearly appertains to us both.
 I think our Father will hence to night.

REGAN: That's most certain, and with you; next
 Month with us.

GONERIL: You see how full of Changes his Age is.
 The Observation we have made of it hath been
 little; he always lov'd our Sister most,
 and with what poor Judgement he hath now cast her
 off appears too grossly.

REGAN: 'Tis the Infirmity of his Age, yet he hath
 ever but slenderly known himself.

GONERIL: The Best and Soundest of his Time hath
 been but Rash; then must we look from his Age
 to receive not alone the Imperfections of long
 ingraffed Condition, but therewithal the unruly
 Way-wardness that Infirm and Choleric Years
 bring with them.

REGAN: Such Unconstant Starts are we like to have
 From him as this of Kent's Banishment.

GONERIL: There is further complement of Leave-
 taking between France and him: pray you let us
 sit together. If our Father carry Authority
 with such Disposition as he bears, this last
 Surrender of his will but offend us.

REGAN: We shall further think of it.

GONERIL: We must do something, and i'th' Heat.

 Exeunt

D.3 *How is the 'exeunt' aurally realised?*

D.4 *Is there an aural link between scene one and scene two?*

[End of scene i]

Appendix Two | Cast

King Lear by The Shakespeare Recording Society (1965)
Time: 3 hours 6 minutes
Directed by: Howard Sackler

CAST

Lear, King of Britain	Paul Scofield
King of France	Wallas Eaton
Duke of Burgundy	John Rogers
Duke of Cornwall	Trevor Martin
Duke of Albany	Michael Aldridge
Earl of Kent	Andrew Keir
Earl of Gloucester	Cyril Cusack *[also BBC4]
Edgar, son to Gloucester	Robert Stephens
Edmund, bastard son to Gloucester	John Stride
Curan, a courtier	Arthur Hewlett
Lear's Fool	Ronnie Stephens
Doctor	Arthur Hewlett
Oswald, steward to Goneril	Willoughby Goddard
Gentleman, attendant to Cordelia	Ronald Ibbs
Goneril	Pamela Brown

Regan	Rachel Roberts
Cordelia	Ann Bell
Knight, attending on Lear	Ronald Ibbs

King Lear by RTE (1988)

Time: 2 hours 2 minutes

Abridged for broadcasting, produced and directed by: Laurence Foster

Special effects by: Brendan Fitzgerald and Kieran Hogan

CAST

Kent	Aiden Grennell
Edmund	Jim Reid
Gloucester	Peter Dix
Goneril	Collette Proctor
Lear	Seamus Forde
Cordelia	Cathryn Brennan
Albany	Conor Farrington
Regan	Kate Minogue
Cornwall	Garvan McGrath
Edgar	Michael Grennell
Fool	Dan Reardon
1st Servant / Doctor	Brendan O'Duill
Old Man	Ivan Hanly
Oswald	Scott Fredericks
France / Curan	David Heap

King Lear by **BBC 4 (1988)**

Time: 2 hours 52 minutes

Directed by: John Tydeman

Music composed and conducted by: Christopher Whelan

CAST

Lear, King of Britain	Alec Guinness
Fool	Ronald Pickup
Goneril	Jill Bennett
Regan	Eileen Atkins *[also BBC3]
Cordelia	Sarah Badel
Earl of Gloucester	Cyril Cusack *[also SRS]
Edgar, son to Gloucester	Robert Powell
Edmund, bastard son to Gloucester	Norman Rodway
King of France	Michael Decon
Duke of Burgundy	David Timson
Duke of Cornwal	Donald Douglas
Duke of Albany	Julian Curry
Earl of Kent	Trevor Martin
Oswald, steward to Goneril	Andrew Sachs

Other parts played by : Rolf Lefebvre, Peter Williams, David Ericsson, Paul Gaymon, Peter Pacey and Stephen Thorne.

King Lear by BBC 3 (1994)
Time: 3 hours and 13 minutes
Incidental music by: Patrick Doyle
Co-produced by: Kenneth Branagh and Glyn Dearman
Directed by: Gyln Dearman

CAST

Kent	Keith Michell
Gloucester	Richard Briers
Edmond	Kenneth Branagh
Lear	Sir John Gielgud
Goneril	Judi Dench
Cordelia	Emma Thompson
Regan	Eileen Atkins *[also BBC4]
Albany	John Sharpnel
Cornwall	Robert Stephens
Burgundy	Denis Quilley
France	Derek Jacobi
Edgar	Iain Glen
Oswald	Bob Hoskins
Knight	Simon Russell Beale
Fool	Michael Williams
First Gentleman	Nickolas Grace
Curan	Sam Dastor
Servant	Harry Towb
Old Man	Maurice Denham
First Messenger	Bernard Cribbins
Second Gentleman	Matthew Morgan
Second Messenger	Nicholas Boulton
Captain	Sam Dastor
Herald	Peter Hall

Other parts played by members of the company.

Notes

Part One – Traditions

Introduction | What Is A Radio Play?

1 Ash, William. *The Way To Write Radio Drama* p.1
2 Callow, Simon. *Orson Welles – The Road to Xanadu* p.373
3 Stoppard, Tom. 'Artist Descending A Staircase' in: *Stoppard: The Plays for Radio 1964 –1991* pp.113/114

1 | Who's Listening? Some Statistics

1 McLuhan, Marshall. *Understanding Media –The Extensions of Man* p.298
2 McWhinnie, Donald. *The Art of Radio* p.11
3 McLeish, Robert. *Radio Production* p.1
4 McLuhan, Marshall. *Understanding Media–The Extensions of Man* p.302
5 Riley, Dominic. 'Who Cares About Radio?' in: *Radio Festival '97– Report* p.19
6 Beck, Alan. *Radio Acting* p.4
7 Esslin, Martin. 'The Mind as a Stage' in: *Theatre Quarterly* Vol.1 No.3 (1971) p.6
8 Imison, Richard. 'Preface' in: *Best Radio Plays of 1984.* pp.ix/xx
9 Imison, Richard. 'Preface' in: *Best Radio Plays of 1987.* p.x
10 Millwood Hargrave, Andrea. *Radio & Audience Attitudes –Annual Review 1994* p.28
11 Beck, Alan. *Radio Acting* p.4.
12 Reynolds, Gillian. 'Radio Future' in: *Radio & Audience Attitudes – Annual Review 1994* p.57
13 ibid. p.57
14 Bartlett, David. 'News Radio – More Than Masters of Disaster' in: *Radio – The Forgotten Medium* p.31
15 ibid. p.31
16 Matelski, Marilyn. J. 'Resilient Radio' in: *Radio – The Forgotten Medium* p.9
17 Fink, Howard. 'The sponsor v. the nation's choice: North American Radio Drama' in: *Radio Drama* p.191
18 Bland, Sir Christopher (Chairman, BBC) from: *Radio Times: Radio Academy Keynote Lecture* (1996)

[19] McLuhan, Marshall *Understanding Media - The Extensions of Man* p.299

2 | The Birth of a Genre

[1] Maine, Basil. *The BBC and its Audience* p.11

[2] Cylindrical recording on shellac cylinders existed since Edison's invention of the phonograph in the late 1800s. This system was a one-take only recording with no editing and was of poor sound quality.

[3] Sara O'Sullivan's article 'The Ryanline Is Now Open ... '–Talk Radio and the Public Sphere' in: *Media Audiences In Ireland* (eds. Mary J. Kelly and Barbara O' Connor) offers an interesting analysis of *The Gerry Ryan Show*. O'Sullivan states that 'talk radio provides a rare opportunity for Irish audiences to participate in mass mediated debate and discussion...What makes this show particularly interesting is that it offers access to listeners, and in this way allows the audience to participate in meaning making' [p.167]. In her conclusion O'Sullivan highlights one of the programme's main constraints. 'However it does offer a forum where listeners can "meet" and discuss important issues, although as entertainment is the producers' top priority, the value of this forum is somewhat limited' [p.184].

[4] Maine, Basil. *The BBC and its Audience* p.11
[5] Seymour-Ure, Colin. *The British Press and Broadcasting Since 1945* p.118
[6] Drakakis, John. *British Radio Drama* p.1
[7] Brecht, Bertholt. *Brecht On Theatre* p.51
[8] Drakakis, John. 'Radio Adaptations of Stage Plays' in: *Radio Drama* (1981) p.115
[9] Rodger, Ian. *Radio Drama* p.12
[10] Drakakis, John. 'Radio Adaptations of Stage Plays' in: *Radio Drama* (1981) p.112
[11] Drakakis, John. *British Radio Drama* p.7
[12] Rodger, Ian. *Radio Drama* p.13
[13] Drakakis, John. *British Radio Drama* p.4
[14] Rodger, Ian. *Radio Drama* p.12
[15] ibid. p.14
[16] Maine, Basil *The BBC and Its Audience* pp.104-5
[17] ibid. p.105

18 Shaw, George Bernard. Television clip on *Radio Arena Night*.
 BBC Tx: 18/12/93
19 Rodger, Ian. *Radio Drama* p.15
20 Drakakis, John. *British Radio Drama* p.2
21 Lewis, Peter. 'Introduction' in: *Radio Drama* (1981) p.8
22 ibid. p.13
23 Rodger, Ian. *Radio Drama* p.15
24 ibid. p.14
25 Maine, Basil. *The BBC and Its Audience* p.99
26 Esslin, Martin. *The Mind as a Stage* Theatre Quarterly Vol 1. No.3
 p.7
27 Imison, Richard. quoted in 'Referable Words in Radio Drama' in:
 Broadcast Talk p.15
28 Roger, Ian. *Radio Drama* p.24
29 ibid. p.24
30 Guthrie, Tyrone. *Squirrel's Cage. and Two Other Microphone Plays.* p.14
31 ibid. p. 140
32 Roger, Ian. *Radio Drama.* p.19
33 ibid. p.22

3 | Radio's *War of the Worlds*

1 Cantril, Hadley. *The Invasion from Mars–A Study in the Psychology of
 Panic* pp.42/43

2 The Radio Act of 1912 was the first U.S. law to regulate radio
 stations and made the Secretary of Commerce and Labour
 responsible for licensing. The Radio Act of 1927 established the
 FRC (Federal Radio Commission) which affirmed that the radio
 spectrum belonged to the people and should therefore be regulated
 in the public interest. This Act and the FRC were replaced by the
 1934 Communications Act, which established the FCC (Federal
 Communications Commission). The FCC remains the current
 statutory body for licensing regulation.

3 Matelski, Marilyn. J. Resilient Radio in: *Radio – The Forgotten Medium*
 p.9
4 ibid. p.9
5 Fink, Howard. 'The sponsor's v. the nation's choice: North
 American radio drama' in: *Radio Drama* (1981) p.189
6 Callow, Simon. *Orson Welles – The Road To Xanadu* p.371

7 Matelski, Marilyn. J. 'Resilient Radio' in *Radio – The Forgotten Medium* p.8

8 Callow, Simon. *Orson Welles – The Road To Xanadu* p.371

9 I use the term 'visionary' to connect a curious coincidence between Welles and Artaud. Welles was romantically drawn to Ireland viewing it as a mystical and timeless place influenced in part by Padraic O Conaire's *'Travels with a Donkey in Ireland.'* ['Come with me, O friend of my heart, and let us enjoy the sight of majestic mountain peaks and dark pine forests…'].

In 1931 Welles disembarked in Galway and having spent some time on the Aran Islands (attempting to learn Irish), eventually made his way to Dublin later in the year where he engineered a meeting with Hilton Edwards and Michael MacLiammoir. Artaud also visited Ireland, but some years later in 1937 during a period when he was deeply involved with religious mysticism. Drawn to Ireland by what he believed was its sense of mysticism, Artaud, clutching his mysterious shillelegh, also made his way to Galway and to the Aran Islands. Welles left Ireland in February 1932 to return to America via London. During these months of his return journey he spent some time in Paris, apparently 'dining, drinking, attending parties and the theatre'; [Callow, *Orson Welles–The Road To Xanadu* p.113]. It is not certain if he met Artaud but it is probable that the Parisian avant-garde scene may have influenced Welles and in particular the theatrical visions of Artaud. Back in America, Welles was having mediocre success in the 'traditional' theatre until his zany 1936 production of an equally zany play *'Horse Eats Hat'* – described as a form of theatre where Jarry meets Labiche. Callow states that Welles wanted the theatre to be 'a place where extraordinary things should happen, where the audience should be continuously assaulted and stimulated'; [ibid. p.260]. Although perhaps a coincidence Welles's wish for a theatre of stimulation was expressed the year after Artaud founded his 'Theatre of Cruelty.'

10 Callow, Simon. *Orson Welles – The Road To Xanadu* p.87

11 ibid. pp.373/378

12 ibid. p.372

13 Fink, Howard. 'The sponsor's v. the nation's choice: North American radio drama' in: *Radio Drama* (Lewis) p.221

14 See *Theatre Semiotics - Text and Staging in Modern Theatre* (Fernando de Toro) for an engaging discussion regarding the Dramatic Text (DT)

and the Performance Text (PF). De Toro, following the theories of Ingarden and Ubersfeld, claims that a 'dramatic text' is composed of two separate strands: (1) a main text made up of the dialogue and the characters and (2), a secondary text comprising the didascalia and the stage directions to which he ascribes the term the Virtual Performance Text (VPT). The dramatic text is, therefore, a dual or bifaceted text.

Koch's script, which is an adaptation of H.G.Wells's source text (ST), becomes the DT for Orson Welles's rehearsals as the VPT, where the actual 'live' broadcast was heard as the PT. It was the PT that became famous and along with it the name of Orson Welles, but not content with this, he also wished to claim the DT as his own. Welles wrote to Hadley Cantril in 1939 suggesting an erratum slip be included in Cantril's forthcoming publication, *The Invasion From Mars – A Study in the Psychology of Panic* (Princeton University Press, 1940):

> 'Think how much more unfavourable an impression your book will make as it now stands and try to conceive the effect on my professional prestige and position in the theatre world. Can see no conceivable reason for your steadfast refusal to believe 'The War of the Worlds' was not only my conception but also, properly and exactly speaking, my creation…Once again, finally, and I promise for the last time, Howard Koch did not write 'The War of the Worlds.' Any statement to this effect is untrue and immeasurably detrimental to me.' [*Orson Welles–The Road To Xanadu* (Simon Callow) pp 490/481].

Cantril replied citing affidavits and a telegram from Houseman's secretary. (Houseman was co-founder with Welles of the 'Mercury Theatre'). The telegram stated that Koch dictated the script to her from a manuscript in his own handwriting, and that Houseman and Paul Stewart made only minor corrections to it. Cantril affirmed that, 'in view of all the evidence we have from him, I find no alternative than to acknowledge him (Koch) as writer but not as creator'; [*Orson Welles–The Road To Xanadu* p. 491]. In Welles's case he was not content to be acknowledged as the creator of the performance text – the famous production as broadcast – but also needed to claim the literary dramatic text of the production.

[15] Wells, H.G. *The War of the Worlds* Everyman p.xxx

[16] ibid. p.174
[17] ibid. p.5
[18] ibid. p.11
[19] ibid. pp.173/4.
[20] Cantril, Hadley. *The Invasion from Mars – A Study into the Psychology of Panic* p.58
[21] Callow, Simon. *Orson Welles – The Road to Xanadu* pp.404/405
[22] Cantril, Hadley. *The Invasion from Mars – A Study in the Psychology of Panic* p.47
[23] Koch, Howard. *War of the Worlds* – [Radio Script] in: *The Invasion from Mars – A Study in the Psychology of Panic* p.4
[24] 'Orson Welles in *The War of the Worlds* by H.G.Wells from: *The Golden Days of Radio Series*. Hodder Headline Audio Books
[25] Callow, Simon. *Orson Welles – The Road to Xanadu* pp401/402
[26] ibid. p. 400
[27] Cantril, Hadley. *The Invasion from Mars – A Study in the Psychology of Panic* p.58
[28] Callow, Simon. *Orson Welles – The Road to Xanadu* p.404
[29] Cantril, Hadley. *The Invasion from Mars – A Study in the Psychology of Panic* p.32
[30] ibid. p.44
[31] ibid. pp.43/44
[32] Associated Press for: *South China Morning Post* (01-11-1988)

4 | A High Hum of Pure Agony

[1] Briscoe. D. & Curtis-Bramwell. R. *The BBC Radiophonic Workshop – The First 25 Years* p.11
[2] ibid. p.16
[3] Smith-Brindle, Reginald. *The New Music – The Avant-Garde Since 1945* p.100
[4] Worner, Karl, H. *Stockhausen – Life and Work* p.123
[5] Although *'musique concrète'* and *'elektronische Musik'* can be said to have created a new palette of 'industrial' sound, the concept of making music from the 'industrial' sounds of the new century had been thought about much earlier. The most persistent and influential of the new Futurist composers was the Italian, Luigi Russolo. He called for 'a music that would relate to the sounds and rhythms of machines and of factories, an 'art of noises' which must be strident, dynamic and eagerly in tune with modern life'; [Griffiths, *A Concise History of Modern Music* p.106]. He built a number of 'intonarumi'

(noise generators), mechanical devices which produced a variety of exploding, crackling, rubbing and buzzing sounds. Russolo exhibited and performed concerts with these devices in Italy and England from 1914, but it was not until they had been exhibited in Paris, in 1921, that they began to receive wide and serious attention, not least from the composers Stravinsky, Honeggar and Varese.

6 Briscoe. D. & Curtis-Bramwell. R. *The BBC Radiophonic Workshop – The First 25 Years* p.13

7 ibid. p.17

8 ibid. p.14

9 ibid. p.18

10 ibid. p.18

11 ibid. p.23

12 McWhinnie, Donald. *The Art of Radio* p.87

13 Bradnum, Frederick *Private Dreams and Public Nightmares* (1957) in: *The BBC Radiophonic Workshop – The First 25 Years* p.21

14 Briscoe. D. & Curtis-Bramwell. R. *The BBC Radiophonic Workshop – The First 25 Years* p.30

15 ibid p.141

16 Tydeman, John. 'The Producer and radio drama: a personal view' in: *Radio Drama* (1981) p.25

17 Guralnick, Elissa. S. *Sight Unseen – Beckett, Pinter, Stoppard and Other Contemporary Dramatists on Radio* p.150

18 ibid. pp.128/150

19 Tydeman, John. 'The Producer and radio drama: a personal view' in: *Radio Drama* [1981] p.24

5 | *Under Milk Wood* (Dylan Thomas)

1 Thomas, Dylan. *Under Milk Wood* BBC Radio Collection * CD release (1995)

2 Thomas, Dylan. *Under Milk Wood* EMI Listen For Pleasure (1992)

3 Zilliacus, Clas. *Beckett and Broadcasting*. (Abo Akademi, 1976) p.15 (footnote 21)

4 Cleverdon, Douglas. *The Growth of Milk Wood* p.20

5 Lewis, Peter. 'UNDER MILK WOOD As Radio Poem' in: *Radio Literature Conference 1977–Conference Papers* pp. 137/138

6 Cleverdon, Douglas. *The Growth of Milk Wood* p.17

7 There were certainly frictions between the Drama and Features departments and possibly more of a personal nature between Val

Gielgud and certain other individuals. In modern parlance a 'turf-war' had broken out.

'Paradoxically, the huge success of *Under Milk Wood* caused a row between the Third and Drama Department. When, a few months later, John Morris [Controller, Third Programme] complained to Val Gielgud that Drama was not offering the Third enough plays, Gielgud snapped back that Features, to whom Douglas Cleverdon belonged, were "running a private drama sub-section of their own", and the Third was taking plays from them without letting Drama know. To the Controller of Entertainment, Gielgud complained that Morris "prefers Cleverdon acting in an unofficial capacity as a source of drama supply rather than Donald McWhinnie [Gielgud's deputy] or myself...it amounts to a vote of little or no confidence in this department". [*The Envy of the World – Fifty Years of the BBC Third Programme and BBC 3* (Humphrey Carpenter) (Pheonix/Orion Books, 1997) p.145]

8 McLeish, Robert. *Radio Production–3rd edition* p.247
9 Horstmann, Rosemary. *Writing for Radio–3rd edition* p.52
10 Evans, Elwyn. *Radio–A Guide to Broadcasting Techniques* p.97
11 ibid. p.7
12 Cleverdon, Douglas. *The Growth of Milk Wood* p.7
13 Thomas, Dylan. *Dylan Thomas narrating 'Under Milk Wood' with the Original Cast.'* Caedmon Cassette [CDL 52005(2c)], New York.
 * Dylan Thomas together with five other voices (Roy Poole, Dion Allen, Nancy Wickwire, Aada Thompson and Allen F. Collins) performed all of the parts.
14 Thomas, Dylan. *The Complete Recorded Stories and Humorous Essays of Dylan Thomas.* [Caedmon Cassette–CDL 530006]
15 Ferris, Paul. *Dylan Thomas.* p. 213 [also in Ferris, Paul. *Dylan Thomas–The Biography (New Edition)* p. 227
16 Thomas, Dylan. *Quite Early One Morning–Stories, Poems and Essays* pp.15-20
17 Carpenter, Humphrey. *The Envy of the World–Fifty Years of the BBC Third Programme and Radio 3* p. 140
18 Thomas, Dylan. *Under Milk Wood – A Play for Voices* (Everyman) p18.
19 Ackerman, John. *A Dylan Thomas Companion* p.260
20 Thomas, Dylan. *Under Milk Wood* (Everyman) p.41
21 ibid. p.60

22 ibid. p.39

23 Holbrook, David. *Llareggub Revisited – Dylan Thomas and the state of modern poetry* pp. 200/201

6 | *Krapp's Last Tape* (Samuel Beckett)

1 Brater, Enoch. *Why Beckett* p.92

2 McMillan, D. and Fehsenfeld. M. *Beckett in the Theatre* p.294

3 Rozik, Eli. *The Language of Theatre* p.99

4 Beckett, Samuel. 'Krapps Last Tape' in: *Collected Shorter Plays of Samuel Beckett* p.56

5 ibid. p.62

6 Bair, Deirdre. *Samuel Beckett* p.520

7 Ben-Zvi, Linda. *Samuel Beckett* p.152

8 Brater, Enoch. *Why Beckett* p.90

9 Bryden, Mary. *Samuel Beckett and Music* p.25

7 | Radio and Language

1 Lewis, P.M. 'Referable Words in Radio Drama' in: *Broadcast Talk* p.26

2 ibid. p.26

3 ibid. p.26

4 ibid. p.16

5 BBC internal memorandum, 18 April 1986 in: *Broadcast Talk* p.17

6 ibid. p.27

7 ibid. p.21

8 Devaney, Martin. *The RTE Writer's Guide* p.39

9 RTE presentation announcement 9.02 p.m. 29/06/99

10 Moxley, Gina. *Danti-Dan* in: *Rough Magic–First Plays* p.319

11 Lewis. P.M. 'Referable Words in Radio Drama' in: *Broadcast Talk* p.28

12 ibid. p.28

13 Lewis, C.A. *Broadcasting From Within* p.175

14 Lewis. P.M. 'Referable Words in Radio Drama' in: *Broadcast Talk* p.22

Part Two – Transitions

8 | Aspects of Radio Drama

1 Paglia, Camille. *Sex, Art, and American Culture East and West* p.151
2 ibid. p.151
3 Hart, Andrew. *Understanding the Media* p.8
4 Zumthor, Paul. *Oral Poetry* p.20
5 Guralnick, Elissa.S. *Sight Unseen: Beckett, Pinter, Stoppard, and Other Contemporary Dramatists on Radio* p.191
6 Birringer, Johannes. *Theatre, Theory, Postmodernism* p.4

9 | Sound Images

1 Broadhouse, John. *Musical Acoustics (or The Phenomena of Sound)* p.1
2 Cage, John. *For The Birds* p.150
3 Serban, Andrei. 'The Life in a Sound' in: *The Drama Review*, v.20 no.14 p.25
4 Broadhouse, John. *Musical Acoustics (or The Phenomena of Sound)*: p.1
5 ibid. p.1
6 Clynes, Manfred. (ed.) *Music, Mind and Brain –The Neuropsychology of Music* p.ix
7 ibid. p.vii
8 ibid. p.vii
9 McAdams, Stephen. 'Spectral fusion and the Creation of Auditory Images' in: *'Music, Mind and Brain– The Neuropsychology of Music* p.279
10 ibid. p.280
11 ibid. p.280
12 Drakakis, John. (ed.) *British Radio Drama* p.23
13 Haworth, Don. *On a Day in a Garden in Summer* in: *Contemporary One Act Plays* p.1
14 ibid. p.2
15 Wade, David. 'British Radio Since 1960' in: *British Radio Drama* p.231
16 Briscoe, Desmond. and Curtis-Bramwell, Roy. *The BBC Radiophonic Workshop–The First 25 Years* p.33
17 Crisell, Andrew. *Understanding Radio* p.161
18 Mc Whinnie, Donald. *The Art of Radio* p.153
19 Gray, Frances. 'The Nature of Radio Drama' in: *Radio Drama* (1981) p.51

10 | Silences | Pauses

1 Rattigan, Dermot. *Radio interview with John Cage.* Tape with the author.
2 McWhinnie, Donald. *The Art of Radio* p.89
3 Crisell, Andrew. *Understanding Radio–2nd edition* p.52
4 ibid. p.52
5 ibid. p.53
6 ibid. p.53
7 ibid. p. 157
8 Zilliacus, Clas. *Beckett and Broadcasting* pp.159/60
9 McCallion, Michael. *The Voice Book* p.204
10 Beckett, Samuel. 'Cascando' in: *Collected Shorter Plays of Samuel Beckett* p.137
11 Zilliacus, Clas. *Beckett and Broadcasting* p.127
12 Beckett, Samuel. 'Cascando' in: *Collected Shorter Plays of Samuel Beckett* p.144
13 McWhinnie, Donald. *The Art of Radio* p.89
14 Thomas, Dylan. *Under Milk Wood* (Everyman) p.3
15 Davies, Walford. 'Introduction' to *Under Milk Wood* (Everyman) p.xliii
16 Stoppard, Tom. 'M Is For Moon Among Other Things' in: *Stoppard: The Plays For Radio 1964- 1991* p.15

11 | Voices

1 Cummings-Wing, Julia. *Speak For Yourself* p.1
2 Pittam, Jeffery. *Voice in Social Action–An Interdisciplinary Approach* p.21
3 ibid. p.21
4 Beck, Alan. *Radio Acting* p.66
5 Berry, Cicely. *The Actor and The Text* p.14
6 Titze, Ingo R. *Principals of Voice Production* p.252
7 ibid. p.252
8 ibid. p252
9 Beck, Alan. *Radio Acting* p.99
10 Pittam, Jeffery. *Voice in Social Interaction–An Interdisciplinary Approach* p.17
11 In Jackendoff and Lerdahl's paper, 'A Grammatical Parallel Between Music and Language' [in: *Music, Mind and Brain* pp.83-155], the authors draw strong parallels between part of generative music theory called 'time-span reduction' and 'prosodic tree structures' in

linguistic theory. Time-span reduction assigns to pitches a hierarchy of structural importance with respect to their position within a rhythmic structure. They then compare and parallel the similarities between time-span reduction in relation to music to prosodic tree structures which is the formulation of syllabic and word stress in a structural hierarchy in relation to linguistics.

12 Titze, Ingo R. *Principals of Voice Production* p.253
13 Beck, Alan. *Radio Acting* p.96
14 Sundberg, Johan. 'Speech, Song and Emotions' in: *Music, Mind and Brain* p.137
15 ibid. p.138
16 Evans, Elwyn. *Radio—A Guide to Broadcasting Techniques* p.129
17 Beck, Alan. *Radio Acting* p.83
18 Horstmann, Rosemary. *Writing For Radio* 3rd ed. p.38
19 Beck, Alan. *Radio Acting* p.84

12 | Words

1 Ong, Walter J. *Orality and Literacy* p.9
2 ibid. p.5
3 Serban, Andrei. 'The Life in a Sound' in: *The Drama Review* pp. 25/26
4 Esslin, Martin. *The Field of Drama* p.84
5 West, Timothy. 'This Gun That I Have In My Right Hand Is Loaded' in: *Writing for Radio* (Horstman)
6 Davies, Walford. 'Introduction' to *Under Milk Wood* (Everyman) p.xliii
7 ibid. *Under Milk Wood* p.xliii
8 ibid. p.xliii
9 Thomas, Dylan. *Under Milk Wood* (Everyman) p.16
10 Ong, Walter J. *Orality and Literacy* p.8
11 Crisell, Andrew. *Understanding Radio* p.43
12 ibid. p.28
13 Ong, Walter J. *Orality and Literacy* p.8

13 | Utterances

1 Rozik, Eli. *The Language of the Theatre* pp.62/63
2 ibid. p.86
3 Dunstone, Stephen. 'Who is Sylvia?' in: *Best Radio Plays of 1984* (Methuen/BBC Publications, 1985) p.30
4 Campton, David. *Boo!* extract in: *The Way To Write Radio Drama* p.85

5 Cassell *Concise English Dictionary* p.26
6 ibid. p.26

14 | Sound Effects

1 McLeish, Robert. *Radio Production* 3rd ed. p.234
2 Crisell, Andrew. *Understanding Radio* p.44
3 ibid. p.44
4 McLeish, Robert. *Radio Production* 3rd ed. p.235
5 Taylor, Derek. 'Speech and Drama' in: *Sound Recording Practice* 2nd ed. p.265
6 Stoppard, Tom. 'If You're Glad I'll Be Frank' in: *Stoppard: The Plays for Radio 1964 -1991*: p.25
7 ibid. p.26
8 ibid. p.25
9 ibid. pp.29/30

15 | Music

1 Jacobs, Arthur. *A New Dictionary of Music* p.258
2 Adorno, Theodor. *Quasi una Fantasia–Essays on Modern Music* p.1
3 Cassell *Concise English Dictionary* p.881
4 Aristotle. *The Art of Poetry* in Classical Literary Criticism p.32
5 Quoted in: Dahlhaus, Carl. *Esthetics of Music* p.11
6 ibid p.19
7 ibid. p.17
8 ibid. pp.17/18
9 ibid. p.12
10 ibid. p.19
11 Crissell, Andrew. *Understanding Radio* 2nd ed. p.48
12 McWhinnie, Donald. *The Art of Radio* p.67
13 Evans, Elwyn. *Radio–A Guide to Broadcasting Techniques* p.149
14 Goffman, Erving. 'The Radio Drama Frame' in: *Communications Studies* (1980) p.165
15 ibid. p.167
16 McLeish, Robert. *Radio Production* 3rd ed. p.236
17 Crisell, Andrew. *Understanding Radio* 2nd ed. p.52
18 ibid. p.52
19 ibid. p.52
20 Crisell's accusation that radio producers often 'cheat' [p.52] is curious. As radio is a sightless medium, the listener has little option but to believe that what is being presented is truthful. However, in the interest of programme quality, particularly where music is being

used as a background for a verbal report, the producer may opt for a clean recording of the band from a record/CD if the actuality recording was considered to be of poor quality. Does this really amount to 'cheating'? The use of a pre-existing recording of military band music does, however, pose an aesthetic consideration. The recording must be of the Argyll and Sutherland Highlanders and not some other regimental bagpipe and drum band.

[21] Willis, Edgar. E. *Writing Television and Radio Programmes* New York p.174

[22] Prendergast, Roy M. *Film Music—A Neglected Art*

[23] ibid. p.201

[24] ibid. p.204

[25] ibid. p.205

[26] McWhinnie, Donald.*The Art of Radio* pp. 71/72

[27] Kinley, Howard. 'Radio Review' in: *The Irish Times*

[28] McWhinnie, Donald. *The Art of Radio* p. 75

16 | Technical

[1] Cassell *Concise English Dictionary* p.12

[2] ibid. p.12

[3] McLeish, Robert. *Radio Production* pp.232/233

[4] Beck, Alan. *Radio Acting* p.48 p.54

[5] ibid. p.56

[6] ibid. p.56

[7] Evans, Elwyn. *Radio—A Guide to Broadcasting Techniques* p.133

[8] Arden, John. *Pearl* pp.20/21

[9] Goffman, Erving. 'The radio drama frame' in: *Communication* (1980) p. 165

[10] MacNeice, Louis. 'The Dark Tower' in: *Selected Plays of Louis MacNeice* pp. 117/118

17 | Text / Script / Aural Literature

[1] De Toro, Fernando. *Theatre Semiotics—Text and Staging in Modern Theatre* p.3

[2] ibid. p.3

[3] Tornqvist, Egil. *Transposing Drama—Studies in Representation* p.191

[4] Quote in: *Beckett and Broadcasting* (Zilliacus) p.3

[5] Mc Whinnie, Donald. *The Art of Radio* p.175

[6] Ong Walter.J *Orality and Literacy* p.135

[7] Zumthor, Paul. *Oral Poetry* p.29

[8] Ong, Walter. J. *Orality and Literature* p.8

Part Three - Transmissions

18 | Introduction to *King Lear*

1 *King Lear* The Everyman Shakespeare p.xv
2 Guralnick, Elissa S. *Sight Unseen – Beckett, Pinter, Stoppard and Other Contemporary Dramatists on Radio* p.99
3 *King Lear* : The Everyman Shakespeare 1.i. 83-90 – p.11
4 Hughes, Ted. *Shakespeare and the Goddess of Complete Being* p.277
5 Elam, Keir. *The Semiotics of Theatre and Drama* p.166
6 Hughes, Ted. *Shakespeare and the Goddess of Complete Being:* p.278
7 Titze, Ingo R. *Principles of Voice Production* p.xvii
8 ibid. p.xx
9 *King Lear.* The Everyman Shakespeare (1993)
10 Crisell, Andrew. *Understanding Radio*, p.42
11 *King Lear.* by The Shakespeare Recording Society: Harper Collins Audio Books (1979)
12 *King Lear.* by R.T.E. Radio 1: RTE Publications MC 112 (1988)
13 *King Lear.* by B.B.C. Radio 4: BBC Radio Collection Publications (1988)
14 *King Lear.* by The Renaissance Theatre Company & B.B.C.3: Random House Audiobooks (1994)

19 | Music Preludes

1 Prendergast, Roy M. *Film Music - A Neglected Art* p.201
2 ibid. p.204
3 Consider the third movement of Chopin's piano *Sonata in B flat minor*, Opus 35 titled *The Funeral March,* (also commonly referred to as *The Death March*), ceremoniously played at funerals. The combination of its minor key and slow ponderous tempo, combined with the lower pitch register of its solemn bass chords and chordal melody, creates a dark mystical and sombre awesomeness that is a chilling reminder of human fragility. The composer Liszt wrote of the *Funeral March:* 'One has the feeling of lamenting for the Death not of one hero but of a whole generation, which has in its passing left behind only women, children and priests' . [Sandved, K.B. *The World Of Music* p.463].
4 Modern brass instruments belong to an evolutionary family of wind or blown instruments whose origins can be traced back to antiquity. Modern valve or chromatic brass instruments invented in the early

19ᵗʰ century have been documented in their oldest forms as animals' horns some fitted with primitive mouthpieces. In their developed forms as various valveless instruments of pre 19ᵗʰ century construction (e.g. the hunting horn, military bugle, ceremonial bugle, natural and classical trumpets etc.), they had a limited range of notes that could be executed. This had the obvious effect of restricting hunting, ceremonial and military calls to very simple melodic and vertically linear patterns. Although there was melodic variation, which identified different types of calls, the most immediate and obvious differences were heard in the varying use of rhythmic structures and tempos. For example, the variety of rhythmic patterns used over a range of military signals and bugle calls. Whether in battle, hunting, or ceremonial use, certain types of calls were clearly understood for the meaning they were intended to convey.

21 | *King Lear* | Discussion | Analysis–A

[1] Barker, Granville. *Prefaces to King Lear* p.30
[2] Bradley, A.C. *Shakespearean Tragedy* p.202
[3] Rissik, Andrew. 'Playing Shakespeare False: a Critique of the 'Stratford Voice' in: *NTQ* v.1/iii p.230
[4] The whimsical confirmation of his illegitimacy acknowledges his legal status within the society of the time. This is a major contributing factor to his characterization but it also draws an interesting parallel between brother-to-brother rivalry and sister-to-sister rivalry. On the one hand, Edmund's greed is fuelled by jealousy while on the other hand, Goneril's and Regan's desires are simply fuelled by greed. Edmund the dispossessed and Edgar the brother possessed; Cordelia, in possession but becomes dispossessed and Goneril/Regan, the sisters in possession who also gain Cordelia's inheritance. Edmund seeks his revenge through untruthful actions, Goneril/Regan affect theirs through complete inaction and silence in their (non)-defence of their sister.
[5] Cassell: *Concise English Dictionary* p.291
[6] The Book of Josue Chapter 6 v.5 *The Holy Bible* p. 227
[7] The Book of Paralipomenon Chapter 15 v.14 *The Holy Bible* p. 453
[8] Handel, George. F. *The Messiah* p.175
[9] Cazeaux, Isabelle. *French Music in the Fifteenth and Sixteenth Centuries:* p.129

22 | *King Lear* | Discussion | Analysis–B

1 Barker, Granville. *Prefaces to King Lear* p.92
2 ibid. p.92
3 ibid. p.79
4 ibid. p.80
5 ibid. p.80
6 Linklater, Kristin. *Freeing The Natural Voice* p.104
7 Titze, Ingo R. *Principles of Voice Production* p.248

23 | *King Lear* | Discussion | Analysis–C

1 *Cassell Concise English Dictionary* (Cassell, 1995)

Conclusion

1 It could be argued in an extended form that dress rehearsals and/or previews are the production phase of a play and, after any adjustments made at this stage, every new audience viewing a subsequent performance are attending the play in its post-production phase. However, I contend that the play can never reach in theory or practice an absolute and definitive performance even if its 'final' performance is considered as an end in itself.
2 Wyatt, Rachel. 'Twenty Thousand Ears in CanPlay', *CBC Radio Drama Internet Publication* (1996)

Bibliography

Ackerman, John. *A Dylan Thomas Companion.* London: Macmillan (1991)

Adorno, Theodor. *Quasi una Fantasia - Essays on Modern Music.* London: Verso (1992)

Andrews, Jim. 'Audiology' in: Strauss, Neil. (ed.), *Radiotext(e).* New York: Semiotext(e) (1993)

Arden, John. *Pearl.* London: Eyre Menthuen (1979)

Aristotle. 'The Art of Poetry' in: *Classical Literary Criticism.* Harmondsworth: Penguin Classics (1965)

Ash, William. *The Way To Write Radio Drama.* London: Elm Tree Books (1985)

Aston, Elaine & Savona, George. *Theatre as Sign-System.* London: Routledge (1996)

Bair, Deirdre. *Samuel Beckett - A Biography.* London: Vintage (1990)

Barker, Granville. *Prefaces to King Lear.* London: Nick Herne Books (1993)

Bartlett, David. 'News Radio - More Than Masters of Disaster' in: Pease, E.C. and Dennis, E.E. (eds.), *Radio - The Forgotten Medium.* New Jersey: Transaction Publishers (1995)

Beck, Alan. *Radio Acting.* London: A&C Black (1997)

Beckett, Samuel. *Collected Shorter Plays of Samuel Beckett.* London: Faber and Faber (1990)

Ben-Zvi, Linda. *Samuel Beckett.* Boston: Twayne (1986)

Berry, Cicely. *The Actor and The Text.* London: Virgin Books (1996)

Birringer, Johannes. *Theatre, Theory, Postmodernism.* Bloomington: Indiana University Press (1991)

Bland, Sir. Christopher (Chairman, BBC). *The Radio Times: Radio Academy Keynote Lecture.* Birmingham: (1996)

Borwick, John. (ed.) *Sound Recording Practice* - (Second Edition). Oxford: Oxford Univerwity Press (1980)

Bowen, John. 'Writing Radio Drama - The Ideal and the Actual' in: *Radio & Audience Attitudes– Annual Report 1994.* London: John Libby & Company (1994)

Bradley, A. C. *Shakespearean Tragedy.* London: Macmillan (1957)

Bradnum, Fredrick. 'Private Dreams and Public Nightmares' (1957) in: Briscoe, D. and Curtis-Bramwell, R. *The BBC Radiophonic Workshop - The First 25 Years.* London: BBC Publications (1983)

Brater, Enoch. *Why Beckett.* London: Thames & Hudson (1989)

Brecht, Bertold *Brecht On Theatre.* (ed. John Willett). London: Methuen Drama (1995)

Bridson, D.G. *Prospero and Ariel.* London: Victor Gollancz Ltd., (1971)

Briscoe, Desmond. & Curtis-Bramwell, Roy. *The BBC Radiophonic Workshop – The First 25 Years.* London: BBC Publications (1983)

Broadhouse, John. *Musical Acoustics (or The Phenomena of Sound).* London: William Reeves (1881)

Bryden, Mary. (ed.), *Samuel Beckett and Music.* Oxford: Clarendon Press (1998)

Cage, John. *For The Birds.* New Hampshire/London: Marion Boyars (1976)

Callow, Simon. *Orson Welles - The Road To Xanadu.* London: Vintage (1996)

Campton, David. Extract from *Boo!* in: Ash, William. *The Way To Write Radio Drama.* London: Elm Tree Books(1985)

Cantril, Hadley. *The Invasion from Mars - A Study in the Psychology of Panic.* New Jersey: Princeton University Press (1940)

Carpenter, Humphrey. *The Envy of the World.* London: Pheonix/Orion Books (1997)

Cassell. *Concise English Dictionary.* London: Cassell (1994)

Cazeaux, Isabelle. *French Music in the Fifteenth and Sixteenth Centuries.* New York: Praeger (1975)

Cleverdon, Douglas. *The Growth of Milk Wood.* London: J.M. Dent (1969)

Clynes, Manfred. (ed.), *Music, Mind, and Brain - The Neuropsychology of Music.* New York: Plenum Press (1982)

Corner, J. & Wawthorn, J. (eds.), *Communications Studies.* London: Edward Arnold Publishers (1980)

Crisell, Andrew. *Understanding Radio.* London: Routledge (1996)

Cummings-Wing, Julia. *Speak For Yourself.* Chicago: Nelson Hall (1989)

Dahlhaus, Carl. *Esthetics of Music.* Cambridge: Cambridge University Press (1982)

Davies, Walford. *Introduction to Under Milk Wood.* London: Everyman (1995)

De Toro, Fernando. *Theatre Semiotics.* Toronto: University of Toronto Press (1995)

Devaney, Martin. *The RTE Writer's Guide.* Dublin: Blackwater Press (1995)

Drakakis, John. (ed), *British Radio Drama.* Cambridge: Cambridge University Press (1981)

Drakakis, John. 'The essence that's not seen: radio adaptations of stage Plays' in: Lewis, Peter. (ed.), *Radio Drama.* London: Longman (1981)

Dunstone, Stephen. *Who Is Sylvia?* in: *Best Radio Plays of 1984.* London: Methuen/BBC Publications (1985)

Elam, Keir. *The Semiotics of Theatre and Drama.* London/New York: Routledge (1994)

Esslin, Martin. 'The Mind as a Stage' in: Esslin, Martin. *Meditations - Essays on Brecht, Beckett, and the Media.* Baton Rouge: Louisiana State University Press (1980) also in: *Theatre Quarterly* Vol.1 No.3 (1971)

Esslin, Martin. *The Field of Drama.* London: Menthuen (1996)

Esslin, Martin. 'Samuel Beckett and the Art of Broadcasting' in: Esslin, Martin. *Meditations - Essays on Brecht, Beckett, and the Media.* Baton Rouge: Louisiana State University Press (1980)

Evans, Elwyn. *A Guide to Broadcasting Techniques.* London: Barrie & Jenkins (1977)

Ferris, Paul. *Dylan Thomas.* London: Penguin Books (1987)

Ferris, Paul. *Dylan Thomas - The Biography (New Edition).* London: Phoenix/Orion Books (2000)

Fink, Howard. 'The sponsor v. the nation's choice: North American Radio Drama' in: Lewis, Peter. (ed.), *Radio Drama.* London: Longman (1981)

Gielgud, Val. *British Radio Drama 1922-1956.* London: Harrup & Co. (1957)

Gilliam, Laurence. (ed.), *BBC Features.* London: Evan Brothers Ltd., (1950)

Goffmann, Erving. 'The Radio Drama Frame' in: Cornre, J. and Hawthorn, J. (eds.), *Communications Studies.* London: Edward Arnold Publishers (1980)

Gray, Frances. 'The Nature of Radio Drama' in: Lewis, Peter. (ed.),
 Radio Drama. London: Longman (1981)

Griffiths, Paul. *A Concise History of Modern Music*. London: Thames &
 Hudson (1978)

Guralnick, Elissa S. *Sight Unseen - Beckett, Pinter, Stoppard and Other
 CoPntemporary Dramatists on Radio*. Ohio: Ohio University Press
 (1996)

Guthrie, Tyrone. *Squirrel's Cage and Two Other Microphone Plays*. London:
 Cobden-Sanderson (1931)

Handel, George. F. *Messiah*. Kent: Novello (1974)

Hart, Andrew. *Understanding The Media - A Practical Guide*. London:
 Routledge (1991)

Haworth, Don. 'On a Day in a Garden in Summer' in: *Contemporary
 One Act Plays*. London: (1976)

Hessing, Kees. *Beckett On Tape*. Leiden: Academic Press Leiden (1992)

Holbrook, David. *Llareggub Revisited - Dylan Thomas and the state of modern
 Poetry*. Bath: Cedric Chivers (1974)

Hollbrook, Hal. 'Forward' in: (Shakespeare) *King Lear*. London:
 The Everyman Shakespeare (1993)

Horstman, Rosemary. *Writing for Radio*. London: A&C Black (Third
 Edition) (1997)

Hughes, Ted. *Shakespeare and the Goddess of Complete Being*. London:
 Faber and Faber (1993)

Imison, Richard. quoted in: 'Referable Words in Radio Drama' in:
 Scannell, Paddy. (ed.), *Broadcast Talk*. London: Sage Publications
 (1991)

Imison, Richard. Preface in: *Best Radio Plays of 1984*. London:
 Methuen/BBC Publications (1985)

Imison, Richard. Preface in: *Best Radio Plays of 1987*. London:
 Methuen/BBC Publications (1986)

Jackendoff, R .and Lerdhal, F. 'A Grammatical Parallel Between Music
 and Language' in: Clynes, Manfred. (ed.), *Music, Mind, and Brain -
 The Neuropsychology of Music*. New York: Plenum Press (1982)

Jacobs, Arthur. *A New Dictionary of Music*. Harmondsworth: Penguin
 Books (1970)

Kahan, Douglas and Whitehead, Gregory. (eds.), *Wireless Imagination -
 Sound, Radio and the Avant-Garde*. Cambridge (Mass.): MIT Press
 (1994)

Kelly, Mary J. and O'Connor, Barbara. (eds.), *Media Audiences In Ireland*
 Dublin: University College Dublin Press (1997)

Kinley, Howard. 'Radio Review' in: *The Irish Times*. Dublin: (1987)

Koch, Howard. 'War of the Worlds' - radio script in: Cantril, Hadley.
 The Invasion from Mars - A Study in the Psychology of Panic. Princeton:
 Princeton University Press (1940)

Laver, J. 'The Gift of Speech' in: *The Analysis of Speech and Voice.*
 Edinburgh: Edinburgh University Press (1991)

Lewis, C.A. *Broadcasting From Within.* London: Newnes (1923)

Lewis, Peter. 'The Road to Llareggub' in: Drakakis, John. (ed.), *British
 Radio Drama.* Cambridge: Cambridge University Press (1981)

Lewis, Peter. '*Under Milk Wood* As Radio Poem' in: Lewis, Peter.
 (ed.),*Radio Literature Conference 1977 - Conference Papers.* Durham:
 Univ. of Durham (1977)

Lewis, Peter. (ed.), *Radio Drama.* London: Longman (1981)

Lewis, Peter M. 'Referable Words in Radio Drama' in: Scannell,
 Paddy. (ed.), *Broadcast Talk.* London: Sage Publications (1991)

Linklater, Kristin. *Freeing the Natural Voice.* New York: Drama Book
 Publications (1976)

Maine, Basil. *The BBC and its Audience.* London: Thomas Nelson &
 Sons (1939)

Matelski, Marilyn J. 'Resilient Radio' in: Pease, E.C. and Dennis, E.E.
 (eds.), *Radio - The Forgotten Medium.* New Brunswick:
 Transaction Publishers (1995)

Mc Adams, Stephen. 'Spectral Fusion and the Creation of Auditory
 Images' in: Clynes, Manfred. (ed.), *Music, Mind, and Brain -
 The Neuropsychology of Music.* New York: Plenum Press (1982)

Mc Callion, Michael. *The Voice Book.* London: Faber and Faber
 (1989)

McLeish, Robert. *Radio Production* (Third Edition). Oxford: Focal Press
 (1994)

McLuhan, Marshall. *Understanding Media - The Extensions of Man.*
 London: Routledge (1995)

McMillan, Donald and Fehsenfeld, Martha. *Beckett In The Theatre.*
 London: John Calder (1988)

MacNeice, Louis. *Selected Plays of Louis MacNeice.* Heuser, Alan and
 McDonald, Peter. (eds.). Oxford: Clarendon Press (1993)

Mc Whinnie, Donald. *The Art of Radio.* London: Faber and Faber
 (1959)

Millwood Hargrave, Andrea. *Radio & Audience Attitudes - Annual Report
 1994.* London: John Libby & Company (1994)

Millwood Hargrave, Andrea. 'Radio and Audience Attitudes' in: *The
 Radio Academy Year Book.* London: The Radio Academy (1995)

Moxley, Gina. 'Danti-Dan' in: Bourke, Siobhán. (ed.), *Rough Magic -
 First Plays.* Dublin: New Island Books (1999)

Ong, Walter J. *Orality and Literacy.* London: Routledge (1995)

O'Sullivan, Sara. "The Ryanline Is Now Open…"- Talk Radio in the
 Public Sphere' in: Kelly, Mary J. and O' Connor, Barbara. (eds.),
 Media Audiences In Ireland. Dublin: University College Dublin
 Press (1997)

Orwell, George. 'Poetry and the Microphone' in: Strauss, Neil. (ed.),
 Radiotext(e). New York: Semiotext(e) (1993)

Paglia, Camille. *Sex, Art, and American Culture East and West.*
 London:Vintage Books (1992)

Pease, Edward C. & Everette, E. Dennis. *Radio - The Forgotten Medium.*
 New Brunswick: Transaction Publishers (1995)

Pittam, Jeffery. *Voice in Social Action - An Interdisciplinary Approach.*
 London: Sage Publications (1994)

Prendergast, Roy. *Film Music - A Neglected Art.* New York: W. W.
 Norton & Company (1977)

Rattigan, Dermot. *Interview for Radio with John Cage* (London 1987)
 Interview tape with author

Reynolds, Gillian. 'Radio Future' in: Hargrave, Andrea Millwood.
 Radio & Audience Attitudes - Annual Report 1994. London: John
 Libby & Company (1994)

Riely, Dominic. 'Who Cares About Radio?' in: *Radio Festival 1997
 Brochure.* London: The Radio Academy, (1997)

Rissik, Andrew. 'Playing Shakespeare False: A Critque of the
 Stratford Voice'. in: NTQ vol.1 no.3 (1985)

Rodger, Ian. *Radio Drama.* London: Macmillan (1982)

Rozik, Eli. *The Language of the Theatre.* Glasgow: Theatre Studies
 Publications (1992)

Serban, Andrei. 'The Life in a Sound' in: *The Drama Review*, v. 20 no. 14

Sandved, K.B. *The World of Music.* London: The Waverly Book
 Company (1957)

Scannell, Paddy. *Broadcast Talk.* London: Sage Publications (1991)

Seymour-Ure, Colin. *The British Press and Broadcasting Since 1945*
 (Second Edition). Oxford: Blackwell (1996)

Shakespeare, William. *King Lear.* London: The Everyman Shakespeare
 (1993)

Shakespeare, William. *King Lear.* (The Shakespeare Recording Society -
 Caedmon). London: Harper Collins Audio Books (1979)

Shakespeare, William. *King Lear.* (RTE) Dublin: RTE Publications
 MC 112 (1988)

Shakespeare, William. *King Lear.* (BBC4). London: BBC Radio
 Collection (1988)

Shakespeare, William. *King Lear.* (The Renaissance Theatre
 Company/BBC3). London: Random House Audio Books
 (1994)

Shaw, George, Bernard. Extract from: '*BBC - Arena Radio Night*'.
 BBC Radio and Television simultaneous transmission for
 'Arena Radio Night (18-12-93)'

Smith-Brindle, Reginald. *The New Music - The Avant-Garde Since 1945.*
 Oxford: Oxford University Press (1975)

Stoppard, Tom. *Stoppard: The Plays For Radio 1964 – 1991.* London:
 Faber and Faber (1994)

Strauss, Neil. (ed.). *Radiotext(e).* NewYork: Semiotext(e) (1993)

Sundberg, Johan. 'Speech, Song, and Emotions' in: Clynes, Manfred.
 (ed.). *Music, Mind, and Brain – The Neuropsychology of Music.* New
 York: Plenum Press (1982)

Taylor, Derek. 'Speech and Drama' in: Borwick, John. (ed.), *Sound
 Recording Practice* - (Second Edition). Oxford: Oxford University
 Press (1985)

Thomas, Dylan. *Under Milk Wood* Everyman (1995)

Thomas, Dylan. *Under Milk Wood.* London: BBC Radio Collection
 (1995)

Thomas, Dylan. *Under Milk Wood.* London: EMI Listen For Pleasure
 (1992)

Thomas, Dylan. *Dylan Thomas narrating 'Under Milk Wood' with the
 Original Cast.* Caedmon Cassette [CDL 52005(2c)]

Thomas, Dylan. *The Complete Recorded Stories and Humorous Essays of
 Dylan Thomas.* Caedmon Cassette (CDL 530006)

Thomas, Dylan. *Quite Early One Morning.* London: J.M. Dent (1967)

Titze, Iago R. *Principals of Voice Production.* New Jersey: Prentice Hall
 (1993)

Tombs, David. *Sound Recording - From Microphone to Mastertape.* London:
 David & Charles (1980)

Tornqvist, Egil. *Transposing Drama - Studies in Representation.* Bsingstoke:
 Menthuen (1991)

Tydeman, John. 'The Producer and radio drama: a personal view' in:
 Lewis, Peter. (ed.), *Radio Drama.* London: Longman (1981)

Utterback, Ann S. *Broadcast Voice Handbook.* Chicago: Bonus Books
 (1990)

Wade, David. 'British Radio Since 1960' in: Drakakis, John. (ed.),
 British Radio Drama. Cambridge: Cambridge University Press
 (1981)

Weiss, Allen S.*Phantasmic Radio.* Durham (U.S.A.): Duke University
 Press (1995)

West, Timothy. 'This Gun That I Have In My Right Hand Is Loaded'
 in: Horstman, Rosemary. *Writing For Radio*. London: A&C Black
 (1997)
Welles, Orson. 'Orson Welles in *The War of the Worlds* by H.G. Wells'.
 London: Hodder Headline Audio Books
Wells, H.G. *The War of the Worlds*. London: Everyman (1996)
Wilby, P. & Conroy, A. *The Radio Handbook*. London: Routledge (1994)
Willis, Edgar. *Writing Television and Radio Programmes*. New York (1967)
Wilson, F.A. *Audio*. London: Barnard Babani (1985)
Wood, Alexander. *The Physics of Music*. London: Chapman and Hall
 (1976)
Worner, Karl H. *Stockhausen - Life and Work*. Berkley/ Los Angeles:
 University of California Press (1976)
Wyatt, Rachel. 'Thousand Ears in CanPlay' CBC Radio Drama
 Internet Publication (1996)
Zilliacus, Clas. *Beckett and Broadcasting*. Abo: Abo Akademi (1976)
Zumthor, Paul. *Oral Poetry*. Minneapolis: University of Minnesota
 Press (1990)

Index

As certain words are used frequently throughout the body of the text it has been decided not to index them at this point. For example, BBC, *King Lear,* music, pause(s), performance, radio play, RTE, Shakespeare, silence(s), sound(s), voice(s), and word(s).

About the author

Dermot Rattigan is a graduate of Trinity College Dublin and University College Dublin. He holds a Ph.D. degree from University College Dublin. His teaching and research interests are in the areas of musicology and media and he lectures on radio drama at the Drama Studies Centre, University College Dublin. He has given guest lectures at a number of institutions including Goldsmiths College (University of London), NUI Maynooth, The National College of Art and Design (Dublin) and has been a specialist radio trainer over a ten year period with The Radio Academy (London) during the annual international radio festival. He has considerable professional experience of radio programme production and music recording. He has made numerous radio programmes in a variety of formats for RTE in the arts, education, and music areas. Some examples of these programmes include *Composers in Conversation* (16 part biographical series), *Brave New Worlds of Sounds* (8 part feature series), *Quiet Please!* (feature), *Drip, Drop, Drip* (documentary), *Monday @ Nine* (115 part education magazine). He is also a music composer/producer whose commissions have included the composition of music and sounds for radio, television, and the theatre. Programmes include *Up the Orinoco, Down the Amazon; Into The Heart of Darkness; The Sad, the Mad, and the Bad; In Pleasant Meads* (documentary about the poet, Francis Ledwidge); *Shame on the Titanic* (docudrama and a Jacobs Award winner).

Publications by Carysfort Press

Theatre Talk

Voices of Irish Theatre Practitioners
edited by Lilian Chambers, Ger FitzGibbon and Eamonn Jordan

A series of interviews/evaluations of the most prominent
playwrights, directors, designers, actors and administrators in
Irish Theatre.

ISBN 0-9534-2576-2 €19.00/$18 *

Theatre Stuff

Critical Essays on Contemporary Irish Theatre
edited by Eamonn Jordan

Best selling essays on the successes and debates of contemporary
Irish theatre at home and abroad.

Contributors include: Thomas Kilroy, Declan Hughes, Anna
McMullan, Declan Kiberd, Deirdre Mulrooney, Fintan O'Toole,
Christopher Murray, Caoimhe McAvinchey and Terry Eagleton.

ISBN 0-9534-2571-1 €19.00/$18 *

Seen and Heard

Six New Plays by Irish Women
edited with an introduction by Cathy Leeney

A rich and funny, moving and theatrically exciting collection of
plays by Mary Elizabeth Burke-Kennedy, Síofra Campbell, Emma
Donoghue, Anne Le Marquand Hartigan, Michelle Read and
Dolores Walshe.

ISBN 0-9534-2573-8 €19.00/$18 *

The Starving and October Song

Two Contemporary Irish Plays
by Andrew Hinds

The Starving, set during and after the siege of Derry in 1689, is a
moving and engrossing drama of the emotional journey of two men.

October Song, a superbly written family drama set in real time in
pre-ceasefire Derry.

ISBN 0-9534-2574-6 €10.15/$9.50*

Publications by Carysfort Press

Urfaust

**A new version of Goethe's early "Faust"
in Brechtian mode, by Dan Farrelly**

This version is based on Brecht's irreverent and daring
re-interpretation of the German classic.

ISBN 0-9534257-0-3 €7.60/$7*

Under the Curse

**Goethe's "Iphigenie auf Tauris",
in a new version by Dan Farrelly**

The Greek myth of Iphigenie grappling with the curse on the house
of Atreus is brought vividly to life. This version is currently being
used in Johannesburg to explore problems of ancestry, religion, and
Black African women's spirituality.

ISBN 0-9534-2572-X €8.15/$7.50*

In Search of the South African Iphigenie

by Erika von Wietersheim & Dan Farrelly

Discussions of Goethe's "Iphigenie auf Tauris" (Under the Curse)
as relevant to women's issues in modern South African: women in
family and public life; the force of women's spirituality; experience
of personal relationships; attitudes to parents and ancestors;
involvement with religion.

ISBN 0-9534-2578-9 €10.15/$9.50*

The Theatre of Marina Carr

**"before rules was made",
edited by Anna McMullan and Cathy Leeney**

Essays by leading commentators and practitioners in theatre,
placing Marina Carr's work in the context of the current Irish and
international theatre scene. This book will examine the creative
dialogue between theatre professionals, Carr's powerful plays, and
their audiences.

2002

* Plus post and packing

General Editor: Dan Farrelly

**Carysfort Press, 58 Woodfield, Scholarstown Road,
Rathfarnham, Dublin 16, Republic of Ireland.**

t: (01) 4937383 f: (01) 4069815
e: info@carysfortpress.com **www.carysfortpress.com**